MAKING**HANDMADE**
BOOKS

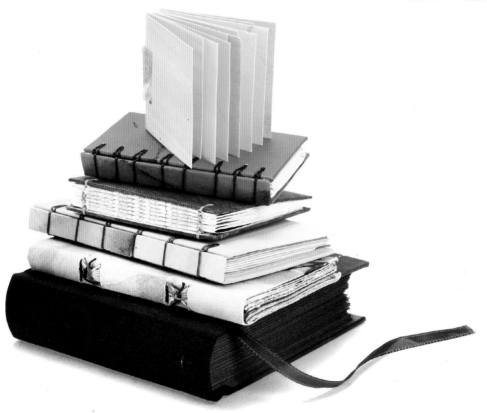

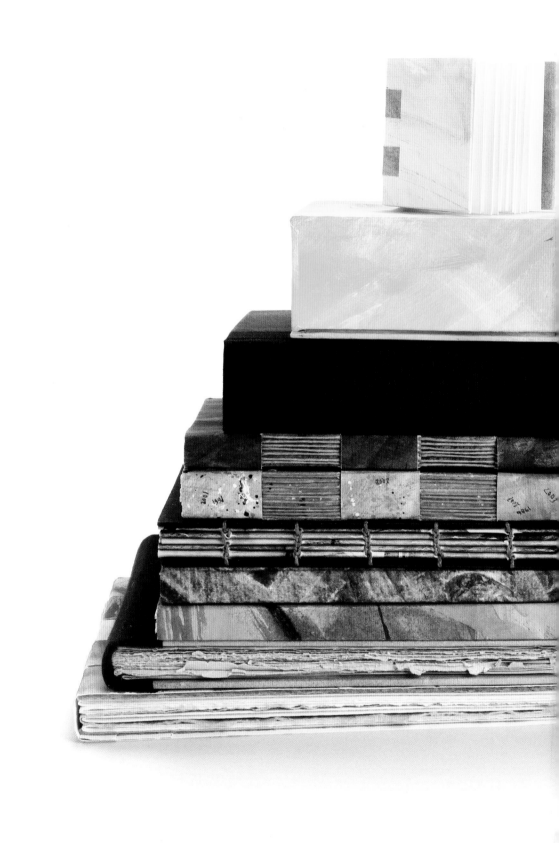

MAKING HANDMADE BOOKS

BOOKS

100+BINDINGS Structures & Forms

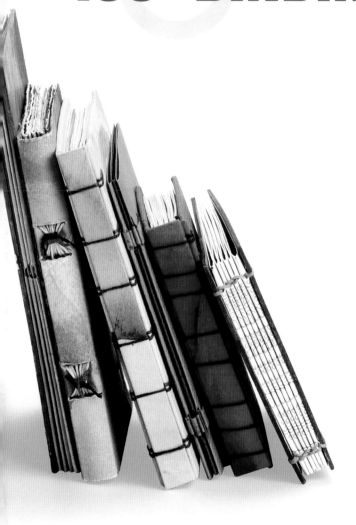

Alisa Golden

LARK
CRAFTS

An Imprint of Sterling Publishing Co., Inc.
New York

WWW.LARKCRAFTS.COM

EDITOR: Kathleen McCafferty

DESIGNERS: Carol Morse
& Travis Medford

ILLUSTRATIONS: Alisa Golden

INTERIOR PHOTOGRAPHY: Sibila Savage
& Jim Hair

COVER DESIGNER: Travis Medford

FACING PAGE: *Rotating Notebooks*,
2000; mixed media books by Patricia
Behning, Alisa Golden, Lynne Knight,
Marc Pandone, Val Simonetti,
Nan Wishner, Yoko Yoshikawa
(photo: Sibila Savage)

Library of Congress Cataloging-in-Publication Data

Golden, Alisa J.

 Making handmade books : 100 bindings, structures & forms / Alisa Golden.

 p. cm.

 Includes bibliographical references and index.

 ISBN 978-1-60059-587-5 (trade pbk. : alk. paper)

 1. Bookbinding--Handbooks, manuals, etc. 2. Book design--Handbooks, manuals, etc. I. Title.

 Z271.G625 2010

 686.3--dc22

 2010001546

10 9 8 7 6 5 4 3

Published by Lark Crafts, An Imprint of
Sterling Publishing Co., Inc.
387 Park Avenue South, New York, NY 10016

This book is comprised of material from the following Sterling titles: Creating Handmade Books © 1998,
Alisa Golden; Expressive Handmade Books © 2005, Alisa Golden; Painted Paper © 2008, Alisa Golden;
Unique Handmade Books © 2001, Alisa Golden

Text © 2010, Alisa Golden
Photography © 2010, Alisa Golden, unless otherwise specified
Illustrations © 2010, Alisa Golden, unless otherwise specified

Distributed in Canada by Sterling Publishing,
c/o Canadian Manda Group, 165 Dufferin Street
Toronto, Ontario, Canada M6K 3H6

Distributed in the United Kingdom by GMC Distribution Services,
Castle Place, 166 High Street, Lewes, East Sussex, England BN7 1XU

Distributed in Australia by Capricorn Link (Australia) Pty Ltd.,
P.O. Box 704, Windsor, NSW 2756 Australia

If you have questions or comments about this book, please contact:
Lark Crafts
67 Broadway
Asheville, NC 28801
828-253-0467

Manufactured in China

ISBN 13: 978-1-60059-587-5

For information about custom editions, special sales, premium and corporate purchases, please
contact Sterling Special Sales Department at 800-805-5489 or specialsales@sterlingpub.com.

For information about desk and examination copies available to college and university professors, requests
must be submitted to academic@larkbooks.com. Our complete policy can be found at www.larkcrafts.com.

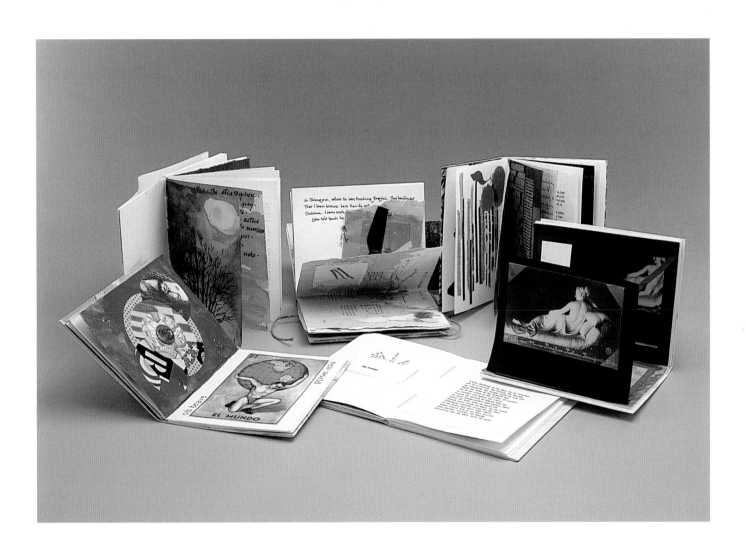

MAKING HANDMADE BOOKS
100+ BINDINGS Structures & Forms

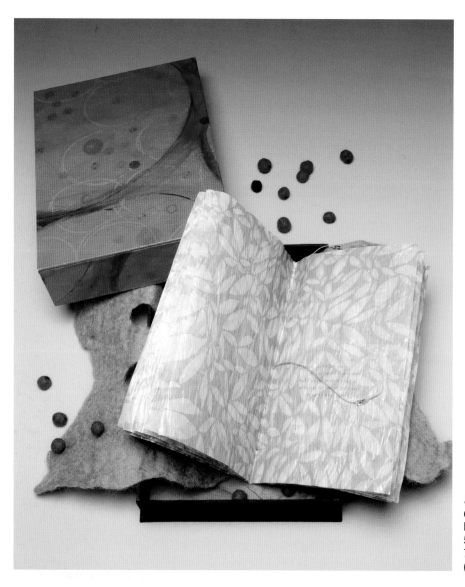

Spotted One Day, 2009; letterpress, linoleum cuts, handmade felt; single signature binding, handmade two-piece box; 5¾ x 8½-inch book, (14.6 x 21.6 cm) 7⅛ x 9¾ x 2¼-inch box (18.1 x 24.8 x 5.7 cm) (photo: Sibila Savage)

INTRODUCTION

Making a book is easier than you think. A piece of paper and a pair of scissors are all that's required to get started. Add a needle and thread, some glue and a brush, and you have the necessary equipment to make a variety of beautiful and creative structures.

The chapters that follow cover the fundamentals of bookmaking as well as more advanced techniques. But don't be intimidated! Think of the first books you create as samples—they'll be blank inside. When you feel comfortable doing your own binding, or when you feel inspired, you can try a different approach to making books—a method I call "working from the inside out." This can mean finding or creating words and images first, then binding them into a book. Or finding something inside yourself—a memory or an emotion—that needs to be expressed and articulating it. Ask yourself two questions: "What do I want to make?" and "What do I want to say?" Answering these questions can get your creative juices flowing.

The structures that follow are arranged within their chapters according to skill level, from simple to complex. Before you begin any of the projects, read the

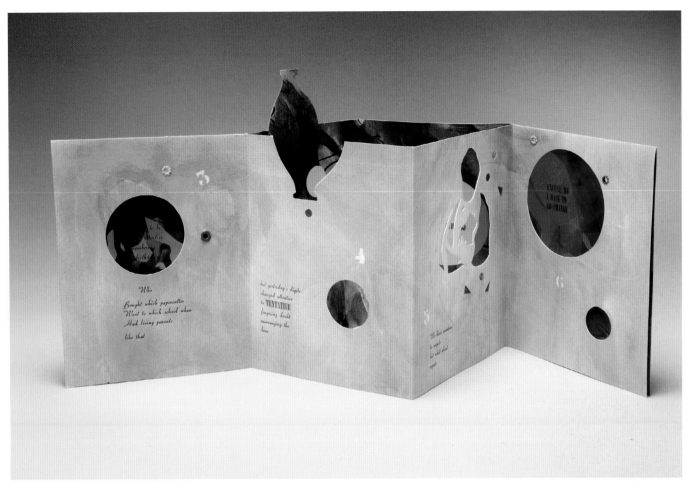

Go Change, 2008; letterpress on acrylic ink painted paper, colored film; X book; edition of 7; 5¹⁄₈ x 7 inches (13 x 17.8 cm) (photo: Sibila Savage)

instructions carefully to familiarize yourself with the process. You'll build your skills as you go along.

This book was originally published as two separate volumes, *Creating Handmade Books* (1998) and *Unique Handmade Books* (2001). From those two titles, I gleaned techniques that focus on a variety of book structures—from simple sewn and glued forms to more sophisticated creations involving boxes and slipcases. I also selected instructions on how to make movable books—playful pop-ups, accordions, and scrolls that represent the interactive side of the craft. To supplement the original text, I asked prominent makers in the book arts community to send me statements about their creative

lives and work processes. A number of these artists have been making books for more than 20 years, and many of them are educators. I hope you'll be inspired by their words and ideas.

The structures you'll discover within these pages are versatile and can be used to tell just about any story. But keep in mind that your binding and your materials should enhance that story. They should relate to your narrative and clarify it. Here's an example: For *The Hand Correspondence*, my art-by-mail series, I put three books into three handmade envelopes and mailed them to buyers. The stamps and the buyers' names became part of the art, and they reinforced my theme, which was communication.

When it comes to learning something new, most of us are afraid to admit we're beginners and worried about making mistakes. As an artist I take the opposite tack—I welcome accidents. There's no better way to become familiar with a new craft. So I urge you to put your fears aside and embrace your mistakes. Be messy. Experiment. Accidents make wonderful learning opportunities. Each time you complete a book, your understanding of what makes a workable structure will increase.

With practice, you'll be able to design bindings to suit specific projects, and you'll find that certain structures suggest certain types of content. For instance, fiction, nonfiction, and groups of images

that clearly have a narrative are most easily read in bound form. And speaking of content, individualizing your books through accents like photographs and memorabilia is one of the most exciting parts of the bookmaking process. You can cover the blank pages with family stories, rubber-stamped poems, improvised doodlings—anything that inspires you. Through personal touches, your hand-made books will be vibrant and alive.

A final word of advice: When you decide to create a book—whether it's a gift or simply an experiment—make an extra one as a backup. You'll feel less stressed if you make a mistake, and binding that additional book will help you improve your skills.

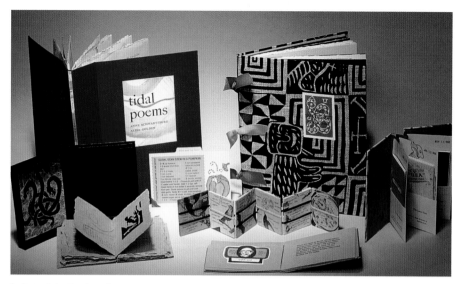

Left to right (back to front): *Tidal Poems*; *Lizard's Snake Suit*; *Waking Snakes*; *Fly on a Ladder*; *Cinnamon & Saffron*; *The Lending Library* (photo: Jim Hair)

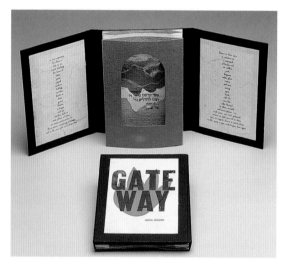

Gateway, 1992; letterpress and torn paper; tunnel book; edition of 40; 5 x 7 inches (12.7 x 17.8 cm) (photo: Jim Hair)

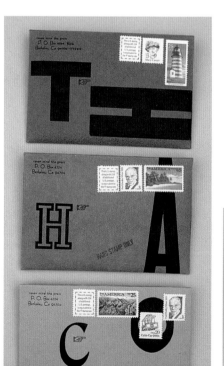

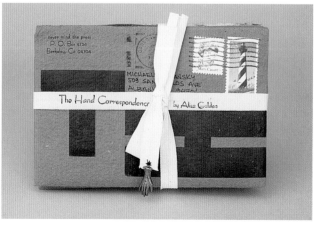

The Hand Correspondence, 1990-1991; letterpress and mixed media; bundle of single signature books in envelopes; edition of 40; 4 x 6 inches (10.2 x 15.2 cm) (photo: Jim Hair)

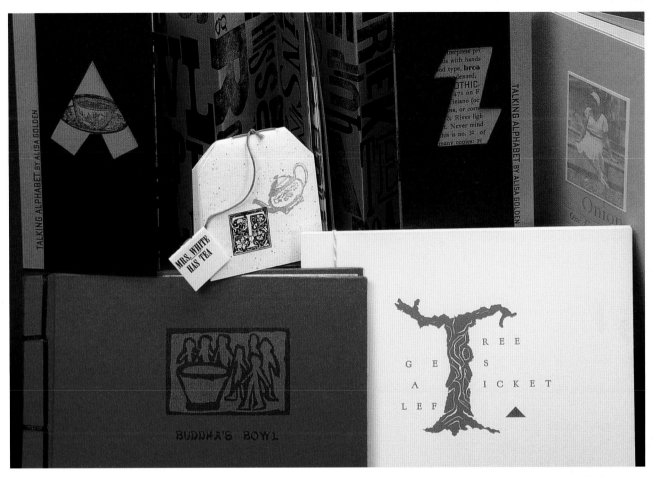

Left to right (back to front): *Talking Alphabet*; *Onion*; *Mrs. White Has Tea*; *Buddha's Bowl*; *Tree Gets a Ticket Left* (photo: Jim Hair)

MATERIALS & METHODS

Throughout history, each culture has made books with available materials. In the Tigris-Euphrates Valley, people inscribed the clay that was abundant there and baked it into a variety of shapes. Although these forms presented pictographic stories, they were not the rectangular books that are commonly seen today; they were cones, columns, and circles. In India, people wrote on palm leaves. In Egypt, they wrote on paper made from the papyrus plant as well as on animal hides, stitching the sheets together to make long scrolls. The Greeks and Romans made thick wooden frames, filled them with wax, and bound them together at the edge to make their first books. The word *codex*, the modern-day book, comes from *caudex*, from the Latin for "tree trunk," "board," or "writing tablet."

Paper is common in our culture and used extensively for bookmaking, yet we continue to seek other materials to make books and art. Berkeley-based artist Lisa Kokin used old sewing patterns in her book titled (after a book by Ken Kesey) *Sometimes a Great Notion.* Lisa's book begins, "Textiles are a genetic condition with me." Cloth is a prominent part of her family's history, beginning with her Romanian immigrant grandmother who worked in a tie factory in the early

1900s. Growing up in her parents' small upholstery shop further influenced Lisa as she made collages out of leftover pieces of vinyl and foam rubber. You can bring your own personality and background to your work by using materials familiar and important to you.

You can make interesting books with ordinary materials, but you may find some materials are easier to work than others and produce better results as well. As you work, take notes. Is the paper too stiff? Is it too translucent? Does it rip too easily? Does the color run when you try to paint on it? Does the glue wrinkle the paper? Working with a variety of materials will give you important knowledge for future projects.

Within the chapters of this book are instructions for books made of paper, although they could be modified for cloth or other materials. While some of the bindings are my own designs, most are designs that have evolved from traditional forms, very often rediscoveries by conservationists who have worked to restore rare books. Perhaps because I have seen the varying condition of these older books in libraries, I emphasize working with archival materials that will remain strong and that will not yellow over time. Stability is one of the rewards for spending time and care on your book project.

The following reference guide can help you choose suitable tools, thread, papers, and boards. It also includes basic stitches, knots, and bindings.

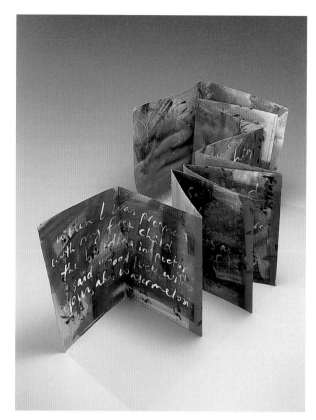

Watermelon, 1998; acrylics, canvas, paper, linen tape; tabbed accordion; 7½ x 10½ inches (19.1 x 26.7 cm) (photo: Sibila Savage)

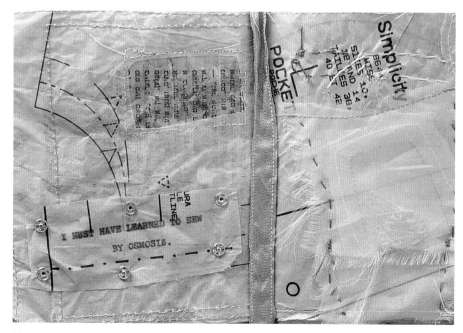

Lisa Kokin: *Sometimes a Great Notion*, 1992; text by the artist; mixed-media sewing notions, fabric, sewing patterns; 6 x 5 x 1 inches (15.2 x 12.7 x 2.5 cm) (photo: Lisa Kokin)

TOOL**BOX**

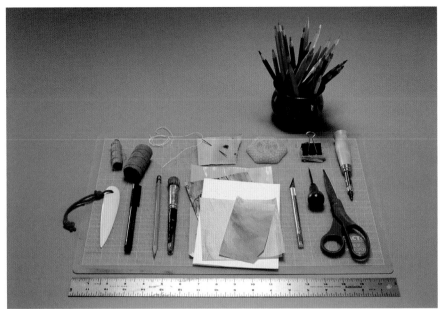

Top:
Watercolor pencils

Second row:
Colored waxed linen, natural linen thread and bookbinding needle, beeswax, binder clip, Japanese screw punch

Third row:
Bone folder, archival superfine black pen, pencil, stencil brush, assorted papers, craft knife, awl, scissors

Bottom:
Metal ruler; cutting mat under all

Some basic tools are necessary to make the structures in this book. You will find more detailed descriptions in the following paragraphs.

Measuring, Marking, and Scoring

Pencil

Metal ruler, 18 inch (45.7 cm) or 24 inch (61 cm)

Bone folder—a wide, flat stick with one pointed end for creasing paper and making grooves in the paper to aid folding

Architectural divider—an adjustable device that looks like a compass

Spacing bar, $3/16$ inch (4.8 mm)—usually made of brass and found in the hobby section of the hardware store

Cutting

Scissors

Art knife and extra blades, such as #1 craft knife and extra #11 blades

Utility knife, craft knife, or mat knife and new blades for cutting boards

Cutting mat (any color self-healing cutting mat) or layers of cardboard

Sandpaper or emery board, fine-grain (to smooth the rough edges of cut boards)

Sewing

Awl, bodkin (clay "needle" tool), or drill with tiny bit and vise/clamp

Needle (a bookbinding needle is strongest)

Curved needle (for chain stitch, often sold with quilting supplies)

Thread (linen, poly-wrapped cotton, or anything that doesn't stretch or break when pulled)

Waxed linen thread in various colors

Beeswax, to wax thread (makes thread less likely to tangle and helps hold the knots more tightly)

Hammer (small ball-peen hammer is good) and punches; or Japanese screw punch

Bulldog or binder clip (medium), paper clips for smaller projects

Mull or Super—a coarsely woven material that looks like cheesecloth and holds a book together

Gluing

Self-adhesive linen tape (for the circle accordion structure)

Wheat paste powder or unbleached white flour

Stainless steel strainer (strains lumps out of paste)

Polyvinyl acetate (PVA) glue

Plastic containers (wide-mouthed, such as cottage cheese containers) and paper plates

Stencil brush, large-size (flat bottom, 1 to 2-inch [2.5 to 5.1 cm] round diameter; make sure bristles are firmly attached) or 2-inch (5.1 cm) flat brush

Pages from glossy magazines or catalogues to use as scrap paper (Use plenty, so you can have a new, clean surface every time you glue something. Use glossy paper, because the ink will not transfer to your project. Do not use newspaper.)

Heavy book or small weight, such as a brick (wrapped in paper to keep project clean. Use as a weight to flatten your book while it is drying.)

Waxed paper (to put on either side of your book as a barrier between glued parts and the weight used for drying; also to put between glued endsheets and the dry book block)

Wood glue (for scroll knobs)

Optional Tools

Woodworker's wedge tool

Circle cutter (for a box made of circles)

Centering ruler—has the zero in the center

Tweezers

Fiberboards, 12 x 16 inches (30.5 to 40.6 cm) (smooth on two sides, to use between books or covers that were glued and need to be dried flat)

Cloth tape, bookbinder's, in different colors (for portfolios)

Polymer clay for making buttons or clasps

Varnish for the polymer clay

Bone clasps

Raffia (a strawlike cord, it comes in a natural tan and in other colors)

Rubber-stamp alphabet

Stamp pads (look for pigmented and permanent, not dyed)

Erasers, white plastic or artgum

Ribbon

Acrylic paints

Acrylic gel medium

Gesso

Acrylic inks

Marking pens, pigmented and archival

PAPER

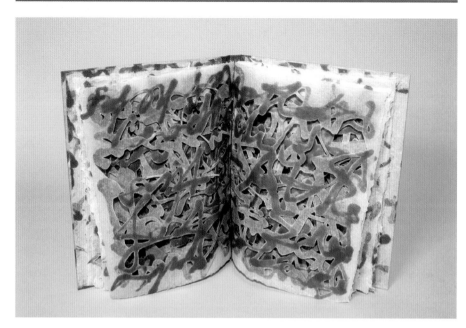

Robbin Ami Silverberg: *Thoughts in the Form of a Letter*, 2003; pulp painted text and cutouts from abaca papers, cut-out pieces in plastic sacks; edition of 5; 9 x 12¼ x 1¼ inches (22.9 x 31.1 x 3.2 cm) (photo: Gregg Stanger)

Since paper is the most versatile material for the structures explained in the following chapters, it is useful to understand the properties of different kinds of papers and how they can be handled in order to make successful books.

Grain

Most papers have a grain, or a direction in which they would more naturally curl. In making books, grain should always run parallel to the spine so that the paper can be folded easily and it will not curl against the natural page-turning action.

To find the direction of the grain: roll or lightly fold the paper in one direction and then with the same side up, do the same motion in the opposite direction. Do not crease. Whichever way the paper bends more easily is the direction of the grain. If the grain is parallel to the longest side of the paper, we say it is grained long. To understand about paper grain, tear a piece of newspaper first one way and then the other to see which yields a straight, not ragged, edge. The grain is parallel to the straight edge. Some Asian and handmade papers have no distinguishable grain.

Photocopy papers are usually grained long; in other words, they are parallel to the longest side of the paper. Some business paper or fine stationery is often grained short, or parallel to the short edge of the paper. At business and stationery supply stores, you may be able to check the grain on a sample sheet before you buy.

Always cut your paper so the grain is parallel to the spine. Cut all boards and papers so the grain runs in the same direction; this is especially important when you begin using adhesives. When the boards and papers become wet with glue, they will curl along the grain and dry that way if they are not flattened while drying. If you glue two pieces of paper with mismatched, or crossed, grain, each will pull in a different direction, and the finished project will be warped.

Choosing Size

Many of the structures in this book can be created from sheets of 8½ x 11-inch (21.6 x 27.9 cm) paper. Once you make a model with which you are satisfied using standard copy paper, you may want to make a book from different paper and of a different size. See the list on page 19 for the suggested weight and type of paper for each project.

Before you begin to make the final book, you may want to decide if the book should be small, medium, or large. Smaller books are from over 3 inches (7.6 cm) to a maximum of 6 to 8 inches (15.2 to 20.3 cm). Whatever you can hold in your hand and still turn the pages is considered a small book. These are the most intimate and are good for personal subjects. Books smaller than 3-inch (7.6 cm) square are called miniature books and are often sought by collectors. Medium-size books can be held in the lap and shared with another person. I think of large books as being suitable for public and political subjects. They are read on a table or displayed in a case. Many people can view them at one time.

The scale of your book may determine the weight of paper you will use; the smaller the book, the thinner your paper and boards can be. Larger books have more presence if they are made from thicker paper and boards, but this is not an absolute rule: your dreamlike content may require a double-folded, translucent paper, for example.

Once you have decided on miniature, small, medium, or large paper, divide a sheet into halves, quarters, and eighths. See if one of these sizes works, which will avoid wasting paper. Some standard sizes of fine art papers are 18 x 24 inches (45.7 x 61 cm) (drawing paper, colored—but not construction—paper); 22 x 30 inches (55.9 x 76.2 cm) (most heavier, printmaking papers); and 27 x 35 inches (68.6 x 88.9 cm) (Asian papers, which some people call rice paper, although the paper contains no rice whatsoever).

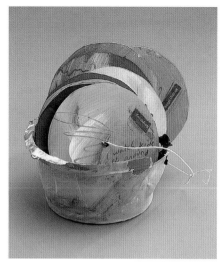

Flavors, 2000; acrylic painted, collaged papers in bowl made of acrylics, gel medium and PVA; palm leaf book; 3-inch (7.6 cm) diameter (photo: Sibila Savage)

TEARING & CUTTING PAPER

While stationery and office supply stores offer decent papers in small sizes, art supply stores stock many fine papers made in larger sheets that can be cut or torn to the desired dimensions. Tearing the paper will feather the edges, making them look somewhat like the deckled edges of handmade paper. Cutting the paper gives a clean, precise look, which can be a nice contrast if you are working with collage or with painted paper.

Tearing Paper

If you prefer a handmade look to your paper and the paper is not handmade, you may tear the paper against a heavy ruler to produce rough edges. First, determine the paper grain. This will give you options for the final size; for a traditional

codex the final tear should be against the grain, so it may be folded in half with the grain. You may, of course, change the size and have random scraps leftover, but this way you can use all of your paper for your book.

For this example, let us assume that you are working with a stack of textweight drawing paper that is 18 x 24 inches (45.7 x 61 cm), grained short. You will be able to make two or four tears since the even tears are against the grain. Your book size could be 6 x 9 inches (15.2 x 22.9 cm) or 3 x 4½ inches (7.6 x 11.4 cm). Measure and mark 12 inches (30.5 cm) (halfway point) along both of the 24-inch (61 cm) edges. Align a heavy ruler (18 inches [45.7 cm] or longer) with the marks. Press down on the ruler with one hand. Pick up the corner of one sheet

on the side that is closest to your free hand and pull up and toward both you and the ruler. Tear up against the ruler. You may need to stop and start as you go. When you are finished, keep your hand on the ruler and tear the next sheet on the stack. Continue until you have torn all of the papers. Align the torn edges. Rotate the stack 90 degrees. Measure and mark at 9 inches (22.9 cm) (halfway point). Tear up against the ruler like you did before. You should now have a stack of paper that is 9 x 12 inches (22.9 x 30.5 cm), ready to be folded into a book 6 x 9 inches (15.2 x 22.9 cm) with the grain going in the proper direction (parallel to the fold and the spine). For thicker paper you may need to tear in shorter bursts of stopping and starting.

Cutting By Hand

We learn to use scissors at an early age; therefore, most people are comfortable with them. When cutting paper for more complicated books, however, scissors can yield an imprecise cut. They are also not practical for cutting large quantities of paper or heavy board. It is much better to cut a precise line with the very sharp blade of a small art knife. So, in addition to scissors, you will need a small knife and blades, a metal ruler, and cardboard or a self-healing mat to protect your work surface and prolong the life of your blade.

Always cut against a metal ruler or straightedge because plastic and wood can be nicked easily, which will give you a wobbly cut. Cork-backed rulers don't slip, but be aware of the extra thickness from the cork. Since the cork does not extend to the edge, a cork-backed ruler is slightly unstable. If you do not press firmly on the ruler, your knife can slip underneath it, and if you press on the edge of the ruler you risk slicing your fingers. You can also put masking tape on the back of a ruler for extra traction. Work on top of cardboard or a self-healing cutting mat to protect your furniture and to keep your knife blade from getting dull too fast.

The good thing about the mat is that you can reuse it for many years. Cardboard is inexpensive, but if you reuse it, the previous cuts in the cardboard will interfere with future cuts.

Cut against a metal ruler only. Do not attempt freehand cuts. Keep your fingers behind the edge of the ruler. I find it easier to maintain a straight cut and even pressure if I am standing up while I cut. I can get a good angle, see what I'm doing, maintain even pressure, and make a cut in one stroke.

A mat knife or utility knife, also with a new or sharp blade, is preferable for cutting stacks of paper and boards. You can tell your blade is getting dull if the board doesn't cut all the way through the first time or has a ragged edge. If you do have a ragged edge, the tiny tip of your blade has probably broken off. In all cases, keep your fingers on top of the ruler, not over the edge! Keep a good stock of fresh knife blades on hand. A dull knife can ruin a project. Dull knives can be more dangerous than sharp ones.

Purchasing a Paper Cutter

When you find yourself cutting paper for many books or for books with many pages, you may consider purchasing a paper cutter. Two kinds are sold in art supply and office supply stores. One has a long, large blade that chops the paper. The other has a sliding or rotating blade that slits the paper, much like a handheld knife. Some cutters have a self-sharpening blade, and sometimes the blades are small and easy to replace without worrying about proper alignment.

I use a large 24-inch (61 cm) chopper and a lightweight 12-inch (30.5 cm) cutter with interchangeable, rotating blades. The standard blade makes a straight cut; the fancy blades make zigzags, perforations, scallops; one even scores paper without cutting it. The small cutter cannot cut boards. The large chopper is excellent for cutting large, heavyweight

paper. To cut boards, it's necessary sometimes to push tightly on them, to prevent them from pulling or shifting as the blade comes down and making a diagonal cut. It helps to pull the handle of the chopper in toward the boards as you bring it down.

Board cutters are also available. If you find yourself making lots of boxes or hardcover books, consider one. They come in a variety of sizes and prices with either a 45° angled/beveled head or a 90° head (you'll want the latter for books and boxes). I find I can measure and cut by hand adequately with a mat knife and a long metal ruler.

Whether you choose a chopping cutter or a slicing one, a ruler printed directly on the cutter is extremely useful. You can measure and cut at the same time, leaving less chance for error.

FOLDING& SCORING PAPER

Fold paper by matching two corners and aligning the edge that is perpendicular to the fold you are about to make. With the side of your hand or a bone folder, smooth and crease from the corner diagonally toward the fold. Work progressively toward the top of the paper. Folding paper by aligning it this way takes into account that the paper may not be perfectly square when you begin. This could be due to a misaligned paper cutter or a hasty mistake by the paper manufacturer.

Any size bone folder is helpful to make a tight, neat crease. But you can use other tools, such as a wooden spoon. A bone folder is a smooth, flat, wide stick made of cow bone, hard plastic, or teflon, although they used to be made of whalebone. Bone folders may have either two rounded ends, or one rounded end and one pointed end. The point is great for scoring paper. You can resharpen the point by sanding it or filing the edges. The teflon folder is best for smoothing bookcloth or black paper, as it leaves no shiny burnishing marks.

Binder's Fold: Folding and Slitting Paper for Signatures

I learned this folding method at a workshop at the San Francisco Center for the Book called "The Ideal Sketchbook," by Dominic Riley, a fine binder from England. It is a particularly handy technique for keeping a four-page signature together when sewing a codex (see Chapter 7, The Codex). It works well for a rustic looking book, with its torn-paper edges. You will generally want to start with a paper that is grained short, or cut it so that it becomes that way. Try different slitting devices like a plastic knife or letter opener for different ragged looks. Generally, you are trying to create a feathered edge, not a

bur. You can also try applying a fine grain sandpaper to the ragged, slit edges.

Example: 18 x 24-inch (45.7 x 61 cm) drawing paper, grained short, for a 6 x 9-inch (15.2 x 22.9 cm) text block

1. Fold paper in half, widthwise (with the grain).

2. Take a butter knife (the diagram shows a craft knife) and, stopping two-thirds of the way, slit inside the fold as if you were opening a letter.

3. Fold in half, widthwise (against the grain).

4. Slit like step 2.

5. Fold in half, widthwise (with the grain).

6. Slit like step 2.

7. Repeat steps 1–6 with a new sheet of paper for as many signatures as you need, always ending by folding with the grain, then slitting for the last time.

Scoring Paper

Score paper by marking it lightly at the top and bottom with a very sharp pencil (a dull pencil can yield a wide mark, which can interfere with your careful measurements). Line up a ruler to the marks; and, with the pointed end of the bone folder, your thumbnail, or butter knife, press a line into the paper.

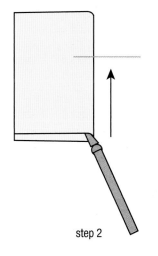

step 2

step 3

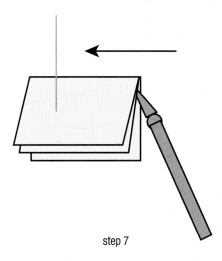

step 7

PAPER**SELECTION**

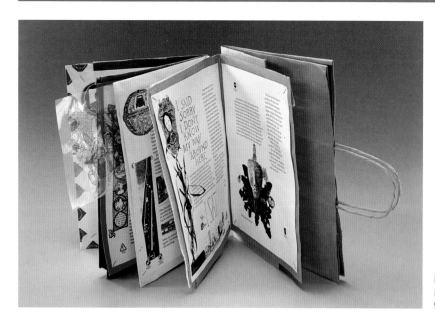

Betsy Davids: *Quest for Arberth*, 1990/1994; mixed media with photocopies and paper bags; 9¾ x 13 inches (24.8 x 33 cm) (photo: Sibila Savage)

Lightweight papers

Papers in this group fold, wrinkle, and tear easily. They are often somewhat translucent. Examples include 20 to 24 lb. bond paper (laser writer, or copy paper), glassine, newsprint, origami paper, and Asian papers such as mulberry paper.

Medium-weight papers

These can be folded repeatedly. They can accept layers of drawing. They are opaque. A sheet of this paper will not tear easily if a hole is cut in it. Examples include the paper of a manila envelope, all-cotton resumé paper, glossy magazine covers, and decorative papers that you cannot see through.

Heavyweight papers

These hold up well to paint and gesso and repeated erasures. Examples include printmaking paper, cover stock, index cards, and watercolor paper.

2-ply board

This is a board that is made of two layers of thick paper. Two-ply museum board is preferred for archival use, since it is 100 percent cotton and does not readily turn yellow or show spots over time. For nonarchival use, you can substitute cardboard that is the thickness of the cardboard used for cereal boxes.

4-ply board

This is a stiff board that is made of four layers of thick paper. Museum board is archival and is available in 4-ply thickness. Mat board and illustration board are nonarchival 4-ply boards that are available in a wide variety of colors.

This is my list for those people who work with archival materials. Archival is generally acid-free or pH-neutral to start. Acids are in the air, oils are on fingers, so unless the book is sealed in a box in the dark, unread and untouched by our

hands, it will change slightly over time. Buffered papers contain an additive that makes them slightly alkaline, which gives them a longer lead time before they yellow, turn brittle, or begin foxing (become spotted). I generally prefer archival materials for making books because of their durability, because they can be folded, glued, and sewn with good results, and because they are a pleasure to use.

For making books in school, copy paper, Manila folders, and white drawing paper are also viable. Book art can be and is being created out of anything. You may like the wonderful selection of recycled papers, or you can use various cardboards or paper bags.

ARCHIVAL PRINTMAKING/FINE ART PAPERS

	WEIGHT	TYPE OF BOOKS	SUGGESTED PAPERS
Text	95–120 grams/ square meter	signature books, slot and tab, chain stitch, multiple-signature books, album accordion, tabs for tunnel books, flexagons	Mohawk Superfine, Rives Lightweight, Yatsuo (Moriki), German Ingres, Lana laid, Nideggan, resumé paper, Canson lightweight, Velin Arches, Strathmore 400
	120–250 grams/ square meter	accordion-fold book, woven accordion	Lenox 100, Arches, Rives BFK, Canson Mi Teintes, Stonehenge, Somerset Textured/Smooth, Velin Arches
	40–115 grams/ square meter	sidebound book, with pages folded in half	mulberry paper, hosho, Yatsuo, other Japanese papers, or very light-weight Western papers: Rives lightweight, Lana laid, Nideggan
	160–250 grams/ square meter	photo album, sidebound book (landscape oriented only)	Arches cover, Canson Mi Teintes black, German Etching black, Stonehenge, Lenox 100, Somerset, Rives BFK
	160–300 grams/ square meter	accordion-fold books, tunnel book pages, palm leaf, Venetian blind, chain stitch (only 1–2 sheets per signature)	Lenox 100, Arches, Rives BFK, Canson Mi Teintes, Stonehenge, Somerset, Magnani Pescia
	90–115 grams/ square meter	pocket book	Rives Lightweight, Nideggan, German Ingres
Scrolls	40–60 grams/ square meter	—	mulberry, Thai Unryu, Yatsuo
Cover paper for softcover or pocket books	160–250 grams/ square meter	—	Canson Mi Teintes, St. Armand, Rives BFK, Stonehenge, Arches Cover, Lenox 100, Somerset, or other thick paper
Paper portfolios	245–250 grams/ square meter	—	medium–heavy weight, non-brittle: St. Armand, Larroque Mouchette
Cover paper for wrapped boards	130–250 grams/ square meter	—	Canson Mi Teintes, St. Armand, Fabriano Ingres
Boards for hardcover books and Jacob's Ladder	—	—	4-ply museum board (100% rag, acid-free); 2 ply for small books, split board, or slipcase, Davey board
Cover paper for hardcover book, box or portfolio	35–75 grams/ square meter	—	any medium-weight Japanese paper or medium- to light-weight Western paper, book cloth, double-sided (laminated) Thai Unryu paper, light papyrus, German Ingres
Endsheets	35–160 grams/ square meter	—	decorative Asian papers, Canson, other light-weight (not sheer) decorative papers (darker colors probably work best, because they hide any of the outside covers' turn-ins), Velin Arches (white, good to paint on)

BOARDS

Boards can be made of wood pulp or cotton; I recommend book board or museum board for best long-term results. Use nonarchival chip board only when it is not important for the project to last long or when cost is an issue, such as in an elementary school classroom.

Museum Boards

All cotton and acid-free, these boards are usually used for picture framing or for presentations in gallery and museum settings. They come in 4-ply and 2-ply and are found in most art supply stores. They are soft and fairly easy to cut with a standard art knife. The 4-ply ($1/16$ inch or 1.7 mm) is recommended for most bookmaking purposes; it may require a new blade or multiple strokes to cut all the way through. Since this board comes in white and off-white, it can be painted on directly with good results. You may also find it in black, gray, and other neutral colors.

Davey Board

Also known as book board or binder's board, this is a high-quality buffered board made of sulphite pulp, which comes in various thicknesses. A good weight for books less than 10 inches (25.4 cm) in either direction, 25 cm is 1.7 millimeters (0.1 inch) thick, which is approximately the equivalent of a 4-ply museum board. Board thicker than this can be very difficult to cut. You will need a heavier knife, such as a utility or mat knife. Davey board thickness is also given as a caliper size, which is measured with a micrometer in caliper points. Each caliper point is equal to .001 inch (0.03 mm).

Some Davey-board thicknesses and approximate equivalents:

1.7 mm, .067 caliper, 1/16 inch, or 68 pt.

1.9 mm, .074 caliper, 5/64 inch (slightly between 1/16 inch and 1/8 inch or 74 pt.)

2.1 mm, .082 caliper, 3/32 inch, or 80 pt.

Illustration Board

Look for boards that say all-cotton (or rag) and acid-free. Some have a backing sheet that is not acid-free. Over time, such boards will yellow or begin to turn spotty (this is known as foxing).

Bristol Board

Generally, this is a board that used for drawing. A 2-ply, all-cotton board with a very smooth plate finish is very good to use as a spine piece for the rounded spine piece for a hardcover book. It is thinner than the 2-ply museum board, and therefore, more flexible. It also comes in 4-ply.

Cutting Boards by Hand

Please refer to Cutting Paper by Hand on page 16 for complete basic instruction. For best results, use a heavy duty mat knife with a sharp blade and work standing up so that you have good control over your knife. Always cut against a metal ruler. You will likely need to make several strokes of a cut in the same place before the board is completely in pieces.

Templates

Making a template is helpful if you are making an edition. By using a template you don't need to measure every time you want to make a window. You can also use the template for a placement guide: you may want a small collage on the front cover of every book in exactly the same place. Draw light pencil lines that can be erased later with a white plastic eraser. (Pink erasers often leave marks.)

Begin with a sturdy, noncorrugated cardboard (like a 2-ply museum board or 4-ply bristol board) the same size as your page. Measure precisely where you want the window, and use an art knife and metal ruler to cut out the hole. Put sturdy plastic tape around the edges of the opening, if you desire. Use this template only for drawing! Do not use it as a cutting guide. With pencil, draw through the template to your project where you want the hole. Use an art knife against a metal ruler to cut the window.

ADHESIVES

With small amounts of thinly spread glue you can quickly connect many pages to make notepad-like books, a flower structure, accordion-folded books, and scrolls.

For an applicator, use a brush of a size suitable for your project (small amounts of glue can be applied with a small brush, larger amounts with a larger brush). A strip of board is also a handy tool. Work atop layers of clean scrap paper (old magazines) so you can discard any sticky sheets and avoid getting unwanted glue spots on your project.

You can make most of the structures in this book with PVA. Polyvinyl Acetate or Adhesive (PVA) is a white synthetic glue that dries quickly and remains flexible and strong. PVA dries clear but shiny and will show, especially if it gets on book cloth.

Wheat paste is an organic substance that dries more slowly and allows a little time for repositioning if necessary. Paste is

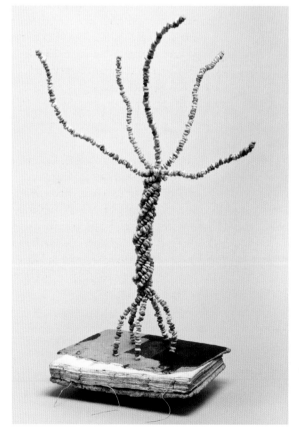

Lisa Kokin: *Un Life*, 2008; reassembled first edition of *Uncle Tom's Cabin* chewed by dog, PVA, wire; 18 x 8 x 6½ inches (45.7 x 20.3 x 16.5 cm) (photo: Lia Roozendaal/Jagwire Design)

easier to wipe off book cloth. I often like to use a combination of both to obtain the advantages of each. The projects described may require paste or glue or a combination. Whatever adhesive you use, work from a small amount at a time; poured onto a paper plate, the glue is easy to work with and keeps the main batch free of paper fibers, brush hairs, and other particles.

If your paste or glue is too thick, add only distilled water to thin it, if possible. Distilled water is most important if you are using all archival materials and wish to keep the book acid-free. Otherwise, the acids in the tap water may eventually cause spots to appear on your book.

A good glue brush needn't be expensive. A round, flat-bottomed stencil brush in a medium to large size (1 to 2-inch [2.5 to 5.1 cm] diameter) or a flat 2-inch-wide brush (5.1 cm) works well. Wash brushes right away when finished. Make sure you have rinsed out all of the adhesive by squeezing the wet ends and checking for traces of white glue. When dry, PVA is extraordinarily difficult to get out of brushes; you can soak it out with warm water over a few days with varying results.

When working with children or making a mock-up or sample, you may wish to use a glue stick. In general, the adhesive in a glue stick is not as strong and the book may fall apart. Pritt glue stick is the stickiest and is pH neutral, but takes a long time to dry (which can be good if you want to reposition something). It can be difficult to locate; however, it is available through some mail-order sources of archival materials. Scotch permanent adhesive glue stick is also pH neutral and archival.

In all cases, when working with adhesives, place waxed paper between pages that have been glued together, and press the book under a heavy book or under boards and weights overnight.

Cold Water Paste

Daniel Smith, Inc., in Seattle, Washington, sells wheat paste powder that does not require cooking. While you can buy wheat paste from art supply stores, I prefer this archival wheat paste powder. I have tried various wheat starch pastes, but find them too gelatinous, hard to spread, and hard to mix with PVA. I now stay away from packages with the word "starch" on the label. If the archival quality of the paste is not crucial to you, use wallpaper paste or flour-type thickeners.

To mix paste and water or paste and glue: Add a teaspoon at a time of the dry powder paste directly to glue or water and stir quickly. It works like oatmeal: when it sits it gets thicker, so give it a minute or so before you add more paste; preferably, mix the batch half an hour before you begin to work. If the paste gets too thick, add water (use distilled water to keep the adhesive acid-free) — tiny amounts at a time to prevent it from getting lumpy. If it does become hopelessly lumpy, strain the paste with a kitchen strainer that you use only for this purpose. Straining works faster when the paste is thinner. Check the consistency; add more paste if you need to. The thickness of paste needed depends on the project; usually, it should be somewhat firm but not dry when it stands on a plate.

A batch of glue/paste will keep, tightly sealed, in the refrigerator about two weeks, if you pour a little at a time into another container, such as a paper plate, and dip your brush into that container instead of your main batch. Hairs, fibers, and other material contaminate the adhesive and encourage mold to grow, even in full-strength PVA glue.

COOKED WHEAT PASTE
(FOR APPROX. FOUR CUPS OF PASTE)

1 cup or one part flour (you may use food-grade flour if necessary)

4 cups or four parts distilled water (you may use clean or filtered tap water)

Cook over medium-high heat, stirring constantly with a wire whisk until the mixture thickens. Remove from heat and stir five minutes or more after it. Cover and cool completely. Refrigerate tightly covered. The paste keeps for several days in the refrigerator, at most a week or two. Strain if necessary. The paste can also be made in the top of a double boiler over hot water or in a microwave. If you use a microwave, you will need to look at it and stir every 30 seconds to prevent it from bubbling over and getting lumpy. When it is cold, I like to add a little PVA (from a few tablespoons to approximately ¼ cup or 59.1 milliliters) to the mixture, because this seems to extend the shelf life of the paste.

BASED ON A RECIPE FROM *JAPANESE BOOKBINDING* (WEATHERHILL, 1986) BY KOJIRO IKEGAMI

Keeping the Paper Flat

You will need a way to press the book or papers flat while the adhesive dries. Some bookbinders use a very heavy piece of equipment called a nipping press. I use several double-sided smooth fiberboards that are 11 x 14 inches (27.9 x 35.6 cm) each. The boards can be any thickness, but heavier is better. Make a book press as follows: one fiberboard, one sheet of waxed paper, the project, one sheet of waxed paper, one fiberboard. If you have more than one project, you can keep stacking them up like so many sandwiches. Make sure you always have waxed paper between the project and the boards. Also use waxed paper between pages of your book so that the pages won't

stick together or warp. Put heavy books (like dictionaries) or bricks on top of the boards. Press overnight or for several days, depending on the amount and type of adhesive used, size of the book, and temperature and humidity of the room. If you use PVA glue on a hot, dry day, you may not need to press the book at all. A book made with paste only on a cold, rainy day may require a week or more under weights.

Mounting Paper

There may be times when you have a drawing or small separate image or text that you would like to include in your finished book. You can mount this drawing onto a heavier book page most easily with a glue stick, since the paper won't warp when the adhesive dries. Spray adhesives do cause paper to warp and bubble over time, and I don't recommend them. When glue is applied to only one side of a paper, the paper tends to pull or warp. For best results, apply glue and paper to both sides of the heavier backing paper or "tip in" the drawing by putting small, thin spots of glue at the corners or edges only. Wheat paste is too wet for tipping in.

To make the drawing into a card for a small project, use a thin coat of PVA. Apply the PVA to the back of your drawing, then smooth the drawing onto the heavier paper. Put the now-laminated papers between two sheets of waxed paper and under a heavy book or some wooden or fiberboards with weights on top. Don't try to mount a picture onto a piece of heavier paper or board that is exactly the same size. It is much easier if you use a piece of heavier paper that is larger than your picture and then trim it to size when it is completely dry.

Some dry-transfer adhesives are also available and hold well. These are usually available in packages of five or more sheets and come with a burnisher. Use the burnisher to rub the adhesive

completely onto the back of your drawing or photograph, then put a clean piece of paper over your image to protect it, and attach the image by rubbing it onto your paper or book project.

Backing Cloth

To use cloth to cover a board you must first adhere the cloth to a sheet of a strong, lightweight paper. Many colors of pre-made book cloth are available, but to customize your project you can make your own by using one of the many fabrics available in a fabric store. The process of "backing" cloth is similar to that of mounting paper except that you use wheat paste with only a tiny amount of PVA. The exact amount is not important, but PVA alone dries too quickly and if you get any spots of glue on the cloth they are nearly impossible to wipe off. The paste should be slightly runny, so that it spreads slowly when put on a paper plate. It should be without lumps. Use a strainer, if necessary, to get rid of the lumps.

Mulberry paper works best for a backing sheet since it is thin but strong.

1. Cut the cloth so that it is slightly smaller than the paper.

2. Put the cloth facedown on the table.

3. Mist the cloth lightly with water and smooth it out on your work surface.

4. Apply paste to the paper.

5. Center and smooth the cloth face up onto the paper, rubbing out any bubbles that may occur.

6. You can let it air-dry or you can cover it with waxed paper and put wooden boards and weights on top. Let it dry at least overnight.

Variation: If you have a smooth, clean work surface that you don't need to use for a day, leave the misted cloth on the table. After applying paste to the paper, turn the paper over and smooth it onto the cloth. Let it dry on the table. It will remain flat this way. Peel it off the table when dry.

Linen tape

Self-adhesive linen tape is archival and works well for some projects such as the Circle Accordion on page 119, and for reinforcing box corners in Chapter 11. It comes on a roll and has a stubborn backing. It helps to bend the corner, then wedge your fingernail between the tape and the backing to help you remove it for use. This is the only tape I can highly recommend for bookmaking purposes. Most tape is evil: leaving residue, turning brittle, cracking, and yellowing over time.

SEWING

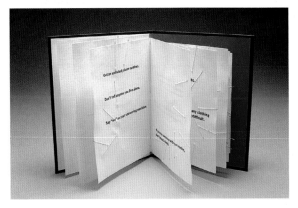

Coriander Reisbord: *Defensive Book*, 1993; letterpress, pins; edition of 15; separate pamphlets sewn through one endsheet; 5¾ x 7¾ inches (14.6 x 19.7 cm) (photo: Sibila Savage)

You may want the needle holes in your book to be unobtrusive, a goal you can achieve by using the smallest needle possible. At the same time you will want a thread that is sturdy, will not stretch or break, and will keep your book secured; the needle size will be determined by the thread thickness. You always have the option of making the stitching decorative with a thicker, colorful thread, or matching it to the page color with a more common thread weight. The scale of your book may also determine the thickness you choose: a smaller book might require a lighter weight thread; a door-sized book might demand a rope.

Needles and Threads

While any sewing needle will suffice, bookbinding needles usually have a sharp end to aid in poking holes and a small, strong eye that will not bend or collapse from the heat of your fingers. Fabric stores often carry a multipackage of several types of needles, which may include a bookbinding needle as well as a curved. Otherwise, a bookbinding supply or art store may be able to sell you one needle or a package of five of the same. They come in different sizes. If you choose ribbon for a sidebound book (ledger, stab, stick),

you will likely need an embroidery needle with a sharp point and a larger eye. Get a few; they tend to break. Curved needles may also be found in stores that sell quilting supplies.

The size of needle may be determined by the type of thread you are likely to need. I generally use a medium-weight linen thread found currently in art supply stores. In the past I have successfully used a heavy-duty poly-wrapped cotton (like buttonhole thread) with a regular needle. In all cases, the thread should not break or stretch under stress.

Wax your thread with beeswax to help keep it from tangling and to hold the final knot. Waxed linen macramé or basket-making thread comes in many brilliant colors. It is useful and decorative for certain structures where the binding is exposed, such as stab-bindings, binding around a stick, and the chain stitch, but it may be too thick for most other bindings. If you don't buy prewaxed thread, you can purchase a small cake of beeswax at a craft or bookbinding supply store. Wax only the amount of thread you will need at one sewing by pressing the end of the thread into the beeswax, leaving ⅛ inch (3 mm) at the edge so you can grab it; put one finger on the thread to hold it down

while you pull the thread and draw it across the wax. The friction will warm the wax and coat the thread.

Calculating Thread

Generally, the length of thread is measured by holding the end of the thread to an end hole or sewing station, drawing it to the last hole, multiplying by the number of signatures, then adding 6 more inches (15.2 cm) total to tie off each end. Sometimes the directions will say "four times the width or sewing side of your book." Working with thread longer than your wing span (when you spread out your arms) is not recommended because it tangles, knots up, and generally takes too much time to work with while you wait to pull it all out of one hole at a time.

Measuring for Holes

Even without a ruler you can figure out where to punch the holes by using either a strip of paper, or an architectural divider tool.

Jig for an Odd Number of Holes

You need a strip of paper exactly the length of the spine, from head to tail (without any hard covers).

1. Fold the paper in half, widthwise, to make it shorter and fatter. Open.

2. For three equidistant holes: from each edge, fold down to the middle. Open. Poke holes at the folds.

3. For five holes, or for less space from the edges: do step 1, then fold down the top edge between ½ and 1 inch (1.3 to 2.5 cm).

4. Fold at the middle fold, closing the paper up again.

5. Fold back the protruding edge until it is even with the other folded edge. Open.

6. Take the new fold to the middle fold, aligning it and creasing it.

7. Repeat with the opposite fold.

8a. For a book with signatures: open the signature and align the folded strip with the center fold. Mark and punch directly through the fold.

8b. For a sidebound book: wrap the strip evenly around the left edge of the book block and mark and poke holes into the book where the horizontal folds of the jig end.

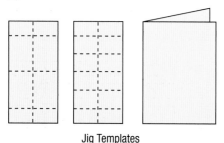

Jig Templates

Divider for an Even Number of Holes

Although I have been making books for decades, I only recently learned about the divider from Dominic Riley; it looks like a circle-drawing compass and is now one of my favorite tools. My students find it easier than measuring with a ruler.

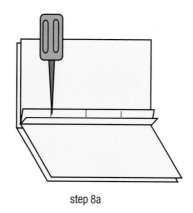

step 8a

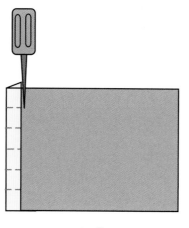

step 8b

You can use this method for any number of holes, odd or even, just change the fraction in step 1.

1. Open the divider and estimate ⅕ of the distance between the head and tail (with no covers).

2. Walk the divider down the spine. Adjust the divider until you can walk it down the spine to make five sections, or four holes.

3. Mark these spots with a sharp pencil.

For six holes, adjust for seven sections.

Punching Holes

When punching holes for the stab-bindings (ledger, stick, sidebound), you may use an awl, ice pick, or bodkin (needle tool or clay tool), punch and hammer, or Japanese screw punch. Always place extra cardboard under your book so you do not damage the furniture. The punch and hammer and the Japanese screw punch actually remove the punched material from the hole and don't leave the bunched-up paper at the back of your book. You may also use a drill with a tiny bit—handheld on slow speed only! A clamp or vise would be advisable when using a drill, as would a thick board underneath if you don't use a vise.

For the stab-bindings, the holes need to be big enough to accommodate two or three thicknesses of whatever thread you have chosen, because you will be sewing through the holes at least twice.

For the signature bindings, hold the signatures open to form a *V*; make sure you punch exactly into the valley fold or groove of the spine.

Clamp

A medium or large Bulldog or binder clip is useful to hold the pages in place while you poke holes or sew. Fold up a piece of clean paper, roughly 5 x 3 inches (12.7 x 7.6 cm), into a small pad first (probably three folds, which makes it into eighths). Wrap the pad over the top of the book (four thicknesses on each side).

Clamp pages with the binder clip on top of the folded paper so the clip will not directly touch or dent your book.

Knots and Stitches

Knowing these three basic knots will be helpful in your bookbinding endeavors. The overhand knot is good for the ledger binding and anytime a decorative knot is needed to hold several strands of thread. You will need a square knot to secure almost every sewn book, and the kettle stitch is necessary for all Western-style, multiple signature bindings.

Overhand Knot

1. Hold both ends of the string in one palm.

2. Wrap over all your fingers and across the piece in your palm.

3. Slip your fingers out and put the ends through the loop.

For smaller thread, wrap around one or two fingers only.

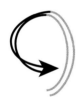

step 1

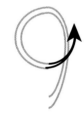

step 2

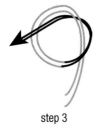

step 3

Square Knot

If you pull this knot very tightly, it should not come undone. If it does, either the string is too slippery or you have made a "granny knot" instead. From childhood, I still hear the chant, "Right over left, left over right." Think of the right piece in step 2 as your working thread; it is the one that becomes the left piece in step 3, and it is the one that does all the work.

1. Hold one end in your right hand, the other in your left.

2. Take the right piece over the left piece and back under the left piece as well.

3. Now the piece that was originally on your right is in your left hand.

4. Take this (now left) piece over the right piece (formerly the left piece) and back under the right piece.

5. Tighten.

step 1

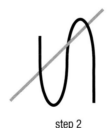

step 2

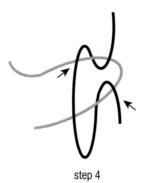

step 4

Kettle Stitch

This makes a half-hitch knot. Use the kettle stitch whenever you have three or more signatures to sew together.

1. Take the needle from the outside to the inside between the preceding signatures. See the diagram.

2. Don't pull the thread all the way into another stitch, but leave a loop.

3. Cross over the thread, and draw the needle through the loop.

4. Pull the knot firmly and vertically upwards to avoid ripping the pages. Then proceed with your sewing.

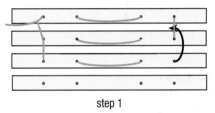

step 1

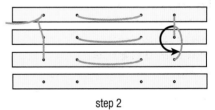

step 2

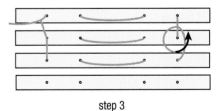

step 3

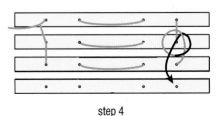

step 4

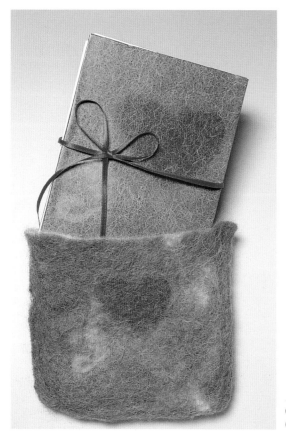

Dear Ezra, 2004; color copies, typewritten and laserprinted text, watercolor crayons, ink, found objects; accordion with pockets; 4¼ x 5½-inch (10.8 x 14 cm) book in felted pouch (photo: Sibila Savage)

Suggestions of content ideas may be found throughout the book, although the focus is primarily on the structures themselves. It is to be hoped that a structure may provide the catalyst for the content, and if it does, here are a few useful techniques for working with the material to create a completed book.

Mock-Ups

Once you decide what to include in your next book, make a mock-up. Create the structure for your book out of scratch paper and tape it together (tape is okay here!). Number the pages. If you have text, write it, type it, or print it out on a single sheet of paper. Look through the text and draw lines between sections that could stand alone on a page. When you are satisfied with the section breaks, number these sections in pencil. Cut them apart and begin taping them to the pages in your mock-up. Leave room at the beginning for a title page and possibly a page in the back for a colophon.

The mock-up can be just as interesting as the final project. In 1976, Dieter Roth made a wonderful-looking book from paper and taped-on images called *Collected Works, Volume 17: 246 Little Clouds*. The "little clouds" in the title refer to the taped-on images and the shadows they cast on the pages. If you want your mock-up to be archival, use only self-adhesive linen tape.

Choosing a Title

You can use the place and date as a title or you can seek out a more imaginative name for your book. Keep a list of interesting phrases that could be titles; sometimes one of these will fit your current book project. I remember reading about a film by Sylvester Stallone, *Paradise Alley*. I was intrigued by the title, which sticks with me even now. I liked the juxtaposition of "Paradise," which I imagined was light, lacy, and beautiful, and "Alley," which made me think of things earthy, man-made, hard, and harsh. When I was making a book about mothers, pigeons, and homes, I was delighted to find that pigeons were called "rock doves." It reminded me of "Paradise Alley," a juxtaposition of two dissimilar words.

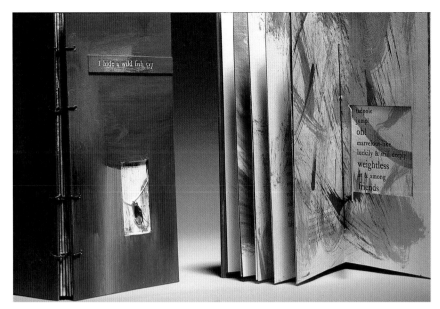

I Hide a Wild Fish Cry, 1999; acrylics, letterpress, linen thread, tied fly; edition of 10; Coptic with curved needle; 3¾ x 7¾ inches (9.5 x 19.7 cm) (photo by Jim Hair)

Combining two or more contrasting words has a striking effect. *I Hide a Wild Fish Cry* came from a refrigerator magnet poem that I discovered as I moved around the words. Always, always, always put a title on your work. It doesn't have to be on the outside, but put it somewhere. It is the gateway to understanding the piece.

Printing

Printing or copying text or images onto paper may be done by letterpress, computer, rubber stamps, typewriter, handwriting, or by using cut-up techniques to name a few examples. Letterpress printing is a relief-printing process that presses wood or metal type or photopolymer plates into the page; computer-generated type sits on the surface of the paper, and the kinds of paper that can be used are limited; rubber stamps are inexpensive; the typewriter can be used on most papers; you can carry your handwriting with you; cut-up or erasure texts can be gleaned from discarded books (see page 184 for references to the latter).

Letterpress printing. Letterpress is a popular means to print artist's books, accessible to those who own one, who live near a book arts center, or who are willing to pay someone else to print for them.

Laserwriting and photocopying. Layouts may be done on the computer and the printing is relatively inexpensive. If your favorite activities involve handwork and not mousework, you may wish to consider the alternatives.

Rubber stamps. These have a distinctive, yet generic look now that they are so readily available. Office supply stores sell sets that enable you to set a whole line or two or three instead of stamping one letter at a time. You can stamp onto most weights and types of paper. Rubberstamping can be time-consuming if you have a lot of text, however. You may prefer to use the rubber stamps as titles or to emphasize certain words.

Typewriter. The typewriter font adds its own layer to your book, reminding readers of historic authors, old manuscripts, and how hard it used to be to correct your mistakes.

Handwriting. Many people complain about their handwriting. I have a theory that we are so used to it that it seems ordinary and perhaps it feels too personal as well. If that is how you feel, you might take a calligraphy class to learn a formal, standardized writing, then adapt it, change it, and create a new "public handwriting" that you use for your books.

An alternative to a class is to spend some time trying to copy different styles of type used in printed matter. Do you like tall, thin fonts? Wide, rounded cursive? You can change your writing, or you can change your writing tool. For example, different nibs, held in a holder and dipped in ink, can affect the look of your work. Brushes, sticks, string—all of these can change the look of your writing if you so desire.

Editioning

Making copies of something is called "editioning." When Ed Hutchins came to San Francisco, he bought several copies of different picture postcards, cut windows in them, and made them into an edition of tunnel books (see page 79). You might decide to make an edition of a travel journal this way, too. Traditionally, editions are signed and numbered. The numbering system can look like a fraction: $1/50$, which means copy number one of a total of fifty copies. Or you can write it out in words. Copy number one doesn't necessarily mean it is the best of the edition or the first to be made. It is merely an identifying mark. If you make more than one copy and want each of the books in the edition to be slightly different and individualized, you can make a

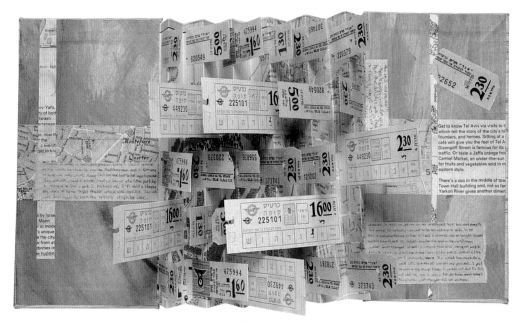

Transit, 2004; color copy, ink, painted paper, book cloth; flag book: 4 x 7¾ inches (10.2 x 19.7 cm) (photo: Sibila Savage)

varied edition, known as edition variée and abbreviated as E.V. Mark those as ¹⁄₅₀ E.V. Don't just write "one of many!"

Colophon

After you finish making your book, you can write information on the last page to remind you what materials you used. This paragraph of information is called a colophon. For example, list the kind of paper, the typeface, how the book was printed, how the illustrations were made, the edition number, any credits, and the date. A few years later you may not remember. The colophon helps you identify materials you might like to use again. The colophon is the one place I feel I can loosen up completely. I may add what the weather was like when I made the book, what song I was listening to, or other anecdotes.

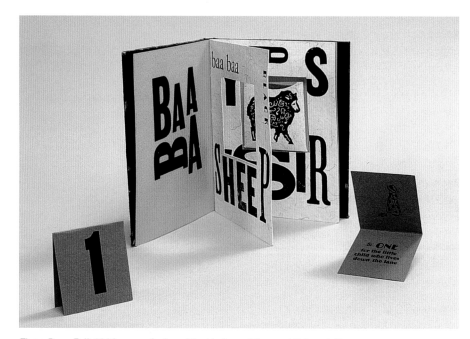

Three Bags Full, 1993; commissioned by Linda and Bernard Faber; letterpress and linocuts; single signature; edition; 4¹⁄₈ x 5 inches (10.5 x 12.7 cm) (photo: Jim Hair)

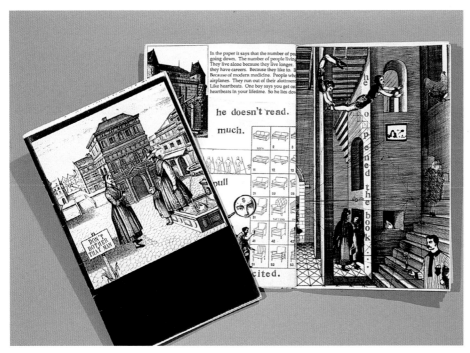

Don't Bother That Man, 1990; collage, photocopies, preparation for an edition; 5½ x 8½ inches (14 x 21.6 cm) (photo: Sibila Savage)

BASIC**TERMS**

Accordion: paper folded to have alternating mountain and valley folds; also called concertina

Artist's book: a book made by a person who likes to make art. The artist controls the work from start to finish, making all the decisions about text, binding, illustrations, and design.

Book arts: an all-encompassing term used to describe bookbinding, paper-making, paper marbling, calligraphy, letterpress printing, etc. I tend to use the singular, "book art," when I talk about handmade books; I use it interchangeably with "artist's book" or "artists' books."

Book block: the group or stack of text papers, sewn or glued together, usually without covers

Edition: formally, a group of identical, multiple copies of a book that are signed and numbered by the author and artist/illustrator. These books are called an "edition." You can vary the books as you make them; there are no book-art police.

Endpapers or endsheets: the papers at the front and back of the book, sometimes glued to the cover as well; usually decorative

Fore edge: the side of the book that opens, usually parallel to the spine

Head: the top edge of the book

Landscape orientation: paper or book placed in front of you horizontally

Mountain fold: a fold that makes a point or peak

One-of-a-kind: a book that is not part of an edition, but the only one you make; also called a "unique book"

Recto: Right-hand page of a spread or book opening

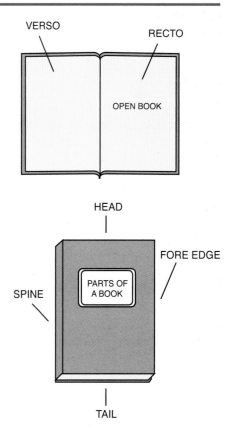

Running stitch: sewing in one hole and out the immediate neighboring hole

Score: to draw an indentation in the paper. It helps to make a straight fold. Scoring also allows heavier paper to crease without rough edges.

Sidebound: an Asian style of binding in which holes are punched along one edge of a stack of pages, and then bound with cord, thread, or ribbon. I use the terms stab-binding, blockbook binding, and side-binding interchangeably.

Signature: a group or gathering of folded pages that nest, one inside the other

Single signature: one group of folded, nested pages sewn together to create a pamphlet; also called pamphlet stitch

Spine: the edge of the book where the pages are bound together (Western books have spines on the left. Many books from Asia and the Middle East have spines on the right)

Spread (or page spread): the (usually) two pages that are shown when a book is opened

Tail: the bottom edge of the book

Turn-ins: where the cover is folded over boards and usually glued

Valley fold: a fold that makes a groove

Verso: Left-hand page of a spread or book opening

ABOUT THE DIAGRAMS

The diagrams illustrate key steps for making books. A solid line shows the edge of the paper, a cut, or a previous fold. A line of long dashes indicates a valley fold. A line of short dashes or dashes and dots indicates a mountain fold. You may have to refold a valley fold into a mountain fold; watch the diagrams. When you need to adhere something, the gray line indicates glue or paste. Arrows show the direction you should sew, where something will go, or if you need to turn the paper over.

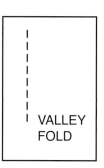

VALLEY FOLD

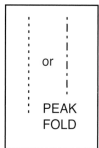

or

PEAK FOLD

or

TURN OVER

or

CUT

POKE HOLES

CLAMP

TRADITIONAL ORDER

Knowing the order of the pages in a traditional book offers more possibilities for your design or more things to rebel against. Your choice. This standard sequence of pages can also be found in *The Chicago Manual of Style* (University of Chicago Press, 2003) or Adrian Wilson's *The Design of Books* (Chronicle Books, 1994). Those books also contain chapters regarding design and typography, papermaking and bookmaking.

Endpapers (decorative, reflecting the colors and mood of the contents)

Blank sheets (a pause before entering the book; gives room if the book needs to be rebound)

Bastard title (also referred to as the half title; just the title—no author's name or publisher)

Frontispiece (image)

Title page (title, author, publisher)

Copyright (usually on the back of the title page; in the United States a c with a circle around it, the year, and author's/illustrator's name follows; for full protection internationally you previously had to add "all rights reserved." These words are now optional. See current laws for details.)

Dedication

Foreword

Preface

Contents

Introduction

Text

Appendix

Bibliography

Colophon (description of how the book was made: media used, typefaces, paper or other materials, anything else you want to add about the creation of the book)

Blank sheets

Endpapers

The list of ordered pages does not take into account the rhythm or pacing of the book and the sequence of the images and text, which are very important to the making of a thought-provoking book.

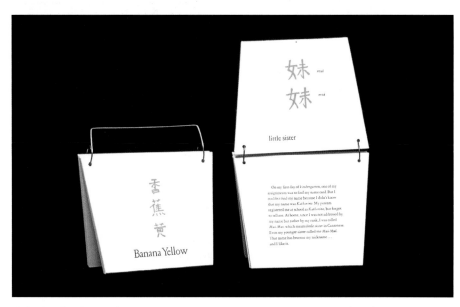

Katherine Ng: *Banana Yellow*, 1991; letterpress printed, recycled wire; 5⅛ x 5¾ inches (13 x 14.6 cm) (photo: Katherine Ng)

BEGINNING WITH CULTURE: BANANA YELLOW

Banana Yellow is a collection of anecdotes about my growing up in a Chinese-American family, inspired by a book by Eloise Klein Healy called *Ordinary Wisdom* (Red Hen Press, 2005), which contained poems based on Chinese type. In my case, I chose words that I wanted to emphasize and had my mother translate the words into Chinese characters. The book reads like a set of bound flash cards where the pages turn from bottom to top. The title is a play on words where banana is used in a derogatory way to describe someone who looks Asian but acts like a white person: yellow on the outside, white on the inside. The structure of *Banana Yellow* reflects a stereotypical icon of the Chinese-American culture: the Chinese take-out box. I bound the books with original wire from these take-out boxes collected from many Sunday evening dinners with my parents at a favorite Chinese restaurant.

KATHERINE NG

FOLDED **BOOKS**

With a cut or series of punches or slits, you can transform a piece of paper into a book. These books are made simply, with little or no adhesive or thread; the primary activity is folding paper. To improve this basic skill, learn a few techniques by heart and then keep little stacks of paper on your desk and practice folding.

Many of the books only need to be printed on one side so they lend themselves just as well to computer layouts as to letterpress printing. A few layouts for the page numbering are provided with the structures.

While these books are often used in the classroom, their seeming simplicity can actually be made more complex by imaginatively cutting out windows, by adding pockets, or by using multiple texts. The shape and form of a book may also give you ideas for its use. For the reader, the physical shape of the book gives the reader a hint of what is inside. The following structures have specific shapes or themes built into them and should provide a good place to start.

Katherine Ng used a trapezoidal shape for her book *Banana Yellow*, which examines Chinese-American culture. She chose a shape to remind the reader of a Chinese take-out box. Ultimately, how you use the form is more important than how complicated it is to make.

XBOOK

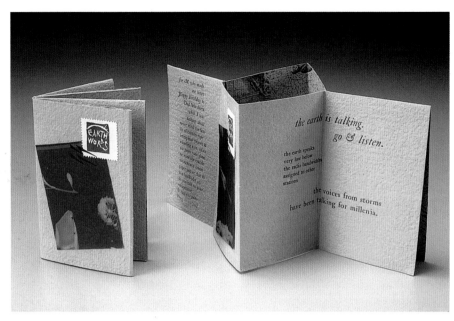

Earthwords, 1995; letterpress, sun prints, photoengravings; edition of 58; X book; 4 x 5 inches (10.2 x 12.7 cm) (photo: Sibila Savage)

BACK AND FORTH: INSPIRATION FROM FOLDED PAPER

I stumbled upon the "snake book" format while investigating approaches to folded sections, imposition, and printing single-sheet books as a grad student at Visual Studies Workshop in the early 1980s. Gary Frost taught me how to make a "binder's section" by folding a sheet in half several times, each time cutting the fold and leaving an inch of the fold intact. When the section was unfolded flat, I observed the individual folios were attached with short "binding folds." By rearranging the pattern of cuts and folds, I found that fold books could be joined the same way. My interest was piqued when I printed a sheet on one side, folded it in this manner, and saw that all the pages were imaged.

SCOTT MCCARNEY

A three-dimensional book is hidden in every piece of paper. This is the structure that has been most commonly taught as a first book in classrooms around the country since about the mid-1990s. I do not know who invented it. *Earthwords* uses this one-page format and has a printed montage on the back, which is only slightly visible to the reader, yet the book can be opened to view the complete picture.

Tools: bone folder; scissors or knife and cutting mat; metal ruler

Materials: 8½ x 11-inch (21.6 x 27.9 cm) paper

Example (book after dimensions):
2¾ x 4¼ inches (7 x 10.8 cm) book

1. Fold a piece of paper in half lengthwise. Open.

2. Fold in half widthwise. Keep it closed.

3. Take one open edge and fold it back to the previous fold. Turn over.

4. Fold the remaining edge back to the same fold as step 3.

step 1

step 2

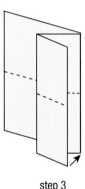

step 3

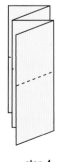

step 4

5. Cut a slit down the lengthwise fold only along the middle two sections.

6. Fold in half again lengthwise.

7. Push the ends together so the middle section will make an *X*, and then form pages.

8. Fold over the middle sections and wrap around to make book.

9. All printing or writing can be done on one side of a piece of paper before it is folded up. (See the diagram for how the pages are oriented.) Or draw a scene on the back of the paper using the middle four sections (two sections right-side up, two upside-down).

Uses: birthday card; greeting card; one poem

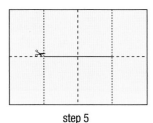

step 5

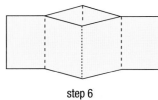

step 6

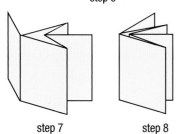

step 7 step 8

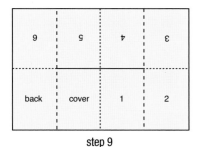

step 9

X BOOK**WITH POCKETS**

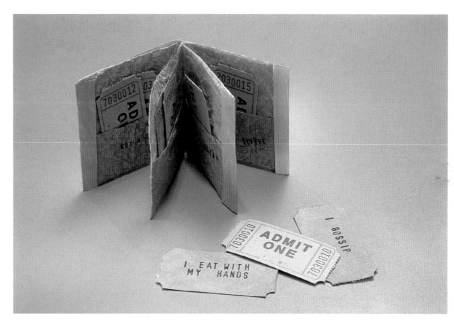

Admit One, 2000; tickets, paper, rubberstamped text; X book with pockets; 2¼ x 2½ inches (5.7 x 6.4 cm) (photo: Sibila Savage)

I devised this version of the X Book so that it might have pockets. In my book *Admit One*, the tickets are loose to permit the reader to rearrange them. If you use tickets or other papers and want to have a fixed order, you can number the loose papers and their corresponding book pages. Or you can punch holes in the papers and punch holes at the top of each book page. Tie threads from the papers to the pages to hold them in place.

Tools: bone folder; metal ruler; pencil; glue or glue stick; scissors or knife; and cutting mat

Materials: inner paper: 8½ x 11-inch (21.6 x 27.9 cm) lightweight paper; outer wrapper: 2¾ x 6 inches (7 x 15.2 cm), grained short

Example: 2½ x 2¾-inch (6.4 x 7 cm) book

For the inner paper

1. Fold the inner paper in half lengthwise. Keep it closed.

2. With the folded edge at the top, fold a single layer from the bottom edge up 1½ inches (3.8 cm).

step 1

step 2

3. Turn the paper over, and fold the matching bottom single edge up 1½ inches (3.8 cm).

4. Open the paper, but keep the pockets folded. With the pockets facedown on the table, fold ⅜ inch (1 cm) in from one of the open sides, making a tab.

5. Keeping the tab folded, fold the paper in half widthwise.

6. Accordion-fold both edges back to the middle fold.

7. Open the paper up. Cut along the lengthwise fold from the first vertical fold to the third vertical fold.

8. Pinch the two middle squares on the right and the two middle squares on the left. The tabs should be inside.

9. Put glue along one of the tabs, and adhere the tabs to each other.

10. Push the ends in to the middle so that the project looks like an X. Flatten the X. Fold it in half so that the glued, tabbed edge is inside.

For the outer wrapper

11. Measure and fold a ⅜-inch (1 cm) flap from each of the short ends.

12. Hook these flaps around the text paper and crease a rounded fold in the middle. Glue down the flaps to the inner paper.

Uses: a book about pockets; a collection of tiny papers such as stamps or tickets

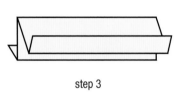
step 3

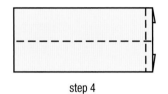
step 4

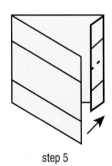
step 5

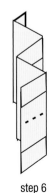
step 6

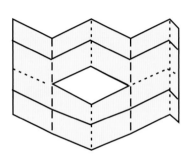
step 7

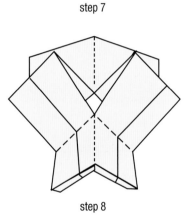
step 8

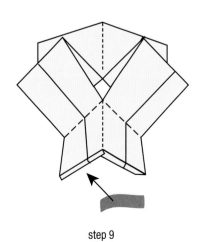
step 9

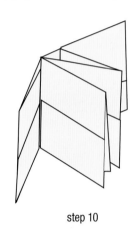
step 10

step 11

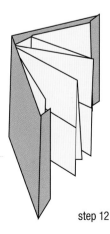
step 12

SHORTS**BOOK/OX-PLOW PAMPHLET**

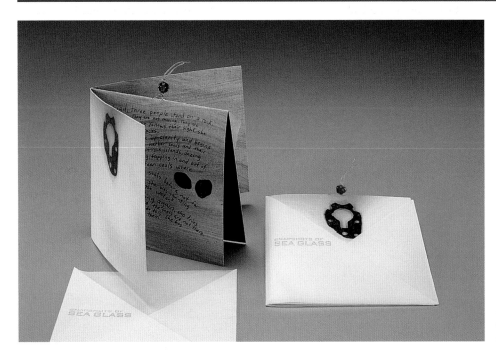

Snapshots of Sea Glass, 2004; color copy, foil stamp title; edition of 40; shorts book with a bead; 4 x 4 inches (10.2 x 10.2 cm) (photo: Sibila Savage)

I have borrowed the style of the pamphlet from a more elaborate form that Scott McCarney named *boustrophedon* (Greek for "as the ox plows" or "as the ox turns"). Boustrophedon is an ancient method of writing; if the first line was read left to right, the next line was read right to left, alternating back and forth. The back-and-forth nature of the folded pages is reminiscent of that writing. Scott now refers to it as the Snake Book. This short version works well as a flyer or pamphlet.

Tools: bone folder; metal ruler; scissors or knife and cutting mat

Materials: 1 sheet medium-weight paper, 8½ x 11 inches (21.6 x 27.9 cm)

Example: 4¼ x 5½-inch (10.8 x 14 cm) pamphlet

1. Place paper in front of you vertically.

2. Fold in half lengthwise. Open.

3. Turn it over.

4. Fold paper in half widthwise. Open.

5. You will now have two folds: one is a mountain and the other is a valley. Position the paper so that the valley fold is the widthwise fold.

6. Make a horizontal slit from the intersection of the two folds to the right edge. (Don't cut the paper completely in half!)

7. Fold the book according to the mountain and valley folds.

The writing or images need to be on both sides of the paper for this one. See the diagrams for the layouts. Page one should be on the back of "front."

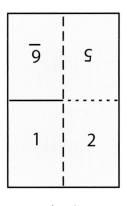

layouts

PANTS**BOOK/SIMPLE ACCORDION**

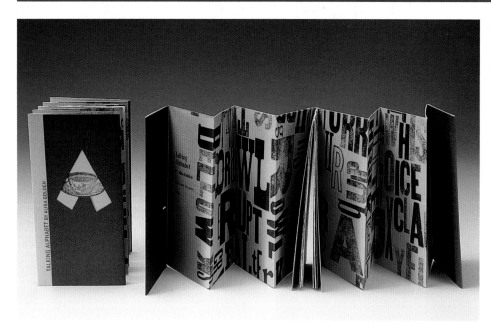

Talking Alphabet, 1994; letterpress;
edition of 34; simple accordion;
3⅜ x 6¼ inches (8.6 x 15.9 cm)
(photo: Sibila Savage)

This is a "long pants" version of the shorts book. When Katherine Ng, an art teacher and book artist in Los Angeles, teaches kids, she calls it by this name; when fully opened, it does look like a pair of pants. The kids think this is hilarious. Well, I certainly cannot say "I made a pants book" with a straight face. I also refer to it as "simple accordion."

The middle of this book has one fold across the top. By opening the book from various directions (back, front, side, and other side), you can use four different texts, just as with *Talking Alphabet*. I added a single signature at the fold.

Tools: bone folder; scissors or knife and cutting mat; metal ruler

Materials: rectangular paper (8½ x 11 inches [21.6 x 27.9 cm] used in this example)

Example: 2¾ x 4¼-inch (7 x 10.8 cm) book

1. Fold paper in half, lengthwise. Open.

2. Fold in half, widthwise. Open.

3. Turn over so the widthwise fold becomes a mountain.

4. Fold in the ends to the widthwise fold. Open.

5. Cut down the lengthwise fold, leaving one rectangle from the edge. Accordion-fold, alternating mountains and valleys.

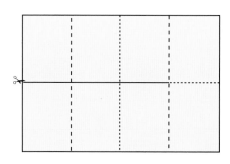

step 5

FORM AND CRAFT

There are two things that are important to the way I make my books:

First, any unusual format chosen must reflect, enhance, or actually embody the content of the work. A novelty format can attract the viewer and facilitate the presentation of the idea of the book. Secondly, craft is as important as format in communicating the content of the work. A well-constructed book invites the viewer in to explore the contents of the book and will hold up for many, many viewings.

EMILY MARTIN

6. When you fold up the book, you may put the horizontal fold over the top like a tent (see diagram) or put the fold at the bottom, like a pocket (see photo of *Silver Every Day*).

Variation: Sew a single signature (see page 95) in the horizontal fold in the center of the book (see *Talking Alphabet*).

Uses: greeting card; change of address; text describing points of view

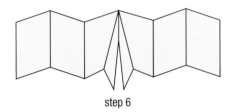

step 6

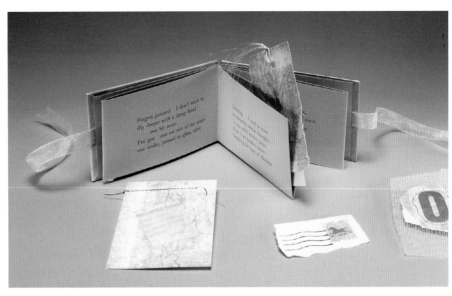

Silver Every Day, 2008; letterpress, mixed techniques, painted paper; edition of 15; pants book; 5¼ x 3¼ inches (13.3 x 8.3 cm) (photo by Sibila Savage)

PANTS**BOOK/SIMPLE ACCORDION WITH TUNNEL**

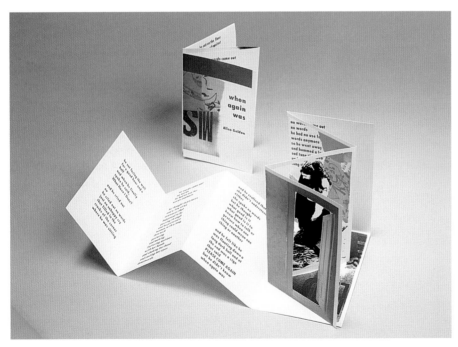

When Again Was, 1997; color photocopy edition; tunnel accordion; 2¾ x 4¼ inches (7 x 10.8 cm) (photo: Jim Hair)

This simple folded book makes an enchanting, dioramalike structure when fully opened. Ed Hutchins likes this structure and sent me a couple of his books that use it, *The Forgotten Closet* and *San Francisco, 1969*, which has cut-outs of a cable car, Coit Tower, and the Golden Gate Bridge. *When Again Was* is my first simple accordion with a tunnel. You can find more of this structure in *A Book of One's Own* (Heinemann, 1992) by Paul Johnson.

Tools: bone folder; scissors or knife and cutting mat; metal ruler

Materials: rectangular paper (8½ x 11-inch [21.6 x 27.9 cm]) sheet used in this example)

Example: 2¾ x 4¼-inch (7 x 10.8 cm) book

1. Fold the paper in half, lengthwise. Open.

2. Turn over.

3. Fold in half widthwise. Open.

4. Turn over.

5. Fold in the ends to the widthwise fold. Open.

6. Cut down the lengthwise fold, leaving one rectangle from the edge.

7. Cut diamonds or ovals in A, B, and C, each one smaller than the one before. (When you pick images for this book, you will cut shapes to match the contour of the images; the diamonds or ovals are just for the sample book.)

8. Fold A, B, C, and D, the top row of rectangles, in an accordion pattern (alternating mountain and valley).

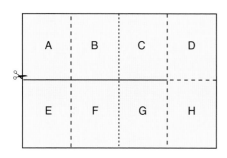

step 6

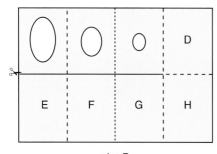

step 7

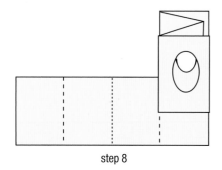

step 8

9. Fold the closed pages down over the last rectangle (H).

10. Accordion-fold E, F, G, and H.

The bottom row of rectangles becomes the main body of the book. The top row is folded forward instead. It makes a folded flap that, when open, becomes the tunnel, sitting zigzag on the far-right bottom rectangle. See the diagrams for the layouts of side one and side two. Page one should be on the back of "front."

Choosing images

You may choose to use copies of the same picture, cutting out different elements for a sculptural effect, or pick or create four unique vertical images.

1. The first image should be mostly cut away (a big open window, gate, door, or other frame).

2. The next picture should also be able to stand out with space around it.

3. The third has less cut out.

4. The last will not be cut at all but needs to be able to be seen through the preceding pages.

Variation 1: Use a color photocopy on one side and a black-and-white photocopy on the other. (See the diagram for placement of images and text.)

Variation 2: Draw a pattern of triangles on page H to indicate where the tunnel sits up perpendicular to the far-right rectangle.

Uses: family greeting card; presentation of a single poem

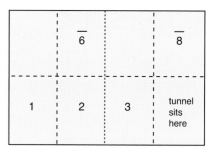

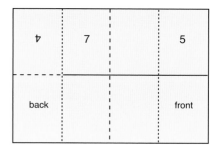

layouts

SNAKE**BOOK**

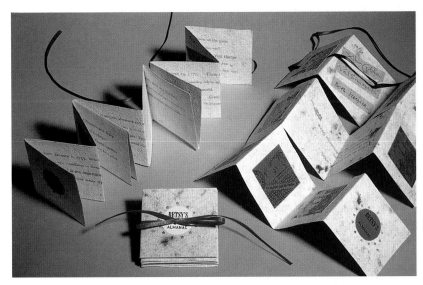

Betsy's Almanac, 1999; with Val Simonetti and Beth Herrick; letterpress on handmade paper, photo-engravings, ribbon; edition of 20; snake book; 2½ x 2½ inches (6.4 x 6.4 cm) (photo: Jim Hair)

Beth Herrick, Val Simonetti, and I used this structure to make *Betsy's Almanac* for our friend and teacher Betsy Davids. Since her birthday is July 4th, we chose texts about Betsy Ross, the American flag, the Statue of Liberty, and the holiday celebration itself. We glued on a ribbon to tie the book closed. Katherine Ng glued some of the folds together in her book *Alphabetical Afflictions*, which makes it more like a typical accordion-style book, and not quite so springy. The original structure was devised by Scott McCarney.

Tools: bone folder; pencil; metal ruler; scissors or knife and cutting mat; glue brush (optional); PVA (optional)

Materials: rectangular paper (7½ x 10-inch [19.1 x 25.4 cm] paper used in this example); ribbon (optional)

Example: 2½-inch (6.4 cm) square book

1. Place the paper in front of you vertically.

2. Fold paper in half widthwise. Open.

3. Turn the paper over so the widthwise fold becomes a mountain.

4. Fold the bottom half up to the middle; fold the top half down to the center. Open. You have four sections.

5. With the paper still vertical, make a mark 2½ inches (6.4 cm) from the left edge.

6. Bring the right edge over, and align it with the mark. Crease.

7. Turn the paper over. The lengthwise fold should be toward the left.

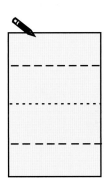

step 5

step 3

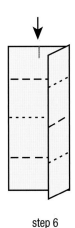

step 6

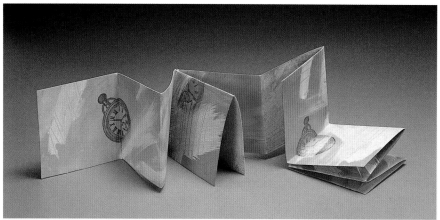

Painted Snake Book Model, 2001; acrylic inks, gesso, rubber stamp; 3 x 3 inches (7.6 x 7.6 cm) (photo: Sibila Savage)

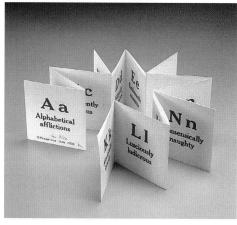

Katherine Ng: *Alphabetical Afflictions*, 2000; letterpress; edition; 2¾ x 2¾ inches (7 x 7 cm) (photo: Sibila Savage)

8. Now bring the right edge to the lengthwise fold. Crease. Open. You should now have accordion folds that make a total of 12 equal-sized sections.

9. Put the paper in front of you vertically. Take the scissors and cut up along the left lengthwise fold for three rows of squares.

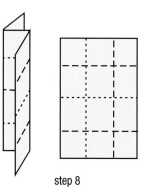

step 8

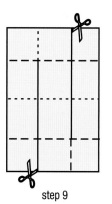

step 9

10. Rotate your paper so the cut is now coming down from the top right.

11. Again cut up along the lengthwise fold (which is now on the left). Leave the fourth row intact. Your paper should look like an *N*.

12. Start folding up your paper, alternating valleys and mountains. When you get to the fourth row, your book will flip over and come back down the next row.

13. Your book should fold up into a neat 2½-inch (6.4 cm) square.

14. To add a ribbon tie: turn the book over so the back page/cover is facing you. Measure and mark 1¼ inches (3.2 cm) from one top and one side edge to find the center. Take a tiny bit of PVA glue and make about a 1-inch (2.5 cm) horizontal line. Find the center of your ribbon and press it on top of the glue line. Spread glue thinly but completely on the back of a 1½-inch (3.8 cm) square piece of paper. Press the square on top of the ribbon, centered on the back page/cover. Open the book completely and press it, sandwiched between waxed paper, under fiberboards with a heavy weight on top.

See the diagrams for the layout of side one and side two.

Uses: presenting a timeline; showing a family tree; travel book

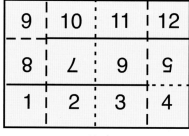

side 1

side 2

STORYBOOK**THEATRE**

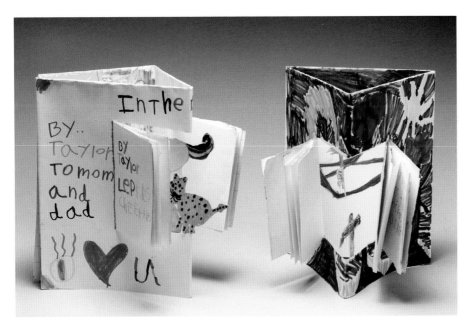

Cathy Miranker, who was coordinating a program funded by an National Endowment for the Arts grant through the San Francisco Center for the Book, taught me this structure, which I in turn taught to third-graders at Lakeshore Elementary School in San Francisco and then to several first grade classes at Ocean View Elementary in Albany, California. I believe this structure's design is credited to Paul Johnson. We also made puppets on craft sticks and created pockets to store the puppets. The first thing the little kids did with their theaters was to put them on their heads like masks, peep out the windows, and shriek.

Tools: bone folder; pencil; metal ruler; permanent glue stick; scissors or knife and cutting mat

Materials: 1 piece of heavyweight paper, 22 x 30 inches (55.9 x 76.2 cm); 2 pieces of textweight paper, each 9 x 12 inches (22.9 x 30.5 cm) and made into Pants Books (page 36); permanent glue stick

Example: 7½ x 11-inch (19.1 x 27.9 cm) theater, with two 3 x 4½-inch (7.6 x 11.4 cm) books as the "curtains"

1. Make two Pants Books (page 36).

2. Fold the heavyweight paper in half, lengthwise, making it longer and narrower.

3. Keeping it doubled, fold in half, widthwise. Open.

4. Fold the ends in to the center fold (cupboard fold).

5. Turn the folded paper over so the flat side is face-up.

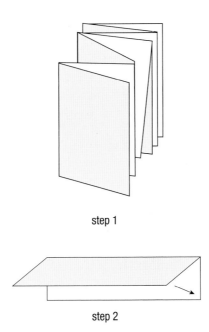

step 1

step 2

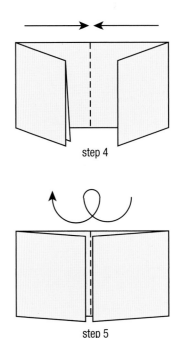

step 4

step 5

6. Place one of the Pants Books so that it is aligned with the vertical center fold.

7. Using the pencil, draw horizontal lines on the theatre at the head and tail of the book.

8. Use a bone folder against a metal ruler and score a vertical line from one cut to the other.

9. Repeat step 8 for the other side.

10. Open the theatre, just keeping it folded long and narrow. Using the knife against the metal ruler, cut a capital I along the marks and at the center fold.

11. Open the flaps like a cupboard or window shutters.

12. Apply the glue stick to the front of one of the books or the inside of one of the window shutters.

13. Nest the book between the two heavyweight "covers."

14. Apply glue stick to the back of the book or the inside of the other shutter and press down the book completely.

15. Repeat steps 12–14 for the second book.

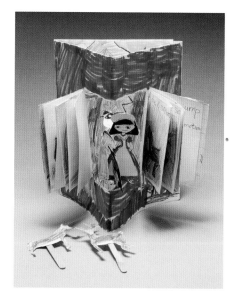

Ocean View Elementary School Book, 2005; marking pens and colored pencil, Manila paper; storybook theatre
(photo: Sibila Savage)

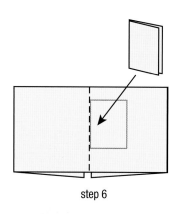

step 6

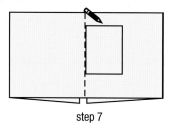

step 7

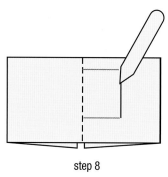

step 8

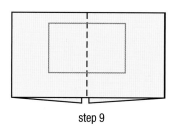

step 9

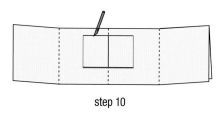

step 10

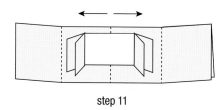

step 11

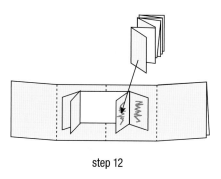

step 12

To assemble the theater

1. Open the theatre again so that it is long and narrow.

2. Stand it up and tuck one end panel under the other end panel to form a triangular tube.

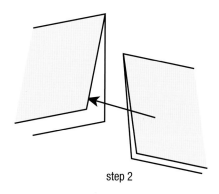

step 2

TWIST**CARD**

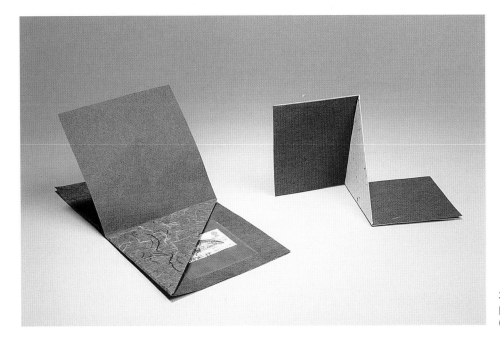

Twist Cards, 1997; sample card, 3 x 3 inches (7.6 x 7.6 cm); with postage stamp, 4 x 4 inches (10.2 x 10.2 cm) (photo: Jim Hair)

For the book arts exhibit, Art and Soul of the Handmade Book in Vashon Island, Washington, Catherine Michaelis and Beth Dunn used this structure for the announcement. It reminded me that I had first seen it in *Creative Cards: Wrap a Message with a Personal Touch* (Kodansha America, 1990) by Yoshiko Kitagawa. Using two sheets of paper gives it a more booklike feel because you can turn the pages.

Tools: ruler; pencil; bone folder; decorative-edge scissors (optional)

Materials: 2 pieces of contrasting rectangular paper (the length is three times the height)

Example: 9 x 3 inches (22.9 x 7.6 cm)

1. Place one piece of paper horizontally in front of you.

2. Staring at the left edge, measure one-third of the paper's width (in this case 3 inches [7.6 cm]), and make a mark.

3. Fold the right edge to the mark. Open.

4. Fold the left edge to the fold from step 3. You should have two valley folds that divide the paper into three even sections.

5. Repeat steps 1–4 with the second paper color, and nest inside the first to match up the folds.

6. Take the top right corner of the center square and bring it over to touch the bottom left corner of the same square. This puts a crease diagonally across the center section.

7. You'll see two squares attached to a triangle. One of the squares and the triangle will be in one color; the other square will be in the contrasting color.

8. Fold the contrasting square back over the triangle.

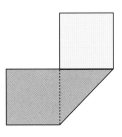

step 7

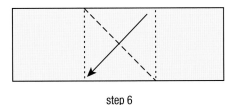

step 6

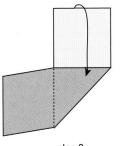

step 8

9. Turn the paper over. Now you will see two triangles in contrasting colors.

10. Fold up the other square over the triangles to make a neat square.

Variation: After you're finished, cut a zigzag or decorative edge on each of the two papers at opposite ends for added decoration.

Uses: birth announcement; birthday card (fold up a check or money inside)

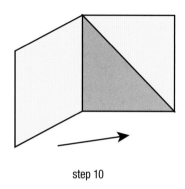

step 10

BRUSH**BOOK**

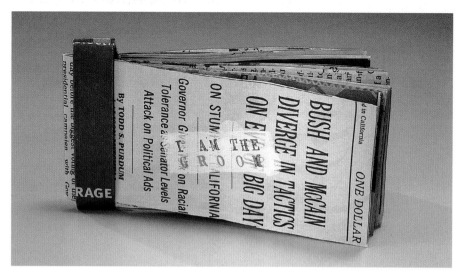

I Am the Groom, 2000; newspaper, gesso, rubberstamped text; brush book; 4½ x 2¼ inches (11.4 x 5.7 cm) (photo: Sibila Savage)

I got the idea for a design for this structure from the gum wrapper chains I made as a kid. This little book uses the same sort of fold for the spine piece. The pages slip right in. I made *I Am the Groom* from newspapers: the word *rage* happened to appear on the spine piece, and by good luck, the word was appropriate to my piece. If you want to work with newspapers, want your book to be archival, and want to make more than one copy, you can photocopy or scan the newspapers to print onto all-cotton paper before you cut up the strips.

Note: this book does not open completely flat.

Tools: bone folder; scissors or knife and cutting mat; metal ruler; glue stick (optional)

Materials: 12 paper strips, each 2 x 11 inches (5.1 x 27.9 cm), grained short; 2 strips, each 2 x 11 inches (5.1 x 27.9 cm) grained long; 1 piece of paper, 2-inches (5.1 cm) square

Example: 5½ x 2-inch (14 x 5.1 cm) book

1. Fold each of the 12 strips in half widthwise.

2. Nest the 12 short-grained strips, one inside the other.

3. Fold one of the leftover strips (that are grained long) in half lengthwise.

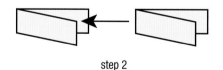

step 2

step 3

4. Keeping the strip folded, fold in half widthwise. Open.

5. Fold the ends in to the center fold.

6. Fold back in half widthwise.

7. Slip the 12 nested strips into the holes created by the single folded spine strip.

8. Bend the pages toward the front and back of the book.

9. Take a square of paper that is the same height as your book (2 inches [5.1 cm]) and fold it in half (folded with the grain, if possible). Open.

10. Fold the ends in to the center fold.

11. Optional: apply glue stick to the two flaps you now see.

12. Open your book to the very center. The pages naturally split here.

13. The new folded piece will look like a *V*. Tuck this piece into the interior slits created by the spine piece. The open side with two folded edges should fit in easily. The side with one folded edge (the point of the *V*) will be slightly exposed inside the book. This interior piece holds the book together.

Uses: collection of words (one word per page); painting-a-day journal

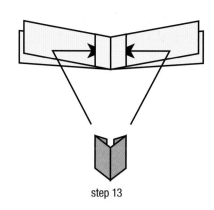

step 13

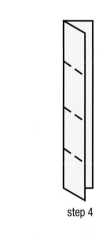

step 4

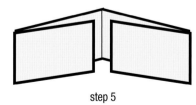

step 5

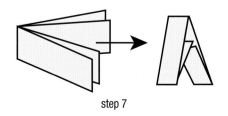

step 7

VENETIAN**BLIND BOOK**

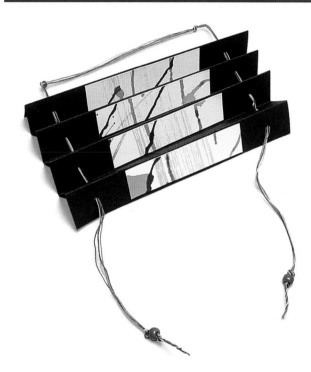

Venetian Blind Book, 1997; acrylic inks, waxed linen thread, glass beads; 1¼ x 8 inches (3.2 x 20.3 cm) (photo: Jim Hair)

I put a tiny Venetian blind in *Mirror/ Error*, Book One in *The Hand Correspondence*. The text was about seeing into a window and watching a couple interact. The instructions use two cords, but you may prefer one long one instead.

Tools: ruler; pencil; awl and cardboard to protect work surface

Materials: medium-weight paper 5 x 20 inches (12.7 x 50.8 cm), grained short; macramé cord or other thick, durable string (approximately two lengths of 20 inches each or 50.8 cm each)

Example: 2½ x 5-inch (6.4 x 12.7 cm) book

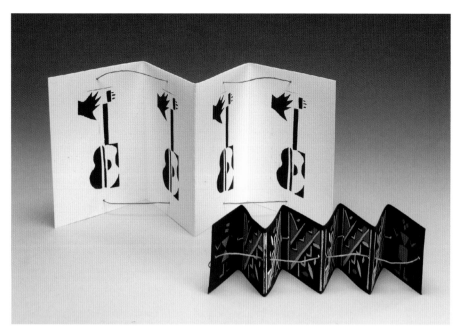

13. To close, pull the strings tightly, pushing the accordion together. Tie the ends together in a bow or make a loose slip knot, using both cords in the same knot. Trim the ends first, if necessary.

Variation 1: Cut a photograph or photocopy into four strips, slightly narrower than the accordions and smaller than the distance between the two holes. Glue down to every other edge. (A glue stick works well with thin papers.)

Variation 2: With pigmented marking pens, write a four-line poem or other text on every other accordion.

Uses: birthday card; sympathy card; short poem about windows

Venetian Blind Book models, 2007; stenciling with gesso (photo: Sibila Savage)

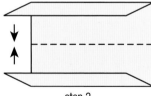

step 1

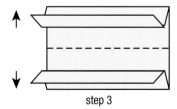

step 2

step 3

step 4

1. Fold the paper in half widthwise with the grain parallel to the fold. Open.

2. Fold the edges in to the center fold.

3. Fold the edges back to the new folds, aligning them.

4. Turn the paper over. Take the folded edges and align them with the center fold, and crease.

5. Fan-fold so the valleys and mountains alternate.

6. Measure approximately 1 inch (2.5 cm) from each end. Mark.

7. With your awl, punch through the folded accordion, putting cardboard underneath in order not to damage your work surface.

8. Repeat step 7 at the other end.

9. Tie a knot on one of the 20-inch (50.8 cm) cords, 2 inches (5.1 cm) from the end.

10. Thread through all the top holes.

11. Tie another knot, leaving another 2 inches (5.1 cm).

12. Repeat for the other cord/end.

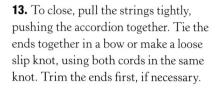

step 7

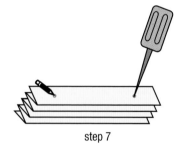

step 10

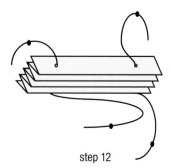

step 12

T-CUT**BOOK**

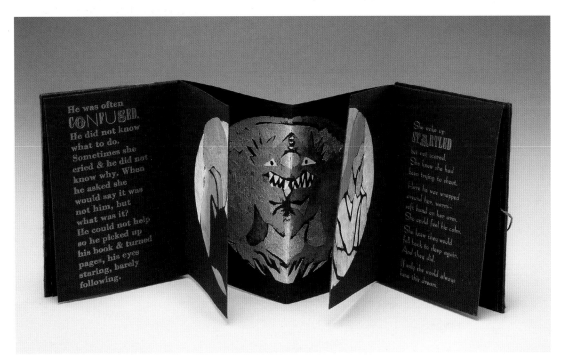

Night Monster, 2004; acrylic inks and gesso stenciling, letterpress, bead and waxed linen; edition of 37; T-cut book; 2¼ x 3¼ inches (5.7 x 8.3 cm) (photo: Sibila Savage)

This structure was brought to my attention by Cathy Miranker, who coordinated a program to send book artists into the schools through the San Francisco Center for the Book and a National Endowment for the Arts grant. When I taught it to a kindergarten class, the children were suspicious because it didn't look like a "real book" to them, so I improvised a wraparound cover on the spot, which changes how the structure can be used. I glued one folded paper to two separate boards for the covers for *Night Monster*.

Tools: bone folder; scissors or knife and cutting mat; metal ruler

Materials: 1 piece of rectangular paper, 8½ x 11 inches (21.6 x 27.9 cm) ; 1 piece of rectangular paper, 11 x 4¼ inches (27.9 x 10.8 cm) (grained short is preferred) for the soft cover OR two separate boards, each 3 x 4½ inches (7.6 x 11.4 cm) (see Covering Separate Boards on page 209); glue (optional)

Example: 2¾ x 4¼-inch (7 x 10.8 cm) book

1. Fold the larger paper in half, lengthwise, making it longer and narrower.

2. Open.

3. Fold the paper in half widthwise. Keep it closed.

4. Fold one open edge to the fold.

step 1

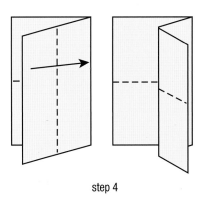

step 4

5. Turn over.

6. Fold the other edge to the fold.

7. Open. Put the paper in front of you oriented horizontally. The vertical center fold should be a valley fold.

8. With the scissors or the knife against the metal ruler along the vertical center fold, cut up from the bottom edge to the center.

9. Cut across the center, making the top of the T at the top of the vertical cut.

10. Rotate the paper 180° so the T is upside down, and fold the top row of rectangles down.

11. Open the center flaps like cupboard doors or window shutters.

12. Refold peaks to valleys so there are valley folds at the ends and a peak fold in the center.

13. Fold up, accordion-style, starting with a valley fold, keeping the flaps down where they are. At this point, you can adhere the end rectangles to boards for a hardcover book. Or continue with the following instructions for a soft cover.

For a soft cover

1. To add the soft wraparound cover, first close the accordion.

2. Fold the long strip of paper in half, widthwise.

3. Fold the ends in to the center fold (cupboard fold).

4. Tuck one section into the front, folded section of the accordion and one into the back section. This should secure the book closed.

5. Smooth out the spine and fore edges.

Uses: short story or poem; when open, a kind of mix-and-match book

step 3

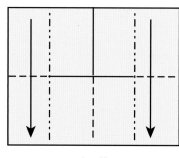

step 10

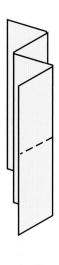

step 6

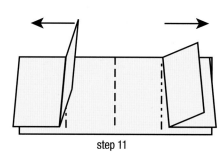

step 11

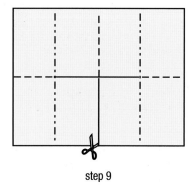

step 9

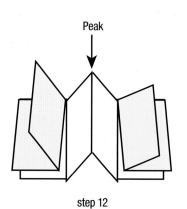

step 12

HOUSE**CARD**

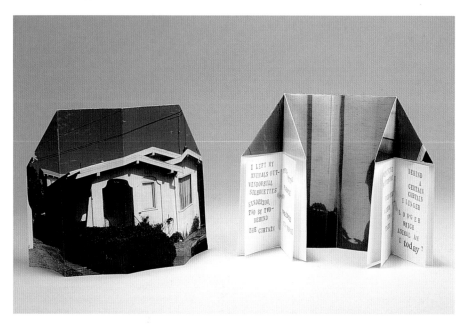

A Certain Curtain, 1997; color photocopy and rubber-stamped text; house card; 5½ x 8 ½ inches (14 x 21.6 cm), open (photo: Jim Hair)

step 1

step 3

step 4

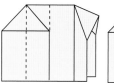

step 5

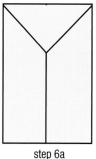

step 6a

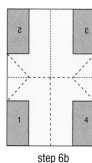

step 6b

Long ago, my daughter Mollie brought this structure home from her first-grade class. The children drew pictures of themselves and their families on each of the open flaps. Anne Hiller, the teacher, didn't remember where she had learned it. I added signatures sewn into the valley folds when I made *A Certain Curtain.*

Tools: bone folder

Materials: 1 sheet of rectangular paper (you can use 2 photocopies or laserprints on one side that fill up the paper, one right-side up and the other upside-down)

Example: 8¼ x 5 ½ inches (21 x 14 cm), open; 2¼ x 5½ inches (5.7 x 14 cm), closed

1. Fold the paper in half, widthwise. (If you are using color photocopies, start with the white side up.)

2. Keeping the paper folded, fold it again, widthwise, then open it.

3. Fold edges in to center fold (cupboard fold). Open.

4. Grasp one side of the top fold with your thumb inside the paper and your forefinger directly pressing on the outside fold. As you pull downward, you will see the panel open up and the beginning of a diagonal shape. Keep pulling downward until the cut edge of the paper touches the fold made by the opening panels. Align the center folds of the top you've just pulled down with the fold below. (See diagram.)

5. Repeat step 4 on other side.

6a. To put the card into an envelope, fold in the outside panels on the existing folds to make the house into a rectangle. You may wish to fold it once again on the existing folds to make a small, compact, booklike object.

6b. you have a full color photo (or two half-page photos, heads touching) on one side and text on the other, see the layout for placement of the text.

Variation: Sew a single signature into the front and back folds. (See page 95 for instructions.)

Uses: housewarming invitation; thank-you note; open-house invitation; birth announcement

LITTLE**ROOM BOOK**

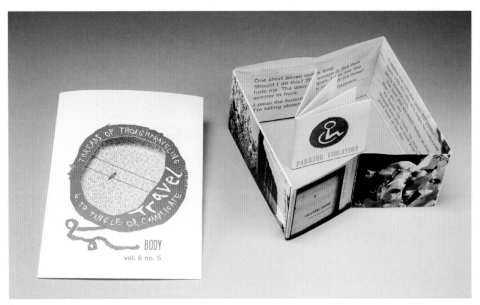

T-ravel: Body, 2007/08; color photo-copy, laserprinted text, letterpress, linocuts; edition of 36; little room book, 2 inches (5.1 cm) tall x 4 inches (10.2 cm) square, open; in handcut window envelope, 3½ x 5 inches (8.9 x 12.7 cm) (photo: Sibila Savage)

Reading through the book *More Than Words: Illustrated Letters from the Smithsonian's Archives of American Art* (Princeton Architectural Press, 2005) by Liza Kirwin, I discovered a letter written and fashioned into the shape of an art gallery by Alfred Joseph Frueh in 1913. I recreated the structure and used it for my artist's book *T-ravel: Body*. My book is about a walk around my neighborhood where an elderly man needs help getting his scooter out of his garage. Just a little glue is necessary here.

Tools: bone folder; scissors or knife and cutting mat; metal ruler; pencil; glue stick or PVA and glue brush; scrap paper for gluing

Materials: square piece of paper

Example: 8½-inch (21.6 cm) square

1. Fold paper in half. (Either way since paper is square.) Open.

2. Fold edges to the center fold (cupboard fold). Open.

3. Fold paper in half the opposite direction. Open.

4. Fold edges to the center fold again. Open.

5. With the knife against a metal ruler, cut a capital *T* across the center four squares. (Or use the scissors, fold the paper in half, and cut a little *T*).

6. Turn the paper over.

7. Fold the paper in half diagonally, just creasing the corner squares.

8. Fold the paper in half diagonally again, only creasing the opposite two squares.

9. Turn the paper over. Open the two flaps in the center as if you were opening window shutters.

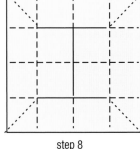

step 8

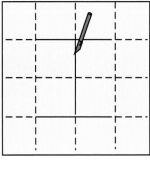

step 5

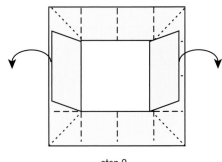

step 9

10. Put the project on a piece of scrap paper. Rotate it so that the *I* becomes an *H*.

11. Flatten the center flaps. Apply glue to the two squares that are parallel and connected to one flap.

12. Bring the adjacent right and left corners over to touch the center fold. Press them down against the two squares, flattening them into double-thickness triangles.

13. Apply the glue to the flap.

14. Press the flap down over the triangles and outer two squares.

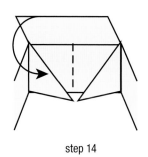

step 14

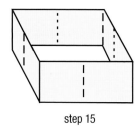

step 15

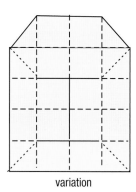

variation

15. Repeat steps 11–14 for the opposite wall.

The "room" will fold long and flat in this position. To make the room fold up more compactly, refold the outer folds from valleys to peaks. Depending on the thickness of the paper, you may be able to fold it into a square and put it into an Origami Pocket Envelope (page 186.) When standing up, the book looks best with the folds visible, open edges on the table.

Variation: To make a pocket on one wall, use a paper that can be divided equally into four squares by five squares. With the paper oriented vertically, cut the *I* with one square depth under it and two squares above it. (See diagram.) After step 8, cut the corners of the fifth row of squares. Apply glue to the attached newly made triangles, and fold the flap down, pressing the triangles securely. Continue with steps 11–15.

GUEST**BOOK**

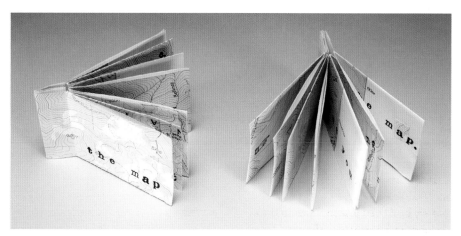

The Map, 2008; rubberstamped text on map; edition of 7; guest book; 3³/₈ x 2¹/₈ inches (8.6 x 5.4 cm) (photo: Sibila Savage)

A friend showed me this structure that she learned from a workshop at the San Francisco Center for the Book. The designer is the highly esteemed Paul Johnson, author of several books on literacy and making books with children in the classroom. According to my friend, Paul makes these little books when he travels, then draws in them and leaves them with his host or hostess as "guest books." It looks like a sidebound book, but it isn't. The glue is optional, but it does keep the book from springing open.

Tools: bone folder; knife and cutting mat; PVA and small glue brush or piece of board

Materials: 1 piece of rectangular paper

Example: approximately 3½ x 2¹/₈-inch (8.9 x 5.4 cm) book

1. Fold the paper in half, widthwise. Keep it closed.

2. Fold one edge back to the fold.

3. Turn over. Fold the other edge back to the fold. Open completely.

4. Repeat steps 1–3, folding the paper in half lengthwise this time.

5. Place the paper horizontally. With a knife, cut an *I* along the folds of the four center squares. Cut two additional slits, as per diagram.

6. Open the flaps out like window shutters.

7. Fold the paper in half, with the flaps inside.

8. Accordion-fold the edges back to the center fold.

9. Gather up the pages and flatten as a pack, leaving one plain (nonflap) point protruding. (If you have printed already, leave the blank pages as the point.)

10. Pleat the plain point into eight segments by first folding the plain point in half.

11. Fold the edge back to the new fold.

12. Fold the folded section to the book block. Open.

13. Skipping the first and last folds nearest the book block and starting with a peak fold, refold so that you have an accordion.

14. Apply glue to the inside of the pleats. Add a dab of glue to the inner edges of the pages as well. This will hold the book together so it doesn't flop open.

See the layout if you wish to create the contents of your book before you fold it.

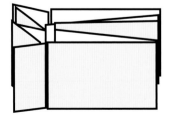

layout

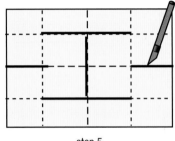

step 5

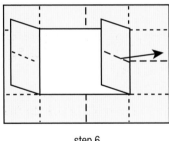

step 6

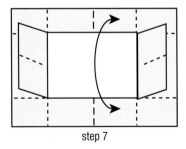

step 7

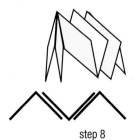

step 8

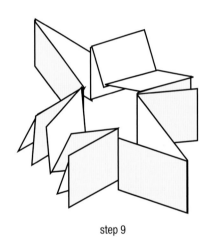

step 9

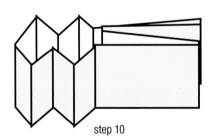

step 10

step 13

CROWN**BINDING**

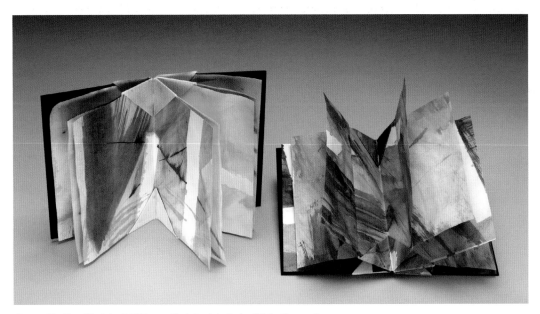

Crown Binding Models, 2007; acrylic inks (photo by Sibila Savage)

This structure took about three years to make its way from the hands of Hedi Kyle in Philadelphia to the San Francisco Bay area. Now it is popular among students in my bookmaking classes at California College of the Arts because the pages are removable and changeable. The crown forms both the spine and the movable tabs that hold the pages in place. With a wider accordion, you can put slips of secret papers in the openings on the outside.

Tools: bone folder

Materials: 1 textweight paper, 8 x 7½ inches (20.3 x 19.1 cm), grain short; 4 textweight papers, each 5¼ x 4¼ inches (13.3 x 10.8 cm), grain short; separate wrapped boards or folded open-spine softcover papers.

Example: 4¼ x 5½-inch (10.8 x 14 cm) book

1. Fold the 8 x 7½-inch (20.3 x 19.1 cm) paper in half, widthwise. Open.

2. Fold the ends in to the center fold.

3. Open the inner flaps out like a window shutter.

4. Turn paper over.

5. Fold the folded ends to the center.

6. Alternate mountains and valleys as you fan-fold the eight-panel accordion.

7. Orient the paper so the first open edge is on the right, the fore edge.

8. Fold the top corner of the paper diagonally forward to touch the spine. Repeat for the bottom corner.

9. Open this first page. Repeat the diagonal folds, this time with the doubled corners.

10. Now fold these doubled corners back along their creases as well so your folds can be either peak or valley folds.

11. Repeat steps 9 and 10 with the remaining peak-folded fore edges.

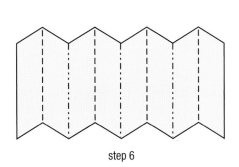

step 6

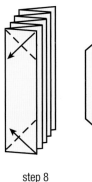

step 8

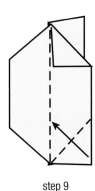

step 9

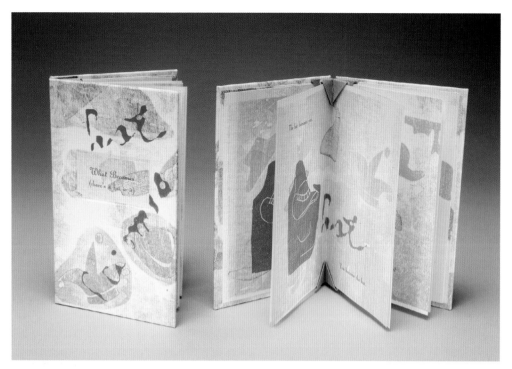

What Becomes (there's a hat in it), 2009; letterpress, mixed techniques; edition of 19; crown binding; 3¼ x 5¼ inches (8.3 x 13.3 cm) (photo: Sibila Savage)

12. Fold the last page with the triangles showing on the very back.

13. Open the accordion completely.

14. Pinch at each mountain fold at the stars shown, and pop the triangles away from you.

15. Close up the accordion, and orient it with the first open edge on the right, as you did in step 7.

16. Open the book to the first spread. Fold the top triangles down and the bottom triangles up.

17. Turn the page.

18. Repeat the folding and turning with the remaining pages.

19. Each of those triangles now becomes the movable tabs. Open the first spread.

20. Fold the smaller pages in half, widthwise.

21. Lift the triangles on the first spread, and align the fold of the new page with the fold of the spine.

22. Fold the triangles back down, locking the new page in place.

23. Repeat steps 21 and 22 for the remaining pages.

24. Add separate wrapped boards or folded open-spine softcover papers. (See page 209 or 206 for details.)

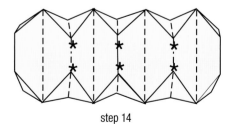

step 14

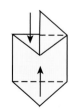
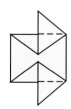

step 16

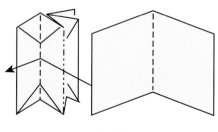

step 21

SLOT**& TAB BOOK**

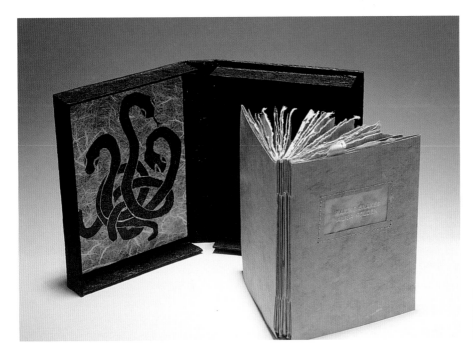

Waking Snakes, 1996; letterpress, linoleum cuts, on paper custom made by Magnolia Editions; edition of 20; slot and tab binding; 3½ x 5 inches (8.9 x 12.7 cm) (photo: Jim Hair)

My husband, Michael, a software engineer, designed this structure in 1995 because, he said, "glue is messy and I don't like to sew." When he said he was going to make up a binding, I snapped, "Maybe you should learn some first!" Well, he showed me. The slot and tab is cool. My students like it. It is thick, has an exposed binding, and looks as if it has signatures. Theoretically, this structure is expandable and can be any thickness, including any number of pages. However, at a certain point (around 2 inches [5.1 cm], too many pages cause the spine to wobble. I designed a cover and used the slot and tab for my edition of *Waking Snakes* in 1996.

The slot and tab structure is very similar to one that New York book artist Ed Hutchins showed me in 1994, but it did not create signatures, and the structure was limited by the thickness of the paper. Two years later, Ed showed me a struc-ture with interlocking pages. It was essentially the slot and tab but had an extra third sheet. He had developed it independently. He said Susan Share had sent him some diagrams for a similar form. On the diagrams I read, "These are the original drawings of that structure circa 1979–80? John Wood, retired professor (print-making and photography) at College of Ceramics at Alfred, N.Y." Two pages fit together, but I saw that he had not linked pairs of signatures to make a thick book.

Within the book art community, many people share ideas, and many people independently devise similar solutions to problems. If you think of something new, I hope you will be inspired to share it. For best results, use a lightweight text paper, preferably with no grain. Handmade paper works particularly well.

Tools: bone folder; knife and cutting mat; metal ruler; pencil

Materials: textweight paper, 5½ x 8½ inches (14 x 21.6 cm); 2 sheets of light-weight cover paper, each 5½ x 12 inches (14 x 30.5 cm) (it could be as short as 10½ inches [26.7 cm]).

Example: 4¼ x 5 ½-inch (10.8 x 14 cm) book

1. Fold all sheets in half, widthwise.

2. Cut tabs in half of these pages in the following manner: along the center fold, measure 1 inch (2.5 cm) from top and bottom, subtract 1/32 inch (0.8 mm), and mark or cut directly. These are the tabbed sheets.

step 2

3. Cut and slot the remaining sheets by measuring 1 inch (2.5 cm) from top and bottom and cutting exactly from the 1-inch (2.5 cm) mark to 1 inch (2.5 cm) from the bottom (in this case, from the 1-inch [2.5 cm] mark to the 4½-inch [11.4 cm] mark). These are the slotted sheets.

4. Take one tabbed sheet, and loosely and gently roll one side of a page from top to bottom. Insert the tab through the still-folded, slotted sheet, pull gently to straighten. Close the "signature." Find the side of this signature that has the slotted sheet with the single-cut edge; make sure the cut edge is on top. You will be adding more signatures here.

5. Make pairs of pages (signatures) with the remainder of the sheets; leave these in front of you with the slotted side up. Take one signature and roll the back tabbed sheet gently from top to bottom, inserting just as you did for the signatures, this time from the outside (again, keeping the

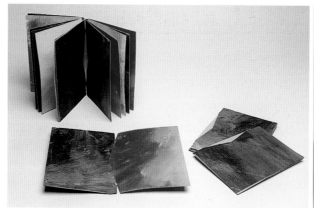

Triangle and Diamond Book Model, 1997; acrylics; 5 x 7 inches (12.7 x 17.8 cm) (photo: Sibila Savage)

slotted page closed). Add the remaining signatures in the same way, building upward. You may need to keep arranging and creasing the spine with a bone folder.

Cover: Use lightweight cover paper, preferably the same weight as the text paper, grained short. Measure 4¼ inches (10.8 cm) from one end; mark and score parallel to the grain. This section of the paper will function as an interior page. Measure 4⅜ inches (11.1 cm) from this score, and mark and score. This section will function as the cover. The remaining bit is a flap that will wrap around the first sheet when the book is fully assembled.

For open pocket pages: Fold 8½ x 11-inch (21.6 x 27.9 cm) pages in half, both widthwise and lengthwise. Orient the paper vertically, and cut a *V* on the bottom two panels. Fold and slit for tabbed pages only.

Tip: If you use a heavy printmaking or drawing paper, you will have to cut narrow triangles instead of the tabs and diamond holes instead of the long slits.

step 3

cover

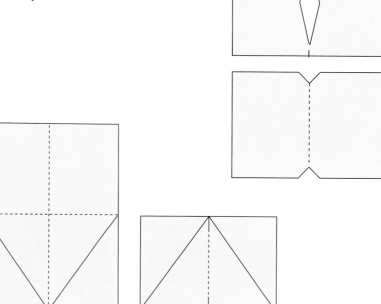

open pocket pages

POCKET**TRIANGLE & DIAMOND BOOK**

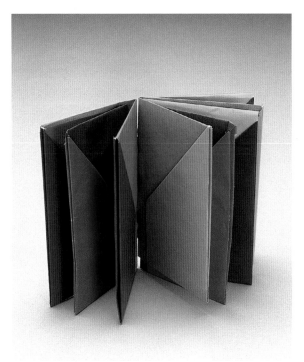

Pocket Triangle and Diamond Book Model, 2000; double-sided origami paper; 1⁵/₈ x 2¹/₄ inches (4.1 x 5.7 cm) (photo: Sibila Savage)

6. Repeat step 5 for the remaining board.

7. Slip the boards back into place in the first and last sections, with the strips at the fore edge.

Variation: Add six heavyweight papers, each 4 x 5 inches (10.2 x 12.7 cm), grained long, to the openings in the pages, or make them 4½ x 5 inches (11.4 x 12.7 cm) and trim to 4 inches (10.2 cm), leaving ½-inch (1.3 cm) tabs at the fore edges.

This is a variation of the slot and tab book. I based the pocket pages on a very elegant origami wallet found in *The Art of Origami* (BDD Promotional Books Company, 2005) by Gay Merrill Gross. Although the simplified wallet page is less elegant than the original, it is easier to fold. See the instructions for the origami wallet and a photo of *Green Tea* on page 195.

Tools: bone folder; pencil; ruler; scissors or knife and cutting mat; glue stick or PVA

Materials: 4 sheets (or more) of light-weight paper, each 11 x 17 inches (27.9 x 43.2 cm), grained short; 2 pieces of 2-ply or 4-ply museum board, each 4 x 5 inches (10.2 x 12.7 cm), grained long; 4 strips of paper, each 5 x 2 inches (12.7 x 5.1 cm) (same color as the pockets), grained long

Example: 4¼ x 5¼ inches (10.8 x 13.3 cm)

Assembling the book

1. Make the larger, lightweight papers into Origami Wallet pages (page 195).

2. Follow steps 2–5 of the Slot and Tab book (pages 55–56), but instead of cutting slots in the pages, cut triangles at the head and tail for one set and cut diamonds in the center of the other set.

3. Slip a piece of museum board into each of the open sections at the front and back fore edge. Trim the boards to fit, if necessary. Remove the boards.

4. Fold the four strips of paper lengthwise.

5. Apply glue or glue stick to the back of one 2-inch-wide (5.1 cm) strip. Wrap the strip around one edge of one board, and press down. Apply glue to a second strip, and press into place across from the first strip. These strips will be parallel to the spine.

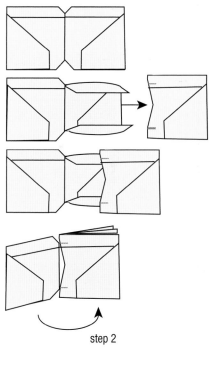

step 2

step 5

PIANO**HINGE WITH SKEWERS**

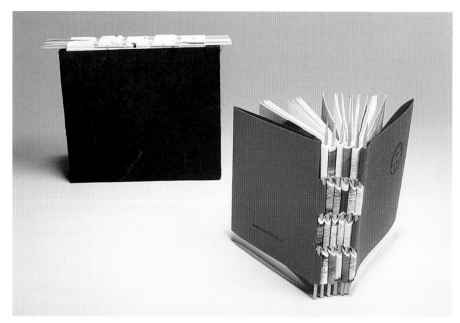

Piano Hinge Book Models, 1997; with hardcover, acrylic inks, 4¼ x 5 inches (10.8 x 12.7 cm); slipcase, 5 x 6 x 1½ inches (12.7 x 15.2 x 3.8 cm) red softcover with offcuts from *Ezra's Book*, 4¼ x 4 inches (10.8 x 10.2 cm) (photo: Jim Hair)

The signatures in this structure are woven together over sticks. When the book is held horizontally, it creates an object like a library newspaper holder. Soft covers work with little pop-up-like folds inside and look similar to the pages. Hard covers are fastened with a modified sidebinding. Create a holder or horizontal slipcase to house the piano-hinge book because the skewers cause the book to sit at an angle. When Adele Crawford took my class, she sewed old recipes to the pages, letting the thread ends hang out of the book; it looked great. The structure is usually attributed to Hedi Kyle. It also appears in *Non-Adhesive Binding: Books without Paste or Glue* (Sigma Foundation, 1999) by Keith A. Smith, and *Cover to Cover* (Lark Books, 1995) by Shereen LaPlantz. I modified the covers.

Tools: pencil; metal ruler; knife and cutting mat or scissors; bone folder; PVA glue and brush; scrap paper

Materials: 15 or more sheets, each 8½ x 5-inch (21.6 x 12.7 cm), grained short; decorative colored paper as section cover-dividers, if desired; bamboo skewers

Example: 5 x 4¼-inch (12.7 x 10.8 cm) book with five "tabs"

Note: The photos show books with six sections, each of which uses three inner sheets per section (18 per book,) plus the decorative dividers (six per book).

1. Group pages evenly into three or more sections, with 2 to 4 inner sheets per section and one decorative sheet faceup on the top of each. Do not fold in half.

2. Pick up one section, and center it to wrap around the skewer.

3. Wrap it, bringing the fore edge ends together and smoothing toward the skewer/spine with the bone folder.

4. Mark horizontal lines, evenly spaced (four, in this example, 1 inch [2.5 cm] apart—you can use a divider to figure out where they go) along this semi-crease. Lines should extend evenly, the width of your skewer (or dowel or pencil, if you use those instead) on both sides of the skewer/spine.

5. With the scissors, using the end of each line as the tip of your triangle,

cut small equilateral triangles (¼ to ⅜ inches [0.6 to 1 cm] for skewers, ½ inch [1.3 cm] if you use pencils). Or open the section and cut small diamonds with a knife. Take care to wrap and crease each subsequent section like the first one. Cut all triangles. Now you have created tabs between the triangles.

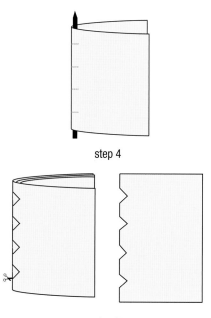

step 4

step 5

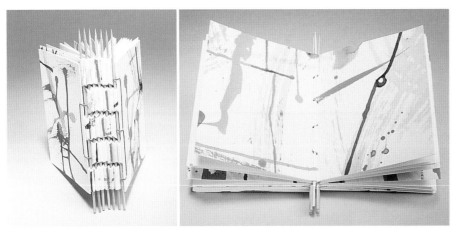

Piano Hinge Book with Hard Cover, 1997; (photo: Jim Hair)

6. Bend the odd tabs one way (let's say to the left) and the even tabs the other way (to the right). Your tabs should alternate sides.

7. Repeat steps 2–6 for all sections.

8. Fit all sections together. Link one section to the next (the tabs from one should nestle over the tabs from the next).

9. Insert a skewer by poking the pointed end vertically through the center of the tabs. The spine will look woven.

10. Repeat until all the sections are linked.

11. Trim off the pointed ends of the skewers, if you like.

Covers for the Piano Hinge

For soft covers: To attach a soft cover to the front and back sections, you will need medium-weight to heavyweight cover paper that will be folded in half. For this example, use two sheets, each 5 x 9½ inches (12.7 x 24.1 cm), grained short.

1. Starting at the right edge of the front cover and the left edge of the back cover, measure, mark, and score ¾ inch, 1 inch, and 1¼ inch (1.9, 2.5, and 3.2 cm) on the back. You should have three scores, each ¼ inch (0.6 cm) apart.

2. For the moment, valley-fold only the 1-inch (2.5 cm) flap, wrong sides together.

3. Measure and cut triangles on this fold as you did for the sections.

4. Bend tabs, alternating left and right. Then open and smooth out.

5. For the front cover, push in any tabs that would otherwise bend right by opening and refolding, like an accordion or inner pop-up with a center valley fold, one mountain fold on either side. You will connect only the left tabs.

6. For the back cover, push in the opposite tabs because you will connect the cover to the text block with only the right tabs.

7. Apply PVA to the cover pieces on both sides of the inner pop-up and along the edge flap to glue the cover to itself. Press down.

8. To complete, thread a skewer through the covers and the text block.

Variations: Use photocopies or handwritten pages of recipes; use a glue stick, hand-sew, or machine-stitch recipes to the paper; write out ingredients, a memorable feast; draw facsimiles of guest checks or receipts; write lists of favorite foods, etc.

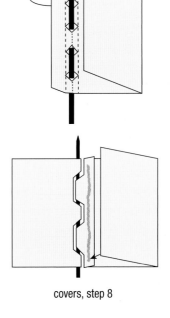

step 6

step 4

covers, step 8

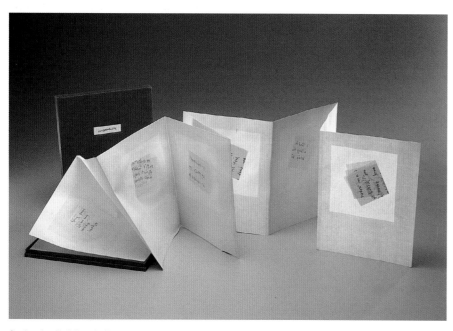

Coriander Reisbord: *Unspeakable*, 1998; Japanese paper and paste; accordion fold with 18 panels; 5³/₈ x 7 inches (13.7 x 17.8 cm) (photo: Sibila Savage)

TWO LAMINATED BOOKS

Unspeakable was made by laminating three sheets of Japanese paper together with wheat starch paste. This book is about secrets and trying to have it both ways: the relief of telling one's shameful secrets, without the shame of people knowing what they are. I like that the secrets are inside the pages, underneath the surface: their existence is revealed but not their substance.

I made *Defensive Book* by laminating text-tweight printmaking papers together over pins. The pages get smaller as you move through the book, and the pins get more numerous. I tried to show that if you try to follow all the rules for self-protection, you end up living an intolerably constricted life. The text was lifted from a university pamphlet on safety for female students.

CORIANDER REISBORD

SIMPLY GLUED

A little bit of glue can hold pages in an assortment of book styles. The perfect binding is the ultimate no-frills structure; the glue at the spine holds together a stack of flat pages or cards. With a few folds and that same amount of glue, you can make the Japanese album; a book that opens into a star shape; an origami-based book with flower fold pages; flag books with pocket, envelope or fortune pages; winged books; and tunnel

books. By laminating (a.k.a. gluing) pages around a support and adding square knots, you can make the tied binding or the tied stick binding.

Working with glue is the main activity in this chapter. Keep stacks of old magazines or catalogues handy to cover your work surface; since the pages are slick, they won't stick quite so easily to your project, and you will have plenty of scrap papers to discard, leaving your final

book as clean of unintended smudges as possible. Avoid squeezing glue directly from the bottle onto your project; pour out some glue onto a paper plate and use a brush or small piece of board to spread the glue thinly and evenly. See page 20 for more information about adhesives, including a section on how to keep the paper flat while it dries.

PERFECT**BINDING**

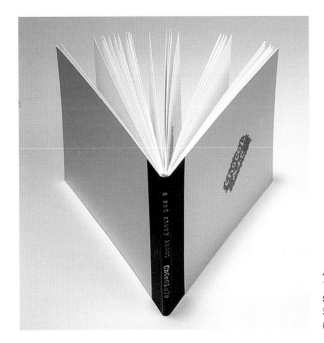

A Sad Story about Chocolate, 1989; linoleum cuts, rubber stamps; perfect-bound; 5½ x 4¼ inches 14 x 10.8 cm) (photo: Jim Hair)

This book structure works only with PVA. Betsy Davids showed me how to do this in college, and I was astonished that I could stack and bind the complete edition of 100 copies of *A Sad Story about Chocolate* in five minutes. You can re-glue mass-market paperbacks that are coming apart by preparing the book block, then attaching the cover at the spine. If you stack and glue many books simultaneously, use a knife to slice them apart when dry. For added stability, adhere a strip of mull/super (bookbinding mesh) before you attach the spine or cover.

Tools: binder clip or clamp (for small stack only); weight; ruler; pencil; glue brush; bone folder; PVA; waxed paper

Materials: stack of pages, each 4¼ x 3½ x ½-inch (10.8 x 8.9 x 1.3 cm), grained short; cover paper, 9¼ x 3½ inches (23.5 x 8.9 cm) OR 2 covers, each 4¼ x 3½ inches (2.5 x 7.6 cm), grained short, each plus spine strip, 1½ x 3½ inches (3.8 x 8.9 cm), grained long; super, 1 x 3 inches (2.5 x 7.6 cm), optional

Example: 4¼ x 3½-inch (10.8 x 8.9 cm) book

1. Line up the loose pages in a stack at the edge of a table.

2. Clip the edge with the binder clip, and clamp together or weigh down, using a heavy book or brick, with the stack edge unweighted and slightly over the edge of the table.

3. Spread the glue thickly on the spine edge. Let dry.

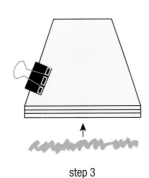

step 3

Add spine piece or cover

4. Measure and make a mark at the center, head, and tail of either the spine piece or the long cover paper (whichever you have chosen to use). Then measure and mark ¼ inch (0.6 cm) (half of the spine depth; this may vary) on either side of the center mark, also the head and tail.

5. With the bone folder, score lines connecting the corresponding head/tail marks.

6. Fold the spine (or cover paper) along the scores.

7. Apply glue to the spine of the book again, this time adding about ⅛ inch (0.3 cm) glue wrapped over the front and back of the book block. Remove the weight, if you were using one.

Optional: Attach the super, centered on the spine, and apply more glue.

8. Nest the book block in the spine piece or cover. Smooth down with the bone folder.

9. Put waxed paper between the cover and first and last pages. Let dry under weight.

Uses: a postcard collection; any pile of pages to be bound quickly

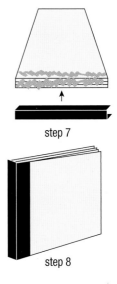

step 7

step 8

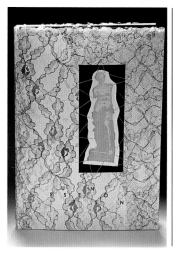

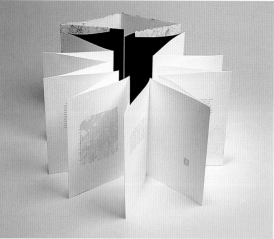

Suspension, 1988; letterpress, photoengravings, printing from lace; edition of 74; album accordion; 6 x 9 inches (15.2 x 22.9 cm) (photo: Jim Hair)

5. Set another page on top. Align the folds (you can always trim the open fore edge later).

6. Repeat steps 2–5 for the remaining pages.

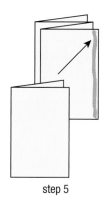

step 5

For the flutterbook

After step 1, spread glue in a thin line along the side of the folded spine (just to the right, not on the fold itself), stack another sheet on top, align the folds, and continue in this manner with all sheets.

Variation 1: Make a soft cover or wrapped hard cover.

Variation 2: Use a series of single-sided photocopies or laserprints for your pages because the printing only needs to be on one side.

Variation 3: Paint a large sheet of paper to cut up and attach, using one section for the wraparound cover.

Uses: travel journal; sketch book; birthday book

I call this album the Japanese album or album accordion to differentiate it from a photo album and because I learned it from *Japanese Bookbinding* (Weatherhill, 1986) by Kojiro Ikegami. I used the binding for *Suspension*, a book about a woman and bureaucracy. Many times I have felt I was between things, suspended; that uneasy feeling was what I was trying to evoke. Venus is sewn "suspended" on the front cover. When the book is pulled open as an accordion, there is tension between the pages where they are glued, another suspended feeling. Both the album and the flutterbook begin in the same manner. The album has folded pages glued at the fore edge. For the flutterbook, the folded pages are glued at the spine. The waxed paper will prevent moisture from the glue from being absorbed by subsequent pages, which would warp the book.

Tools: small brush for gluing; magazines for scrap paper; glue; waxed paper

Materials: paper, 5½ x 8½ inches (14 x 21.5 cm)

Example: 4¼ x 5½-inch book (10.8 x 14 cm)

Tips: For cleaner gluing, place a sheet of scrap paper as a mask over the sheet you wish to glue, leaving only the edge exposed that will actually be glued. Spread the glue, remove the scrap paper, and proceed with the remaining pages. Work from the last page to the first, aligning the folds and stacking as you go. Use a minimal amount of glue.

1. Fold the pages in half. Face the open edges to the right.

2. Put a sheet of the scrap paper inside one page (and one on top as a mask).

3. Spread the glue in a thin, flat line along the fore edge of the exposed page.

4. Remove the scrap paper and discard it, replacing it with a sheet of waxed paper.

Flutterbook

ALPHABET**STAR BOOK**

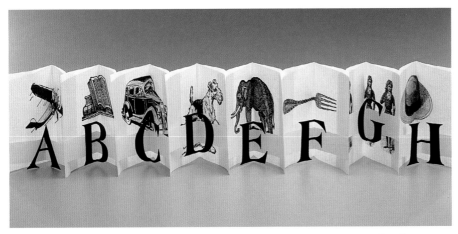

Three Dimensions in the Alphabet, 2000; laserprinted; 4¼ x 5½ inches (10.8 x 14 cm) (photo: Sibila Savage)

A friend organized a gift book for me when I was expecting my first child. She assigned each of my friends a letter of the alphabet and told them to make a page with that letter. After they sent back their pages, she slipped the illustrated alphabet into plastic sleeves in a commercially made notebook. For a handmade alphabet book, you could make a larger version of the Pocket Frame Book, page 73, or the Alphabet Star Book.

For *Three Dimensions in the Alphabet*, the images were taken from Dover clip art and the typeface is Americana Bold. The structure is a marriage of a Japanese album accordion and a star book. While this one is only a model, I could have planned an edition because it could be easily reproduced.

Tools: ruler; pencil; scissors or knife and cutting mat; weight; scrap paper; PVA or glue stick

Materials: 26 sheets of paper, each 8½ x 5½ inches (21.6 x 14 cm), grained short; 26 strips of lightweight paper, each 2x 7 inches (5.1 x 17.8 cm), grained short

Example: 4¼ x 5½-inch (10.8 x 14 cm) book

1. Draw, collage, or write on the large sheet of paper about things that relate to the letter.

2. Fold the paper strip in half widthwise. Open.

3. Draw the letter, centered, on the strip, making the letter 2 inches (5.1 cm) tall.

4. Measure ½ inch (1.3 cm) from top and bottom of the strip. With the pencil, lightly draw two lines at these places that are parallel to the longest edges of the paper.

5. Cut out the edges of the letter above the top line and below the bottom line, leaving the letter connected to the paper in the middle. Also make a cut along the top line and the bottom line, again leaving the letter connected to the 7-inch (17.8 cm) piece of paper.

6. Fold the large sheet of paper in half widthwise. Open.

step 4

7. After masking with the scrap paper, put a thin line of glue on the back of the left side of the letter strip.

8. Press down, aligned with left edge of the larger paper. Fold the letter strip over so it is closed.

9. Put a line of glue on the back of the right side of the letter strip.

10. Close the larger paper on top of the strip and press down.

To connect the completed sheets

11. Connect as for the Album Accordion, page 62, steps 2–6.

12. Press under weights overnight.

A variation of this book may be made with sewn layers of accordion-folded pages (see the photo of Julie Chen's book *Radio Silence*, page 111.)

Uses: alphabet book; carousel book; constellations; acrostic poem

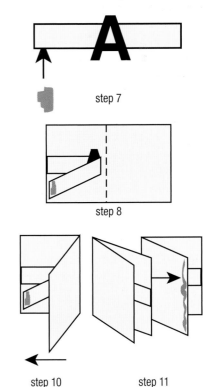

step 7

step 8

step 10 step 11

CONCERTINA**WITH TABS**

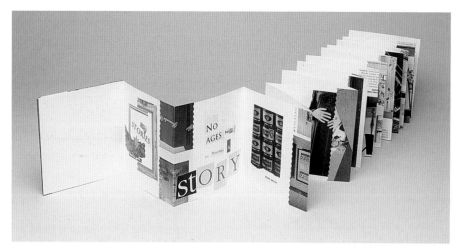

Life Stories, 1996; collage; concertina with tabs; 4¼ x 4¾ (10.8 x 12.1 cm) (photo: Jim Hair)

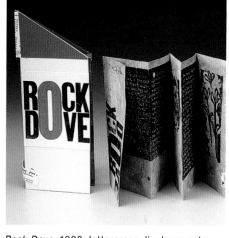

Rock Dove, 1998; letterpress, linoleum cuts, photocopy; edition of 44; 4 x 10 inches (10.2 x 25.4 cm) (photo: Sibila Savage)

At a Berkeley homeless shelter where Lisa Kokin was teaching, she invited me to make books with the temporary residents. We made the concertina with tabs, using strips of magazines to attach the inner folded papers. The students seemed pleased with the process and with the thick books they made quickly. The men and women looked through the strips thoughtfully for images that appealed to them; they didn't just take random pieces. I made *Life Stories* as an example during that class.

For *Rock Dove* I used tabs to hold the concertinas together. The Mexican bark paper was brittle, so I didn't want to poke holes and try to sew it for fear of tearing it. Sometimes, like in this case, the materials dictate the structure for mechanical reasons.

Tools: glue brush; waxed paper; scrap paper; PVA or glue stick

Materials: pages 5½ x 8½ inches (14 x 21.6 cm), grained short; decorative tabs or strips, 1½ x 5½ inches, (3.8 x 14 cm), grained long; 2 pieces of contrasting paper for cover, each 5½ inches, 8½ inches (14, 21.6 cm), grained short

Example: 4¼ x 5½-inch (10.8 x 14 cm) book

1. Fold all the pages and cover papers in half, widthwise.

2. Face the pages with the open end to the right.

3. Fold all tabs or strips in half, lengthwise.

4. Face the folded strips with the open end to the left.

5. Place the waxed paper inside one page.

6. Place one strip on a sheet of scrap paper, and brush glue on the inside of the strip.

7. Line up the top sheet of one page so it is even with the fold on the strip. Rub the page down on the strip. The strip should be at the fore edge.

8. Quickly line up the bottom of another sheet, so when you close the sticky strip, two pages will be adhered into a concertina.

9. Continue gluing strips and aligning the pages—page, strip open, page, press strip closed—until done. Add covers at the front and back in the same manner.

Uses: recipe book; journal; guest book; book about shopping

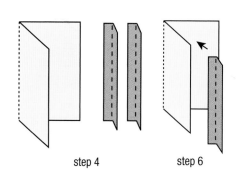

step 4 step 6 step 8 step 9

MINIATURE**TIED BINDING**

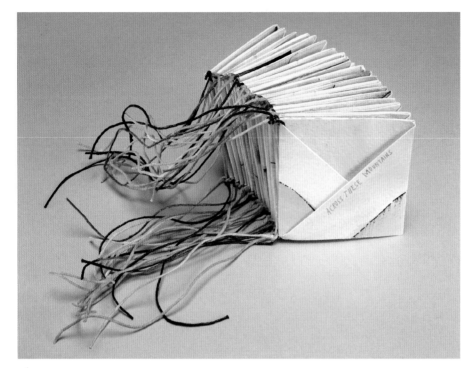

Across These Mountains, 2007; acrylic inks, linen thread; origami envelopes with tied binding; 2 x 2 x 2 inches (5.1 x 5.1 x 5.1 cm) (photo: Sibila Savage)

I keep going back to the Mills College library in Oakland, California, to look at the Daniel Kelm wire-edge binding used for Tim Ely's book *Synesthesia*. This is my variation of the binding, using colored waxed linen instead of wire and leaving wild threads loose at the ends. A student in my bookmaking class at California College of the Arts tied them back in on themselves, leaving random knots at the spine, which looked good, too. For books larger than 3 inches (7.6 cm) tall, use the Sewn and Tied Binding that follows.

Tools: scissors; ruler; glue brush; bone folder; knife and cutting mat; magazines for scrap paper; PVA

Materials: rectangular paper, all the same size, no larger than 3 inches tall (7.6 cm) grain parallel to this height) by any width; various colors of waxed linen thread

Example: 3 x 3-inch (7.6 x 7.6 cm) book

1. Fold all of the pages in half. Open.

2. Cut enough pieces of linen thread 7 inches (17.8 cm) long so that you have one per page.

3. Put one page on the scrap paper, decorative side down.

4. Apply glue to one half of the page.

5. Center one thread in the groove of the fold.

6. Fold the page in half, aligning the corners.

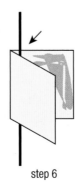

step 6

7. Press and smooth down with the bone folder.

8. Repeat steps 3–7 for all remaining pages.

Tying the book together

9. Stack two pages, one atop the other. With two corresponding threads, tie a square knot at the head.

10. Tie a square knot at the tail.

11. Keep stacking and tying until all the pages are attached.

12. Trim the fore edges with the knife against the metal ruler.

Note: As you add a page, try to use the threads of the preceding and adjacent page for one thread of each of the new knots. Using different colors of threads for each page will help you see the pattern.

Uses: book about loose ends; book using maps and navigation; color sample book; collection of words or images; book about hair or beards and moustaches, any subject

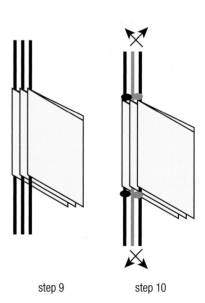

step 9 step 10

SEWN& TIED BINDING

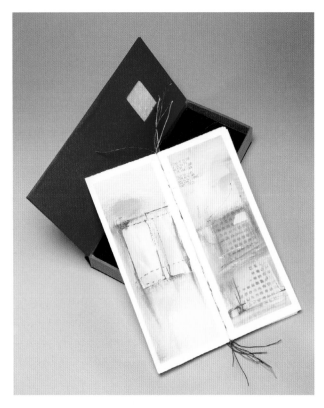

Lookout, 2007; acrylic inks, museum boards, linen thread; 4 x 10 inches (10.2 x 25.4 cm) (photo: Sibila Savage)

5. Thread the needle with about 18 inches (45.7 cm) of regular thread and start from inside one of the pages at a point that is about 1½ (3.8 cm) inches from the head.

6. Sew from out to in across the spine to the next page.

7. Make a stitch, from the inside to the outside along the fold in that same page.

8. Sew across the spine again to the third page.

9. Keep making little stitches and sewing across the spine until you get to the last page.

At the last page, come back up the spine from about 1½ inch (3.8 cm) from the tail.

10. Knot the end.

11. Put a little bit of PVA on both ends to secure them inside the pages.

This variation makes a decorative spine. You can also make it without the boards. If you make a taller book, like my book *Lookout*, use the dry transfer adhesive mentioned at step 11 to ensure that your book stays flat and doesn't curl.

Tools: scissors; ruler; glue brush; bone folder; knife and cutting mat

Materials: rectangular paper, all the same size, no larger than 3 inches tall (7.6 cm) grain parallel to this height) by any width; various colors of waxed linen thread; magazines for scrap paper

Example:
4 x 5-inch (10.2 x 12.7 cm) book

1. Measure out six lengths of colored waxed linen, each 9 inches (22.9 cm) long.

2. Fold each of the sheets of paper in half, widthwise.

3. Knot the end. Thread the needle with one thread. Directly in the fold, sew a random running stitch from the inside to the outside, and end with the thread back inside again.

4. Repeat step 3 for the remaining threads and sheets of paper.

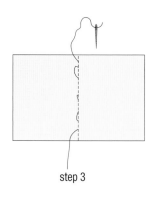

step 3

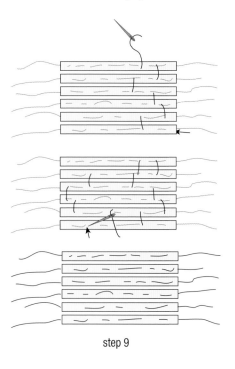

step 9

12. Rub the transfer adhesive onto one side of one board or place the board on some scrap paper and apply glue with the brush.

13. Open one page, and align the board with the fore edge and with the corners of the page.

14. Apply adhesive to the other side of the board and press down.

15. Repeat steps 11–13 for the remaining boards and pages.

16. If you are using PVA, sandwich the pages with waxed paper and put the project under a weight to dry.

17. Tie one thread from one page to one thread from a second page in a square knot at the head. Tie a square knot at the tail as well.

18. Continue taking one thread from each page and tying it to the next until all pages are tied together at the head and tail.

Uses: book about rooms; photo display; wedding guest book (tying the knot)

step 12

FLOWER**FOLD**

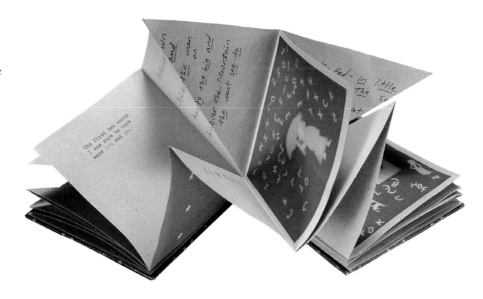

One Word, 2003; typewritten text, handwriting, sun prints; flower fold; 4¼ x 4¼ inches (10.8 x 10.8 cm) (photo: Sibila Savage)

I think a student showed me this one long ago. Anna Wolf alternates right-opening squares and left-opening ones for her diamond-fold books. For one kindergarten class that was studying plants, we drew a flower's life cycle on the pages, then made little seed packet envelopes to house them. We worked in groups of six children with two or three adults in each group, and they were able to complete the project.

Tools: bone folder; small brush for gluing; glue or glue stick

Materials: origami paper or other square paper, each 8-inch square (20.3 cm) Example: 4-inch (10.2 cm) book

1. Put the paper on a work surface, colorful side down (or place facedown the side that will be the outside).

2. Fold the paper in half. Open.

3. Fold in half crossways. Open.

4. Turn over. Fold diagonally. Stand it up on the table.

5. Put your finger down on the very center to "pop" up the corners.

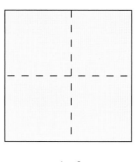

step 3

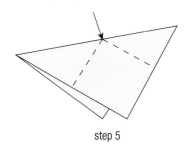

step 5

6. Take the corners that have the diagonal fold through them, and bring them together; while doing this, fold in the sides. You should have a square with two flat sides and folds in between.

7. Repeat these steps with four or more pieces of paper.

8. Line up the squares with their openings to the right.

9. Put glue on one of the flat sides, with the opening facing to the right (it will look like a diamond shape).

10. Place another diamond on top of this one, lining it up carefully.

11. Press down.

12. Repeat for the rest of your squares.

Variation: Put the loose ends together. With a hole punch, punch through both pieces; then thread a ribbon or raffia through to make a hanging star or flower decoration.

Uses: put one descriptive word inside each "petal" and use as a greeting or friendship card; write about flowers, stars, or other things that unfold or blossom

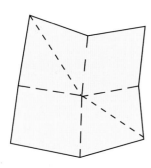

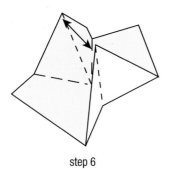

step 6

ACCORDION**BOOK WITH** **FLOWER-FOLD PAGES**

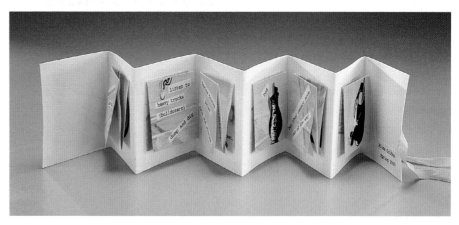

Daytime Daisies, 2000; paste paper, collage, laserprinted text; 2¾ x 3 inches (7 x 7.6 cm) (photo: Sibila Savage)

My daughter made a book like this in elementary school. I like the way the pages expand. I used this structure for *Daytime Daisies*, which is about daisies growing and dying while children play in the dirt at their feet and bulldozers move dirt at the construction site nearby. It is a metaphor for the way we are sometimes rooted in one place watching everything, unable to move except through our children. The following example has four panels.

Tools: bone folder; metal ruler; art knife and cutting mat; glue

Materials: 4 sheets of medium weight paper, each 8½ x 11 inches (21.6 x 27.9 cm), any grain; 1 sheet of heavyweight paper, 4½ x 18 inches (11.4 x 45.7 cm), grained short

Example: 4 ½-inch (11.4 cm) square book

To make a square from rectangular paper

1. Fold each piece of the four 8½ x 11-inch (21.6 x 27.9 cm) medium-weight papers on the diagonal so that the edges align (see diagram).

2. Cut across the edge that is not doubled. You should now have a triangle left over.

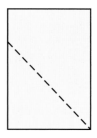

step 1

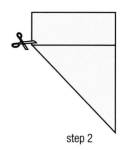

step 2

Daytime Daisies, 2000; paste paper, collage, laserprinted text; 2¾ x 3 inches (7 x 7.6 cm) (photo: Sibila Savage)

10. Arrange the long, folded cover strip so that it begins with a valley fold.

11. Since the folded square pages will open out from the corner, decide if you want the page to open up or down. To open up, place the open corner in the bottom left or right corner. To open down, position the open corner in the top left or right corner. Put glue on one of the flat sides of one of the 4¼-inch (10.8 cm) squares. Press into place, centered on the first section of the cover strip.

12. Repeat with other three squares in second, third, and fourth sections.

Note: In the diagram, pages one and three open up, and pages two and four open down.

Uses: book about something that expands or grows; book of surprises; guest book of wishes

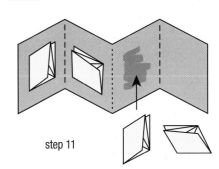

step 11

3. Open the triangle. It is now a perfect 8½-inch (21.6 cm) square. Turn it over so that the mountain is facing up.

Continue to make the flower-fold pages

4. Fold the square in half one way. Open. Fold in half the other way. You will have two valley folds on this side and one mountain fold.

5. Bring up the corners of each end of the diagonal fold. Match them.

6. Press down one flat square to meet the opposite flat square. You now have a folded 4¼-inch (10.8 cm) square.

7. Fold all four squares. Set aside.

8. Fold the longer paper in half widthwise.

9. Fold each end back and match it to the fold. You should have three alternating mountain-and-valley folds.

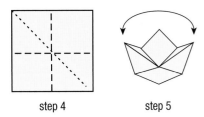

step 4 step 5

WINGED**BOOK**

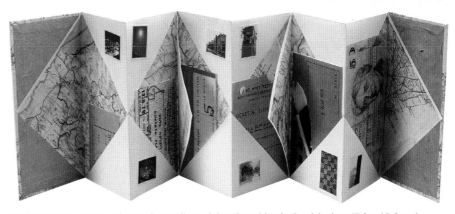

Israel Touring, 2004; color copies, collage, ink; winged book; 3 x 6 inches (7.6 x 15.2 cm) (photo: Sibila Savage)

A friend brought back some hexagonal, pressed-paper coasters from Spain, which inadvertently contributed to my designing this book; I wanted to make a book shaped like a hexagon. When the pages are joined, the hexagon is not visible. I originally called it a "check book" because the size and aspect ratio was exactly like that of a bank check, but the flaps are looking more and more like wings to me. The wings can be glued back-to-back or sewn together at the folds with pamphlet stitches. Like traditional origami, the pages start with a square; directions for finding a square are steps 1 and 2 of Accordion Book with Flower Fold Pages on page 68.

Tools: bone folder; pencil; ruler; brush for gluing; magazines for scrap paper; PVA

Materials: 5 sheets of medium-weight paper, each 8½ x 8½-inch (21.6 x 21.6 cm)

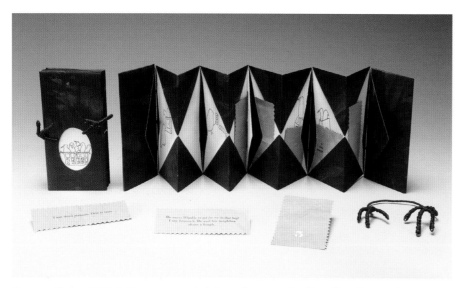

Crows at Home, 2008; letterpress, acrylic inks and gesso, wire, linen thread, paper bgas; edition of 22; winged book; 2¾ x 5¾ x 1 inch (7 x 14.6 x 2.5 cm) (photo: Sibila Savage)

Example: 3 x 6-inch (7.6 x 15.2 cm) book, (with added hard covers: 3⅛ x 6¼ inches [8 x 15.9 cm])

1. Put the paper in front of you like a diamond. Fold it in half diagonally from corner to corner (if you haven't already). Open. Turn the paper over.

2. Find the exact middle and make a light mark with a pencil. Fold the remaining two corners so that they touch this middle mark. All of your folds are now parallel.

3. Fold the top and bottom corners in toward the center mark.

4. Open the side triangles. These will be flaps that will attach to neighboring segments, holding the book together.

5. Repeat steps 1–4 for the remaining sheets of paper.

Assembling the book

6. Work from back to front. Place the pages in front of you in a row.

Start with the last page. Put scrap paper from a magazine between the left triangle and the rest of the folded sheet. Apply a thin, even coat of glue to the back of the triangle. Remove the scrap paper.

7. Align the back of the right triangle from the preceding segment with the sticky left triangle. Press down.

8. Repeat steps 6 and 7 until the segments are joined in a line. You should have one loose flap at the front and one at the end.

Optional Cover Choices

Soft cover: Use one heavyweight paper, 6½ x 6¼ inches (15.9 x 15.9 cm), grained short. Measure, score, and fold a ¼-inch (0.6 cm) spine in the center (see diagram) that is parallel with the short side (and the paper grain). Align the valley fold of the first page of the book block with the valley fold of the front cover. Do likewise for the back page and back cover. Glue or stitch the end triangles to the front and back covers in these places.

Wrapped hard cover: Use two 2-ply museum boards, each 3 x 6 inches (7.6 x 15.2 cm), grained long; two sheets medium weight paper, 3 x 8 inches (7.6 x 20.3 cm), grained short; two sheets medium weight paper, 6 x 6 inches (15.2 x 15.2 cm). Make the folds parallel to the grain. Center and sew or glue the end triangles to the 3 x 8 inches (7.6 x 20.3 cm) sheets; these are the inner endsheets.

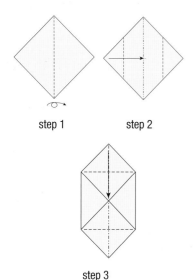

step 1 step 2

step 3

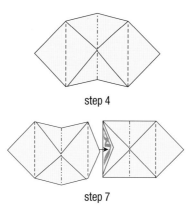

step 4

step 7

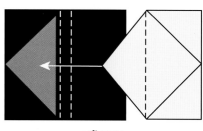

soft cover

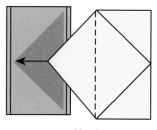

wrapped hard cover

Adhesive hard cover: You will need two 4-ply museum boards, 3⅛ x 6⅛ inches (8 x 15.6 cm), grained long; 2 sheets lightweight paper or book cloth, each 8½ x 8 inches (21.6 x 20.3 cm), grained short; 1 lightweight endsheet, 6⅜ x 6¼ inches (16.2 x 15.9 cm), grained short. You may glue boards front and back like sandwiches (see Covering Separate Boards, page 209); this will enable your book to extend to its full length. Add a triangular recess in the inner front and back covers, like in Israel Touring, for a more integrated look. If you use fewer pages or want your book to be more contained and not pull out into a long accordion, you can make a connected hard cover instead that has a ⅜-inch gap at the spine (see page 215 for a Case Binding with single signature).

Uses: book about birds, kites, airplanes; cut the triangular wings into different shapes

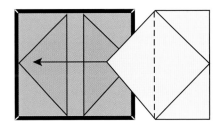

Adhesive hard cover

FLAG**BOOK**

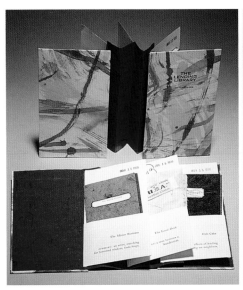

The Lending Library, 1996; letterpress, mixed media; single flag structure with library pockets; 3¾ x 6¾ inches (9.6 x 16.5 cm) (photo: Jim Hair)

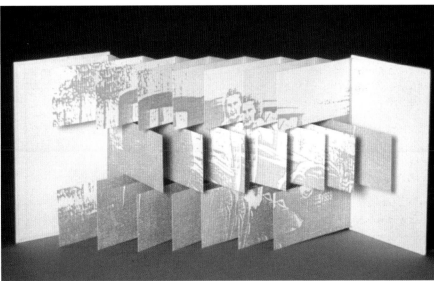

Susan King: *Women and Cars*, 1983; letterpress and offset; edition of 500; hardbound flag book; 8⅛ x 5⅛ inches (20.6 x 13 cm); produced with a grant from the Women's Studio Workshop (photo: John Kiffe)

The multiple flag book pops open in a surprising way. Betsy Davids taught me how to make this structure after showing the class Susan King's *Women and Cars*. The cards in Susan's book open to create one complete photograph. The structure was created by Hedi Kyle, who was one of the first people to discover, create, and teach interesting, nontraditional structures. *The Lending Library* makes use of only a single flag per page, which makes all of the pages face the same direction like the Pocket Frame Book on page 73.

Tools: bone folder; ruler; glue brush; scrap paper; PVA

Materials: medium-weight or lightweight paper for spine accordion, 8 x 5½ inches (20.3 x 14 cm), grained short; 9 cards, each 1½ x 4¼ inches (3.8 x 10.8 cm), grained short

Example: 4¼ x 5½-inch (10.8 x 14 cm) book with 9 cards

To make an accordion with eight 1-inch (2.5 cm) panels

1. Fold the paper in half, widthwise. Open.

2. Fold the edges to the center fold, one end at a time.

3. Fold the edges back to the new folds, making sure they are aligned.

4. Turn the paper over, keeping everything folded.

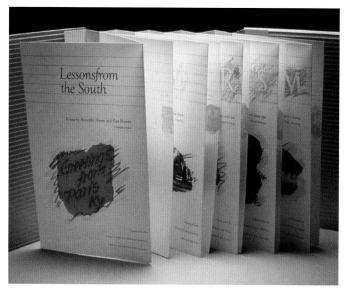

Susan King: *Lessonsfrom the South*, 1986; offset, UV Ultra II, corrugated plastic, paper; edition of 500; die-cut accordion; 7 x 10¾ inches (17.8 x 27.3 cm); produced with a Nexus Press artist-in-residence grant; Clifton Meador, printer (photo: John Kiffe)

INSPIRED BY HEDI KYLE

In the 1970s, I ran up against the bastions of conservatism in the fine print and binding worlds. Letterpress printers maintained I could only print in black, with an occasional initial cap in red if I were feeling adventurous. But I wasn't completely comfortable in the artists' camp either. I cared about craft.

Then I attended a Fine Printing conference in New York. When Hedi Kyle arrived with her now famous "flag" book, I stood around a table of her models, hastily drawing the diagram of the flag book, hoping I could remember it long enough to figure out what she'd done.

I was inspired by her models, and my work with multiple narratives changed. My book, *Lessonsfrom the South*, could be read as a traditional codex or as a concrete poem with chapters whose multiple texts could be read top to bottom. The book could also stand—become a stage set—show more than one opening of the book at once.

Hedi's book models are elegant and deceptively simple. Meeting and working with her changed me and my work.

SUSAN E. KING

5. Align the folded ends with the center fold; crease. You should now have an accordion with alternating mountain-and-valley folds at every inch (2.5 cm).

6. Arrange the accordion to start with a valley fold on the inside, or faceup.

Note: Glue all the top and bottom cards down first, because they are on the same side of the fold. Then turn the "pages," and glue the center cards so that there is space between the top and bottom the cards. Although it looks tricky, just remember to apply just a little glue to the back of the cards only. You are only attaching about 1 inch (2.5 cm) of the card to the accordion. Top and bottom cards have glue on the back right margin; the center ones have glue on the back left margin only.

Glue cards in a row on each fold from back to front as follows:

7. Put a thin coat of glue on the back of last top card (landscape orientation) on the right 1-inch (2.5 cm) margin only. Align the card with the top of the accordion on the front of the last mountain fold, pushing the left edge of the card all the way into the valley fold.

8. Glue the second card, aligning it with the bottom of the accordion on the front of the last mountain fold, also with the edge aligned with the valley fold.

9. Glue the next set of top and bottom cards to the front of the preceding mountain fold.

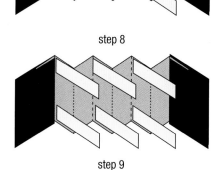

step 8

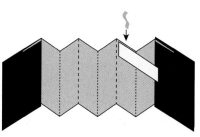

step 7

step 9

10. Continue the same pattern of steps 1 and 2 on the front of the first mountain fold.

11. Starting from front to back, align the center third cards, one at a time, now on the back of the same mountain folds. Remember, the glue is on the back of the card. It will look as though the image faces the opposite direction. Don't worry. Align all center cards with the previous center cards as you go.

12. The pages/cards should end up all the same length. Trim if necessary.

13. Make an open spine cover or cover separate boards (see Chapter 10). A wrapped hard cover doesn't work well un-less you glue the end tabs of the accordion inside the wrapped hard cover, which defeats the original concept of that particular cover: no glue. However, the point of this book is that you are free to choose the projects you like, and you are encouraged to customize each structure.

Variation 1: Make the covers connected to the accordion by using a longer paper (17 x 5½ inches [43.2 x 14 cm]). For nine cards, you need 6 inches (15.2 cm) for the accordion in the middle. Measure 4½ inches (11.4 cm) from each edge. Score and fold. Then fold the accordion in the center of the long paper by aligning the folds and creasing.

Variation 2: Make larger cards from heavy black paper. Mount photographs on them.

Variation 3: Glue two or three accordions together to make room for 18 or 30 cards. If you use an even number of accordions, you must cut off the end flap for the book to be properly oriented; hence, 18 cards. (See Accordion with Signatures, page 113, for directions about gluing accordions together.)

Uses: book of sayings; photo display album; collaborative project; definitions of one word; birthday book; business card holder; postcard display; honor roll list (one name per strip)

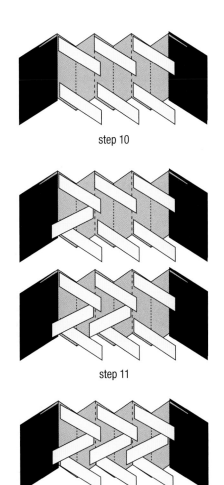

step 10

step 11

step 12

POCKET**FRAME BOOK**

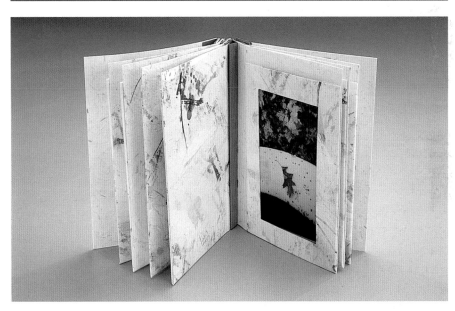

Photos, 2000; handmade pocket frame pages, photographs; 5 x 6½ x ¾-inch (12.7 x 16.5 x 1.9 cm) depth (photo: Sibila Savage)

I created handmade envelope pages with windows for *Photos*, a pocket frame book. I left a margin at the top of each page for a caption. For the following example, you will have a ½-inch (1.3 cm) top margin.

Tools: ruler; pencil; scissors or knife and cutting mat; metal ruler; glue or glue stick

Materials: 7 sheets heavyweight paper, each 13½ x 5⅝ inches (34.3 x 14.3 cm), grained long; 1 sheet medium-weight paper, 12 x 7 inches (30.5 x 17.8 cm), grained short

Example: approximately 5 x 7-inch (12.7 x 17.8 cm) book to hold seven 4 x 6-inch (10.2 x 15.2 cm) photos

1. Fold the 12 x 7-inch (30.5 x 17.8 cm) paper into an accordion with 16 panels. (It may be easier to start with the eight-panel, steps 1–5 on page 71, fold each of those panels in half, then adjust the mountain and the valley folds to alternate.)

2. Put one sheet of the heavyweight paper in front of you, vertically (portrait orientation).

3. Measure and mark ¾ (1.9 cm) inch from the right and left edges, making the marks at top and bottom.

4. Score lines vertically, connecting these two sets of corresponding marks.

5. Measure and mark 6½ inches (16.5 cm) from the top, making the marks on the right and left edges.

6. Score a horizontal line at this mark.

7. Starting at the left edge, cut a slit along the horizontal line, stopping at the vertical score (the slit will be ¾ inch [1.9 cm]).

8. On the right-hand side, cut off the top right rectangle. (Leave the bottom right rectangle.)

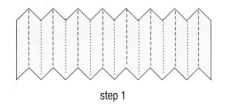

step 1

9. Measure and mark a window in the bottom panel, leaving at least a ¾-inch (1.9 cm) margin of paper all the way around.

10. Using a knife against a metal ruler, cut out this window.

11. Valley-fold along the bottom right and left rectangles. Open.

12. Apply a thin line of glue to cover these two rectangles. They are flaps.

13. Keeping the two flaps folded, fold the paper in half widthwise, along the horizontal score.

14. Press and smooth down the glued tabs. This is a frame. You will notice a third tab sticking out on the left.

15. Repeat steps 2–14 for the other six pieces of paper.

Attaching the pocket frames to the book

16. Arrange the accordion-folded paper in front of you with a valley fold as the first fold on the left.

17. Adhere the pages from back to front. Apply a thin, flat line of glue to the segment of the accordion that is just to the right of the second-to-last valley fold. Keep the very last valley fold unglued.

18. Press down the tab of one of your frames onto the accordion, making sure you align it with the fold.

19. Repeat steps 17 and 18 for the other six frames, each time gluing to the segment just after a valley fold. Try to align each frame with the previous frame as you go.

20. Add two 7¼ x 5-inch (18.4 x 12.7 cm) glued separate hard covers (see page 209), or two 7 x 4⅞-inch (17.8 x 12.4 cm) wrapped hard covers (see page 208).

Note: if you want more pages/frames, make two accordion-fold spines. The first accordion should have a valley fold for its first fold; the second should be oriented with a mountain fold as its first fold. Glue the accordion-fold spines together. You will have to cut off the last segment of the last accordion.

Uses: photos from one event; postcards; collection of related small drawings or paintings, put image on front with text on the back

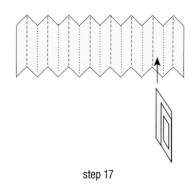

step 17

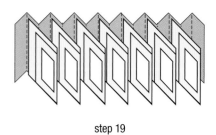

step 19

step 5 step 7

step 10 step 13

FLAG BOOK**WITH ENVELOPE PAGES**

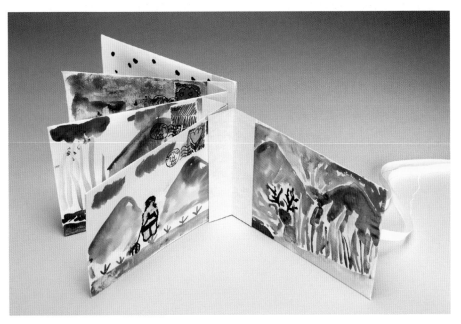

Instead of making the Pocket Frame Book, you can use commercially made envelopes, then glue them to the accordion spine starting at step 16. For a front cover, seal a piece of 2- or 4-ply museum board into a fourth envelope; use a fifth envelope and board for the back cover. In the third grade classes at Ocean View Elementary, we made books about their families; in the fourth grade classes, the teachers connected it to the curriculum with *"History of Albany"* books, using one envelope for each of the three time periods: Ohlone Indians, Spanish settlers, and present day. Many kids put the new Target store on the present day envelope.

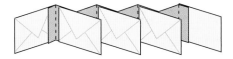

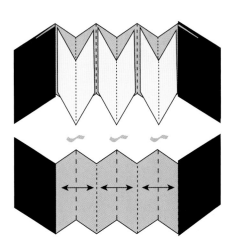

History of Albany by a fourth grade Ocean View Elementary School student, 2005; watercolors, envelopes; flag book with envelope pages (photo: Sibila Savage)

FLAG BOOK**WITH FOLDED PAGES**

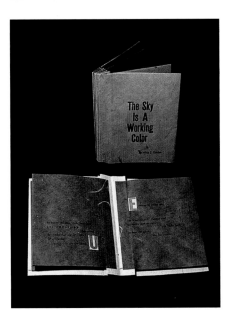

The Sky is a Working Color, 1985; handmade abaca paper, letterpress; edition of 22; flag book with folded pages; 4$^1$/$_4$ x 5$^3$/$_8$ inches (10.8 x 13.7 cm) (photo: Jim Hair)

Another alternative to the Pocket Frame or the Envelope Page is the plain folded sheet. *The Sky is a Working Color* was one of my earliest artist's books. I used the concertina spine with pages folded at the fore edge and glued on the front and back of each mountain fold, sandwiching the mountain/spine folds.

In the top illustration, the folded pages are glued to the front of the accordion; the back of the accordion is left alone. The accordion in this case lends a bit of springiness to the book. If you want a compact structure that feels more like a traditional book, you can glue the back of the accordion together, as shown by the center diagram. The third drawing illustrates how that version of the book might look when opened.

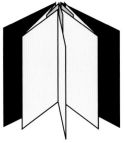

FLAG BOOK**WITH FORTUNES**

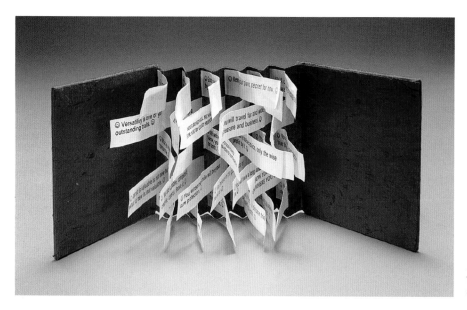

Fortune Book, 1997; paper, fortunes;
flag book; 3 x 3 inches (7.6 x 7.6 cm)
(photo: Sibila Savage)

I know they're in there. Clean out your desk, bag, pockets, wallet, and count those fortunes. Once you have fifteen, you can make this book.

Tools: bone folder; glue stick or PVA

Materials: 8 x 3½-inch (20.3 x 8.9 cm) piece of medium-weight paper; magazines for scrap paper; 15 fortunes from cookies (or 2¼ x ¼-inch to ½-inch [5.7 x 0.6 x 1.3 cm] paper strips)

1. Fold the paper into an accordion with eight segments (see steps 1–5 on page 71).

2. Apply glue stick or a dot of PVA to the back of the first fortune (the glue will be on the far right on the back). Press the first fortune down just a tiny bit below the top edge of the accordion on the front of the last fold.

3. Apply glue stick or a dot of PVA to the back of the second fortune (this time on the far left on the back). Press the second fortune down on the back of the last fold just below the first fortune.

4. Repeat steps 2 and 3 for the third, fourth, and fifth fortunes on the last fold.

5. Repeat steps 2 and 3 for all the fortunes on the second and first folds.

6. Using 3 x 2½-inch (7.6 x 6.4 cm) boards, grained long, attach a wrapped hard cover (see page 208) or separate boards and endpapers (page 209). If you make the latter, adhere the ends of the accordion to the boards before adhering the inner paper in step 7.

Uses: graduation, birthday, or wedding gift; book of political or social commentary

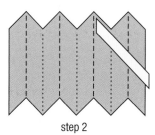

step 2

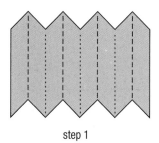

step 1

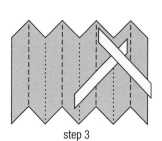

step 3

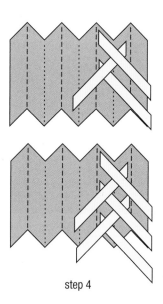

step 4

TUNNEL **BOOK**

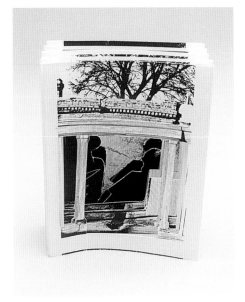

New Mexico, 1995; photocopy, colored pencil; tunnel book with strips; 4¼ x 5½ inches (10.8 x 14 cm) (photo: Jim Hair)

The first tunnel book I made was *Gateway*. I saw later that just gluing pages into one long accordion-folded paper made the pictures/pages stand at a diagonal, and the tunnel didn't open completely; it looked warped. After examining some of Edward H. Hutchins's tunnel books, I began using this method instead. It is similar to the endless accordion but can be thicker because it has two "spines."

The tunnel book offers a challenge to the maker: how to see many layers at once. The finished piece is dramatic. If you like making these, consider making the Theatre Box on page 231 to help you.

Tools: knife, and cutting mat; metal ruler; pencil; bone folder; small brush for gluing

Materials: at least 5 photocopies or original art/prints or picture postcards of the same or different 5½-inch (14 cm) (tall) image(s) (drawing, photograph, text) onto cardstock or heavy paper, grain vertical (from 6 inches [5.2 cm] up to 8½ inches [21.6 cm] wide); 8 papers, 3 x 5½ inches (7.6 x 14 cm) for spines, grained long; magazine as scrap paper; glue

Example: 5½ x 6 to 8½-inch (14 x 21.6 cm) book

Tips: Pick a horizontal/landscape drawing with perspective or with many objects in it that are clearly defined. Or pick an abstract image or series of images that you can add to by cutting out your own interesting shapes. The pictures should have at least a ½-inch (1.3 cm) border on the sides.

1. Pick the image that is to be the final one. Set it aside. You will not cut this one.

2. Cut a large hole in the first image. You can vary the shape of the holes or cut out distinct objects in each layer.

3. Cut holes of decreasing size into the other three images. The top and bottom can be cut to within ⅛ inch (0.3 cm).

4. Make eight M-shaped concertinas (accordions) by folding the strips in half, lengthwise; then fold the edges back to the center fold.

5. Turn one toward you so that when tightly closed, the concertina opens from the right (like a regular book in English). Put this accordion on your left.

6. Take another one that would open from the left and put it to the right of your work surface.

7. When gluing, open the flaps. Cover with scrap paper everything but the end you need to glue. Brush on the glue. Remove the scrap paper. Press the flap down to the image.

8. Glue your last image (the one without any holes) to the back two flaps (one on either side). The flaps will be glued on top of the last image. Glue the pages from back to front and from the smallest hole to the largest.

9. Next, glue the fourth page on top of the flaps, and then glue two more flaps on top of the fourth image.

10. Repeat with all the images. The first image should sit on top of the flaps.

Uses: birthday card, presentation book; table decoration; one poem

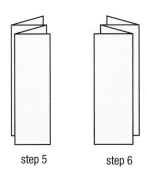

step 5 step 6

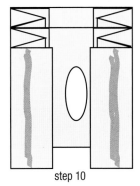

step 10

Eat As I Say: unrecognizable recipes, 1997; collage, rubber stamps; endless accordion; 6 x 4³/₈ inches (15.2 x 11.1 cm) (photo: Jim Hair)

This structure does not depend on one long piece of paper folded up precisely but on a series of short, easy *M*-shaped accordion-folds. Although it appears endless, this structure works best if it is kept under ½ inch (1.3 cm) thick. The spine of this accordion starts to curve to the right if you use more than approximately ten strips.

I started out to create only a model of the endless accordion but ended up with a finished piece. First, I decided to use tabbed index cards. So I glued those together with the accordions. It looked so empty. I rummaged around and found some old recipes I always thought I would make but never did. They were yellowed. I glued them to the cards. "Yeah, so what?" I said to myself. I got out the *New York Times* and found two articles: one about a beauty queen factory in Venezuela, the other about how the employees of the FDA don't eat according to their own standards. I mixed them up and glued parts of each in the book. I didn't like it. I ripped some of the recipes off, thinking it would be funnier if each tab had the wrong title for the recipe below it. Then I thought of a text and rubber-stamped it around the torn paper. I added some decorative torn papers. *Eat As I Say: unrecognizable recipes* was born.

Tools: glue brush; bone folder; PVA or glue stick

Materials: 5 decorative tabs or strips, grained long, each at least 1½ x 5½ inches (3.8 x 14 cm) tall; magazines for scrap paper; 6 inner pages, each 5½ x 8½ inches (14 x 21.6 cm), grained short; 2 heavier decorative cover pages (same size as inner pages)

Example: 5½ x 4¼-inch (14 x 10.8 cm) book (with six pages)

1. Make five *M*-shaped concertinas (accordions) by folding the strips in half, lengthwise; then fold the edges back to the center fold. Turn them all toward you so that when tightly closed, the concertina opens from the right (like any regular book in English). Put these accordion strips on your left.

2. Open the flaps of one of the *M*s.

3. Using scrap paper, cover all but the edge you need to glue.

4. Brush on the glue. Remove the scrap paper.

5. Press the flap down on the top of the last page.

6. Put glue on the top flap, align, and press the second-to-last page on top of the flap.

7. Glue a second *M* on top of this page.

8. Continue until all *M*s and pages are glued together in alternating order.

Variation 1: Glue recipe cards to the *M*s.

Variation 2: Use folded pages, gluing the open edges of each page together at the spine.

Uses: recipe book; photo album

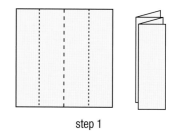

step 1

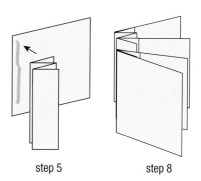

step 5 step 8

TUNNEL BOOK**WITH CONTINUOUS SIDES**

Edward Hutchins: *San Francisco & Friends*, 1997; eight postcards, color photocopies from collaged photos; edition of 12; tunnel book; 6 x 4 inches (15.2 x 10.2 cm)

A BOOK EVOLVES

I'm thinking about a book of poems and letters written by a poet to his teacher, letterpress printed, bound by hand, small edition. Bodoni might be nice; the beautiful, clear black type on the page is classic, pure. But it seems cold to me, particularly cold in relation to the warm emotion in the poems.

On my worktable I saw a sheet of paper with a stain on it. I had set my cup down, and some coffee had sloshed out, making a beautiful irregular circle. How great it would be to scan that stain and print it on the cover of the book. As though the negligent writer had spilled coffee on this pristine book, as if the poet were actually working on it.

Then it seemed to me that Bodoni would be all wrong, and I decided on American Typewriter to further the idea of the poet still writing. All it lacks is a dusting of cigarette ash, but unfortunately nobody smokes any more.

MARIE C. DERN

The first tunnel books like this I ever saw were made by Ed Hutchins, a book artist and teacher, who continues to share with me what he learns and what he creates. When he visited San Francisco, he promised everyone a book if they would pose for a picture. The book was a tunnel book made from postcards of San Francisco with his friends flanking the continuous sides of the accordion spines. There are several ways to make this book.

Tools: bone folder; oval template or metal ruler; pencil; knife and cutting mat; glue

Materials: 2 pieces of medium-weight or lightweight paper, each 6 x 6 inches (15.2 x 15.2 cm); 5 postcards or pieces of heavy-weight paper, each 4 x 6 inches (10.2 x 15.2 cm), grained long, if possible

Example: 4 x 6-inch (10.2 x 15.2 cm) book

1. Fold two 8-panel accordions with the folds parallel to the grain (see page 71 for folding details).

step 1

2. Put one accordion on the table, with a valley fold as the first fold.

3. Measure and/or draw and cut a shape (that does not go beyond the mountain fold) on the left side of the second and third and fourth valley folds. You will glue your cards to these flaps.

4. Repeat steps 2 and 3 for the second accordion spine.

5. Cut out the variously shaped holes in your cards.

6. Face the two accordions so that their open ends point inward. Apply glue to the front of the last panels of each accordion, and press the last (uncut) card down, aligning the edges.

7. Push all the flaps in, and apply glue to the fronts of the last set of flaps.

8. Press the next to last card down onto the sticky flaps.

9. Repeat steps 7 and 8 for the second and third sets of flaps.

10. Apply glue to the front panels and press the front card in place.

Variation: For a book with no holes in the sides, use spine papers that are 1 inch (2.5 cm) taller than the example papers given (grain long, for this example). Fold into two accordions as directed. **A.** Center and draw around half a penny on each of the valley folds starting with the second valley fold. **B.** Cut around the half-penny shape. **C.** Also cut a slit that corresponds to one panel. See diagram. **D.** Fold the shapes down, then fold the slit part over. The cards will be glued here and to the front and back panels as indicated previously.

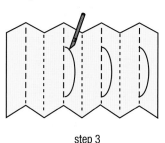

step 3

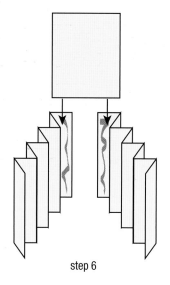

step 6

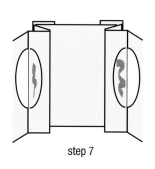

step 7

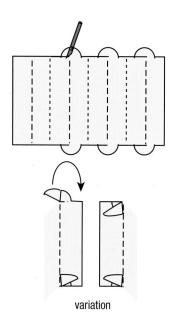

variation

MINIATURE TIED STICK BINDING

Bacon Squares, 2009; painted paper, toothpicks, thread, handmade wool felt, meat sign; tied stick binding and two-piece box; 2³/₈ x 2¹/₄-inch book (6 x 5.7 cm) (photo: Sibila Savage)

1. Using one square of the museum board as a guide, hold the toothpick on the cutting mat and trim the pointed ends with the knife so that they are the same size as the board.

2. Paint the toothpicks with the acrylic ink. Paint the ends, also. Set aside to dry.

3. Fold each paper in half, widthwise (with the grain).

4. Open each paper. Place it horizontally on the table, and align one board with the right or left edge (ultimately, the fore edge).

5. With the pencil, draw a light line against the board.

6. Repeat step 5 for the remaining pages.

7. Close one page. Measure and mark ½ inch (1.3 cm) from the head and tail.

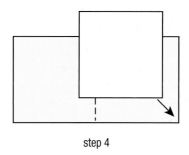

step 4

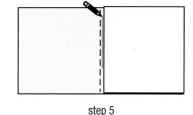

step 5

step 7

I'm still experimenting with different ways to recreate the Daniel Kelm Wire-Edge Binding. My latest version uses—don't laugh—toothpicks. And why not? I'm making bacon squares.

Known for founding the Wide-Awake Garage, a bookbindery in Massachusetts, and the Garage Annex School, Daniel Kelm has his name invoked most often when the Daniel Kelm Wire-Edge Binding is mentioned. I was most fascinated and inspired by the book *Synesthesia* by Timothy Ely, bound with same Wire-Edge Binding, a copy of which is housed in the special collections department at Mills College in Oakland, California. Daniel's technique involves wire rods and a dry mount press, but I wanted to make a version that could be done using ordinary materials. The key to success is finding thin rods or sticks that are the same thickness as the boards you are using. This miniature book uses the same principles

as Daniel Kelm's book, but because it is so small, you can make it with PVA and toothpicks. I believe the tying method is the same. Multicolored thread looks nice.

For the pages, try painting one sheet of paper with acrylic inks and cutting it up. Painting techniques are in my book *Painted Paper* (Sterling, 2008).

Tools: knife and cutting mat; pencil; bone folder; metal ruler; hole punch (preferably rectangular or ³/₈ inch [or 1 cm] diameter circle), scissors; glue brush; paper plate to decant the glue; PVA

Materials: 8 squares of 4-ply museum board, each 2¼ inch (5.7 cm); 8 toothpicks; acrylic ink (color of your choice); 8 pieces of textweight paper, 2¼ x 4 ¹³/₁₆ inches (5.7 x 12.2 cm), grained short; magazines for scrap paper; regular sewing thread (color of your choice)

Example: 2³/₈ x 2¼-inch (6 x 5.7 cm) book

8. Use the hole punch and punch halfway, making either a slit or semi-circle, across the fold. This one will be your template.

9. Using the template as a guide, place it atop the next folded page. Punch.

10. Repeat step 9 for the remaining pages.

11. Check the grain for all the museum board squares. Arrange in front of you with the grain vertical (parallel to the spine).

12. Take one open page and place it on top of a scrap paper sheet. Apply glue in the square you marked and just across the punched fold as well.

13. Remove the glued paper to a clean surface.

14. Align one square of museum board with the marking.

15. Place one toothpick in the fold.

step 8

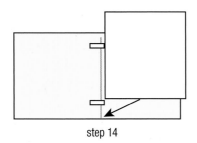

step 14

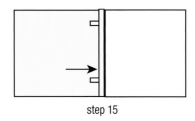

step 15

16. Put the project onto more clean scrap paper. Apply glue to the other side of the page.

17. Remove the glued paper to a clean surface.

18. Fold the glued side over, and align the edges and corners with the board.

19. Repeat steps 12–18 for the remaining pages.

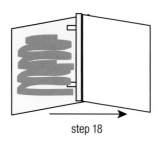

step 18

Attaching the boards

20. Cut two lengths of thread, each approximately 20 inches (50.8 cm).

21. Fold each thread in half, doubling it.

22. Thread each doubled thread through the holes in one page, centering them so that you see four strands dangling down at each hole. Pull the toothpick closer to the fold if you need room.

23. Tie each doubled thread tightly in a square knot.

24. Stack another board under the first board. Arrange them so that the threads and holes hang off the edge of the table.

25. Using the folded ends of the threads, push the threads through the corresponding holes in the second board.

26. Tie each doubled thread tightly in a square knot.

27. Repeat steps 24–26 for the remaining boards.

28. Tie two square knots at the very end.

29. Trim the knots. Add a dot of PVA to the knots to secure them.

⚜ WATCHING THE READER

The best part about making books is watching readers interact with them. Watching their eyes and hands move across a work reveals the book's true successes and weaknesses. The body doesn't lie, so the artwork can be evaluated wordlessly, and as the maker, I can silently follow the reader through the story, over and over again.

ANNE HAYDEN STEVENS

30. Add a title or image to the front cover. (I use the knotted side as the front, but you can just as easily use it as the back.)

Uses: one stamp on each page; book about building (make brick-shaped); thumbprint autograph book; miniature portraits; book of haiku, family sayings

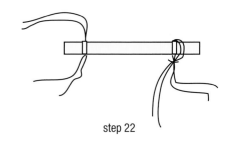

step 22

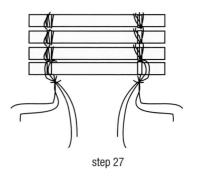

step 27

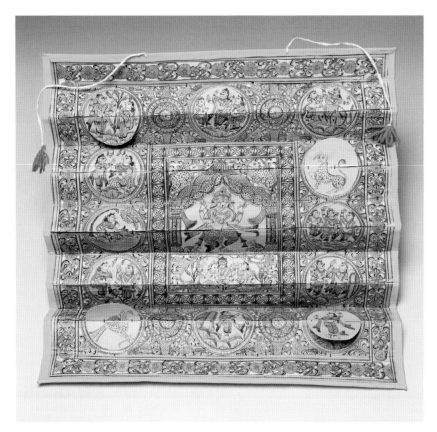

Unnamed artist from Orissa, India: *How Ganesha Got His Elephant Head*, 2006; palm leaves; 1¹/₈ x 14⁵/₈ x 1¹/₈ inches (2.9 x 37.1 x 2.9 cm), closed, 16¼ x 14⁵/₈ inches (41.3 x 37.1 cm) open

LEARNING FROM PAPER

I thought I was a painter until Japanese paper made me into a book artist. We get a relatively small selection of Japanese paper in the United States, and we get it out of context, so I had to go to Japan to see the real thing. In Japanese art/craft, the paper is the artist's partner, not her servant. In the painting I'd been doing, the paper was inert. I made the art on top of it. Japanese paper is too specific for that. It promises more, and demands more. "What *is* this stuff?" I thought. "How can I use it?" My first artists' books were basically paper plus verb: fold, cut, tear, sew. When I was a painter, other peoples' opinions were what I steered by: what they praised, I did more of. With the books, I work from the picture in my mind's eye.

CORIANDER REISBORD

SIMPLY SEWN

An arm's length of thread is all you need to assemble the books in this chapter, with the exception of the fan book, which uses a small piece of hardware. A few tools, such as an awl, ruler, pencil, and scissors will be helpful as well. These are basic structures that can each be made in less than an hour.

I learned the pamphlet stitch from Kitty Maryatt in a calligraphy class at Santa Monica High School, and I was thrilled to be able to put together a book without staples. You may have some booklets at home that are meaningful to you, but that are stapled together; try taking the staples out and sewing the booklet back together with the pamphlet stitch. The palm leaf and fan books can be put together in a few minutes. The sidebindings are user-friendly because you can easily put your pages in order without having to figure out what goes where in advance. All of these structures are good for practical applications, such as programs and guest books, but if you have a developed concept and limited time, these bindings can be elegant ways to present your ideas.

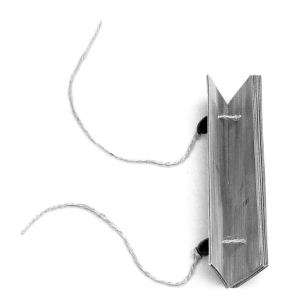

Tall Green Grass or *Tickling Your Palm*, 1995; acrylics and rubber stamps; palm leaf book; 2 x 6½ inches (5.1 x 16.5 cm) (photo: Jim Hair)

In college, Betsy Davids took our book-making class to the Bancroft Library at University of California, Berkeley, where I saw an authentic palm leaf book; the text was inscribed on real palm leaves. Since that time, she has developed her own fascination for the form, fueled by a trip to India and the purchase of some palm leaf books there. Those books are slightly different; the palm leaf pages are doubled and movable, with small flaps that open to reveal new images, and they function more as an accordion than as a fan or string of cards. Betsy has made a similar book called *Darshan of Dancing*, out of paper that combines her interest in learning the Tamil language and her ongoing study of dreams. The following are instructions for a structure like the one I first encountered, which is simpler than the one Betsy made.

Tools: pencil; ruler; small hole punch (can be a diamond or any shape) or awl

Materials: 14 or more cards or heavy paper cut into 1½ x 5 inches (3.8 x 12.7 cm) strips; waxed linen thread or other thick, durable string (approximately 2-feet [61 cm] long)

Example: 1½ x 5-inch (3.8 x 12.7 cm) book

1. With one strip vertically oriented, measure and mark 1 inch (2.5 cm) from top and bottom, centered right and left.

2. With your small hole punch, punch a hole at each end, 1 inch (2.5 cm) from the edge on the mark.

step 1

TRAVELS WITH THE PALM LEAF BOOK

I returned from travels in South India with examples of an intriguing palm leaf structure from Orissa. It is unlike most traditional palm leaf manuscripts, in which stacks of palm leaf strips are strung together through holes like Venetian blinds. Instead, these palm leaf strips are double-layered and attached by stitching each doubled strip to the next, thereby forming a two-layered accordion structure. The exciting feature for me is the semicircle sliced into the top layer of each strip; at first look, a circular image area defines itself, and then each semicircle can be finger-lifted to reveal another and another circular image area beneath on the bottom layer. Sequences of discovery, hiding and revealing, outer and inner: that's what I like to explore in book structures. Because my primary writing practice has been writing dreams, I am always looking for book structures that make a space for the inner life.

BETSY DAVIDS

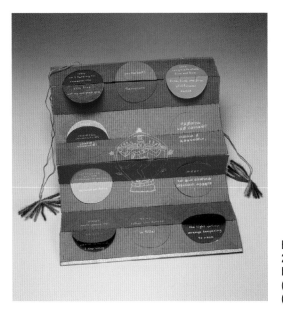

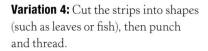

Variation 4: Cut the strips into shapes (such as leaves or fish), then punch and thread.

Variation 5: Alternate rectangular strips with semicircular strips to conceal and reveal the contents.

Variation 6: Leave enough cord so the book flattens out, creating an effect like a game when all the cards are spread out. See the book Esther made with Shu-Ju Wang below.

Uses: guest book (each guest signs one leaf); a book about trees, fishing, or a series of things connected (palm reading or family ties)

Betsy Davids: *Darshan of Dancing*, 2009; mixed media, paper; palm leaf book; 2 x 12 x ½ inches (5.1 x 30.5 x 1.3 cm) (photo: Sibila Savage)

3. Use this card as a template to line up all the holes. Don't try to punch the rest through the template: use the pencil to draw lines through it.

4. Measure out about two feet of the waxed linen thread or other string. Make a knot at 6 inches (15.2 cm) from the end. Begin threading through the top holes of all the cards.

5. When you get to the last one, make another knot, leaving room for the cards to turn but not to flatten out.

6. Make another knot the same measurement as the distance between the holes. Then continue threading through the bottom holes. Make the last knot leaving a 6-inch (15.2 cm) tail.

7. The book should be able to "open"; that is, the pages should be able to move snugly but not be too cramped, and loose enough but not so loose as to be unwieldy. It should probably be able to sit up in a V shape. To close, simply pull and tie ends together in a bow.

Variation 1: You may choose to put large beads on each of these ends and knot again. The two or more beads should be larger than the hole.

Variation 2: Rubber stamp with a poem or invitation before assembling.

Variation 3: Collage the cards before assembling with photocopies of family members or friends.

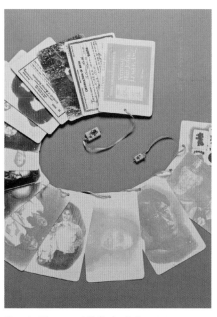

Shu-Ju Wang and Esther: *Esther*, 2008; gocco printing on paper, mah-jongg tile closure; edition of 20; palm leaf book; 6$^{1}/_{16}$ x 3$^{15}/_{16}$ x $^{5}/_{8}$ inches (15.4 x 10 x 1.6 cm) (photo: Bill Buchhuber)

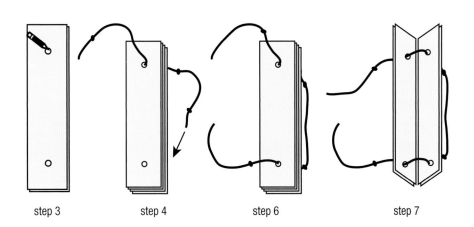

step 3 step 4 step 6 step 7

FAN**BOOK**

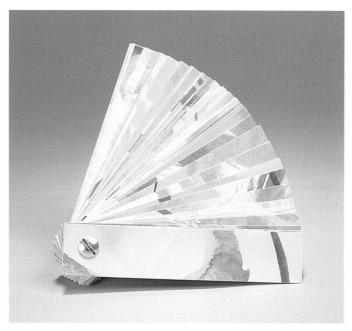

Fan Book from offcuts of the book *Tidal Poems* with
Anne Schwartzburg (Stevens), 1995; inks, watercolors;
1 x 5 x ⅞ inches (2.5 x 12.7 x 2.2 cm) (photo: Jim Hair)

Pick a card, any card. It stays in a stack in a fixed order.

Tools: hole punch; pencil; ruler

Materials: a stack of cards or heavy-weight pages, approximately ¼ inch up to 2 inches (0.6 to 5.1 cm) thick; a screw post the same height as the stack of pages (hardware stores often have aluminum screw posts; bookbinding supply stores may have aluminum, plastic, or brass)

1. Punch a hole in one of your cards. Use this for a template.

2. Line up the template with the top of the next card; draw a small, light circle in pencil on the second card.

3. Punch with the hole punch.

4. Continue until all cards are done, using the first card as the model.

5. Undo the screw post. Slide the cards onto it, then replace the top.

Uses: guest book (each person signs one card); list poems; pocket photo album; color sample book; field guide to birds, plants, hair colors, cars, or trees

Variation 1: Make hard covers covered with paper or fabric (see page 208).

Variation 2: If you don't like the metallic look of the screw post, make a circle of soft, lightweight paper or fabric, apply glue to the back, and cover the front of the screw post, pressing the glued paper or fabric into the groove.

step 1

step 5

STICK**BINDING**

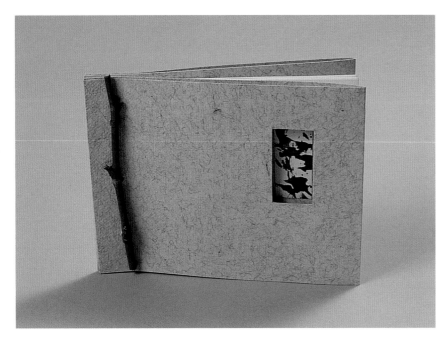

Stick Binding Model, 1997; acrylic ink, dried raffia, camphor stick; 5½ x 4¼ inches (14 x 10.8 cm) (photo: Jim Hair)

I noticed this structure, which is attributed to Hedi Kyle in *Cover to Cover* (Lark, 1995) by Shereen LaPlantz. One student in my Creative Book Structures class put the knot in the front. Then she split the raffia ends into so many strands that the book looked as if it had a hula skirt.

Tools: pencil; ruler; bone folder; clip; awl; scissors

Materials: stack of paper, each 5½ x 8¼ inches (14 x 21 cm), grained short; thicker paper for covers, 5½ x 8¼ inches (14 x 21 cm) OR 5½ x 17 inches (14 x 43.2 cm), folded in half, widthwise, grain short; raffia or waxed linen thread; bamboo skewer, stick, or rod

Example: 5½ x 8¼-inch (14 x 21 cm) book

1. Stack the paper evenly, including the front and back covers, top and bottom.

2. With the stack horizontally in front of you, measure and mark 1 inch (2.5 cm) from the left side at the head and tail.

3. With the bone folder, score a line that connects these marks.

4. On the line, measure and make one mark exactly centered and two more marks 1½ inches (3.8 cm) from the head and tail. (You can also make a jig to make even marks. See the instructions on page 24.)

5. Secure the book at the head with the clip, away from the holes. Use the awl to punch holes at the marks.

6. Cut a piece of raffia or thread that is double the height of your book (parallel to the spine).

7. Begin sewing from the back; position the stick so it bisects the holes. You may wish to glue the stick to the cover to hold it.

8. Come out the front and take the stitch over the stick and back into the same hole.

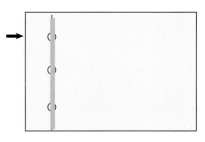

step 7

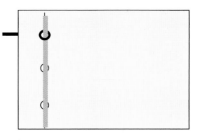

step 8

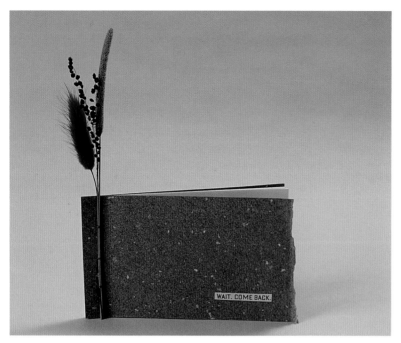

Binding around dried flowers, 1997; blank book; stick binding (photo: Jim Hair)

9. Proceed to the second hole from the back.

10. Go out the front, sew over the stick, and go back into the same second hole.

11. Sew from back to front through the third hole. Wrap over the stick, and go back into the third hole from front to back. Turn over.

12. Tie off in a square knot at the back.

Variation 1: Use dried flowers with strong stems instead of a stick.

Variation 2: Cut a window in the cover.

Uses: valentine book; nature journal; herbarium (pressed flowers or leaves)

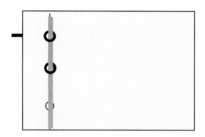

step 10

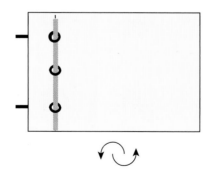

step 11

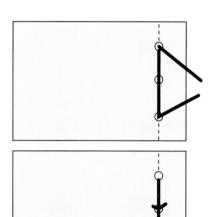

step 12

LEDGER

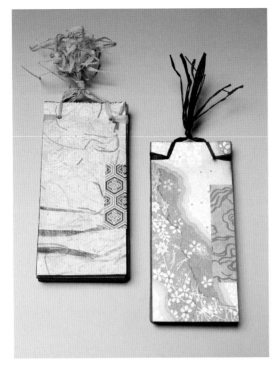

Ledger Models, 2009
(photo: Sibila Savage)

I learned this from *Japanese Bookbinding* (Weatherhill, 1986) by Kojiro Ikegami. It looks particularly nice with different colors of raffia and with handmade clay beads. I like to think of it as a vertical hanging book that could be hung on the wall rather than kept on a bookshelf. The vertical orientation makes it perfect for poetry that has short line-lengths. I currently use one for a long-term to-do list.

Judith Tannenbaum, then a poet-in-residence at MacGregor Primary School, invited me to teach a book structure to second-graders in Albany, California. As people have done throughout history, I used material available; I looked in the school's supply closet and found Manila covers, white drawing paper, and fat, colorful yarn for threading the book. Since the yarn could not be threaded through a needle, we wrapped the sewing end with tape so it could pass through the holes easily. The children's abilities varied: some could braid the yarn, others couldn't make an overhand knot.

Tools: ruler; pencil; clip; awl or punch; scissors; needle

Materials: stack of paper, each 3 x 8½ inches (7.6 x 21.6 cm), grained short; 2 medium-weight papers for covers, each 3 x 8½ inches (7.6 x 21.6 cm) OR 2 light-weight papers, each 3 x 17 inches (7.6 x 43.2 cm), folded in half, widthwise; raffia or thread; wooden beads

Example: 3 x 8½-inch (7.6 x 21.6 cm) book

1. For these instructions, orient horizontally, spine at left. Stack the pages evenly, with covers top and bottom. If using folded covers, stack with open edges at the spine.

2. Measure and mark 1 inch (2.5 cm) from the left side, 1½ inches (3.8 cm) from top and bottom (or pick two even places to punch holes).

3. Secure at the top edge (away from holes) with the clip.

4. Punch holes with the awl or punch.

5. Cut two pieces of raffia, each about 10 inches (25.4 cm) long.

6. Thread one piece through the top hole, starting from the front.

7. Take the same piece up around the top of the book.

8. Go back through the same hole. Even out the raffia ends, if possible.

step 6

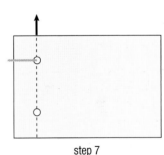

step 7

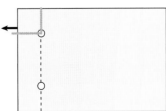

step 8

9. Tie the two raffia ends in a square knot, centering the knot on the depth of the spine.

10. Repeat steps 6–9 with the second piece of raffia, taking it in the other hole, around the bottom edge, and back through the same bottom hole. Tie.

11. Tie the two ends (actually four strands) together with an overhand knot.

Variation: Run beads through the joined threads before tying.

Uses: vertical wall hanging; photo album; journal; poetry book; to-do list

SIDEBOUND**BOOK**

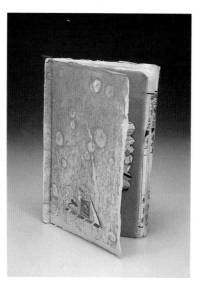

Val Simonetti: *Harvest Journal*, 1982; handmade and store-bought papers, found materials, letterpress, handwritten text; sidebound; 6 x 9 inches (15.2 x 22.9 cm) (photo: Sibila Savage)

step 10

step 11

This structure is called the stab or blockbook binding because it was created to hold together a series of wood-block prints long before movable type was invented. When you choose the paper, note that sidebound books are easiest to open if the pages are long and thin (in a horizontal, or landscape, format), so consider making the width of your book at least two times the height of the spine. This traditional binding works with two or more holes. To calculate thread, count out the same number of lengths (a length is the height of the book's spine from head to tail) as the number of holes plus one.

Tools: ruler; pencil; awl or punch and hammer; scissors; binder clip; needle; bone folder

Materials: stack of paper, each 8½ x 5½ inches (21.6 x 14 cm), grained short; 2 cover papers, each 8½ x 5½ inches (21.6 x 14 cm), grained short, OR 2 lightweight papers, each 17 x 5½ inches (43.2 x 14 cm), folded in half, widthwise, grained short; thread or ribbon

Example: 8½ x 5½ inches (21.6 x 14 cm) (sewn along the short side)

Note: In order not to become confused while sewing this book, look only at the front cover.

For two holes

1. Pile the pages into a stack. Assemble the covers on the front and back.

2. Measure for 1½ inches (3.8 cm) from the top and bottom, and ½ inch (1.3 cm) from the left edge. Mark these places. Clip the stack together to keep it in place.

3. Poke holes with the awl.

4. For a book with two holes, take a length of thread roughly three times the width, or sewing side, of your book.

5. Start sewing by picking one hole and coming up from the back to the front, leaving a tail of thread about 3 to 4 inches (7.6 to 10.5 cm) long. Do not knot.

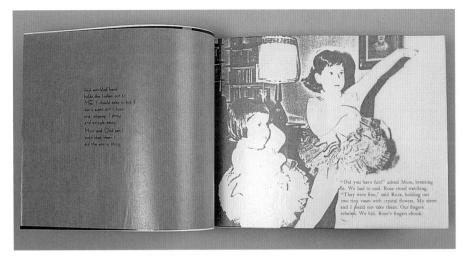

Nina, Rose & Me, 1995; letterpress, photocopy (of photos by Roger Golden), acetate, wire, beads; sidebound; 9 x 6 inches (22.9 x 15.2 cm) (photo: Jim Hair)

step 8

step 9

6. Bring the thread over the end of the book and go through the same hole again.

7. Wrap the thread around the side edge of the book and back through the same hole for a third time.

8. Sew to the last hole from front to back.

9. Take the thread to the side.

10. Bring the thread around the side of the book and back through the last hole.

11. Bring the thread around and over the end of the book, and go back through same second (last) hole.

12. Tie off tightly in a square knot at the back of the book, centering the knot over the hole.

13. Push the knot into the hole with a bone folder, if you wish.

14. Trim the ends from ⅛ inch to ½ inch (0.3 to 1.3 cm) from the knot.

For a book with three holes: Take a length of thread roughly four times the width, or sewing side, of your book. After step 7, sew into the middle hole, then bring the thread around the side of the book and back into the middle hole. Continue to the last hole (see steps 8–14).

Variation 1: Use heavy paper 1 inch (2.5 cm) longer than the above example. Score and fold 1 inch (2.5 cm) from the left margin. Keep them folded. These folded "tabs" become spacers for a scrapbook or photo album. Sew as for sidebound book, stick, or ledger.

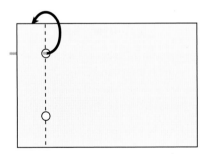

step 6

step 7

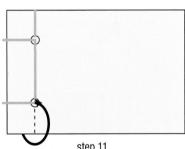

step 10

step 11

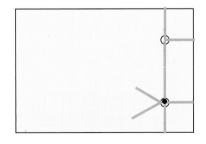

step 12

<p style="text-align:center">step 14</p>

Variation 2: Use a lightweight Asian paper 5½ x 17 inches (14 x 43.2 cm). Fold in half, widthwise. With the open ends on the left and the folded edge at the fore edge, sew these doubled pages.

Variation 3: Flip Book: A series of drawings or photographs can become animated when they are printed on cardstock and sidebound into a flip book. Some pre-scored notecards for inkjet printers are grained short and work perfectly for this book. Set up eight images, 2 x 5 inches (5.1 x 12.7 cm) on one horizontal sheet of 8½ x 11-inch (21.6 x 27.9 cm) card. Format three cards with eight images for a total of 24 images. If you are working on the computer, flip one card horizontally, and use this for the back cover. You may need to "scale to fit" page to print. Cut out carefully so all the pages are exactly the same size. Trim if necessary. Align all the fore edges, clamp at the head, and bind with three evenly spaced holes, approximately ¼ inch (0.6 cm) to ½ inch (1.3 cm) from spine edge. This book should be made with a softcover only so it will flex.

Tip: When planning the book, keep the main imagery closer to the center or fore edge.

Uses: memory book of a lifecycle event; capturing a moment while traveling; noticing changes of a place, person, or thing over time; presenting a mood in nature; party favor; memento

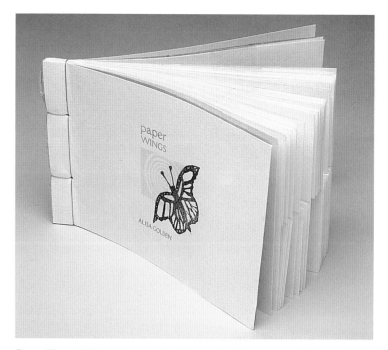

Paper Wings, 1992; letterpress, hand-carved rubber stamps; sidebound with split pages; edition of 56; sidebound with split pages; 4 x 6½ inches (12.2 x 16.5 cm) (photo: Jim Hair)

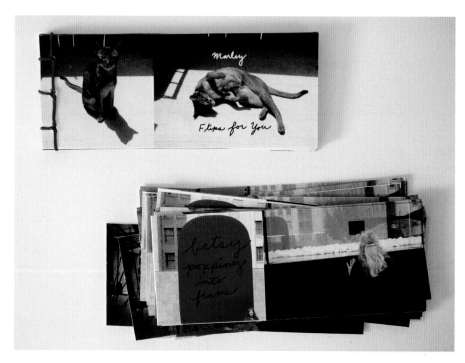

Marley Flips for You and *Betsy Popping into Frame*, 2009; Blurb.com printed books cut apart and rebound as flip books; open edition; 4 x 1½ inches (10.2 x 3.8 cm) (photo: A. Golden)

HARD**COVER FOR SIDE BINDING**

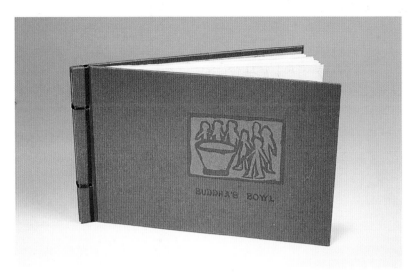

Buddha's Bowl, 1993; letterpress, linoleum cuts; edition of 30; sidebound; 8 x 5 inches (20.3 x 12.7 cm) (photo: Jim Hair)

This cover may be made in any size and used with most side bindings. Just make sure the grain of your papers and boards are parallel to the spine; also, the cover paper should be 1½ inch (3.8 cm) larger than the boards in both directions. For more about gluing techniques, see page 20. Terry Horrigan created a version that lay a bit flatter when opened by articulating the front cover for the book *The China I Knew.*

Tools: pencil; ruler; knife and cutting mat; brush or piece of board for gluing; ³⁄₁₆ inch (0.5 cm) spacing bar; weight; fiberboard; PVA or PVA/paste mixture

Materials: 2 pieces of 4-ply museum board, each 8½ x 5¾ inches (21.6 x 14.6 cm), (short); magazines for scrap paper; 2 pieces of cover paper or book cloth, each 10 x 7¼ inches (25.4 x 18.4 cm), (short); 2 endsheets, each 8 x 5½ inches (20.3 x 14 cm) (short); waxed paper

Example: approximately 8¾ x 5¾ inches (22.2 x 14.6 cm)

1. Trim the boards so that you have two pieces that are 5½ x 8 inches (14 x 20.3 cm) and two pieces that are ½ x 8 inches (1.3 x 20.3 cm).

2. Cover your work surface with pages from a magazine, giving yourself a few layers. You will be discarding these layers as they get messy.

3. Arrange one outer cover paper in front of you horizontally, wrong-side up.

4. Spread adhesive evenly on your paper with a brush or piece of board, working from the center outward. Discard one layer of scrap paper to give yourself a clean surface.

5. For the front cover, place one ½-inch (1.3 cm) strip approximately 1 inch (2.5 cm) from the right edge of the paper. Press down. (For the back cover: place at the left edge.)

6. For museum board, leave approximately ³⁄₁₆ inch (0.5 cm) (you can use a ³⁄₁₆-inch [0.5 cm] spacing bar as a guide; take it out before wrapping the boards) and place one of the larger main cover boards aligned with the spine strip.

7. Cut diagonals at the corners, leaving a slight margin, approximately two board-widths. Don't cut right up to the edge of the board. Remove the triangles.

step 5

step 6

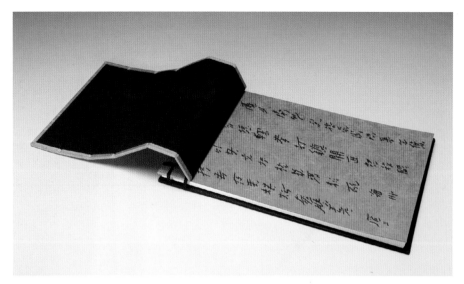

Terry Horrigan: *The China I Knew* by Rose Covarrubias, 2005; letterpress, photoengravings of line drawings by Miguel Covarrubias, book cloth; edition of 60; sidebound with articulated cover; 9½ x 6 inches (24.1 x 15.2 cm) (photo: Sibila Savage)

8. Apply more glue to each flap, if necessary. Fold the flaps over the boards, one at a time. I like to work on top and bottom, then do the sides; after you cover the top and bottom edges, use your fingernail to give little push at the corners. (You want to make sure that the boards will be covered at the corners, but you also don't want the paper to bulge there). Move the project to a clean surface.

9. Place the endsheet undecorated side up (or what seems to be the back of the paper) on a second piece of scrap paper. Apply glue completely to the edges.

10. Carefully pick up this endsheet and center it on the covered boards. Press and rub down.

11. Repeat steps 2–10 for the second board. Note that the back cover will have the spine strip on the left instead of on the right, as indicated in step 5.

12. Place the covers between two pieces of wax paper and put these between fiberboards. Put books or heavy bricks on top. Let the covers press flat overnight,

step 7

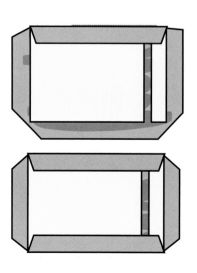

step 8

preferably for a few days. Use these covers for the sidebound ledger or stick book.

Variation: For an articulated cover, instead of using one larger board, glue smaller strips of board to the covering paper. Calculate the appropriate spacing between the boards by multiplying the thickness of the board by three.

step 10

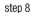

SINGLE **SIGNATURE BINDING**

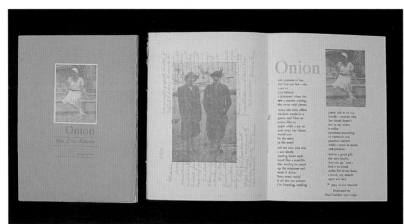
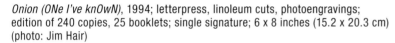

Onion (ONe I've knOwN), 1994; letterpress, linoleum cuts, photoengravings; edition of 240 copies, 25 booklets; single signature; 6 x 8 inches (15.2 x 20.3 cm) (photo: Jim Hair)

Onion (ONe I've knOwN), 1994; collage, laserprinted text on translucent paper; 3³/₄ x 3⁵/₈ inches (9.6 x 9.2 cm) (photo: Jim Hair)

At a Berkeley homeless shelter, I asked if anyone wanted to learn a simple pamphlet stitch. Three younger men who were attending this free class said they did. We had about 45 more minutes to fill.

"Would you like to do another book, with sewing?" I asked a middle-aged woman.

"Honey," she said, "I've done so much sewing in my life, I don't need to do any more." The stitch is so easy, she would have been a natural at it. After I showed them that the thread wasn't doubled and taught them how to tie a square knot, the men all did fine with the sewing.

For a single signature book, use only enough paper so that the book will lie flat and not pop open when sewn together. For heavy paper, sew only two sheets together. With lightweight paper, use approximately three to eight sheets (I generally use four). With many sheets, you may wish to trim the fore edges with a knife after binding. When paper cut all the same size is folded and nested, the thickness of the paper causes each successive sheet to protrude slightly. If you don't

like this uneven look, trim these front edges very carefully with a utility knife against a metal ruler. See page 15 about cutting paper.

If the book will have a hard cover or you wish to see the ends (to decorate or put beads on, etc.), start sewing from the outside. If you intend to start sewing from the inside (the knot will be inside) and you do not wish the stitching to interfere with the text or images, choose a thread the same color as your pages. "Skip the center" is a way to remember this sewing pattern.

Tools: bone folder; binder clip; scissors; ruler; pencil; knife and cutting mat; needle

Materials: 4 pieces of textweight paper, each 8½ x 5½ inches (21.6 x 14 cm), grained short; thread

Example: 4¼ x 5½-inch (10.8 x 14 cm) pamphlet

1. Fold the papers in half.

2. Nest the pages inside each other.

3. With the binder clip, clamp half the book at the top or bottom.

4. Poke three holes in the fold, at even intervals, leaving at least ½ inch (1.3 cm) from each end.

Sewing pattern

5. After threading the needle, start with the center hole and sew into it.

6. Go back out to one end hole.

7. Skip the center and make a long stitch to the other end hole.

8. Come back through the center, and tie a square knot around the long stitch. It should look like two stitches now.

Sewing pattern for a larger book

Use five holes. If the book is enormous, a larger odd number of holes is fine. Start at the center hole, as for the pamphlet. Instead of making the long stitch immediately, sew a running stitch up to the head of the book and back down toward the center again. When you get to the hole

immediately neighboring the center hole, skip the center and proceed the same way, tying off in a square knot.

Variation: Cut the pages into different shapes before you sew (i.e., graduated sections of an onion) or when the sewing is complete (i.e., the slanted top of a tea bag).

Uses: program; wedding booklet; poetry book; short story; series of photographs; 'zine

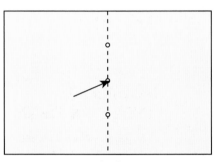
step 5

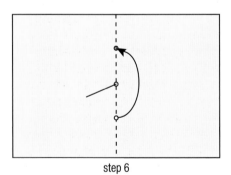
step 6

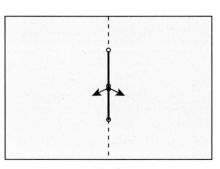
step 8

PAPER**BAG BOOK**

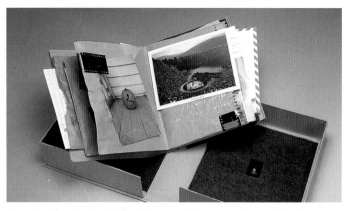

Betsy Davids: *Turning into a Pumpkin*, 1994; assemblage with photos, postcards, paper bags; 8¼ x 7¼ inches (21 x 18.4 cm) (photo: Sibila Savage)

Betsy Davids began making books from bags and found materials when she was traveling. She continued the practice when she returned home, using materials that she acquired from daily life. If you want to make a series or edition of lunch-size bag books and you don't have any, look in the grocery store. Paper bags are one of the cheapest paper sources available.

Tools: pencil; awl; bookbinding needle; sewing machine (optional); ruler or jig for 5 holes (see page 24); markers, crayons, or pens to write on bags

Materials: 3 lunch-size paper bags; thread; postcards, other ephemera

Example: 5¼-inch (13.3 cm) square book

1. Fold each bag in half widthwise.

2. Nest them one inside the other, alternating the open sides with the bottom flaps. One bag may be facing left (open), and another may be facing right.

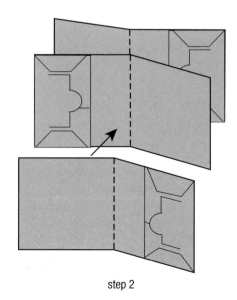
step 2

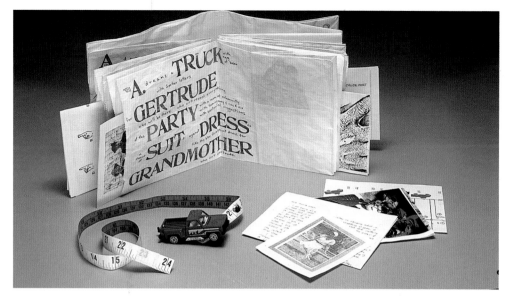

Betsy Davids: *GerTRUDES & TRUCKS*, 1994; bakery bags, rubber stamps, handwritten text, photocopies, tape measure, refrigerator magnet; mini-edition of two; 7 x 6½ x 2 inches (17.8 x 16.5 x 5.1 cm) (photo: Sibila Savage)

3. Poke five holes in the spine through all the bags and sew a single signature (See page 96), or machine-sew a line down the centerfold.

4. Write on the bags and add things to the pockets.

Note: A very thick book may not stay closed. To secure it, you may want to tie a piece of ribbon around it. Betsy Davids used a flexible tape measure and a little truck with a magnet to contain *GerTRUDES & TRUCKS*. Her book incorporates a three-way dream exchange by mail about Gertrude Stein, grandmothers, trucks, and femininity.

Variation: To make a book like Betsy's, use PVA, glue stick, or staples, and attach the back of one folded bag to the front of the next one. Use a larger bag for a wrap-around cover if desired.

Uses: travel book; daily ephemera journal; book about collecting or shopping or anything else related to bags

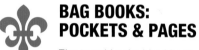

BAG BOOKS: POCKETS & PAGES

The travel books I had been making gave rise to a series of bag books, most of them using a simpler structure I devised of same-size bag folios joined at the fore edge with a slightly larger bag wrapped around as cover. I like that bag structure because it's so self-evident (great for teaching beginners). The bag openings create pockets, compartments, in which things can be put that can be pulled out and read or handled, and the bags also create page surfaces. Personal contents can be secluded in the pockets and flaps, and more general public content can go on the bag surface pages. The outside bag surfaces carry the more accessible contents, so that even a superficial viewing will yield something, but a longer, deeper viewing will yield much more. I also like embedding the actual artifacts from lived experience into the book about them.

BETSY DAVIDS

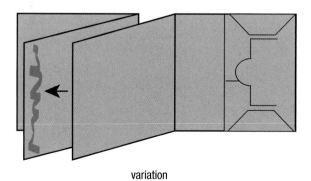

variation

TEA**BAG BOOK**

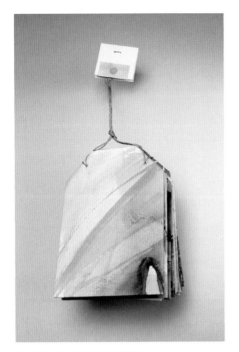

Tea Bag Book Model, 2009
(photo: Sibila Savage)

When I approached a local gallery in Berkeley to see if they would show my series of prints in a portfolio, called *A Tea Party*, they were hesitant about just showing the prints. I suggested a tea show. For the show, I figured out how to fold a tea bag and started making collages with the tea bags and old stamps.

Tools: metal ruler; pencil; bone folder, knife and cutting mat; awl or punch and hammer; binder clip; needle

Materials: 6 pieces of very lightweight paper, each 9 x 6 inches (22.9 x 15.2 cm); 2 pieces of heavier paper, each 9 x 6 inches (22.9 x 15.2 cm), grained short; magazines for scrap paper; embroidery or other thread

Example: 3 x 4-inch (7.6 x 10.2 cm) book

1. With the lightweight paper oriented vertically, measure and mark at the top and bottom 1½ inches (3.8 cm) from the right and left edges. Fold in.

2. Fold this paper in half, widthwise. Open. Score a ½-inch (1.3 cm) line on each side of the fold. Close again.

3. Fold the paper back on itself (at score marks) like an accordion. Do both sides in this manner.

4. Repeat steps 1–3 for all six sheets.

5. Measure and mark ½ inch (1.3 cm) down and ½ inch (1.3 cm) across.

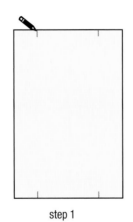

step 1

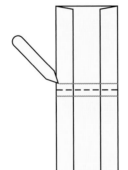

step 2

step 3

6. Line up the ruler with the two diagonal marks, and trim off the corners OR fold over diagonally.

7. Line up the pages with the open end at the top and the folded edge at the bottom. Clip them together at the side with the binder clip over a few folded-up pieces of scrap paper so the clip is not directly touching your book.

8. Proceed with the ledger binding on page 89.

9. Attach a tag for the title. See the following section.

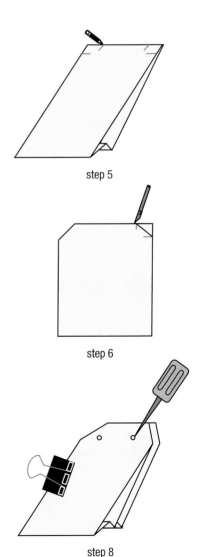

step 5

step 6

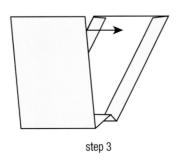

step 8

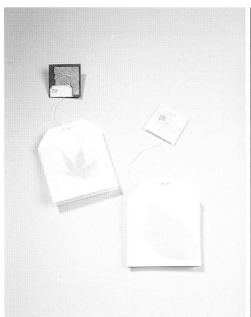

Tea Bag Cards, 1997; glassine, Japanese maple leaf, ginkgo leaf, rubber stamps; 3 x 3½ inches (7.6 x 8.9 cm) (photo: Jim Hair)

Mrs. White Has Tea, 1993; photocopy, letterpress and rubber-stamp cover; first edition of 50; single signature; 3 x 3¼ inches (7.6 x 8.3 cm) (photo: Jim Hair)

To make a single tea bag: Do steps 1, 2, 3, and 5, fold the corners in, fold the top over, and staple or sew a 5-inch (12.7 cm) piece of embroidery thread or string to the tea bag. Attach the tag.

For Tea Bag Shape on a Single Signature Book

For the tea exhibit, I also made the little tea bag-shaped book, Mrs. *White Has Tea*. It is about colors and friendship. I dedicated it to Mollie, who at age two asked me to read it over and over.

First, make a single-signature book, sewing from the outside and leaving one 5-inch (12.7 cm) tail to attach to the tag. Trim the other thread. Then measure evenly from the corner along the edge on the folded side, top and bottom. Using a metal ruler and knife, cut off the corners.

Variation: Make pages in other shapes, such as hearts or the graduated ovals as in the one-of-a-kind book *Onion* (photo on page 95).

Making a Tag

Make a tag with a rectangle of medium-weight paper folded in half.

1. Thread the needle through the 5-inch (12.7 cm) tail of thread.

2. Go in the folded rectangle and out again and back in again, creating one stitch.

3. Tie off the thread to itself. Trim.

4. Staple or sew closed at the edge.

For a hard tag: cut a square of 4-ply museum board into a square, approximately 2 inches (5.1 cm). Punch a hole in the board with a leather punch or hole punch, awl, eyelet punch, etc. Tie the ends of the thread to the hole.

Uses: invitation or party favor for a tea party

step 3

TWO-SEWN-AS-ONE

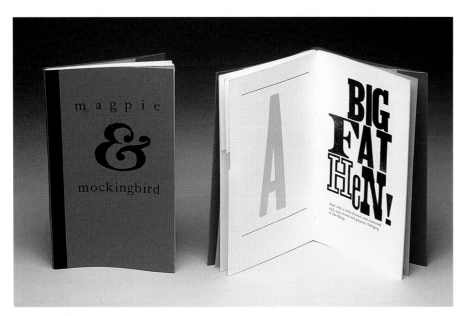

Magpie & Mockingbird, 1992; letterpress, linoleum cuts; edition of 29; two-sewn-as-one; 5¼ x 8¼ inches (13.3 x 21 cm) (photo: Jim Hair)

When my daughter Mollie was seven months old, I decided she was like a magpie, because she liked to pick up bits of shiny things, and like a mockingbird, because she could imitate sounds. For the book about her, I used the two-sewn-as-one and tabbed the inner pages to differentiate between magpie and mockingbird. I gave copies of the book to all our relatives.

The two-sewn-as-one is the easiest way to make a thicker, more "booklike" book. You don't need any special skills or lots of practice. I learned this book from Betsy Davids; it was one of the first I learned in college.

Tools: binder clip; cardboard to protect table; awl; jig with the desired odd number of holes; needle; bone folder; fiberboards; weights

Materials: 8 sheets of paper, each 5½ x 8½ inches (14 x 21.6 cm); thread

Example: 4¼ x 5½-inch (10.8 x 14 cm) book

1. Fold the papers in half to make pages 5½ x 4¼ inches (14 x 10.8 cm)

2. Make two sets or signatures of papers, nesting four sheets, one inside the other for each, with back folds aligned.

3. Keeping their folds back-to-back and still nested, open the two signatures and clip them with a binder clip to hold.

4. After protecting your table with cardboard, poke the desired odd number of holes. See page 24 for making a jig.

5. Sew as for a single signature. See page 95.

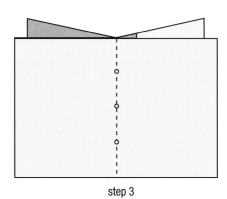

step 3

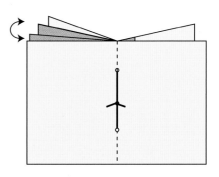

step 5

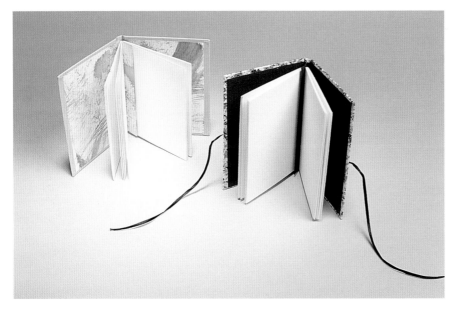

Two-Sewn-As-One Models, 1995-96; hard covers; approximately 4 x 6 inches (10.2 x 15.2 cm) each (photo: Jim Hair)

6. When done, fold up again into the two signatures back-to-back; then fold these together, one atop the other, and smooth them down with the bone folder. For best results, press them flat between two fiberboards held down with bricks or under heavy books.

step 6

Variation 1: Soft Cover: before sewing, cut a cover sheet twice the width of the book, plus 1 or 2 inches (2.5 or 5.1 cm). Fold the cover in half. Fold back the 1 or 2 inches (2.5 or 5.1 cm) to make a tiny *M*-shaped accordion in the middle. Tuck this tab between the two signatures before sewing, with one signature in each of the valleys.

Variation 2: Use same method as above, except use decorative paper facing the signatures, and glue the backs to a hard cover.

Variation 3: Make the tab the same width as the signature pages.

Variations 4 and 5: Make a soft-wrap cover or make a wrapped hard cover.

Uses: collaborative book with two different points of view opening from both sides; simple hardcover journal; guest book

 THE FLOW OF TRANSLUCENT IMAGES

In the book format, a translucent sheet may be used to create a "collage" with the printed page beneath on one or both sides of the page: recto and/or verso. When two or more translucent pages in succession are used, the book expands, revealing the depths below. Now the viewer can see through several transparencies as a single, compound image. At the same time, by turning one transparency, a fragment of the total picture is removed. Picture and page are no longer synonymous. But what happens on the left side of the gutter? Does the viewer merely see the former right-hand image in reverse? Here, the artist has the opportunity to make something different happen on the verso. That is the challenge.

KEITH SMITH

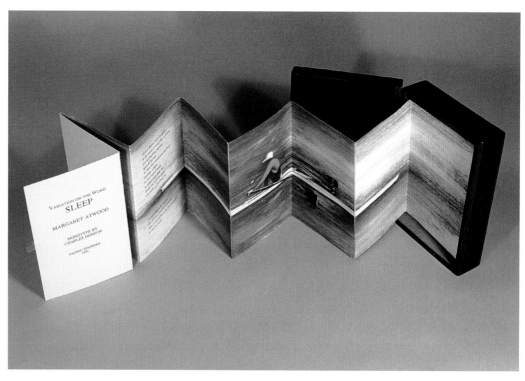

Charles Hobson: *Variation on the word SLEEP* (text by Margaret Atwood), 1991; pastel/monotype on accordion in lacquered box; edition of 20; 5¼ x 7 x 2¼ inches (13.3 x 17.8 x 5.1 cm) (photo: Charles Hobson)

SCROLLS & ACCORDIONS

The invention of paper in China in the year 105 opened up new possibilities for books. Prior to that time, manuscripts were on silk rolls or bamboo strips. Our word *volume* comes from the Latin ("roll") *volumen* and the French ("to roll") *volvere*. The world's oldest printed book on paper, a Buddhist text that dates from 868 titled *The Diamond Sutra*, is a rolled book or scroll. Scrolls are still popular in Asian countries, such as China, Japan, and Korea, primarily for wall hangings of calligraphy and brush painting. The contemporary Korean calligrapher Son Man Jin makes some of the most wonderful scrolls that can be found hanging in museums and galleries today.

The accordion-fold book naturally evolved from the scroll—long sheets were folded and stacked flat instead of rolled and glued together. Some scholars consider it as an intermediate step, perhaps a temporary one, before the invention of the sewn book, but the accordion is used widely today, in part because the entire book can be displayed without needing to be handled by the viewer.

Taking the spotlight once again, the accordion book described here is not only a simple structure, but it features tabbed pages; becomes layered; contains pockets or signatures; becomes a back-to-back tunnel book; and is transformed into a circular binding, using self-adhesive linen tape.

More historical references may be found in the book *The Invention of Printing in China* and *Its Spread Westward* (Columbia University Press, 1931) by Thomas Francis Carter.

HAND**SCROLL**

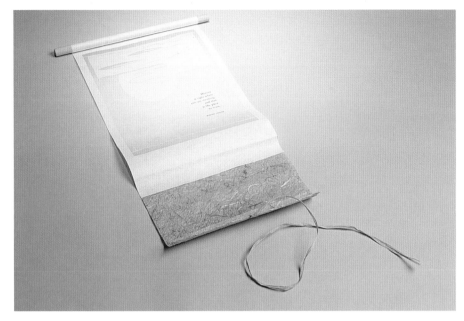

Heaven, 1996–97; letterpress printed from a text by Morihei Ueshiba, linoleum cut, acrylics, gesso; edition; 11 inch (27.9 cm) dowel, 9 x 18-inch (22.9 x 45.7 cm) mulberry paper (photo: Jim Hair)

The scroll is a very traditional book structure, particularly in China, Japan, and Korea, and often is stored in a long, thin box for protection. On mulberry paper I printed a linoleum cut and several copies of a text by Morihei Ueshiba, the founder of Aikido, a defensive Japanese martial art. I bound one sheet into a hanging scroll for my Aikido instructor, Elizabeth Lynn. A second copy I made into the hand scroll *Heaven.*

Tools: sandpaper; hammer; brushes; ruler; pencil; bone folder; knife and cutting mat; scissors; awl

Materials: one 8-inch (20.3 cm) wooden dowel, ⅜ to ½-inch (1 to 1.3 cm) diameter; scrap paper; 2 brads or nails, 1 inch (2.5 cm); 1 or 2 round wooden drawer pulls (optional); PVA; acrylic paints; mulberry paper, chiri (with no inclusions, such as bits of bark or confetti), Yatsuo, or other noncreasing Asian paper, 7 x 10 to 25 inches (17.8 x 25.4 x 63.5 cm), grained short or no grain; decorative or contrasting cover paper, 7 x 6 inches (17.8 x 15.2

cm); one 7-inch (17.8 cm) piece of half-round reed or bamboo skewer; flat ribbon or cord approximately 18 inches (45.7 cm) long; cellophane tape (optional)

Example: 7-inch (17.8 cm) scroll

1. Sand the ends of the dowel.

2. Put down layers of old magazines for scrap paper.

3. If you wish to add a small wooden drawer-pull for a knob at the end, hammer a 1-inch (2.5 cm) brad into the end of the dowel, put glue on the end of the dowel and inside the hole in the drawer-pull, and glue the knob to one end of the dowel. You may wish to have knobs at both ends.

4. Paint the ends with acrylic paint, if desired (the middle will have paper covering it). Let dry.

5. Brush about a 1-inch (2.5 cm) flat line of PVA glue along the left end of the long scroll paper.

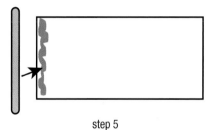

step 5

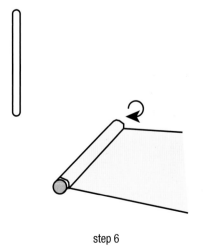

step 6

6. Wrap the paper around the dowel. Smooth down.

7. On one end of the cover paper, measure ½ inch (1.3 cm) in from the 7-inch (17.8 cm) side. Score a line with your bone folder.

8. Glue down the half-round reed strip or bamboo skewer on the back, flat-side up, along the score.

9. Clip very small bits of the corners diagonally.

10. Apply more glue to the back of the cover (the flap you just made) and fold it over the reed. Press down.

11. Use a bone folder to smooth and flatten the paper against the reed strip.

12. Make a line of glue on the very front edge of the text sheet of the scroll.

13. Glue down the front or outside of the cover on top of this edge, aligning it carefully. Smooth down.

14. Cut a slit for the cord or ribbon in the cover paper, centered, just behind the reed strip.

15. Poke the cord from the right side to the inside. (For threading, it may help to wrap the end with cellophane tape.) Leave only about ½ inch (1.3 cm) showing.

16. Make a small slit at the short end of the cord.

17. Thread the long end all the way through it.

18. Trim the short end. Glue down the inside.

19. Paste a small bit of the cover paper over it. Let dry.

20. Roll up the scroll and wind the cord.

Uses: birthday poem or wish; personal message or greeting

Variation: Omit the 7 x 16-inch (17.8 x 40.6 cm) covering paper. Use a longer text paper, and paint a section at the end with acrylic inks and gesso, covering both sides of the paper. The painted part will serve as a decorative cover.

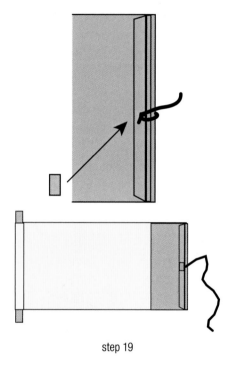

step 19

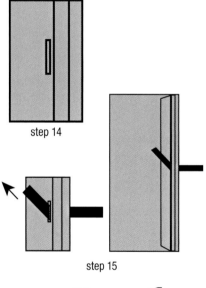

step 14

step 15

step 16

step 17

steps 9 & 10

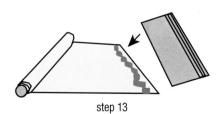

step 13

Winding a Hand Scroll

According to a traditional Japanese bookbinder, the cord should wrap around the scroll 3½ times, each turn of the cord moving down the scroll slightly, the end tucking in partway. My husband visited a shop in Japan where he learned to wind a scroll. He taught me.

To wind: Hold the scroll in the left hand, and wind the cord around one or two fingers that are resting on the scroll. When you remove your fingers, you will tuck the looped end into this space. Adjust the tightness by pulling the loop and tightening at the end. Pull back and forth until the cord is snug.

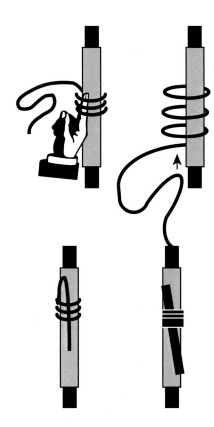

HANGING**SCROLL**

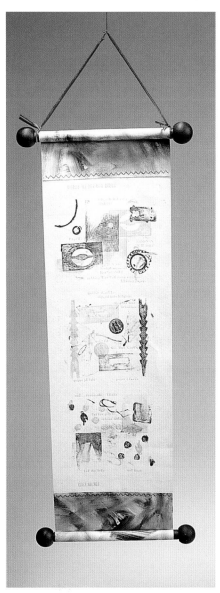

Where We Put Our Hopes (Wishing Scroll), 1994; collagraphs, letterpress, acrylics, gesso; edition; hanging scroll; 8½ x 20 inches (21.6 x 50.8 cm) (photo: Jim Hair)

Marilyn Webberley has some nice scrolls in her how-to book, *Books, Boxes and Wraps* (Bifocal Press, 1995). Another good source is *Japanese Bookbinding* (Weatherhill, 1986) by Kojiro Ikegami. *Where We Put Our Hopes* (*Wishing Scroll*) is my first hanging scroll. I used gel medium to collage and attach the objects to the underside of a linoleum block. Then I coated the entire surface with three coats of the gel medium. When it dried, I inked the block and printed the "collagraph." I painted the endpapers with acrylics mixed with lots of gesso. Gesso keeps the paper from sticking when it is rolled up.

Tools: hammer; sandpaper; small brush

Materials: 4 brads or nails, 1 inch (2.5 cm); 2 dowels of the same diameter and length, 9 x ⅜ to ½-inch (22.9 x 1 x 1.3 cm) diameter; 4 wooden drawer pulls; wood glue; acrylic paints; PVA glue; 1 long text paper, 8½ x 20 inches (21.6 x 50.8 cm); 2 decorative endpapers that will wrap all the way around the dowels and still show 2 inches (5.1 cm) or more, each 8½ x 3 inches (21.6 x 7.6 cm) each; ribbons or cord

1. After sanding the ends of one of the dowels, hammer a 1-inch (2.5 cm) brad or nail into the center of the end.

2. Put a dab of wood glue around the nail and into the hole in the end of the knob (wooden drawer pull).

3. Hold the knob on top of the nail/dowel for a minute or two until the glue sets.

4. Repeat steps 1-3 for the remaining knobs and for the second dowel as well.

5. Paint with acrylic paints when dry.

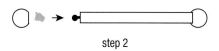

step 2

Attach text sheet to the decorative sheets at each end

6. Run a line of PVA glue along the edge of the decorative sheet, and glue the text sheet on top of it.

7. Glue the ends of the decorative sheets to the dowels. Glue them so the sheets wrap once around the dowels and the wood does not show.

8. To hang, add a decorative cord or ribbon at the top of the scroll.

Variation 1: Add the decorative cord or ribbon for hanging by attaching it at either end to the brads before gluing the knobs.

Variation 2: Stitch together by hand or machine instead of gluing.

Variation 3: Paint the text area with white gesso to create a nonporous writing or drawing surface.

Variation 4: Make knobs from colorful polymer clay instead of painted wood. Leave holes in the clay knobs so they can be glued around the nail and dowel.

Uses: amulet; housewarming scroll with good wishes; inspirational poem or quotation; biblical quote

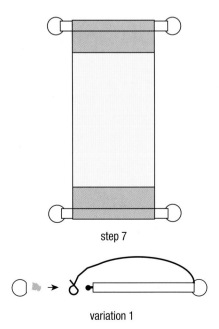

step 7

variation 1

Hanging scroll with attached ribbons to tie closed

Follow the above directions, but glue the cover or decorative sheets to the dowels first. Leave about 1½ inches (3.8 cm) extra on the end of what will be the lower decorative sheet.

1. Working up from the bottom of the scroll, at least 1 inch (2.5 cm) from the right and left edges, make two slits on the right side and two on the left, one an inch (2.5 cm) above the other vertically.

2. Thread the ribbon from the back to the front through each pair of slits, and straighten the ends.

3. Glue the middle of the ribbon to the paper.

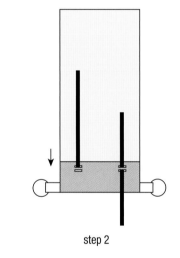

step 2

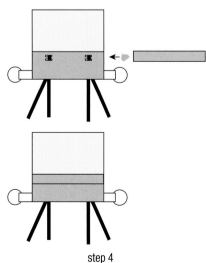

step 4

4. On the front, glue a paper sheet to cover the 1-inch (2.5 cm) portion of the ribbon that is exposed. You should have two ribbons with four ends hanging out the back.

Variation: Sew by machine, attaching the ribbons as you join the decorative sheets and text.

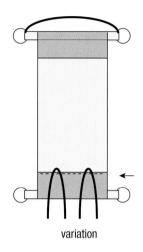

variation

OSCAR365

Shortly before my son Oscar was born, I decided that I would take a picture of him every day for the first year of his life and that these photos would become the primary content of a book. Committing to this daily practice brought up some unexpected issues and questions. How, when, and where to shoot each day? Each morning I would lay Oscar on the floor and take a picture. By using a digital camera, I could immediately ascertain the quality of the shot, which also helped sustain my motivation. What to do after forgetting to shoot one day? I missed several days, but I cut myself some slack and carried on because, being a new parent, I was often very tired and distracted. Almost every day brought an unexpected event, but the daily photograph became a welcome routine. The photos have become an amazing 15-foot long accordion book documenting Oscar's first year.

MICHAEL HENNINGER

DOUBLE**SCROLL**

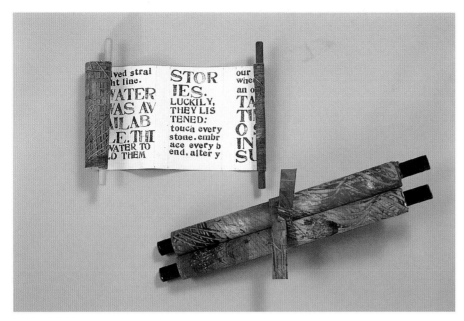

Water Stories, 2000; paste paper, dowels, acrylic paints, rubber stamps; 5 x 1½ inches (12.7 x 3.8 cm) Scroll Model, 2000; paste paper, dowels; 10 x 2 inches (25.4 x 5.1 cm) (photo: Sibila Savage)

The double scroll is an ancient form that can be seen in synagogues today in the Torah scrolls, the handwritten Five Books of Moses. The Torah is made of parchment and has many sections sewn together. You can make this scroll any length just by joining more paper. Glue will make the paper bulge when it is rolled. Glue stick may work but be a little stiff. Sewing will work best, and the stitching adds color and another design element to the completed piece. Purchase dowels in an art supply or hardware store and saw them to the desired length. For added color, use paste papers for your inner paper. Paint gesso on the back of the paste paper first so the paper doesn't curl. Let it dry before proceeding. When you need to apply the glue, put it on the gesso side of the paper.

Tools: glue brush; saw for cutting dowels; sandpaper to sand the rough edges

Materials: PVA; magazines for scrap paper; lightweight paper for inner paper (cut 2 inches [5.1 cm] shorter in height than the dowels and as long as you like); 2 wooden dowels (cut one long one down if necessary); book cloth or heavy paper for cover, same width as the inner paper, long enough to wrap around both scrolls

Example: 10-inch scroll x 2 inches (25.4 x 5.1 cm) wide

1. Brush about a 1-inch (2.5 cm) flat line of PVA glue along the left edge of the lightweight paper.

2. Use the saw to cut the dowel to the desired length and sand the rough edges smooth. Then place the dowel on top of the leftmost edge of the paper, making sure it is even.

3. Roll the dowel carefully in the paper until you can no longer see the glue.

4. Repeat for the right edge. Let dry.

5. Wrap the cover paper around both scrolls and mark. Apply glue to the cover, and attach it to itself to make a wide ring. Press to secure. Let dry. Slip over the double scroll.

Variation: Instead of the cover described in step 5, make a paper clasp as described on page 218.

Peter and Donna Thomas, longtime bookmakers working in Santa Cruz, California, devised a house for the double scroll in 1994. In their book, *More Making Books By Hand* (Quarry Books, 2004), Peter explains that his inspiration for the scroll book comes from the notion that since we call a computer screen a page, he wanted to make a book "scroll like a computer." In his version of the scroll, we cannot see the entire scroll at once; we must turn the dowels continuously to read the text or see the images.

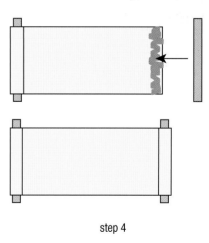

step 4

step 1

variation

ACCORDION-FOLD**BOOK**

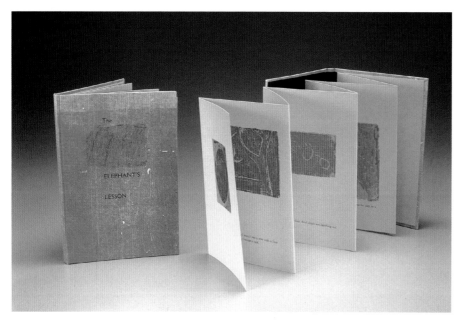

The Elephant's Lesson, 2003; letterpress, collagraphs; edition of 32; accordion; 5³⁄₈ x 7³⁄₄ inches (14.3 x 1.9 cm) (photo: Sibila Savage)

Accordion-fold (also called *concertina*) books make the best books for displaying under glass because the pages can be revealed simultaneously. Use any size paper, but allow for a tab of at least one ½ inch (1.3 cm). I learned this accordion-fold technique from Betsy Davids.

Tools: ruler; knife and cutting mat; pencil; bone folder; glue brush

Materials: 2 sheets of paper, each 5½ x 21 inches (14 x 53.3 cm); PVA; scrap paper; waxed paper

Example: 5 x 5½-inch (12.7 x 14 cm) book

1. Cut off an inch (2.5 cm) from one of the papers, making it 5½ x 20 inches (14 x 50.8 cm).

2. On the other sheet, mark, score, and fold in an inch (2.5 cm) parallel to the shorter side.

3. Keeping the tab folded, fold this sheet in half, matching one cut edge to the fold with the tab inside.

4. Fold the ends to the middle fold, one end at a time. Open and turn over. You should have valley, mountain, valley, mountain.

5. Fold the 20-inch (50.8 cm) sheet in half.

6. Fold the ends back to the new fold and crease, making sure they are aligned. Open. You should have valley, mountain, valley.

7. Apply glue in a thin, flat line to the front of the tab on the sheet.

8. Set the other sheet on top. Press down. The tab will be hidden behind the second sheet.

9. Place a sheet of waxed paper between the pages immediately before and after the glued-down tab. This will prevent the moisture from the glue from warping the pages. Let dry under weights.

Variation 1: Add a wrapped hard cover with removable spine or an adhesive hard cover (no spine).

Variation 2: Put pop-ups in the valley folds first. See page 122 for a simple pop-up.

Uses: display of small pictures; photo album; sketch book or journal; guest; or honor book

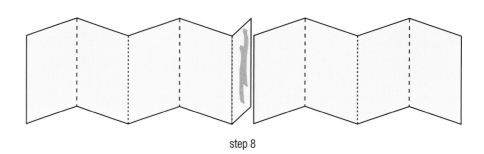

step 8

MINIATURE**TABBED ACCORDION**

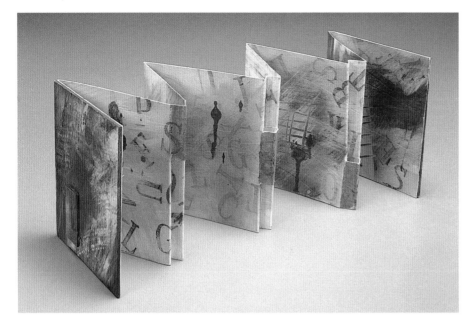

Tabbed Accordion Model, 2001; acrylic inks, rubber stamps, gesso, graphite; 3 x 3 inches (7.6 x 7.6 cm) (photo: Sibila Savage)

I adapted this structure from a book written in Italian by Laura Badalucco called *Kirigami* (Sterling, 2001), which is Japanese for a type of paper cutting. I don't know Italian—or Japanese. From looking at the pictures, I realized it was a type of pop-up structure. Then I modified it. In *Kirigami*, the book is made into an address book.

Tools: bone folder; ruler; pencil; knife and cutting mat

Materials: text/lightweight paper, 3 x 17 inches (7.6 x 43.2 cm), grained short; boards or wrapped hard cover

Example: 2¾ x 3-inch (7 x 7.6 cm) book with three fore edge tabs

1. Fold an eight-paneled accordion. (See page 71.)

2. Put the accordion in front of you horizontally so that the first fold is a valley fold.

3. Measure and score a vertical line ¼ inch (0.6 cm) on either side of the folded edge of the first mountain.

4. Repeat step 3 for the remaining two mountain folds.

5. Measure and mark 1 inch (2.5 cm) down from the top of the first mountain fold.

6. Cut a horizontal slit from the left score to the right score at the first mountain fold.

7. Measure 1 inch (2.5 cm) down from the top and 2 inches (5.1 cm) down from the top of the second mountain fold.

8. Cut horizontal slits at these two places on the second mountain fold.

9. Measure 2 inches (5.1 cm) down at the third mountain fold, and make a horizontal slit.

10. Refold the fore edges so that the little tab sticks out and has a mountain fold in the center (it pops out); the rest of the fore edge bends inward.

11. Attach a wrapped hard cover or separate boards (see page 208 or 209).

step 1

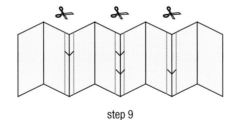

step 9

step 3

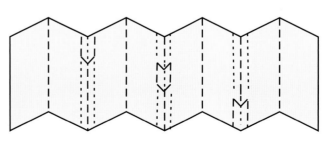

step 10

LAYERED**ACCORDION BOOK**

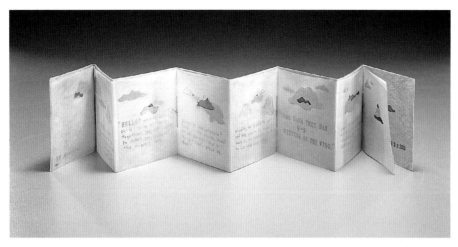

On the Wing, 2000; paper, rubber-stamped text; 2¾ x 3 inches (7 x 7.6 cm)
(photo: Sibila Savage)

In a newspaper article about immigrants, one man called his French passport the "green snake." The passport was made of green paper in an accordion format and rubber-stamped: a "found" artist's book.

For the layered accordion book, you will need three sheets of lightweight paper, each 24 inches (61 cm) long. You can also make a tiny book for practice out of an 8½ x 11-inch (21.6 x 27.9 cm) sheet cut into thirds lengthwise. I recommend a colored or painted paper for the bottom layer and two sheets of translucent paper such as drafting film for the top two layers. You may also choose three sheets of colored paper into which you have cut shaped holes so the previous colors show through.

Tools: binder clip; cardboard to protect work surface; ruler; pencil; awl; needle

Materials: 3 pieces of paper (see above), each 5 x 24 inches (12.7 x 61 cm), grained short; scrap paper; thread; 2 fore edge strips, each 5 x 2 inches (12.7 x 5.1 cm), grained long

Example: 3 x 5-inch (7.6 x 12.7 cm) book

1. Fold paper into an accordion with eight segments.

2. Make all cuts, rubber stamps, illustrations, or other marks on the papers now. Let dry, if necessary.

3. With the valley fold as the first fold from the left, nest all the pages from bottom to top. Secure all three sheets with a binder clip placed at the edge of one of the panels. Make sure the binder clip has a small pad of protective scrap paper under it so it does not directly touch and dent your book.

4. Measure and poke three holes in the first valley fold. Put one hole equidistant from the head and tail of the book, the other holes each 1 inch (2.5 cm) from the center hole. Sew a single signature. (See page 95.)

FORM AND CONTENT IN *ECO SONGS*

We thought very carefully about connecting form and content when we created *Eco Songs*, two single signature books placed in the first and last valleys of an accordion. The poems on which the song cycle was based were set in type as originally written, then printed and bound into the first signature. The same words are spread across accordion panels, reflecting how they appear in the music, with repeats and overlaps plus typographic representations of volume, timbre, and tone. Since the music is continuous, the accordion was the perfect structure for that section, allowing continuous flow over the panels. We returned to a signature for backmatter: biographies of the composer, soprano, and poets, and the colophon. The paper is handmade from 42 plant fibers from around the world, representing the global environment referenced in the texts, and we also included information about the fibers and their sources. The book with attached CD is housed in a handmade paper slipcase, introducing the reader to the material and content of the book by initial tactile experience.

JOHN RISSEEUW

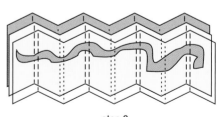

step 3

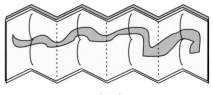

step 4

5. Poke holes in the next valley fold and repeat step 4, using the same measurements for hole placement so the stitching will match from one signature to the next. Repeat for the third and fourth valley folds.

For a more finished look

6. Take two strips of the colored paper the same height as your book (5 inches [12.7 cm] in this example) and 2 inches (5.1 cm) wide.

7. Fold each paper in half lengthwise to make it long and narrow.

8. Put a line of glue or glue stick on the side with the valley fold.

9. Close your book by folding it up completely. Now take one of the strips and face the open edge to the left and the folded edge to the right. Adhere the strip around the three layers of the first section only. The book is now contained at the fore edge (see diagram for steps 6–10).

10. Repeat for the last section (the back of the book) and the last strip.

Variation: Use one layer that is approximately 1 inch (2.5 cm) shorter and a second layer that is approximately 2 inches (5.1 cm) shorter for a more three-dimensional look, resembling Julie Chen's *Radio Silence*.

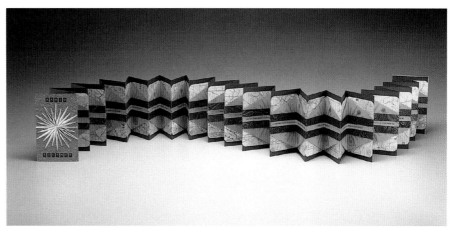

Julie Chen: *Radio Silence*, 1995; letterpress printed on a variety of papers including found objects; boxed edition of 75 (box not shown); 5 x 3½ x 2¼ inches (12.7 x 8.9 x 5.7 cm) when closed, expands completely to 7 feet (2.1 m)

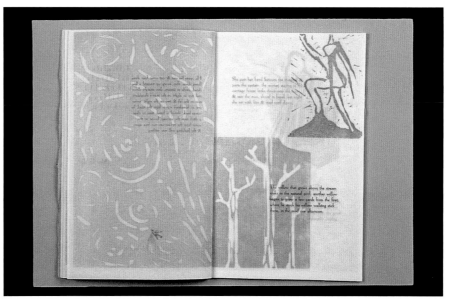

Digging a Hole, from *Four in Transport*, 1990; letterpress, linoleum cuts on waxed masa paper; edition; sidebound; 6 x 10 inches (15.2 x 25.4 cm) (photo: Jim Hair)

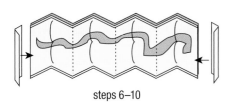

steps 6–10

ACCORDION**WITH POCKETS**

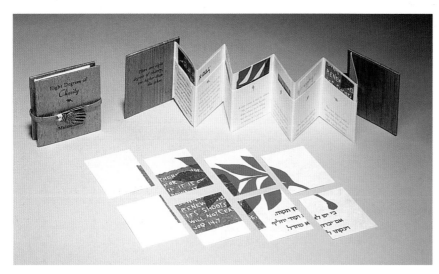

Eight Degrees of Charity (text by Maimonides), 1995; letterpress, linoleum cuts; edition of 60; accordion with pockets; 2¼ x 2½ inches (5.7 x 6.4 cm) (photo: Jim Hair)

Vicky Lee showed me a blank book with this structure that she had purchased at a calligraphy fair. After studying it, I figured out how to make one. In my book, *Eight Degrees of Charity*, the pockets contain the pieces of a double-sided puzzle. Since the author, Moses Ben Maimon (Maimonides), lived in the 12th century, I wanted the book to reflect the style of binding used at that time. Dominic Riley, a fine bookbinder from England who was then based in Berkeley, California, kindly lent me information about 12th century books, some of which was based on his own research. The old book probably would have had a wooden cover and been sewn to cords. For protection, it likely had a cover or "chemise" with pockets. A clasp would have held together the springy parchment signatures. I used elements of a 12th century book—woodlike veneer paper for the covers, pockets, a clasp (a bone closure, in this case)—but did not set out to literally copy the historical binding. The copper hand is for decoration, but readers often try to undo the book by pulling on it. I liked the hand charm and didn't want to omit it, even to avoid confusion—a trade-

off. I found good historical information in *The Coming of the Book: The Impact of Printing* (Verso, 2010) by Lucien Febvre and Henri-Jean Martin and *The Art and History of Books* (Oak Knoll Press, 1995) by Norma Levarie.

Note: Use care and work slowly when you fold the accordion over the pockets. It is easy to make unwanted wrinkles.

Tools: ruler (a 24-inch [61 cm] metal ruler is helpful); scissors; pencil; bone folder; knife and cutting mat; decorative scissors (optional); glue brush

Materials: 2 soft lightweight inner papers, each 12 x 24 inches (30.5 x 61 cm), grained short; scrap paper; PVA; waxed paper

Example: 5½ x 8-inch (14 x 20.3 cm) book with 4-inch (10.2 cm) pockets

1. Cut off an inch (2.5 cm) from one of the papers, making it 12 x 23 inches (30.5 x 58.4 cm).

2. Mark, score, and fold both long papers at 4 inches (10.2 cm) (to make them long and skinny). These 4 inch (10.2 cm) segments will be the pockets. It helps to fold

this long fold against a 24-inch (61 cm) metal ruler, holding the ruler next to the score and folding up.

3. On the 24-inch (61 cm) sheet of paper, fold back an inch (2.5 cm) from the right edge, making a mountain fold (the plain sides should be touching). The tab (the folded 1 inch or 2.5 cm) should be on the right. The pocket should be on the bottom.

4. Optional: "Shape" the horizontal pocket edges at this time (diagonals, curves, diamonds, etc.) by unfolding again and cutting the edge to the desired shape with a knife or decorative scissors.

5. Fold the paper in half, widthwise, to where you folded the tab, backs together, pocket-side up.

6. Fold the edges back in half (pocket-side in) to the first fold to create an accordion with three folds (plus the tab).

7. Repeat the accordion fold for the 23-inch (58.4 cm) paper (no tab).

8. Glue the pocket edge of the tab down to its parent paper.

9. Glue the complete tab to the back of the other paper. Glue the edges of the exposed pocket on the end. Glue down the very edges of the end pockets to the parent sheet if you will not have a cover.

10. Place sheets of waxed paper between the pages. Let dry under weights.

11. Add a soft, open spine cover or separate wrapped hard covers (see chapter 7 on covers). If you make a hard cover with separate boards, you may wish to trim the edges of the end pockets so they won't be so bulky under the endsheets.

Note: When you make a cover, you lose the front and last pockets (yielding six pockets), but I think a cover makes this book complete.

Variation: Add three signatures, one in each of the valley folds on the side opposite the pockets.

Uses: scrapbook; business card holder; booklet of stationery; postcard collection; photograph wallet. Write personal text on the folded papers placed in the pockets for an intimate reading experience.

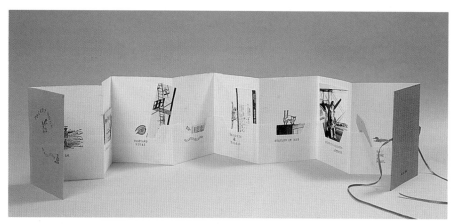

Pocket Book, 1995; rubber stamps, found objects; accordion with pockets; 5 x 6½ inches (12.7 x 16.5 cm) (photo: Jim Hair)

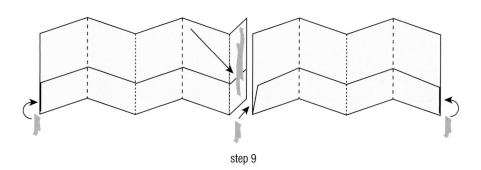

step 9

ACCORDION**WITH SIGNATURES**

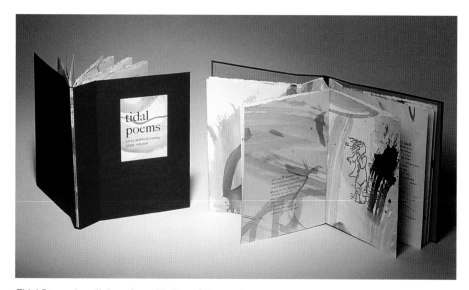

Tidal Poems (a collaboration with Anne Schwartzburg), 1995; letterpress, inks, watercolors, linoleum cuts, photoengravings of drawings by Anne; edition of 60; accordion with signatures; 10 x 11½ inches (25.4 x 29.2 cm) (photo Jim Hair)

Anne Schwartzburg (now Anne Stevens) and I used this wavelike structure for our book *Tidal Poems* because we wanted the reader to physically experience the flow of the tide. The poems are about water and the sea. For this example, we will make a 1-inch (2.5 cm) accordion with three signatures on the mountain fold.

Tools: bone folder; knife and cutting mat; metal ruler; glue brush; needle; pencil; clip; needle, bodkin or awl; weight

Materials: 1 sheet for the concertina spine, 5½ x 8 inches (14 x 20.3 cm), grained short; scrap paper; PVA; dish for glue; thread; 6 to 12 sheets for the signatures, each 5½ x 8½ inches (14 x 21.6 cm), grained short; waxed paper

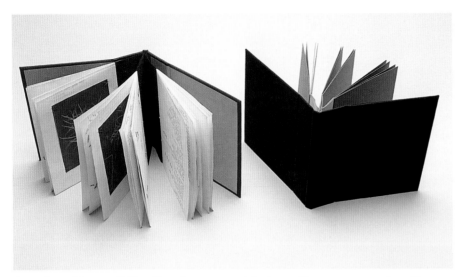

Paper Has a Memory, 1995; rubber stamps, sun prints, typewritten pages; accordion with signatures at the mountains; 6 x 5½ inches (15.2 x 14 cm) *Model*, 1995; Canson Mi Teintes paper; 5⅝ x 5½ inches (14.3 x 14 cm) (photo: Jim Hair)

Example: 5½ x 5¼-inch (14 x 13.3 cm) book

1. Fold the spine paper in half. Open.

2. Fold the ends to the middle fold one end at a time.

3. Fold the ends back to the new folds, making sure they are aligned.

4. Turn the paper over, keeping everything folded.

5. Align the folded ends with the middle fold; crease. You should now have an accordion with alternating mountain and valley folds at every inch (2.5 cm).

If two folded papers are needed, as for a book with more signatures

6. Fold two accordions, following the above instructions, steps 1–5.

7. Cut off a 1-inch (2.5 cm) segment from one sheet.

8. Place the uncut, 8-inch (20.3 cm) accordion in front of you, open. The first fold on the left should be a valley fold. Glue the accordion that you cut to the end of this one. Place the 7-inch (17.8 cm) ac-

cordion next to this one, facing opposite so that its first fold is a mountain.

9. Apply glue in a thin, flat line to the front of the first 1-inch (2.5 cm) segment of the 7-inch (17.8 cm) accordion.

10. Align completely with the first segment of the 8-inch (20.3 cm) accordion and smooth down. The final accordion should continuously alternate valley and mountain. To sew the book, the first and last folds should be valley folds.

For the signatures

11. Fold all the paper for the signatures in half, widthwise. Group and nest the folded papers into three even piles (six for "doubled" accordion).

12. Mark each mountain fold on the front with a light pencil mark. Refold these mountains into valleys for sewing. Align one signature with each mark; clip together temporarily with a binder clip.

13. With your needle, bodkin, or awl, poke three holes through the folds where you will sew. The holes go through each signature and its corresponding accordion fold. Leave at least ½ inch (1.3 cm) from each end. (For help in making the holes at even intervals, see page 24.)

FROM CURIOSITY TO PRODUCTION

Curiosity compels me to make books and broadsides from discovered marks and symbols. Each of the pieces I make has a unique beginning, although many originate in research I do before or after a trip. The initial impulse usually arises from a certain attraction to the graphic element of the marks and from a sense of communication with a past unknown creator. The process from information gathering to book/broadside seems a natural continuation. If the marks are of interest to me, I suppose that others might wish to know more about them, too. Some of the marks are alphabetic; some are what I call preliterate. An example: a poet friend and I were enticed by the marks hobos left behind to designate the vagaries of travel. The collaborative broadside and booklet project, *Hobo Traveling Notes*, was based on our responses to a selection of these marks.

TERRY HORRIGAN

14. Sew as for single signature/pamphlet stitch (see page 95).

15. Refold the marked valleys back into mountains.

16. Place waxed paper between parts of the accordion and the pages that have been glued together (if applicable).

step 15

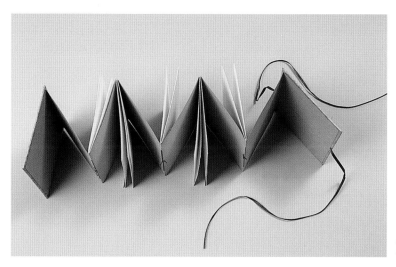

Accordion with Signatures in the Valleys, 1996;
4½ x 5¾ inches (11.4 x 14.6 cm) (photo: Jim Hair)

17. Press under heavy book overnight (not necessary if you did no gluing).

18. Add covers (choose from Chapter 10). If you choose a wrapped hard cover, it should be ¼ inch (0.6 cm) taller than the pages, while the width should equal the width of the spine plus the width of the pages plus ¼ inch (0.6 cm); in this example, then, the hard cover would measure 5¾ x 5½ inches (14.6 x 14 cm). You can also use an adhesive hard cover with hinged spine or cover separate boards.

Notes: If you choose to use the hinged hard cover, make your accordion out of a lightweight paper. As with most accordion-style books, this book expands when you open it. It will not open as much with a hinged hard cover. The signatures are connected only to the accordion spine, not to each other.

Variation: Sew the signatures in the valley folds. The dimensions of the boards for a hard cover would be 5½ x 4½ inches (14 x 11.4 cm) in this example.

Uses: three (or six) separate stories or sets of text; series of photos of three (or six) connected people, places, or things

BACK-TO-BACK**ACCORDION BOOK**

Val Simonetti: *B-babble*, 1984; letterpress text, screenprint image; edition of 17; closed: 6¾ x 8 inches (17.1 x 20.3 cm), open: 6¾ x 34 inches (17.1 x 86.4 cm) (photo: Sibila Savage)

My friend Val Simonetti learned this structure from Karen Zukor, a conservationist and teacher, and used it to make a book for her new niece Bianca, called *B-babble*. The book had many words beginning with the letter B. Val writes, "What I like about this particular structure is that it comes close to being a continuous loop. It has a title page, but I notice that people are often unsure just where the text begins. Since I made *B-babble* to celebrate the arrival of the only child of my only sister, it seems appropriate that there is no logical conclusion to it."

The Road Unfolded, 2000; rubber-stamped text, acrylic paint, torn maps; 5 x 5 inches (12.7 x 12.7 cm) (photo: Sibila Savage)

3. Keeping them together, flatten the accordions and clip them together.

4. Measure, mark, and poke three holes at each of the valley folds: one centered, one measured 1½ inches (3.8 cm) up from the center hole and then one measured 1½ (3.8 cm) inches down from the center hole. These holes should be in the second, fourth, and sixth folds.

5. Sew the accordions together as if you were sewing a single signature in each of these three valley folds.

6. After sewing, reverse the folds of the back accordion so that mountains of both accordions meet at the sewing.

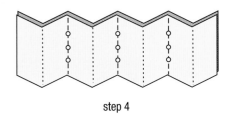

step 4

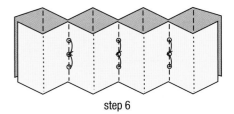

step 6

For this particular version you will only see six pages on each side. Keep the ends blank. For more pages, follow the instructions for the Back-to-Back Accordion with Tunnel (page 117) but do not cut out any holes.

Tools: bone folder; binder clip; pencil; needle

Materials: 2 pieces of paper, each 24 x 5½ inches (61 x 14 cm), grained short; thread; a folded piece of scrap paper. Choose one type of cover.

For a hard cover: two pieces of 4-ply board, 5¾ x 6¼ inches (14.6 x 15.9 cm), grained short; two pieces of bookcloth or cover paper, 8¼ x 7¾ inches (21 x 19.7 cm), grained short; glue; waxed paper

For a flexible, nonadhesive cover: two 2-ply boards, 3 x 5 ½ inches (7.6 x 14 cm); two pieces of paper, 5 x 5½ inches (12.7 x 14 cm), grained long; two pieces of paper, 7½ x 3 inches, (19.1 x 7.6 cm), grained

short; one spine piece of medium-weight paper, 3 x 5½ inches (7.6 x 14 cm), grained long

Example: 6¼ x 5¾-inch (15.9 x 14.6 cm) book

1. Make two accordions from the 24 x 5½-inch (61 x 14 cm) paper with eight small segments each.

2. Place accordions in front of you so that the first folds are mountain folds.

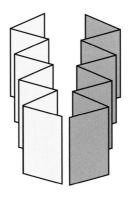

step 2

For hard covers

1. Cover two separate boards with cloth or paper. See page 209, for additional help.

2. Cut diagonals at the corners.

3. Fold down the edges, one by one.

4. Repeat steps 8 and 9 for the second board.

5. Place the folded papers in front of you so that they are accordion-folded and closed. The top layer should have an open middle and folded right and left edges.

6. Apply glue to the top pages. Align the front cover and press it down.

7. Turn the book over. Repeat steps 5 and 6 for the back cover, trying to align it with the front cover as well.

8. Place waxed paper between the covers and the front and back sheets. Press under a heavy weight overnight.

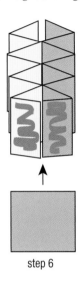

step 6

For non-adhesive, flexible covers

1. See instructions for Wrapped Hard Cover, page 208. For the front and back of this book, the open edges will be on the long sides.

2. Place the spine piece in front of you vertically. Mark the spine piece in the center 1½ inches (3.8 cm) from either edge.

3. Measure and mark ⅛ inch (0.3 cm) on either side of the center mark. Score two lines that are parallel to the long side of the spine piece.

4. Insert the spine piece into the wrapped covers, connecting them.

5. If it seems too tight, cut slight diagonals at each of the corners.

6. Insert the accordion-folded book into the wrapped covers at the right and left edges.

Uses: two related narratives that can be read in any order; words on one side, images on the other; dream on one side, waking life on the other; travel book; circular concepts

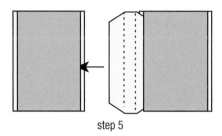

step 5

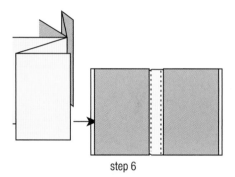

step 6

BACK-TO-BACK **ACCORDION BOOK WITH TUNNEL**

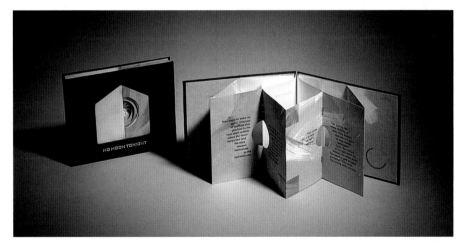

No Moon Tonight, 1999; letterpress, book cloth, paper; edition of 35; 6¼ x 5¼ inches (15.9 x 13.3 cm) (photo: Jim Hair)

I adapted the previous structure to make a tunnel book for *No Moon Tonight*. The gray side has a story of insomnia. The translucent side has the names of each season's full moons. I used a lighter weight, translucent paper for one side of the accordion, which looks nice but doesn't sit up quite as well when the book is opened. I decided that the translucent paper was important to my concept of "moonness," so I used it anyway. In bookmaking, you will find that there is always a trade-off.

If you do use translucent paper, you will need to add endpapers (see step 17). You can make this book longer by adding more inner papers and paper strips to connect them. The structure works best when all accordions are made from the same weight of paper. Use medium-weight or heavyweight paper for best results.

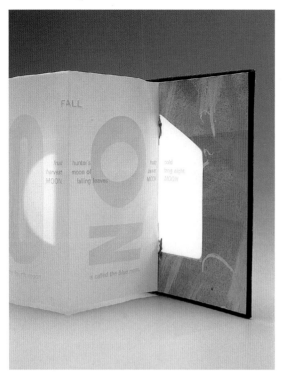

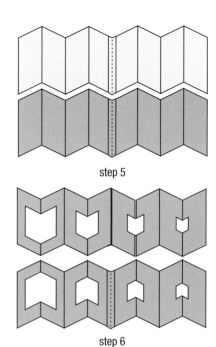

step 5

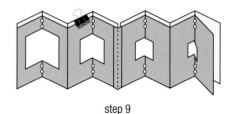

step 6

No Moon Tonight, 1999; letterpress, book cloth, paper; edition of 35; 6¼ x 5¼ inches (15.9 x 13.3 cm) (photo: Sibila Savage)

Tools: bone folder; glue brush; scissors; binder clip; metal ruler; pencil; needle; knife and cutting mat

Materials: 4 pieces of paper, each 12 x 5½ inches (30.5 x 14 cm), grained short; 2 paper strips, each 5½ x 1 inches (14 x 2.5 cm), grained long; glue; a folded piece of scrap paper; thread. For the cover: 2 pieces of 4-ply board, each 5¾ x 6¼ inches (14.6 x 15.9 cm), grained short; 2 pieces of bookcloth or cover paper, each 8¼ x 7¾ inches (21 x 19.7 cm), grained short

Example: 6¼ x 5¾-inch (15.9 x 14.6 cm) book

1. Fold the four pieces of paper into accordions of four panels each.

2. Fold the paper strips in half lengthwise.

3. Apply glue to the back of one of the paper strips.

4. Press the end of one of the accordions on one-half of the strip. Press the end of another accordion to the other half of the strip.

5. Repeat steps 3 and 4 for the other two accordions and the other paper strip. Do not connect these two accordions to the first two accordions.

6. For a tunnel effect on one side only, take one of the sets of accordions and cut shapes in the valley folds from large to small. (Repeat the same shapes for the other set of accordions if you want the tunnel to be symmetrical.)

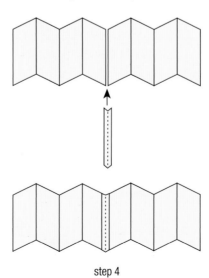

step 4

To sew

7. Place the accordions in front of you horizontally and with their backs together.

8. Flatten them and clip them together.

9. Measure, mark, and poke four holes at each of the valley folds so that you have a pair of holes above the hole for your tunnel and a pair below. These should be on each of four valley folds.

10. Sew the accordions together with one stitch at the top and one stitch at the bottom. Tie off each with a square knot.

step 9

11. After sewing, take the back accordion and reverse the folds so that the mountains of both accordions meet at the sewing.

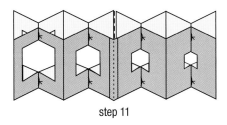

step 11

For the hard covers

12. Using your knife against a metal ruler, cut a window in the top cover board.

13. Glue and cover the boards. For the window board you will need to cut an *X* from corner to corner of the window. Cut a rectangle ½ inch (1.3 cm) inside the window. Fold the cloth or paper over the edges of the window.

14. Place the inner folded papers in front of you so that they are closed (the top piece should have a folded middle and open right and left edges).

15. Apply glue to the top pages. Press the front cover board down, aligned.

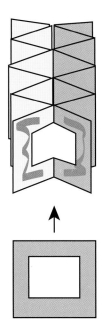

step 15

16. Turn the book over. Repeat steps 14 and 15 for the back cover, trying to align it with the front cover as well.

If you are using translucent paper

17. Cut out a window in the endsheet that matches half the window in your front board. Apply glue and press over the translucent paper that is already adhered to the board. See the details in the photo of *No Moon Tonight.*

Uses: book about another world; two-sided narrative; anniversary or birthday book of "then and now"

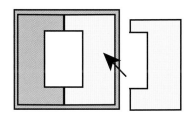

step 17

CIRCLE**ACCORDION**

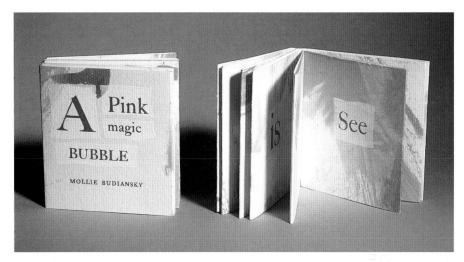

A Pink Magic Bubble (by Mollie Budiansky), 1999; letterpress text over acrylic inks and gesso-stenciled rectangles; edition of 35; 2¾ x 3 x ⅜ inches (7 x 7.6 x 1 cm) (photo: Jim Hair)

The circle accordion is a good first book. When I described how I painted one sheet of paper and cut it into strips to make many of these books, someone said, "I don't do art, but I think I could do that." When fully open, this accordion makes a modified circle with all the pages connected. I initially developed it because I was dissatisfied with accordion books that were not attached to (and therefore fell out of) their front covers. It has become one of my favorite painted book-in-a-day books to make. When my daughter was in elementary school, we made a book based on a refrigerator magnet poem she wrote: "A pink magic bubble is a tiny see through song." We painted paper together, I printed the text

and bound the book, and we gave a copy to each of her teachers on the last day of school. They were pleased. Mollie was proud.

Note: The depth of the spine may vary, depending on the thickness of the paper.

Tools: knife and cutting mat; metal ruler; pencil; bone folder

Materials: 5 pieces of heavyweight paper, each 6 x 22 inches (15.2 x 55.9 cm), grained short, (they can be cut from one 22 x 30-inch [5.9 x 76.2 cm] sheet of printmaking paper, grained long); self-adhesive tape

Example: 5¼ x 6-inch (13.3 x 15.2 cm) book

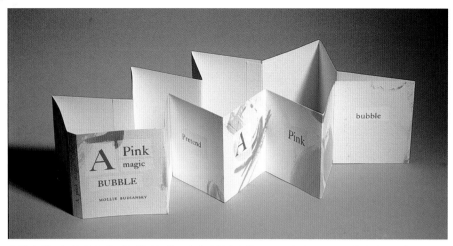

A Pink Magic Bubble (by Mollie Budiansky), 1999; letterpress text over acrylic inks and gesso-stenciled rectangles; edition of 35; 2¾ x 3 x ³⁄₈ inches (7 x 7.6 x 1 cm) (photo: Jim Hair)

1. Pick one piece of paper to be your cover. Cut off ½ inch (1.3 cm) to make it 6 x 21½ inches (15.2 x 54.6 cm). Measure 10½ inches (26.7 cm) from each edge, and mark and score. You should have a ½-inch (1.3 cm) spine in the center.

2. Fold each edge in to the closest center fold. You may wish to score the paper first at the 5¼-inch (15.2 cm) mark.

3. With the remaining sheets, cut 1 inch (2.5 cm) off the edges to create four sheets that are each 6 x 21 inches (15.2 x 53.3 cm).

4. Fold one sheet in half. (If it has writing or a design on it, fold right-side in.) Crease it well with the bone folder.

5. Keeping the paper folded, bring the ends back to the center fold, align, and crease well. You will have mountain, valley, mountain.

6. Repeat steps 4 and 5 for the three remaining sheets.

7. Cut five 6-inch (15.2 cm) lengths of self-adhesive linen tape.

8. Start connecting the pages by placing the cover piece in front of you, the outside cover facing up.

9. Take the backing off one piece of the tape. Attach the tape to the edge of the cover, sticky-side up, leaving half the sticky side available. Tip: to remove the tape from the backing, fold the corner over, rub the edges a bit, then slide your fingernail in between the two parts at the corner. Fold the backing in half so you don't mistake it for one of the tapes later on.

10. Attach the next page by aligning it with the cover ends and pressing down on the available half of the tape.

11. Continue to tape and attach pages until you get to the last one. Tape the last page to the back flap of the cover in the same manner.

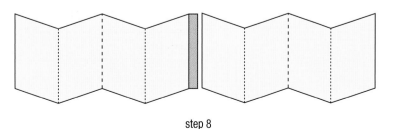

step 8

IN FORESTS SERIES

From California to Alaska, I trek into wild forests, on foot or by kayak, carrying what is needed to work for hours, days, or weeks at a time. I draw, paint, and write in direct response to the forest, using ink, watercolor, gouache, and pencil on folded pages of hot press watercolor paper. The weather, trees, animals, birds, bugs, wind, daylight—all have a deep impact. I format my pages with a common grid that contains various regions for writing and drawing/painting. If I don't have much time, I work in a small space. If I have many hours, I work in a larger region and really settle down. Returning home, I sort my field journal folios by theme, place, and/or color, and bind them together into unique accordion books. The marks of fieldwork remain on the pages: rain spots, paint spatters, imperfect language, and forest traces. I like sitting on the ground in wild forests with other creatures and using the book form to document these experiences.

ANDIE THRAMS

Variation: Paint the large sheet first with acrylic inks before you cut it into strips.

Uses: texts that involve life cycles, seasons, or other recurring, circular events

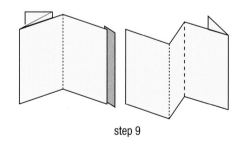

step 9

step 11

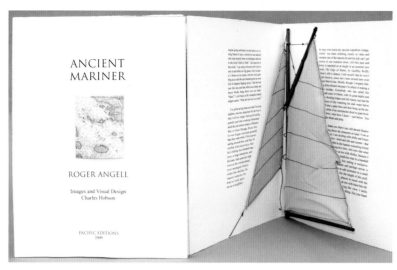

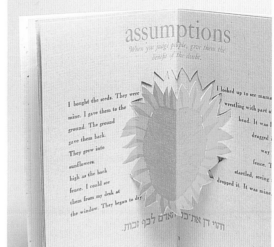

Charles Hobson: *Ancient Mariner*, 2009; essay by Roger Angell; letterpress, digital prints from monotypes with pastel, model sail and rigging; edition of 39; 11 x 15 inches (27.9 x 38.1 cm)

Sunflowers in December & Sunflowers for Sale or Rent, 1995; interior pop-up from Book Three of *A Garden Variety Book*; letterpress, linoleum cuts; edition of 42; 3½ x 5½ inches (8.9 x 14 cm) (photo: Jim Hair)

MOVABLE **BOOKS**

Paper magic. No batteries, mice, track balls, or devices. The movable paper book has that awe-inspiring characteristic, the "wow factor," as book artist and teacher Charles Hobson likes to call it. The images or words are revealed gradually; the construction is mysterious. The reader cannot see the entire book at once. The challenge, in addition to getting the book to work correctly, is to cultivate the mystery through the revealed and concealed content, without resorting to overused concepts. There should always be a transformation or a twist. Instead of a clown, the jack-in-the-box might be a shark.

This chapter only touches on a tiny portion of paper engineering with a simple pop-up card, a volvelle, and a variety of flexagons and Jacob's ladders. Following the instructions precisely is absolutely necessary to create these structures. To make the process easier, just focus on one step at a time.

SIMPLE**POP-UP CARD**

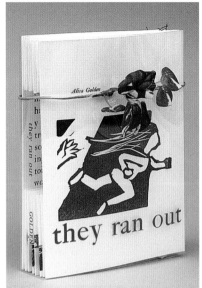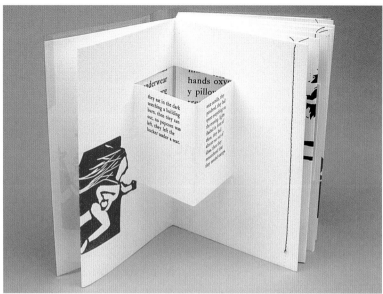

They Ran Out, 1991; letterpress, linoleum cuts, polyester film; pop-ups with accordions sewn at the fore edge in album accordion style; 5 x 7 inches (12.7 x 17.8 cm) (photo: Jim Hair)

With a few cuts you can make a piece of paper pop up to become three-dimensional. Fold a piece of paper in half, draw a shape centered exactly on the fold, then cut precisely around the outside of the shape, leaving the right and left edges still attached. By refolding the valley fold to a mountain fold, you create a pop-up.

After you experiment with simple shapes, try rubberstamping or photocopying in the middle of the page and cutting around the edges, leaving a generous margin and two spots where the picture is attached. To learn some more elaborate and wonderful pop-up techniques, see *The Pop-Up Book* (Holt Paperbacks, 1993) by Paul Jackson or *The Elements of Pop-Up* (Little Simon, 1999) by David A. Carter and James Diaz.

Carol Barton and Dorothy Yule are masters of the pop-up artist's book, often using two or more "pops" in a single image. I admire their intricate work. Carol lives in Maryland, curates shows, teaches,

and is the author of *The Pocket Paper Engineer, Volumes 1 and 2* (Popular Kinetics Press, 2005 and 2008). Dorothy is based in Oakland, California. Both have books in *500 Handmade Books* (Lark Books, 2004) and in special collections departments of libraries around the United States.

Tools: bone folder; metal ruler; pencil; knife and cutting mat

Materials: 1 sheet of heavyweight paper, 7 x 5 inches (17.8 x 12.7 cm)

Example: 3½ x 5 inches (8.9 x 12.7 cm)

1. Start with a square. On the valley fold measure a 2-inch (5.1 cm) square, exactly at the center.

2. Against the metal ruler, cut along the top and bottom lines.

3. Score the right and left lines with a bone folder against the ruler.

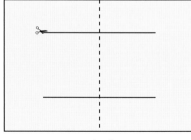

step 2

step 3

4. Fold the sides of the squares up to make valley folds.

5. Fold the original center valley into a mountain.

Variation 1: Fold another paper the same size, and glue it to the side edges of the first, as a cover.

Variation 2: Use paper 8½ x 11 inches (21.6 x 27.9 cm). Fold in half, widthwise. Fold this folded page in half, widthwise. Unfold completely. Place paper in portrait orientation. Cut your pop-up image on the lower two sections with the valley fold in the middle. Fold again after your pop-up is complete for a self-contained card with a cover.

Tips: Circles must have flat sides. The center of the image can be cut the same way and folded back into a valley fold for an extra three-dimensional effect.

Uses: holiday cards; book about movement

step 5

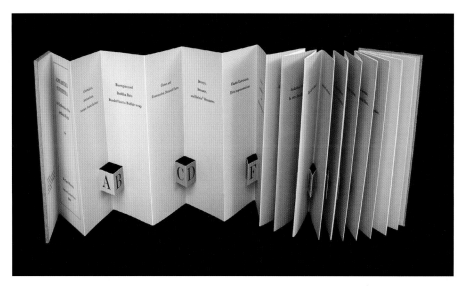

Carol Barton: *Alphabetica Synthetica*, 2003; laserprinted, book board; edition of 10; album accordion; 2½ x 7 x 70 inches (6.4 x 17.8 x 177.8 cm) opened fully (photo: Carol Barton)

VOLVELLE

Daniel Mayer: *Book Arts Jargonator*, 2000 (with Ed Lebow); letterpress from photopolymer plates; edition of 500; hand circle cut and assembled volvelle; 8½-inch (21.6 cm) diameter (photo: Dana Davis)

Color wheels and star wheels got me started wondering about volvelles. I saw pictures of the ones in the Bancroft Library at the University of California at Berkeley, so I know they have a large collection there, but I got to actually see some lovely old ones at the San Francisco Public Library in the Special Collections department. How to make them? I asked Ed Hutchins, keeper of the knowledge of movable things, if he knew where to get fasteners to make volvelles; instead, he told me how to fashion them out of paper. For my book *T-ravel: Space*, I printed an astronaut, then cut him out and affixed him to a pivot to float around and around on the page.

Dan Mayer of Arizona has been exploring the volvelle to find out all the possibilities of the form and how it can affect the thinking of both the maker and the reader.

Tools: hole punches or circle cutter or circle template or compass; pencil; knife and cutting mat; scissors; small glue brush, toothpick or cotton swab for gluing

Daniel Mayer: *Rhetoric Sticks*, 2007–09; letterpress on ceramic; 250 sticks made for installation (photo: Dana Davis)

VOLVELLES: MOVABLE TEXT

Originally used to chart stars, planets, tell fortunes, and date religious holidays, contemporary volvelles can track language in a movable fashion, creating new meaning. Collaborating with the writer Ed Lebow, I began the exploration of this form by creating two letterpress-printed volvelles. Each volvelle generates 27,000 possible combinations such as "*Boustrophedonically-monkish-scribe*" (The Book Arts Jargonator) and "*Dubya's-snippy-chad*" (The Election 2000 Wonkwheel).

Three Nearly New Poems, a commissioned work and a collaboration with National Public Radio poet and essayist Andrei Codrescu, features a movable text title. A series I call "*Rhetoric Sticks*" are a spin-off of the volvelle; these ceramic sticks have type impressed in a spiral pattern that requires the reader to turn, read, and decipher. My most recent volvelle is *Holy Smoke a 1950s Oldsmobile hubcap*; it's a tribute to Saint Christopher. Altogether, these works reflect my interest in language, art, and the changeable form of the book, with content, meaning, and a twist.

DAN MAYER

Materials: medium-weight to heavy-weight paper for the support; Tyvek (some mailing envelopes are made of this material. See page 203 for further description) or sturdy medium-weight paper; medium-weight to heavyweight paper for the volvelle top and back; PVA

Example: pivot for any size volvelle

1. Decide where the pivot is to go. Does it go on an existing page, for example, or are you putting it on a piece of cardstock or heavyweight paper? We will refer to it as the support. Cut out a small hole in this support.

2. Out of Tyvek, cut out a circle that is twice the diameter of the hole in step 1.

3. Fold the circle in half, then in half perpendicular to the first fold.

4. With scissors or knife, make cuts along these folds, not all the way to the center but just over halfway to it.

5. Fold up two opposite sides so they look like a bowtie.

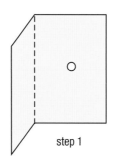

step 1

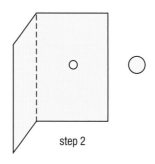

step 2

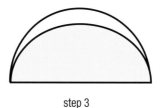

step 3

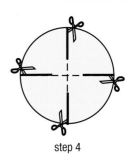

step 4

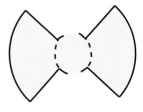

step 5

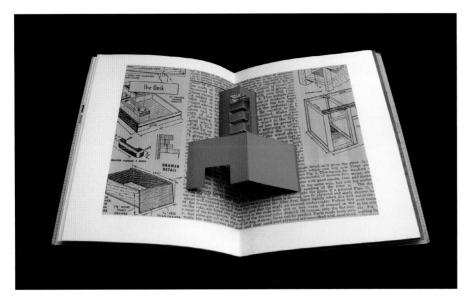

Carol Barton: *Instructions for Assembly,* 1993; offset lithography with overlapping pop-ups; edition of 250; 8¼ x 11 inches (21.6 x 27.9 cm) (photo: Carol Barton)

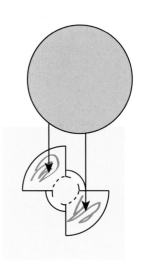 **POP-UP PAGES: IMAGINATION'S ARCHITECTURE**

The surprise in turning a flat page to reveal the dimensional form of a full-blown pop-up is a key element in most of my artist's books. Designing pop-ups, or paper engineering, involves a bit of architecture, a basic understanding of mechanics, and a lot of trial-and-error problem solving. I am intrigued by the structural use of materials in furniture, buildings, and outdoor environments and often glean ideas for my books from observations of how things are constructed. I use the pop-up in various ways: to pull viewers into the narrative; to solidify an idea; or to add a new interpretation to the narrative. The pop-up can encourage readers to explore the page from various angles and perspectives and challenge them to rethink an idea in the text. Pop-ups can be literal or very abstract, depending on what is required to enhance the total book experience.

CAROL BARTON

6. Take the two folded up sides, and press them together so you can thread them through the hole in the support.

7. Thread them through the hole in the support.

8. Flatten out the bowties.

9. With PVA applied to the flaps, attach a small circle to the back side of the pivot to cover up the bow tie there.

10. Attach a larger circle or shape to the other, front side, of the pivot in the same manner as step 9.

Variation 1: Attach shapes to both sides for a two-sided card or page.

Variation 2: Cut a window in the volvelle top before you attach it to the pivot. Match the window to the support, and put words or images there that will become visible as the wheel goes around.

Variation 3: Make one of the tunnel books in Chapter 3, and affix a volvelle to the last panel.

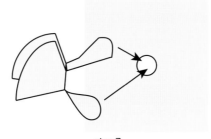

step 7

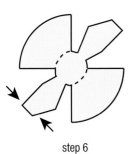

step 6

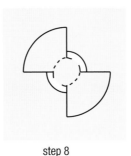

step 8

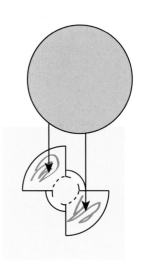

step 9

SQUARE**FLEXAGON**

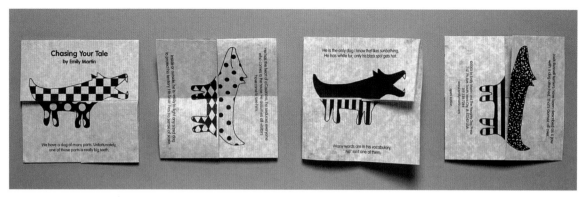

Emily Martin: *Chasing Your Tale*, 2000; archival inkjet on paper; open edition; flexagon; 4 x 4 inches (10.2 x 10.2 cm) (photo: Sibila Savage)

Ed Hutchins sent me a box of flexagons, introducing me to this structure whose creator is unknown. I loved Emily Martin's *Chasing Your Tale*; this humorous story has a whimsical picture of a dog in the center of every page, which breaks in half and seems to come together again. You see the image, then it disappears and forms into something else. The really lovely thing about this one is that it keeps going round and round. You don't have to back up to put it right again. The finished flexagon is half the size of the paper you start with.

Tools: bone folder; scissors; small glue brush (optional)

Materials: a square piece of paper, 8½ inches (21.6 cm); glue or glue stick

Example: 4¼-inch (10.8 cm) flexagon

1. Fold paper in half. Open.

2. Fold ends in to the middle fold (gate fold or origami cupboard). Open.

3. Turn the paper over.

4. Fold the paper in half the other way. Fold the ends in to the middle fold.

5. Cut out the four squares in the center, leaving a square-shaped ring.

6. Arrange the paper so that the valley folds on this side are all horizontal.

7. Apply glue to the top left and bottom right squares.

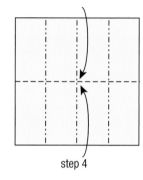

step 4

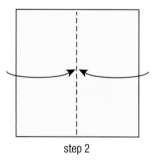

step 2

step 5

step 3

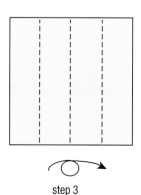

step 7

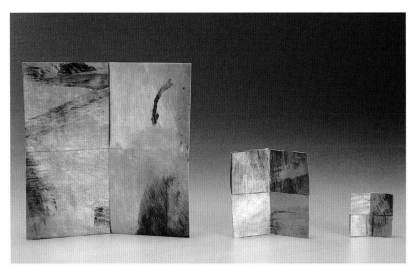

Square Flexagon Models, 2004; gesso and acrylic inks; descending squares: 6 inches, 3 inches, and 1½ inches (15.2, 7.6, and 3.8 cm) (photo: Sibila Savage)

8. Re-fold the top and bottom edges to the middle fold, pressing down on the glued squares. Smooth them down.

9. In this configuration, apply glue to the top right and bottom left squares. Fold the right and left edges in toward the middle; press and smooth down. Let dry, if necessary.

Note: If you work with children, this is a terrific way to illustrate fractions: the square hole you cut out to make the first flexagon can be folded to another square flexagon that is one-quarter the size of the first. With the example size given here, you can fold up four flexagons, each one equal to one quarter of the previous one.

To activate (read) the flexagon

Notice the open edge in the center. It will be easiest to open if the edge is vertical.

10. Fold the flexagon away from you, along the edge; at the same time pull open the middle as if you were opening any standard European-style book. You will see that the center edge is now horizontal.

11. Turn the book so that the open edge is vertical again and repeat step 10.

Layouts: To print on both sides of the paper before folding, cutting, and gluing, first arrange your pages for side one and side two. The back of the righthand 2B (at the corner) should be blank; the back of the lefthand 2B should be 4A.

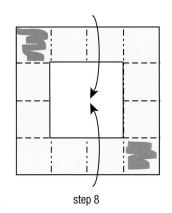

step 8

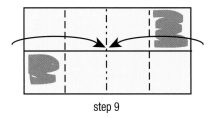

step 9

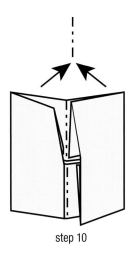

step 10

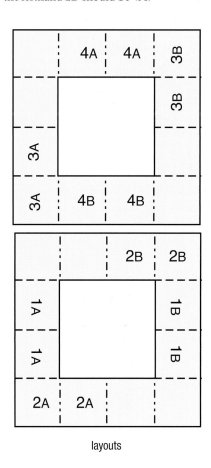

layouts

TETRA-**TETRA-FLEXAGON**

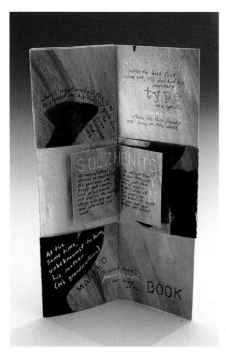

Gulag Treasure, 2004; acrylic inks and gesso, stencils; tetra-tetra-flexagon; 5½ x 8¼ inches (14 x 21 cm) (photo: Sibila Savage)

PRESENTS FROM EVERYDAY LIFE

I enjoy pop-ups and movable books, so I am always looking out for objects that suggest structural possibilities for artist's books. I have one ongoing project that involves making a honeycomb of interlocking strips of card into a cloud of butterflies. Last January, I was putting away my tree ornaments and found an old paper box with intersecting dividers; I immediately recognized the genesis of the butterfly cloud. The world continues to present me with all kinds of structures, and I collect the ones that I find interesting sometimes the physical object, sometimes the memory of something I see then I use them as building blocks for new books. When I find myself trying to express some story or feeling, I search among my dusty memories for fitting structures to use.

DOROTHY YULE

Technically, most flexagons don't qualify as origami since they use scissors and a little bit of adhesive. They also didn't originate in Japan. It is generally agreed that Arthur H. Stone, then a mathematics student, created a type of this structure in 1939, which launched an interest, or perhaps a renewed interest, in it years later; Martin Gardner wrote about flexagons in a variety of puzzle books in the 1960s. Edward Hutchins, a book artist and teacher in New York, has been interested in this structure for many years and introduced me to it. He views the flexagon as "the book equivalent of the dissolve shot in movies, powerful at showing how one image melds into another." Ed discovered flexagons in the 1966 book *The Mysterious Flexagons* (Crown Publishers, 1966) by Madeline Jones and made his first one as a book list for his show at the Small Press Center in Manhattan called Playing with Pages in 1992, a time when few people were familiar with flexagons.

Choose snippets of text, related anecdotes, or images that can be seen in a variety of orders, or choose images that are obviously sequential (baby to adult, seasons of a tree). Check the diagrams carefully. This is a tricky one. It appears to be like a Jacob's ladder, or like woven paper. I had fun drawing in the squares before I assembled the book, but it is much easier to assemble the book first, then add text or imagery. The only drawback to making an all-white flexagon is that it is more confusing to find the first side. Label the sides with light pencil marks to aid you using the layout below. You may actually devise a layout in any number of ways; this is just one.

Tools: knife and cutting mat; metal ruler; pencil; bone folder; glue brush

Materials: 8½ x 11 inches (21.6 x 27.9 cm) medium-weight paper; self-adhesive linen tape OR a strip of paper that is ¼ to ½ inch (0.6 to 1.3 cm) wide and PVA (if you

are working with a child you may use a glue stick)

Example: 5½ x 8¼-inch (14 x 21 cm) flexagon

1. With your knife, trim the paper to 8¼ x 11 inches (21 x 27.9 cm).

2. Place the paper in front of you, horizontally.

step 1

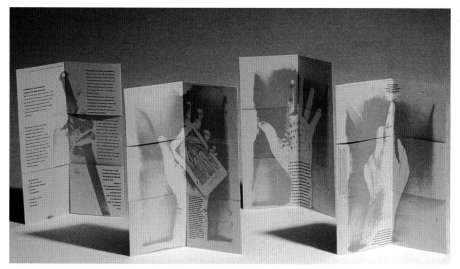

Susan King: *Queen of Wands*, 1993; offset printed from Haloid photocopy original, gold foil stamping; edition of 800; tetra-tetra-flexagon; 7$^1$/$_{16}$ x 12$^1$/$_{16}$ inches (18 x 30.6 cm) (photo: John Kiffe)

Susan King, a book artist in Kentucky, made a good-looking book, *Queen of Wands*, that works well because you don't have to read it in one correct sequence.

3. Divide the paper into three equal sections vertically as follows: measure and mark 2¾ inches (7 cm) along the right and left short sides.

4. Score two horizontal lines with a bone folder or your thumbnail.

5. Fold in half, widthwise.

6. Fold the ends back to the center fold to make an accordion fold with four horizontal and three vertical sections.

7. Mark each square with the number/ letter combination in the layout diagram. Or draw, color, or collage your squares at this point, following the layout for whatever part of the picture goes where. Make sure you mark side one and side two.

8. On side one, with your art knife against a metal ruler, cut a horizontal flap out of the two middle sections, like a squared-off letter *C*, leaving one side connected.

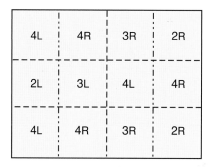

4L	4R	3R	2R
2L	3L	4L	4R
4L	4R	3R	2R

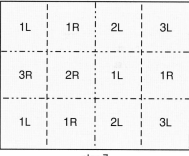

1L	1R	2L	3L
3R	2R	1L	1R
1L	1R	2L	3L

step 7

step 3

step 4

steps 5 & 6

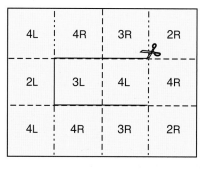

4L	4R	3R	2R
2L	3L	4L	4R
4L	4R	3R	2R

step 8

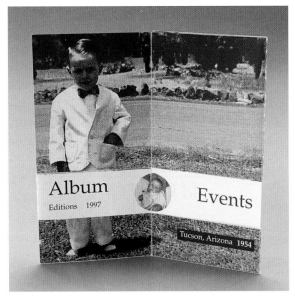

Edward Hutchins: *Album*, 1997; offset printing and collage; edition of 350; tetra-tetra-flexagon; 5 x 4¹³/₁₆ inches (12.7 x 12.2 cm) (photo: Sibila Savage)

This particular flexagon is divided into squares. Actually, the height of the three sections can vary; the width must be equal for the book to flex properly. You can see in Ed Hutchins' *Album* how he used a narrower height for the text segment.

the tape is made of archival materials, this paper strip will be probably last longer than the tape.

15. Turn the flexagon over again to get it into position to flex. For this layout, all the movement begins with side 2.

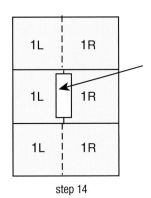

step 14

To activate the flexagon

Turning the pages of this book reminds me more of separating sections of an orange or turning a sock right-side out.

16. Grasp the center panel edges with your thumbs. Hold the edges of the flexagon with your fingers.

17. Bring the right and left back sides together, away from the center while gently pulling the panels away from the center with your thumbs. Your fingers will meet on the back.

18. Open flat.

9. Lift the flap out, and fold it over the right-hand row. It will stick out to the right.

10. Fold the leftmost row of rectangles to the right to cover the middle-left row.

11. Keeping the fold from step 10, fold the left row over to the right again.

12. Turn the paper over.

13. Fold the left square to the right.

14. Place a piece of self-adhesive linen tape along the open vertical edge in the very center. Or apply glue to a thin strip of paper that is 2¾ inches (7 cm) tall. Use this strip in place of the tape. Although

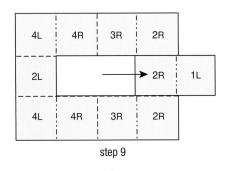

step 9

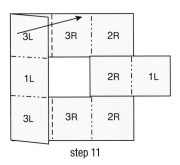

step 11

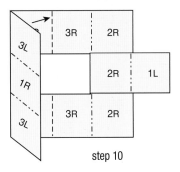

step 10

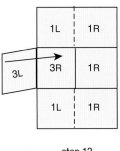

step 13

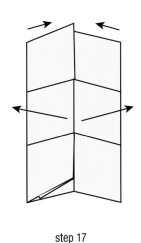

step 17

Daniel Mayer: *Three Nearly New Poems*, 2001 (with Andrei Codrescu); letterpress from photopolymer plates with movable text title page; edition of 155; 4 x 6 inches (10.2 x 15.2 cm) (photo: Dana Davis)

19. Repeat the three steps (16, 17, and 18) three times, until you get to the fourth section.

20. Reverse the steps to return the flexagon to its original position. This means that this time, you'll be using your fingers to grasp the center panel at the back and pushing toward the center with your thumbs.

Regarding the layout for the Tetra-Tetra-Flexagon

There are many ways to lay out your pages. Here is one. To make this process easier, mark both sides of your paper, after step 6, like the diagram.

When the flexagon is put together, all like numbers will align vertically. The 1L/1R side is the side with the tape. Once you turn the flexagon over, you will see first the 2L/2R side, then the 3L/3R side, and lastly, the 4L/4R side. The 1L/1R side is a good side to use for a colophon or title page.

Variation 1: When attaching the flexagon to itself, use a wider strip, such as 2¾ inches (7 cm) tall x 3 inches (7.6 cm) wide, and write a title on one part of it, thereby incorporating the attaching strip into the content of the book. Allow a 2½-inch (6.4 cm) overlap on the front (1L and 1R) and ¼ inch (0.6 cm) on the back.

Variation 2: The width of the columns must all be equal to each other, but the height of each panel may vary and be irregular, such as in Edward Hutchins' *Album*.

Variation 3: Make a completely visual book, using only images. Put words on a separate paper that measures slightly less than the height of the flexagon and 2 times the width of one column minus ½ inch (1.3 cm) (such as 8 x 5 inches [20.3 x 12.7 cm], grained long). Fold this paper into a very thin strip and tuck it into one of the middle sections of the flexagon. It will stay there, unless the reader removes it. The first one I saw like this was shown to me by Ed Hutchins; it was *Salmagundi* by Heather Hunter, made in 1998.

CONTENT AND COMPLEXITY

Books can be relatively simple or very, very complicated and everything in-between. Simple books offer immediate impact by straightforwardly presenting an idea in a few pages. Brief writings about everyday events or objects, such as coffee beans or kites, could find their way into the simplest of structures. Books that expand on or tell a story in multiple ways offer opportunities for lengthier investigation. Complicated books, where a game must be played and items manipulated, involve the reader/viewer by direct interaction. For example, with Julie Chen's book *View*, after reading two small books, one finds instructions to turn the container box over to view a diorama-like scene that is undetectable on first handling. I am continually in awe of where ideas for content can be found and how to work these ideas into the form of a book.

LINDA RACE

Variation 4: After you have made and assembled the basic tetra-tetra-flexagon, sew a tiny book (less than 2-inch [5.1 cm] in height or width) in the middle fold of 4L and 4R, the second row down. This change puts a tiny book at the very end of the manipulation. Use the single signature stitch from page 95.

variation 4

CROSS-FLEXAGON

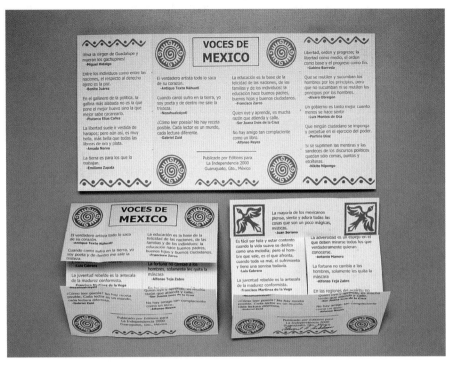

Edward H. Hutchins: *Voces de Mexico* (Voices of Mexico), 2000; two-color offset printing; edition of 600; cross-flexagon; 5 x 5 inches (12.7 x 12.7 cm) (photo: Sibila Savage)

FLEXAGONS IN MEXICO

We gave copies of our flexagon to everyone who helped us during our year in Mexico: people we asked for directions, shop keepers, police officers, children in classes we visited, wait staff in restaurants, visitors to the studio, people next to us at concerts. The goal was to pass out 600 copies before we left the country. Once, while waiting for a bus, I decided to get my shoes polished ,and a young boy did an especially nice job. Besides paying him and giving him a tip, we gave him a copy of *Voces de Mexico*, and he went off seeking new customers. A little while later we were suddenly surrounded by a dozen kids asking for the *rompe cabeza* (literally, "head breaker"). As we left the plaza to catch our bus, we spied the fellow who polished my shoes with his shoeshine box in one hand and the flexagon clutched tightly in the other.

ED HUTCHINS

When Ed Hutchins and Steve Warren went to Mexico for a year, they created the Cross flexagon or hexa-tetra flexagon *Voces de Mexico* in honor of Mexican independence. The four faces have quotes from famous Mexicans on art and education, life, death, and politics. It was printed in red and green on white cardstock, the colors of the Mexican flag. You can make one any size, as long as the length is twice the height. Whatever the height, that is the size of the finished book.

Tools: pencil; metal ruler; bone folder; knife and cutting mat; glue brush

Materials: 1 piece of heavyweight paper or cardstock, 10 x 5 inches (25.4 x 12.7 cm); PVA; scrap paper

Example: 5 x 5-inch (12.7 x 12.7 cm) cross-flexagon

1. Put the piece of paper in front of you, oriented horizontally or landscape format.

2. Measure and mark half the height (in this case, 2½ inches [6.4 cm]) from the right and left at the top and bottom.

3. Using the bone folder, make vertical scores connecting the marks. Turn over.

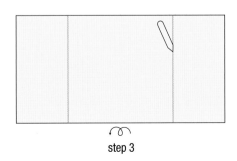

step 2 step 3

4. Measuring in toward the center, measure and mark one quarter of the height (in this case, 1¼ inches [3.2 cm]), again from the right and left edges, marking at the top and bottom.

5. Using a bone folder, make two more vertical scores.

6. Measure and make a dot every 1¼ inch (3.2 cm) down (one-quarter of the height) along the outer scores (now mountain scores) for three along each outer score and three along R and L edges.

7. With the knife against the metal ruler, cut the shape of an *H*: cutting vertically from first to third dots on both outer scores, then cutting horizontally, second dot to second dot, connecting them.

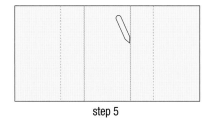

step 4

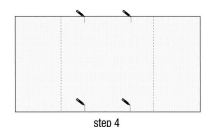

step 5

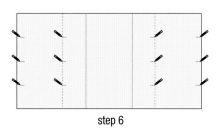

step 6

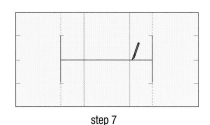

step 7

step 8

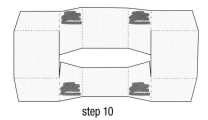

step 9

step 10

step 11

8. With the bone folder against the ruler, make a score connecting the first dot on the edge with the first dot down the outer score and another score connecting the third dot on the edge with the third dot down the score. Repeat for the other edge and outer score.

9. Make folds at the scores as follows: outer horizontal lines are valley folds; inner vertical lines are valley folds; outer vertical lines are mountain folds. Turn over.

10. Apply PVA to the four squares above the *H* cut. See diagram.

11. Bring the side flaps over and press down on the adhesive. Hold for a minute or so.

To activate the cross-flexagon

12. Turn it over so that you see a cut horizontal line in the center. Grasp the top and bottom edges so that your fingers are top and bottom, your thumbs in the center.

13. With your thumbs, lift up toward you at the cut line, bring the cut edges top and bottom. You'll be pushing back with your fingers.

14. Grasp the flexagon at the right and left edges, thumbs in the center, on the vertical line.

15. Pull open with thumbs and push back with fingers, so that the center sections move right and left, pulling out to form a cross.

16. Grasp the flexagon at the top and bottom edges again, thumbs on the center, on the horizontal line.

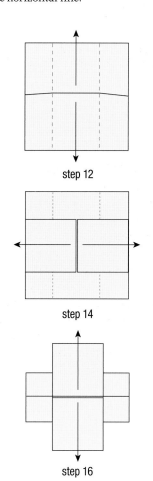

step 12

step 14

step 16

FROM ORIGAMI TO POP-UPS: INSPIRATION FROM FORM

My initiation into the book arts came when I discovered an origami book in an origami book; I was astonished that a three-spread book could be made so easily. This led me to taking published books to pieces, dissecting pop-up books, and copying the techniques. In the university where I taught, I saw textile students using fabric dyes, and I experimented by using these dyes on paper before making my own pop-up books.

Through a colleague, an expert on literacy education, I started to think about the book form as a vehicle for children's writing development. The book forms I describe in my books and classes originated as origami models, packaging design, or my improvisations. I call them universals, anyone could have thought them up, and so I don't take any special credit for them. I make books with children in the shapes of bridges, aircraft, Victorian houses, shopping baskets—the list is endless. It is astonishing what you can do with a sheet of paper and how it can transform your creative and professional life.

PAUL JOHNSON

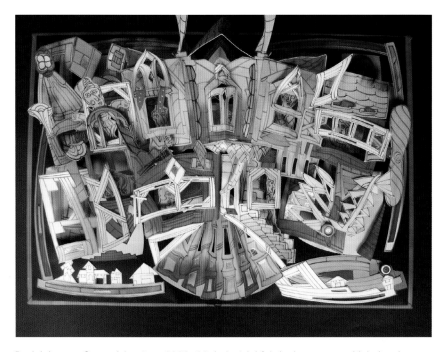

Paul Johnson: *Space Adventure*, 2003–08; industrial fabric dyes, pen and ink drawings on watercolor paper; pop-up glued to boards, case bound; 11¼ x 11¼ x 7 inches (30 x 30 x 18 cm) (photo: Paul Johnson)

17. Pull open top and bottom. You'll see a fold in the center, cut edges at the edges.

18. Grasp the flexagon right and left again, thumbs in the center.

19. Pull out to right and left to get back to the beginning.

Layouts: To print on both sides of the paper before folding, cutting, and gluing, first arrange your pages for side one.

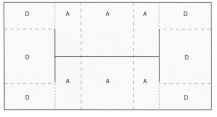

layout side 1

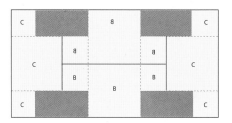

layout side 2

Cross Flexagon from Four Pieces

This is a variation of the cross flexagon. Ed Hutchins made this version of the cross flexagon, which is made from four pieces of paper, as a keepsake catalogue for his exhibit, *Thinking Editions*, in 1999. It is much simpler to assemble, and each piece only has two scores (measure these at half the length of the shortest side). Each strip also has the edge ratio of 1:2. Two pieces are grained short, two are grained long, with the outer scores parallel to the grain on all.

A. Arrange two sets of paper strips side by side: two horizontal strips (folds vertical) on the left and two vertical strips (folds horizontal) on the right. Apply glue to the outer squares at two corners of each of the two vertical strips. Press down.

B. Activating the flexagon is the same as the previous Cross flexagon. Here is the first face, cut line is horizontal.

C. Second face: long strips at top and bottom, two squares float horizontally side by side in the center.

D. Third face (the cross): two squares are vertical in the center.

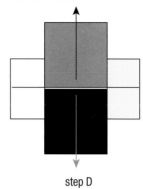

step D

E. Fourth face (next fold will be the beginning again): long cut is vertical.

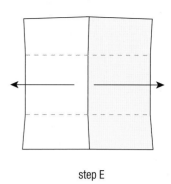

step E

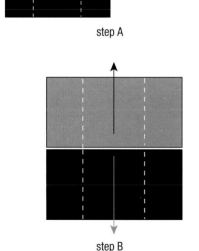

step A

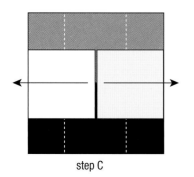

step B

step C

WOVEN**ACCORDION**

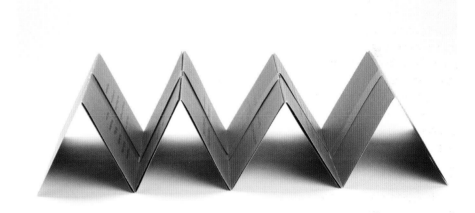

Bonnie Thompson Norman: *Turn, Turn, Turn*, 2002; letterpress; woven accordion; 3 x 6¼ inches (10 x 15.9 cm) (photo: Bonnie Thompson Norman)

Bonnie Thompson Norman works full-time for a commercial bindery, but evenings and weekends, she devises new bindings and teaches letterpress printing and book arts classes in her studio in Seattle, Washington. In 2002, Bonnie sent me a new book structure she designed. It is a Jacob's ladder made out of paper: a woven accordion. I sometimes refer to it as "Bonnie's Ladder." To make it function, you have to separate the pages because they do not naturally drop open like the child's toy. Making one is easier than the traditional toy; all you do is cut slits and weave cards. No adhesives, rib-bon, or thread is necessary. An advantage to this structure is that you can arrange the cards until you get a pattern that you like. If you don't like one card, cut another from the extra scraps and reweave it.

Tools: pencil; 24-inch (61 cm) metal ruler; art knife and cutting mat (or a paper cutter); bone folder

Materials: one 22 x 30-inch (55 x 76.2 cm) piece of heavyweight paper

Example: size: 2¾ x 5-inch (7 x 12.7 cm) book

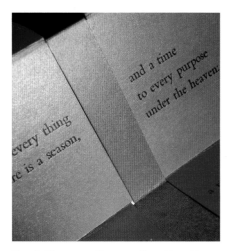

Bonnie Thompson Norman: *Turn, Turn, Turn*, 2002; letterpress; woven accordion; 3 x 6¼ inches (7.6 x 15.9 cm) (photo: Lark Books)

Making the accordion book

1. Using the pencil, ruler, knife and cutting mat, divide and then cut the paper into two 22 x 5-inch (55.9 x 12.7 cm) strips; reserve the remaining paper for other projects.

2. Select one strip to make the accordion, and choose one side to be the front. Place the strip, front side down, horizontally on a work surface. Fold the strip in half, aligning the edges.

3. Unfold the strip. Fold each edge in, aligning it with the center fold. In origami, this is called a cupboard because of its shape.

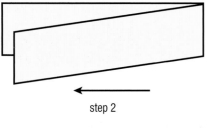

step 2

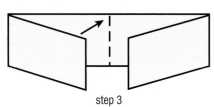

step 3

4. Now fold each top section back, aligning the edges with the existing folds—like opening the shutters on a window. Turn the folded paper over.

5. Now it looks like a table. Fold the paper again, aligning the folded ends with the center fold.

6. Unfold the paper. You should now have a fan fold with alternating valleys and mountains.

7. Unfold the accordion strip completely and flatten it, arranging it so there is a valley fold at each end; you should see three complete mountains. Measure and mark 2 inches (5.1 cm) from the top edge and again from the bottom edge on the valley fold at each end.

8. Place the flattened accordion on the cutting mat. Using the ruler to guide the knife and beginning and ending exactly on the outermost valley folds, cut a slit parallel to the top edge to connect the top marks. In the same way, cut another slit to connect the bottom marks.

9. Cut the second 22 x 5-inch (55.9 x 12.7 cm) strip of paper into eight 2⅝ x 5-inch (6.7 x 12.7 cm) cards (you need six cards for the project, but it's good to have choices).

Note: If your cards are too narrow, they will fall out of the accordion. If they are too wide, you will not be able to weave them into it. Allowing a ⅛ inch (0.3 cm) difference between the width of the cards and the width of the accordion panels is sufficient and preferred.

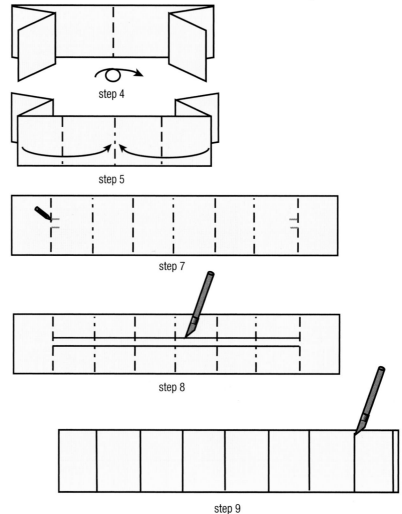

step 4

step 5

step 7

step 8

step 9

Weaving the cards

10. With the accordion still flattened and faceup, lift the long center strip and slide one card under it; slide the card to the left, snug against the end of the slits.

11. Now hold down the long center strip and, starting from the back of the accordion, weave a card over it and out to the back again. Make sure the card is snug against the first card.

12. Repeat the weaving process for the remaining cards, alternately inserting them under or over the center strip and tightening them as you go by sliding them over to the previous card.

13. When you are finished, accordion-fold the book.

Note: To make three 2¾ x 4-inch (7 x 10.2 cm) books and three 2¾ x 4¼ x ½-inch (7 x 10.8 x 1.3 cm) slipcases out of one piece of paper, cut the size of the paper for the books to 22 x 4 inches (55 x 12.2 cm) and the size of the paper for the slipcase to 6 x 5¼ inches (15.2 x 13.3 cm) tall, grained short. See instructions for slipcase on page 222.

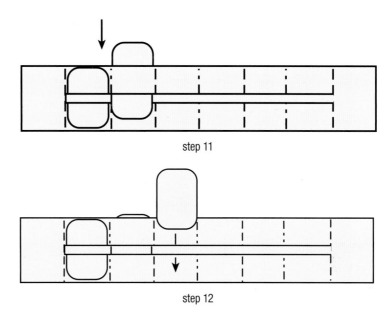

step 11

step 12

MAGIC **WALLET**

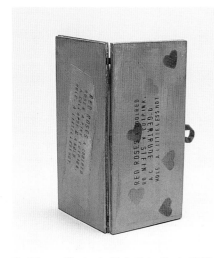

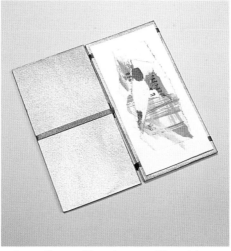

Red Roses (Gertrude Stein Valentine), 1997; acrylics, collage, rubber stamps; edition of 4; magic wallet; 2 x 4 inches (5.1 x 10.2 cm) (photo: Jim Hair)

Bonnie Thompson Norman, a fellow teacher and book artist, introduced me to the Jacob's ladder with cards, also known as a magic wallet. She sent me one that her students had created called *The Army Cook Kissed My Sister.* I was baffled for an hour until I realized just how the pages turned. I include the instructions for reading the book after the directions for making it. This variation is particularly fun when words are written on each of a set of cards. The words could be found poetry or an existing poem or sentence, cut up.

Tools: scissors; ruler; glue brush; weight

Materials: ⅛- to ¼-inch (0.3 to 0.6 cm) ribbon, approximately six times the width of one board; four 4-ply boards cut to the same size, all grained the same way (these may be painted, collaged, or covered first); PVA; scrap paper; 6 cards, each ¼ to ½ inch (0.6 to 1.3 cm) smaller than the board in both directions; waxed paper

Example: 4½ x 5¾-inch (11.4 x 14.6 cm) book with six cards, using 36 inches (91.4 cm) of ribbon

1. Cut ribbon into thirds.

2. Line up your boards in pairs, covers on the bottom.

3. Brush a thin layer of glue in the middle on the back of the first inside (noncover) board.

4. Glue down an inch (2.5 cm) of each one of three ribbons as follows: one ribbon facing right, centered, and the other two ribbons facing left, top and bottom (about ¼ inch [0.6 cm] from head and tail).

5. Take the front cover, and apply glue completely to the back of it.

6. Glue it down to the first board, sandwiching the ribbons.

7. Flip the book over so the front cover is facedown (the middle ribbon is now facing left and the two ribbons right).

8. Put the back cover facedown next to the first "sandwich."

9. Pull the middle ribbon over to the right.

10. Apply a line of glue, centered on the back of the back cover.

11. Glue down the middle ribbon.

12. Trim the end so the ribbon doesn't stick off the edge of the board, or double it and glue down the end of the ribbon to make a hanging loop.

13. Pull out the top and bottom ribbons to the left.

14. Place the inside back panel facedown on top of the ribbon.

15. Put two lines of glue on this inside board.

16. Glue down the top and bottom ribbons.

17. Trim the ribbons so that when they are glued down, the ends do not stick out from between the boards.

18. Apply glue completely on top of this board and the ribbons you just glued down.

19. Glue this panel on top of the back cover, sandwiching all the ribbons.

20. Put waxed paper around it and place it under a heavy book overnight. Check to make sure the boards are securely glued if you decide not to put the book under a weight.

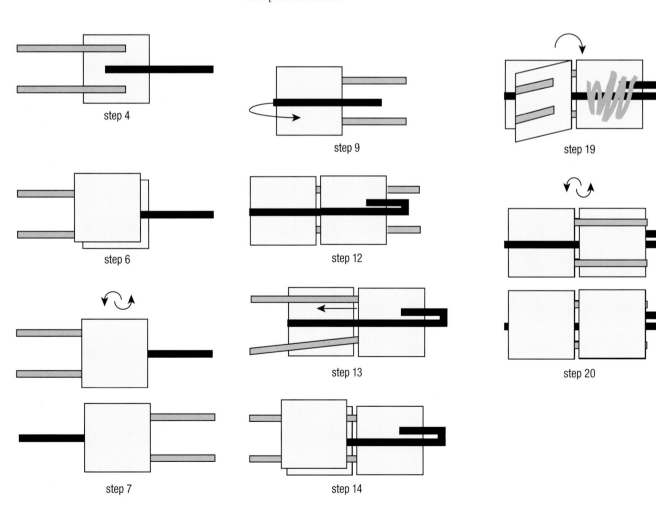

step 4

step 9

step 19

step 6

step 12

step 20

step 7

step 13

step 14

How the cards work

Open the book. Place one card at a time on the right-hand side on top of the ribbon. Close the book. Open it from the other edge. You will have to pull. Don't worry: you aren't tearing anything. The card should get caught up under the ribbon. Repeat for all cards, opening and closing the book from alternating edges. The cards should stack up three to a side. Eventually all the cards will be trapped under the ribbons. When you want to read or interact with this book again, slide the cards out carefully from under the ribbons, shuffle or arrange, and read again.

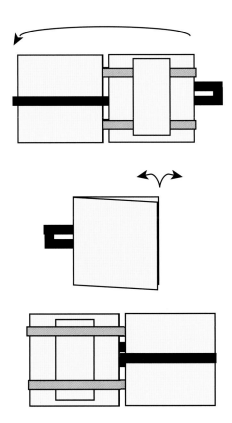

THREE-PANEL JACOB'S LADDER BOOK

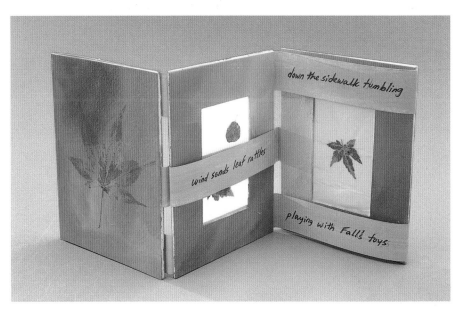

Wind Sends, 2000; acrylics, glassine, leaves; Jacob's ladder; 11¼ x 5 inches (28.6 x 12.7 cm), open (photo: Sibila Savage)

I first saw a two-panel book like this made by Coriander Reisbord. A three-paneled version behaves like an accordion because of the alternating mountains and valleys. However, the three-panel Jacob's ladder is different because it is made up of many layers rather than of a single sheet of folded paper. My first mock-ups for this book were made of cereal box cardboard and laserprinter paper.

Tools: ruler; pencil; glue brush; waxed paper; weight

Materials: 6 strips of paper, each 11 x 1½ inches (27.9 x 3.8 cm), grained short, or three 11-inch (27.9 cm) ribbons. (If you use ribbons, skip step 1.); PVA; scrap paper; 6 boards, each 2½ x 5 inches (6.5 x 12.7 cm), grained long

Example: 2½ x 5 inches (6.4 x 12.7 cm)

1. Prepare the strips by applying glue to the back of one strip of paper and adhering it to the back of another one. Repeat for two more strips. You may do this step in advance. Place the strips under a heavy weight overnight.

2. Line up your boards in pairs. Top row: front cover, board, board; bottom row: board, board, back cover.

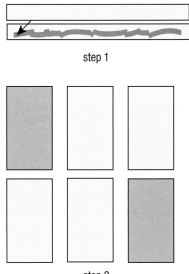

step 1

step 2

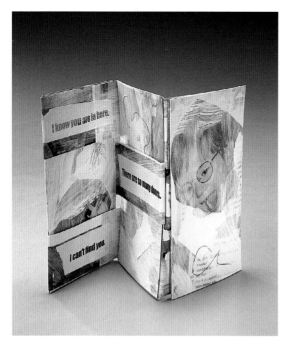

I Know You Are in Here, 2000; photocopies, acrylics, collage; Jacob's ladder; 2¾ x 5 inches (7 x 12.7 cm) (photo: Sibila Savage)

step 3

3. Brush a thin layer of glue on the wrong side of the left board in the bottom row (as arranged in step 2).

4. Apply glue to the end of one paper strip (about one inch [2.5 cm]). Repeat for the other two strips. Glue the three paper strips to the board as follows: one strip facing left, centered, and the other two strips facing right, positioned top and bottom (about ⅛ inch [0.3 cm] from the head and tail).

5. Take the left board of the top row, and apply glue completely to the back of it.

6. Glue it down to the first board, sandwiching the strips.

7. Flip the glued boards over so that the front cover is facedown. (The middle strip now faces right, and the two strips face left.)

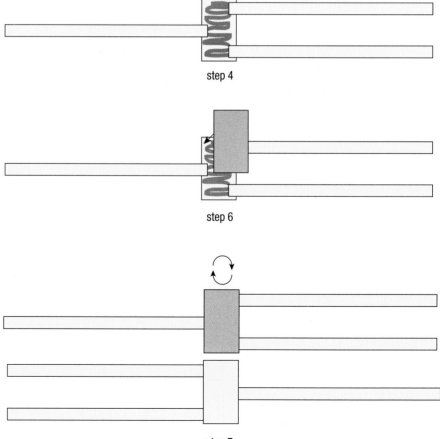

step 4

step 6

step 7

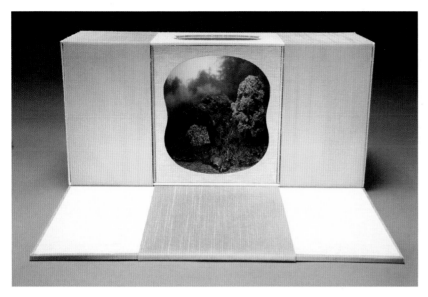

Julie Chen: *View*, 2006; letterpress from photopolymer plates, wood blocks, pressure printing; edition of 100; three-dimensional Jacob's ladder; 6¼ x 13½ x 4½ inches (15.9 x 34.4 x 11.4 cm) (photo: Sibila Savage)

8. Fold the top and bottom strips to the right over the board.

9. Glue the top and bottom strips to the middle board of the bottom row (of step 2). Leave a ¼-inch (0.6 cm) margin between the boards from the first set and the boards from the second set.

10. Pull the middle strip out from underneath. Fold it to the left.

11. Place the other board of the second set wrong-side up (if there is an unpainted or wrong side) on top of all three paper strips on the left.

12. Wrap the middle strip (by folding over to the right), and glue it down to the left board only. This is the back of the second board.

13. Tuck the middle strip completely under the board to the back.

14. Glue the second set of halves together by flipping the left board over to the right; the glued-down strips are hidden inside the sandwich.

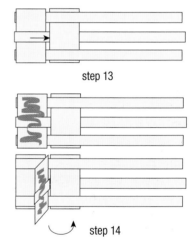

step 13

step 14

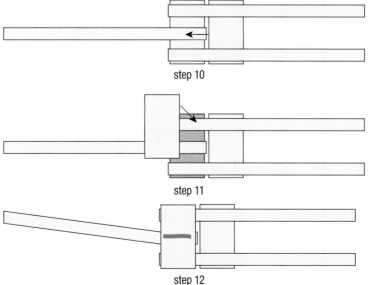

step 10

step 11

step 12

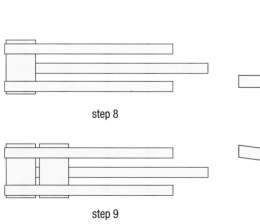

step 8

step 9

15. Place the bottom of the third set of boards (from the top row) under the middle strip. Glue the middle strip down across the board to the right. Leave a ¼-inch (0.6 cm) margin between the boards from the second set and boards from the third set.

16. Wrap the top and bottom strips back to the left. Glue down to the right board.

17. Glue the top of the third set (this is the back cover) on top of all three strips.

18. Making sure both covers (no strips across them) are on the outside, accordion-fold the book. Align the boards as you make one a peak fold and the other a valley fold.

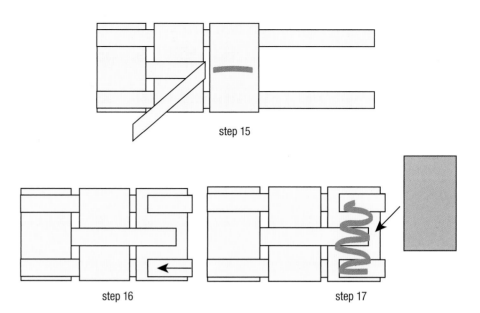

step 15

step 16

step 17

JACOB'S LADDER

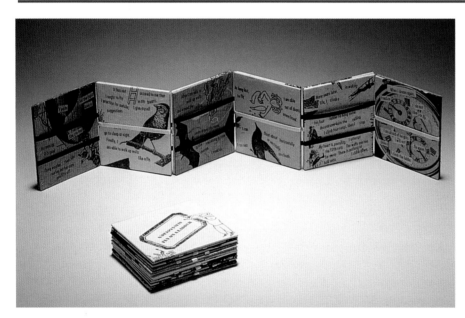

Fly on a Ladder, 1996; letterpress from photoengraving; edition of 40; 2½ x 2¾ inches (6.4 x 7 cm) (photo: Jim Hair)

The Jacob's ladder is a traditional child's toy, but it has characteristics of a book. You interact with it at your own pace. It is movable. It has a sequence. It opens and closes, and it has front and back covers. I saw Paddy Thornbury's Jacob's ladder in *Cover to Cover* (Sterling, 1998), then spent several hours trying to figure out how to make one. The structure calls out for words that will appear and disappear as the book moves.

When I decided I wanted to make a book with this structure, I knew the book had to have a reference to a ladder in the text. I started with the biblical story of Jacob and his dream about angels ascending and descending a ladder. I thought about angels and flying. Flying in dreams is something my friend Val told me she does naturally; I thought it would be fun to fly, too. So for many nights I thought about flying before I went to sleep. Finally, I could fly in my dreams. Then, in waking life I climbed a tall ladder. I broke out in a sweat; I discovered I was afraid of heights. That experience ended my dream-flying. *Fly on a Ladder* contains Jacob's story on one side and mine on the other.

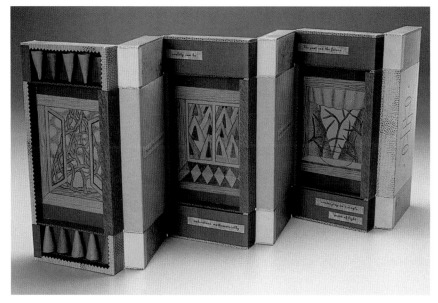

Julie Chen: *Space-Time Geometry*, 1996; illustrations by David Turner; letterpress and color photocopy; edition of 10; three-dimensional Jacob's ladder; 5 x 11 x 6½ inches (12.7 x 27.9 x 16.5 cm), opens to 30 inches (76.2 cm) (photo: Sibila Savage)

ribbon faces right; the top and bottom ribbons face left.

2. To make a "sandwich," glue the mate board to the first board, which will act like a cover as it will have no ribbon across it.

3. Flip it over. The middle ribbon now faces left, and the top and bottom ribbons face right.

4. Wrap the middle ribbon over the top of the board to face right again.

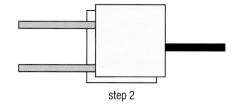

step 1

A hand-sized (2½- to 3½-inch [6.4 x 8.9 cm]) version of this book is pleasant to hold, but any size will work. I recommend two ribbons the same color for the top and bottom and a third, contrasting one for the middle, but any combination will do.

Tips: When you glue the ribbons, try to align them as you go. Glue the ribbons near the center, not too close to the top and bottom edges, or they may slip out. The boards should be almost touching, with not too much space between the "sandwiches."

Tools: glue brush; ruler; pencil; scissors

Materials: 3 ribbons, each ⅛ to ¼ inch (0.3 to 0.6 cm) wide and each ribbon two times the length of 6 boards in a row, just barely touching; PVA; scrap paper; twelve 4-ply boards, all the same size and the grain going the same way

Example: 2½ x 2¾-inch (6.4 x 7 cm) book

1. Glue down the ends (approximately 2 inches [5.1 cm]) of the three ribbons to the back of the first board (not the front cover, but the inside cover). The middle

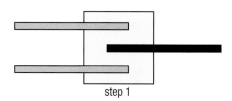

step 2

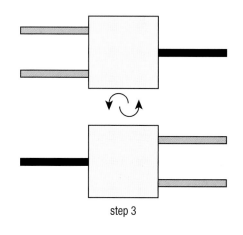

step 3

materials

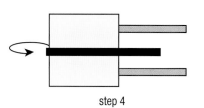

step 4

5. Glue the middle ribbon to the bottom board from the second set (the right-hand board, in this case).

6. Pull the top and bottom ribbons out from under. Face them left.

7. Place the other piece of the second set wrong-side up (if there is a wrapped, unpainted, or wrong side) on top of the two ribbons on the left.

8. Wrap the top and bottom ribbons (by folding over to the right), and glue down to the left board only. This is the back of that second board.

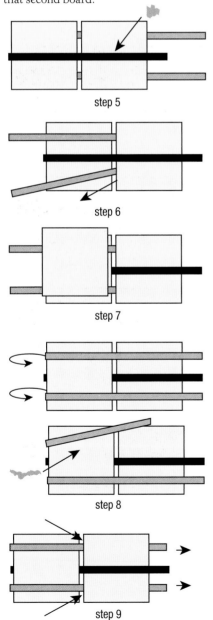

step 5

step 6

step 7

step 8

step 9

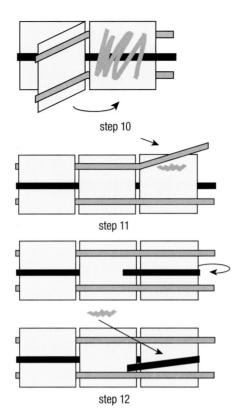

step 10

step 11

step 12

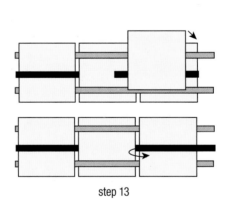

step 13

9. Pull the top and bottom ribbons through to the back.

10. Glue the halves together; the glued-down ribbons are hidden inside the sandwich.

11. Place the bottom of the third set of boards under the top and bottom ribbons. Glue the top and bottom ribbons down across the board to the right.

12. Wrap the middle ribbon back to the left. Glue down to the right board.

13. Glue the top of the third set on top of all three ribbons. Wrap the middle ribbon back to the right.

14. Glue the middle ribbon to the bottom board from the fourth set. See step 5.

15–19. For the fourth board, repeat steps 6–10.

20–22. Follow steps 11–13 with the fifth set of boards.

23. Glue down the middle ribbon to the bottom of the sixth board. Trim the end so that the ribbon won't stick out of the last panel, or fold it over to make a hanging loop.

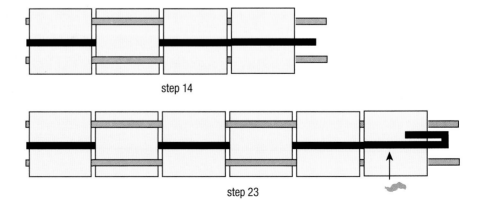

step 14

step 23

24. Pull out the top and bottom ribbons and face them left.

25. Put the top board of the sixth set on top of the two ribbons on the left.

26. Wrap or fold the ends over and glue them down. Trim them if necessary, so they won't stick out if you don't want a hanging loop.

27. Glue the two last boards together with ribbons inside the sandwich. This is the "back" or inside.

28. The outside looks like the diagram with no ribbons across the first and sixth panels.

Variation 1: Photocopy close-ups of people's faces to glue over the boards.

Variation 2: Use different, decorative papers, and wrap the boards first (see Covering Separate Boards, in Chapter 10) or paint them instead.

Variation 3: Use portrait-oriented boards and paper strips one-third the height of the boards less ⅛ inch (0.3 cm) in place of ribbons. Align the top and bottom paper strips with the top and bottom edges of the boards.

Uses: toy; hidden text that gets revealed when the book flips over; book about ladders or climbing; intricate party invitation or keepsake; baby book of photocopies of small photographs; anniversary book

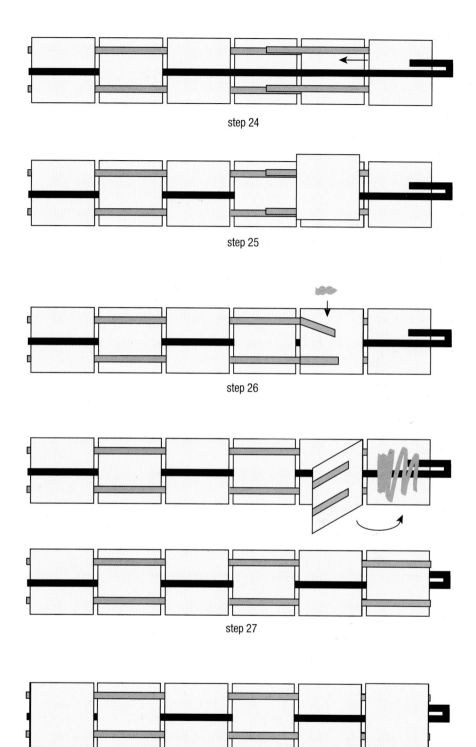

step 24

step 25

step 26

step 27

step 28

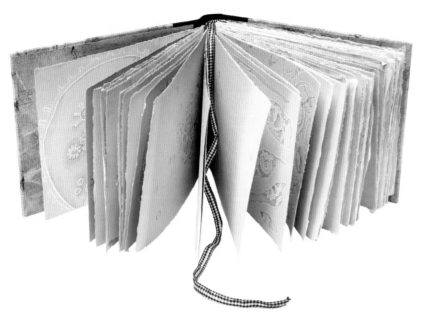

Inner Workings, begun 2009; white ink and graphite drawings of gears and ears; case bound with ribbon bookmark and endbands; 6¾ x 5¼ x ¾ inches (17.1 x 13.3 x 1.9 cm) (photo: Sibila Savage)

CODEX: THE BASIC FEATURES

A book is a space of exchanges supported by the codex structure. Every basic feature of the codex can be brought into play to help the elements in any book talk to each other, interact, create a field of intertextual play. The basic structural unit of the book is the opening, of course. The dialogue across the gutter and the impact of turning the page put a whole set of possibilities into action—sameness and difference, changes of scale, movement, sequence, narrative, rupture, continuity, suspense. A book space is time-based as well as spatial. Page sequences have depth as well as linearity. When the tensions between what is present and what is invoked, what is anticipated and expected, are put to imaginative use, the codex shows that its conventional structure has inexhaustible possibilities.

JOHANNA DRUCKER

THE CODEX

The codex is the classic, Western-style book, the commercially produced book that we most often find in bookstores. For personal use, the codex may be a journal, a place for daily practice of handwriting, a notebook, a collection of random things. Beyond blank books, the codex offers possibilities that rely on the storytelling and not the structure. The whole book cannot be revealed at once, so memory is important. What can the reader remember from page to page? When creating an artist's book with the codex form, you are asked for a deep look and careful thought.

Keith Smith and Scott McCarney are separately using the codex for their own books. They design the books on the computer, send them to a print-on-demand service, then remove the staples, and rebind the books, often casing them

into hard covers. My daughter decided this would be a special way to make the alternative "year booklet" that she creates for her friends at the end of each high school year; the print quality is better than the inkjet printer we have, and she can easily get color printing on both sides of the paper.

The diary or journal has become elevated in recent years, so much so that several books have been devoted to diaries. Some inspiring ones are *Drawing from Life: The Journal as Art* (Princeton Architectural Press, 2005) by Jennifer New; *The Principles of Uncertainty* (Penguin Press, 2007) by Maira Kalman; and *The Diary of Frida Kahlo* (Harry N. Abrams, 1995) by Frida Kahlo. Consider making one of the books in this chapter, giving it a theme or title, and filling a page at least once a week. Choose a topic like alligators, architecture,

or postage stamps, and an artistic style or medium that you want to explore, such as watercolors, collage, or colored pencil drawings, and try creating your own world in a book.

The following books are variations on the Western multiple signature. Each book has several signatures or gatherings of pages, nested one inside the other, and an almost identical sewing pattern that uses the kettle stitch (page 25). Thinner books can be contained in soft covers; thicker books may have a flat spine or a rounded one. In the case of the Crossed-Structure Binding, the Secret Belgian Binding, and the Multiple Signature Sewn onto Ribbon, the book blocks are sewn onto their supports and have distinctive looks. You may wish to refer to measuring for an even number of holes, (on page 24).

END**BANDS**

A finishing touch, really, but endbands can enhance a book by adding color and hiding the gap between the book block and the spine. Formerly known as headbands, these are now most commonly found at head and tail, hence the change in term. While you can purchase pre-made endbands anywhere that sells bookbinding supplies, making them yourself is less expensive, and your color choices are endless.

Tools: glue brush; bone folder; knife and cutting mat or scissors

Materials: 1 piece of decorative paper or bookcloth, 1¼ x 2 inches (3.2 x 5.1 cm); scrap paper; PVA; thick string, 2 inches (5.1 cm) long

Example: approximately two ½ x 1½-inch (1.3 x 3.8 cm) endbands

Note: the endbands should be the same depth as the spine of your book block. A book with a 1-inch (2.5 cm) spine, for example, would have 1-inch (2.5 cm) endbands.

1. Arrange the decorative paper facedown on some scrap paper, vertically oriented.

2. Apply glue to the top ¼ inch (0.6 inch) of the paper. Remove project to clean surface.

3. Align the string across the top edge of the glued paper.

4. Grasping the paper and pushing down on the string, roll up the string in the paper as per diagram 4a. It may be easier

to first fold the paper over, then roll it like this one in diagram 4b. You could also fold the paper over, then crease at the strings with a bone folder like this (see diagram 4c).

5. Hold for about 30 seconds while the glue begins to dry.

6. When completely dry, use scissors or knife to cut the exposed ends of the string.

7. Cut into two ½-inch (1.3 cm) sections.

8. When ready to add to your closed book block: apply glue to the exposed strip of the endband, rest the rolled part on the outside of the spine of the book block, center and press down the strip. Repeat for the second endband.

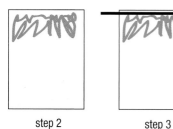

step 2	step 3

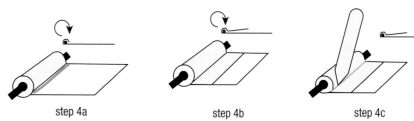

step 4a	step 4b	step 4c

WESTERN**MULTIPLE SIGNATURE**

This sewing pattern is the most common for binding books of more than two signatures. The kettle stitch is employed at the end of the third signature and at the end of every signature thereafter. The goal is for the book to be connected at both the head and tail. Smaller books may be bound with two holes, larger books may need four, six, or eight holes. Allow for a maximum of 1½ inches (3.8 cm) between holes (less is certainly acceptable), a minimum of ½ inch (1.3 cm) and a maximum of 1 inch (2.5 cm) from head and tail. The diagrams and instructions show sewing from the first signature to the last; it is often easier to start from the last and build upward.

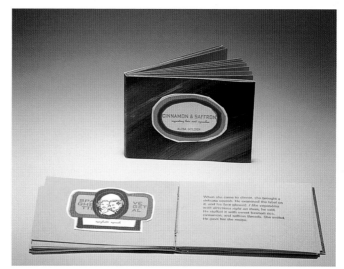

Cinnamon & Saffron, 1997; letterpress, linoleum cuts, custom paper by David Kimball of Magnolia Editions; edition of 49; 5 x 3½ (12.7 x 8.9 cm) (photo: Jim Hair)

I chose to use the macramé thread for *Cinnamon & Saffron* because it is available in that great yellow-orange squash color. To make the gaps between the signatures less obvious, I glued a strip of paper that matched the text paper over the spine. When Nan Wishner went to France, she found squash names in French. Inside the book, I included two squash recipes as well as a short story and devised vegetable labels printed in English and French. *Cinnamon & Saffron* is a romantic comedy of love and squash.

Tools: bone folder; metal ruler; pencil; knife and cutting mat; awl; needle; scissors

Materials: 16 textweight pages, each 8½ x 3 inches, (21.6 x 7.6 cm), grained short; thread, 20 inches (50.8 cm)

Example: 4¼ x 3-inch (11.4 x 7.6 cm) landscape book

Two-Hole

1. Fold all pages in half, widthwise.

2. Nest four pages inside one another. Make four sets of four.

3. Stack the sets with the folded edges aligned.

4. Put the stacked signatures flat on the table with the spines facing you.

5. Measure 1 inch (2.5 cm) from each end; draw vertical lines, so that you mark all four folds at these two places.

6. With a knife, cut a groove along the pencil marks. You have just made sewing holes that should be aligned. Check the insides of the signatures: use an awl or needle to open up any holes, if necessary.

7. Stack the signatures, spines aligned and facing you. Starting on the outside at the top signature, go in one hole and leave a tail of about 3 inches (7.6 cm) (something you can tie off easily).

step 2

step 5

step 7

step 8

step 9

8. Go out the other hole in that signature. Pick up the next signature, and go from out to in on the corresponding hole.

9. Come out the top hole, and tie the thread tightly in a square knot to the end remaining.

10. Go in and out the third signature. At this end, do a kettle stitch: take the needle between the signatures and out, drawing the needle through the loop and making a half-hitch knot. See page 25 for details of the kettle stitch.

11. Proceed with the remaining signatures, always making a kettle stitch to the preceding signature if that end would otherwise remain unattached.

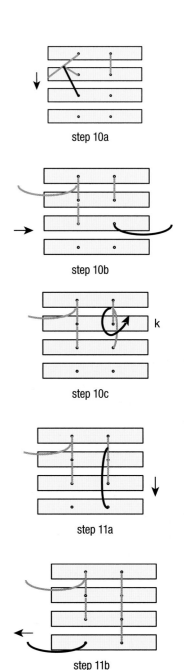

step 10a

step 10b

k

step 10c

step 11a

step 11b

12. To finish, make a last kettle stitch and tie off with a square knot.

13. Make a wrapped hard cover or a hard cover for multiple signatures. (See page 208.)

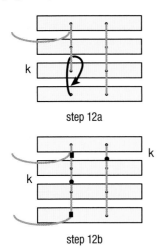

step 12a

step 12b

Note: The centerfold of each of the signatures looks like this:

Four-Hole or More

I used the multiple signature for my first book, *never mind the crowd*, but mistakenly sewed with waxed macramé thread, which is too thick; it created wide gaps between the signatures.

Tools: bone folder; knife and cutting mat; needle; awl; scissors; metal ruler

Materials: 16 textweight pages, each 8½ x 7 inches, (21.6 x 17.8 cm), grained short; thread

Example: 4¼ x 7-inch (10.8 x 17.8 cm) book

Never mind the crowd, 1983; letterpress, photocopies, photo corners; edition of 30; 4⅞ x 7 inches (12.4 x 17.8 cm) (photo: Jim Hair)

1. Assemble signatures, mark the spines, and slit or make holes to make four, six, or more holes (in this case, four). See Measuring for an Even Number of Holes on page 24 for more details.

2. Stack the signatures as before, spines aligned and facing you.

Sewing pattern

Thread the needle with a length of thread that is five times the height of the book, from head to tail.

3. Start on the outside at the top signature. Go in and out that signature, then in and out again with a running stitch.

4. Go into the next signature, and sew a running stitch again.

5. When you finish that signature, tie it tightly to the remaining tail of thread.

6. Sew the third signature. When you complete the third, do a kettle stitch.

7. Proceed until the last signature. Make two kettle stitches to finish. Trim the ends to ¼ to ½ inch (0.6 to 1.3 cm).

8. Make a wrapped hard cover or hard cover for multiple signatures. (See page 208.)

Note: when you are working with signatures, remember that the book needs to be joined at both head and tail. Signature one and two join at the end with a square knot. The end of signature three gets a kettle stitch. The end of every signature thereafter also gets a kettle stitch. Finish with two kettle stitches. The centerfold of each signature looks like this:

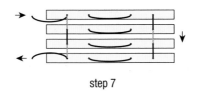

step 7

CROSSED-STRUCTURE**BINDING**

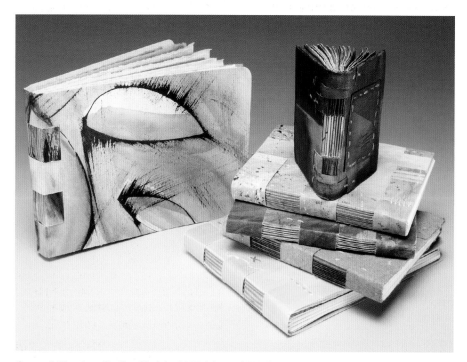

Crossed-Structure Binding Models, 2009 (photo: Sibila Savage)

If you like texture and sewing, you may like this book. I learned it from Jody Alexander at a workshop at the San Francisco Center for the Book. The design is by Carmencho Arregui, a Spanish-born bookbinder and conservationist who lives and works in Italy. You can see more of her work at www.outofbinding.com. The signatures are sewn together with the cover, which holds the book together securely. It is a softcover binding that works well as a journal because it opens perfectly flat. You can make endless combinations of the weaving and stitching for the covers by tearing the slits; tacking down the strips with different kinds of decorative thread; painting the cover paper differently front and back; or making shaped cutouts in the cover.

Note: The dimensions of the cover paper are the height of the book by three times the width + the depth h(3w + d).

Tools: bone folder; metal ruler; divider; pencil; knife and cutting mat; awl and cardboard; needle, glue brush (optional)

Materials: 40 textweight papers, each 8½ x 5½ inches, (21.6 x 14 cm), grained short; heavyweight cover paper, 14 x 5 ½ inches, (35.6 x 14 cm), grained short; scrap paper; waxed linen thread; PVA

Example: 4¼ x 5½-inch (35.6 x 14 cm) book

1. Fold all of the text paper in half, widthwise. Make 10 signatures, each with four folded sheets.

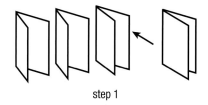

step 1

2. Stack the sheets, one atop the next, spines aligned.

3. Place the cover paper in front of you, horizontally oriented. Measure and score the width of the pages (in this case 4⅛ inches [10.5 cm]) from the right and left edges.

4. Using the divider, measure and mark for five sections (in this case 1⅛ inches [2.9 cm]) down both of the scores from step 3.

5. Using the knife against the metal ruler, cut horizontal lines at the marks, starting and stopping at the scores.

step 2

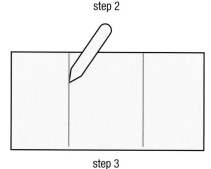

step 3

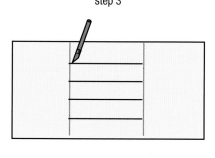

step 5

6. Cut alternating verticals to separate the front and back covers, making the two covers look like teeth. One will have two teeth or tabs; the other will have three.

7. Put aside the cover with three tabs. Place the one with two tabs so that the flat cover is resting on the table and the tabs are perpendicular (folded up in the air) like tapes. You will sew over these tabs.

8. Cut a strip of scrap paper for a jig that is exactly the height of your folded pages. Align it with the two-tabbed cover, and use a pencil to mark on either side of the tabs, plus ½ inch (1.3 cm) from head and tail. You will need six sewing stations, or holes.

9. Using the jig as a guide, put it inside one signature at a time, and use an awl or needle to poke six corresponding holes exactly in the valley folds of all 10 signatures.

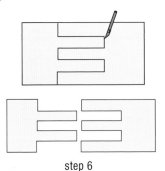

step 6

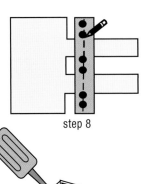

step 8

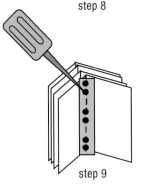

step 9

10. Stack the signatures in the two-tabbed cover with the spines (folded edges) against the tabs. Starting from one end, sew from the outside to inside of the first signature. Leave a tail of thread about 2 inches (5.1 cm) long.

11. Sew over the first tab and back into the first signature.

12. Continue sewing out and in, going over a tab when it appears. When you get to the end of the first signature, add the second and sew directly into the corresponding end hole.

13. Continue sewing in and out of the holes, going over the tabs. Tie off at the end of the second signature to the tail of thread left from step 10. Do not cut.

14. Add the third signature, and continue sewing as before.

15. At the end of the third signature, do a kettle stitch (see page 25 for details).

16. Continue adding signatures, sewing, and doing a kettle stitch at the end of every signature. When you come to the last signature, do two kettle stitches.

17. Take the three-tabbed cover, and fit it around the exposed side of your book, the tabs lacing through the two-tabbed cover.

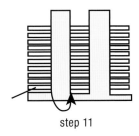

step 11

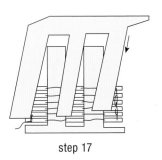

step 17

A GOOD TEXT

The more books I make, the more I want and need to make. It all begins with a good text, no matter how small. While reading something that makes my heart flutter, I see the words begin to appear in type in my mind's eye, designed and placed on a page, with maybe a line drawing to be hand colored or a color inkjet image to be tipped on that is just right. This book becomes full-blown in my head very fast. The method of binding and paper choices are often there too. Sometimes my limited budgets dictate certain changes but I try to make every element work to create a unified whole. Even after thirty-six years of running Warwick Press, the acts of writing, designing, printing, illustrating, and binding of books still give me the greatest thrill.

CAROL J. BLINN

18. Here you may decide whether you want to weave the tabs or simply glue them down. Wrap the tabs around to the other side, mark a few places, and make slits so they can weave through. Slit and weave both the front and back covers.

19. Add drops of PVA to hold the tabs close to the spine on the front and back. Then either glue down the tabs or make some decorative stitches to hold them in place.

Variation: Apply glue and cover the inside front and back covers with decorative endpapers.

FRENCH**LINK STITCH**

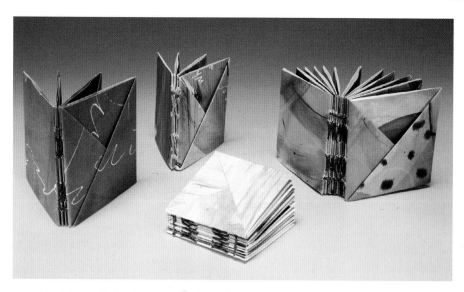

French Link Stitch Models (photo: Sibila Savage)

Hermineh Miller gave me a little book that used this stitch as a decorative element. Used for any multiple-signature technique, it adds strength, linking the signatures not only at the head and tail but also across the spine in many other places as well. It can be visible, when used with separate covers or the Crossed-Structure Binding, or it can be invisible inside a case binding. The sewing pattern can be used with any of the bindings in this chapter, except the Secret Belgian Binding.

1. Assemble pages for one of the multiple-signature bindings.

2. Begin to sew the first signature, from out to in, leaving a tail about 2 inches (5.1 cm).

3. Continue sewing in and out until you get to the end of the first signature.

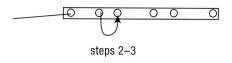

steps 2–3

4. Add the second signature, and sew into it.

5. Sew out of the second signature, then make a slight detour: catch the stitch from the first signature before you go into the third hole.

6. Repeat this catching up, or linking, whenever you come out of a hole in the second signature. Each stitch will then look like an *X*.

step 4

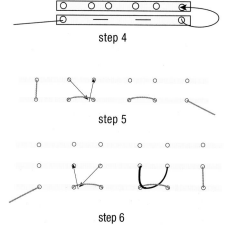

step 5

step 6

7. Tie off in a square knot with the tail from step 2 at the end of the second signature. Do not cut.

8. Add the third signature. This time, when catching or linking, only take the thread from the second signature. Do not go under the *X*. Just go under the part that corresponds to the second signature. Go under this stitch so that it is nearest to the next hole in the third signature; think about linking in the direction in which you are sewing.

9. Continue sewing, adding signatures, doing kettle stitches—just as you would a straight multiple-signature binding, except linking as you go—until complete.

Variation: use this stitch to sew several origami envelopes together (see page 186)

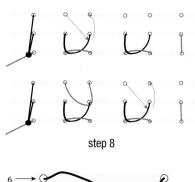

step 8

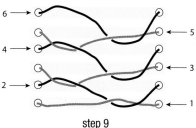

step 9

MULTIPLE SIGNATURES ONTO A RIBBON

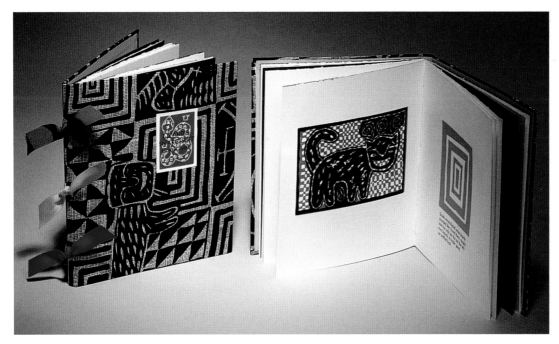

Lizard's Snake Suit, 1996; letterpress and linoleum cuts, Nigerian cloth; multiple signatures onto a ribbon, inset title block; edition of 30; 9 x 11 inches (22.9 x 27.9 cm) (photo: Jim Hair)

My mother-in-law gave me some Nigerian cloth. Instead of curtains, it became the book *Lizard's Snake Suit*. I thought I might make a book for her; maybe I'd make a recipe book or guest book. But, after studying the animals in the pattern of the cloth, I realized I had to write a story about them. Michael, my husband, said jokingly, "Lizard got up and put on his suit." My eyes lit up, and I scribbled out *Lizard's Snake Suit*. I was inspired by a structure in *Cover to Cover* (Sterling, 1998) by Shereen LaPlantz. Ribbons add immediate color to the outside of this book.

Tools: bone folder; metal ruler; pencil; knife and cutting mat; needle; scissors

Materials: 16 sheets, each 8½ x 5½ inches (21.6 x 14 cm), grained short; two ribbons, each ½ inch (1.3 cm) to 1 inch (2.5 cm) wide, each a minimum of 6 inches (15.2 cm) long (long enough to tie in a knot or bow); thread

Example: 4½ x 5¾-inch (11.4 x 14.6 cm) book with two ribbons

1. Fold the paper in half, dividing the pages by the number of signatures you will use (in this example, four).

2. Stack the sheets into four signatures, fold-side facing you.

3. Measure ½ inch (1.3 cm) from each end. With a pencil, draw vertical lines, marking all four signatures at these two places. These are the holes at the head and tail. Between the head and tail holes, measure for four more holes: one set of two holes for each ribbon. Each pair of marks should be spaced just slightly farther apart than the width of the ribbon you are using. With a pencil, mark vertically down all the folded spines again.

Note: No matter how many ribbons you use, you will need an even number of holes, always with two free holes at the head and tail. With two ribbons, you need six holes. If you want three ribbons, you need three sets of holes plus the two at the ends, or eight holes.

4. Poke the six holes in the fold of each signature with your needle. Or use the knife to make nicks in the folds along the lines.

Sewing pattern

5. Start the needle from the outside of the first signature using the end hole.

6. Sew as for a multiple-signature binding or a French link stitch, threading the ribbon through the loops after you sew two signatures so it won't fall out.

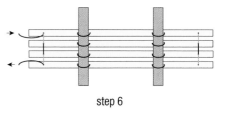

step 6

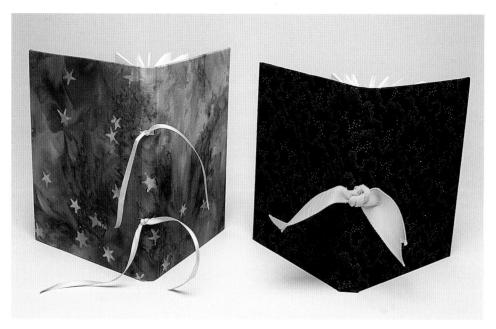

Multiple Signature onto Ribbon Models, 1995; approximately 4½ x 5½ x ¾ inches (11.4 x 14 x 1.9 cm) (photo: Jim Hair)

If you make a hard cover

7. Once your boards are covered and dried, center the book block (the sewn signatures) on the spine on the inside. Mark lightly with a pencil where the ribbons will go.

8. Make parallel slits on each side of the spine for each ribbon.

9. Thread the ribbons through the slits from inside to outside.

10. Tie outside on the spine in bow or square knot.

Variation: As you sew the last signature, put a loop around each stitch that holds a ribbon and knot. (Use if you make a book with four or more signatures.)

Uses: wedding book; journal; guest book; sketchbook

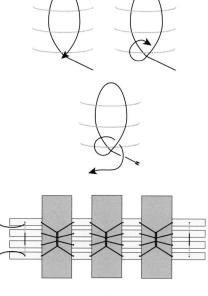

variation

MULTIPLE SIGNATURE WITH ROUNDED SPINE

Dominic Riley teaches a casebound book, based on a historical model, that he calls "The Ideal Sketchbook." I learned the original from him in a class held at the San Francisco Center for the Book. In his version, you must bevel the boards, and the endpapers are single sheets. In this variation, I omit the paring of the boards, the endpapers are folded, and endbands and a ribbon bookmark are added. Eileen Wallace describes a nice version of what she calls the simplified binding, which is similar, in *The Penland Book of Handmade Books* (Lark, 2004).

Tools: bone folder; weight; divider; pencil; ruler; knife and cutting mat; needle or awl; scissors; glue brush; hammer; fiberboard

Materials: 40 sheets textweight paper, each 11½ x 9-inch (29.2 x 22.9 cm), OR use 10 sheets and the binder's fold described on page 17, grained short OR 20 sheets heavyweight paper (torn or cut); 3 linen binder tapes, each ¼ to ½ inch (0.6 to 1.3 cm) wide x 3 inches (7.6 cm), grained short; linen thread; beeswax (optional); low-tack tape (optional); PVA; scrap paper for gluing; 2 boards (Davey or 4-ply museum, grained long), each 5¼ x 9¼ inches (13.3 x 23.5 cm); 1 piece of bookcloth or covering paper, 14 x 10¾ inches (35.6 x 27.3 cm), grained short; 1 strip of bristol, 1 x 9¼ inches (2.5 x 23.5 cm), grained long; waxed paper; 1 strip of mull/super (a book mesh), 3 x 9 inches (7.6 x 22.9 cm); 1 strip of mulberry paper or brown bag paper, 1 x 9 inches (2.5 x 22.9 cm), grained long; 2 decorative endpapers, each 11½ x 9 inches (29.2 x 22.9 cm); ¹⁄₁₆-inch (0.2 cm) dowel or rod (optional)

Example: 5½ x 9¼-inch (14 x 23.5 cm) book

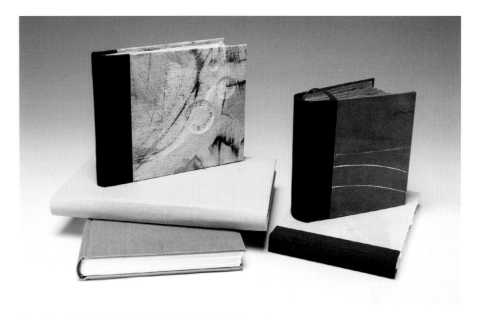

Casebound Models, 2008–2009 (photo: Sibila Savage)

1. If using the binder's fold, fold and slit the paper as described on page 17. If using separate sheets, fold the papers in half, widthwise, then make ten signatures with four folded papers in each one. Use the bone folder to make the folds flat and compact.

2. If you are using separate sheets, stack the signatures and knock them up (yes, that is the term) so they are square. For either the binder's fold or separate sheets, arrange the signatures so the spines are facing you and a little bit off of the edge of the table. Put a weight on top. Use your divider to mark out four sections.

3. Hold a linen tape, centered widthwise, over each of the three marks you have made and make a mark on either side of the tape. You will be marking for six holes.

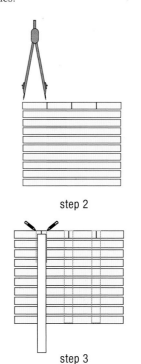

step 2

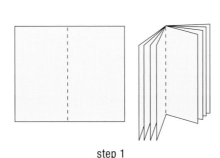

step 1

step 3

4. Use your ruler and pencil to mark ½ to ¾ inch (1.3 to 1.9 cm) from each end as well. These two extra marks will make the total come to eight marks.

5. Use the side of the knife to slice vertically across (also known as "kerfing") the spines in those eight places.

6. Check all of your signatures, and open the holes up with a needle or awl, if necessary.

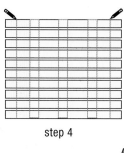

step 4

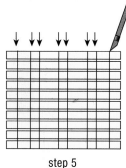

step 5

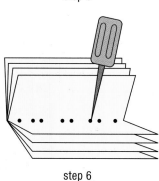

step 6

7. Stack the signatures again. Use a length of thread that is comfortable to work with (approximately your wingspan). Wax it, if you like. Pull the bottom signature from the stack. Start from the outside of the bottom signature. Leave a tail of about 2 inches (5.1 cm).

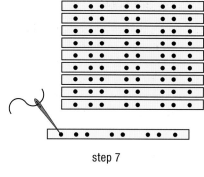

step 7

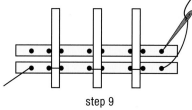

step 8

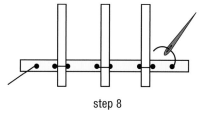

step 9

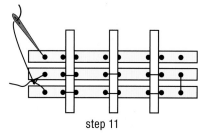

step 11

8. When you get to a set of holes, try sliding the tape in (you might want to use a piece of very low tack tape to hold the linen tapes in place until they are secure).

9. At the end of one signature, just go into the second one.

10. Use the bone folder to compact the folds after you sew each signature.

11. Repeat the in and out (running stitch) until you get to the end of the second signature. Tie a square knot with the tail of thread you left in step 7. Do not cut. Keep sewing by adding the third signature.

12. At the end of the third signature, do a kettle stitch. That's taking the needle between the two previous signatures, making a loop, and taking your needle through the loop, knotting it.

13. Add the fourth signature.

14. Now, every time you add a signature, you will do a kettle stitch at the end so that all of the heads and tails of the signatures will be connected. When you get to the last signature, do two kettle stitches. Trim the thread to about ¼ inch (0.6 inch). If you have to add thread in the middle of sewing, try to do it at the head or tail, after doing a kettle stitch, if possible. Then you can tie on to the end as well.

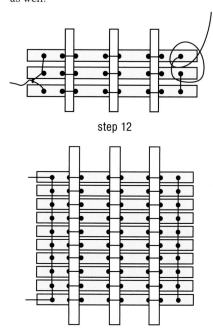

step 12

step 14

MEMORY

When I was a child, my mother took me on a visit to her former employer, who was a publisher. After I was introduced to him, he opened a door to a small closet that was filled with stacks of children's books much higher than I was. He invited me to sit and read while he spoke with my mother. I sat on the floor tucked tightly between the walls of books but was really on a journey guided by the pictures and stories in the books that I opened. When it was time to leave, he told me to choose a book that I would like to take home with me. I carried away a whole world in my hands that I, as an artist, continue to fall into each time I design and create a book.

KAREN SJOHOLM

Preparing to glue

15. Put the book between your covers, put a weight on top. Use the bone folder to flatten the backs of the signatures, making the pointed folds at the spine into squared-off sides. This will help keep the glue out later.

16. Fray your thread ends by using the point of a needle to comb through them.

17. Glue up the spine, using PVA. Don't put glue on the boards. Don't put glue on the tapes. Let dry about five to fifteen minutes.

To round the back

18. Take it out from under the weight and board. Pull gently on the fore edges of several of the top signatures at once and hammer them. Flip the book over, and hammer the other side. Keep doing this until you are satisfied that it appears to be an even curve.

19. Put it back under the weight, and apply more glue, this time over the whole spine, covering the tapes this time. Leave it to dry.

20. Keep the book under the weight if you can. This time, glue up the spine all the way again and add the mull, centering it across the depth. It will wrap over the front and back of the book block. Trim it if it sticks out over the head and tail.

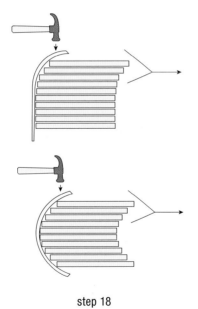

step 18

21. If you want a ribbon bookmark, add it first, before the endbands. Put some glue on an inch (2.5 cm) of the ribbon, stick it to the head, with the rest of the ribbon trailing outward.

22. Add endbands at this stage (or after step 22). Glue one at the head and one at the tail, the little rolled-up area just touching head/tail. (You can make them by rolling up some of the cover material or using decorative paper rolled over a thick piece of string. See page 146 for more details. They are also available pre-made.) Let dry under the weight.

23. Cut a piece of the spine liner paper (mulberry or brown paper) that is exactly the depth of the spine (from the center of the top signature to the center of the bottom signature), and glue it down. Use the bone folder to burnish it. Let dry completely under the weight.

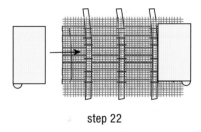

step 22

Preparing the covers

24. Use a strip of scrap paper and measure the depth of the spine. Note this. Trim the strip of bristol to this depth. Curl the spine piece, vertically, with your hands or by rolling gently over a pencil.

25. Arrange the boards on the wrong side of the book cloth, with spine piece between them. Add two boardwidths on either side of the spine piece. Glue these down. Cut the corners, and turn-ins.

step 25

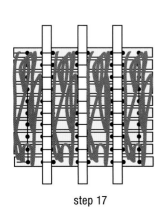

step 17

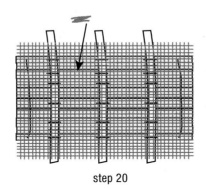

step 20

26. While the case is drying, use the edge of the table to round the spine again.

27. Wrap the book block in waxed paper and put the book block inside the case. Leave to dry for about an hour, if possible.

Casing In

28. Take the book block and, leaving at least 1-inch (2.5 cm) flaps, tear a page off of the front and back of the book block. Tear against a ruler for best results.

29. Trim the mull and tapes so they will not stick out from under the torn flaps. You may need to miter or angle the mull a bit.

30. Make sure the book block fits snugly against the spine. Open the book, and put a small weight on the book block (fit into the case) while you work on the front cover. Put some waste sheets under the paper flap. Put glue on the mull and on the flap. Remove the waste sheets. Press the flap over the board. Wait a few minutes, close the book with a piece of waxed paper inside, then glue out the back cover. Use a knife to miter the turn-ins slightly.

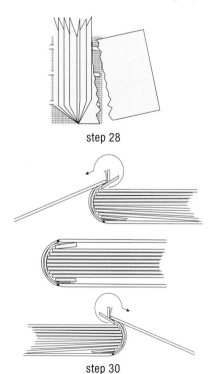

step 28

step 30

31. Put waxed paper between the front cover and book block, the back cover and book block, and between the boards. Put a weight on top. Let dry an hour or more, if possible.

32. Fold your endsheets in half. Apply glue to one half of the back of the paper (on one side of the fold), plus a tiny bit over the fold to the other half. Glue in the endsheet to the cover, pressing the tiny bit down to the book block. Smooth out with a bone folder. Repeat for the other cover. Notice that the glue is applied on the left half of the back of the front endpaper and the right half on the back of the back endpaper.

33. If you happen to have two $\frac{1}{16}$-inch (0.2 cm) rods or dowels, put them into the grooves between the boards and the spine. Put waxed paper over and under the book, and between the pasted-down endpapers and the book block. Place under fiberboards with a weight on top (or under a dictionary) for a couple hours or overnight.

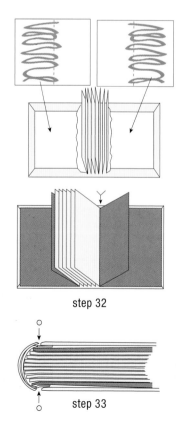

step 32

step 33

Variation with bookcloth supports

This is Dominic's version, also taught by Michael Burke. It adds an extra step, but that makes the book very sturdy.

Additional Materials: 2 strips of book cloth that match your covering material, each 1½ x 6 inches (3.8 x 15.2 cm), grained long

Omit: 2 decorative endpapers, each 11½ x 9 inches (29.2 x 22.9 cm); and **Replace** with 2 decorative endpapers, each 5 x 9 inches (12.7 x 22.9 cm), grained long

A. Proceed with steps 1–6 of the preceding Multiple Signature with Rounded Spine instructions.

B. Put one of the book cloth strips in front of you, right-side up, vertically oriented. Using a piece of scrap paper as a mask, leave approximately ¼ inch (0.6 cm) of the rightmost strip exposed, then apply a thin line of PVA. Remove mask.

C. Take the first signature and press it to the glued area, wrapping the strip around the signature as well.

D. Flip the book over, and repeat steps 2 and 3 for the last signature (now the first).

E. Open the holes in the first and last signatures again so they now pierce the new book cloth strips as well.

F. Proceed with steps 7–27 of Multiple Signature with Rounded Spine instructions.

G. Trim the mull and tapes so they will not stick out from the book cloth strips. Miter the corners, if necessary.

H. Continue with steps 30, 31, and 33 to complete the book.

SECRET**BELGIAN BINDING**

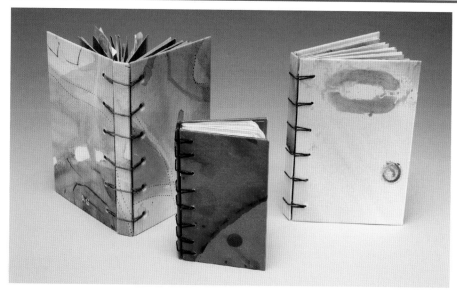

Secret Belgian Binding Models, 2008–2009 (photo: Sibila Savage)

Here is another binding given new life by Hedi Kyle. She found a historical model—which had been kept secret for hundreds of years—figured it out, then began to teach it. Emily Martin was visiting from the University of Iowa and taught a class on this structure at the San Francisco Center for the Book, which brought it to my attention. I believe she learned it from Alice Austin, who learned it from Hedi. I added folded partial-pocket pages so you can add your own secrets.

Tools: a small weight; glue brush; knife and cutting mat; bone folder; metal ruler; pencil; divider; awl or hammer/punch; bookbinding needle; scissors; curved needle

Materials: 2 boards, each 3½ x 4¾ inches (8.9 x 12.1 cm), grained long; board for spine strip, ½ x 4¾ inches (1.3 x 12.1 cm), grained long; magazines for scrap paper; PVA; 8 sheets of textweight paper, each 6 x 9 inches (15.2 x 22.9 cm), grained long; 2 pieces of bookcloth or covering paper, each 4¾ x 5½ inches (12.1 x 14 cm), grained long; 1 piece of bookcloth or covering paper, 1¼ x 6¼ inches (3.2 x 15.9 cm), grained long; colored

waxed linen thread; lighter-weight natural-colored linen thread

Example: 3½ x 4¾-inch (8.9 x 12.1 cm) book

1. Wrap the boards and spine as separate boards, and let dry under weights (see page 209).

2. Fold each of the eight sheets of paper in half, widthwise.

3. Keeping each folded, fold each in half again (perpendicular to first fold).

step 2

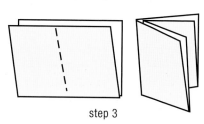

step 3

4. Open one folded page (keeping it folded the other way), and measure and mark ½ inch (1.3 cm) from the head and tail along the fold.

5. Using the divider, measure and mark five equal sections, also along the fold, between the two end marks.

6. Using the awl or a needle, poke holes at your marks from step 5.

7. Using the page you just punched as a guide, put it on top of one page at a time, and poke through all of the holes.

8. Take your cover and measure ⅜ inch (1 cm) in from what will be the spine edge of the book and make a light pencil line or hold the ruler there.

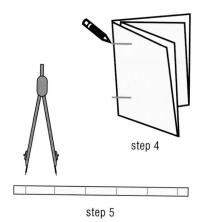

step 4

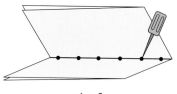

step 5

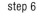

step 6

step 8

9. Using one page as a guide, make pencil marks at each of the six holes on the cover along the pencil line or against the ruler.

10. Using the awl or hammer/punch, poke holes in the cover.

11. Align one cover with the other (insides touching), and make pencil marks for the holes in the second cover.

12. Poke the holes in the second cover.

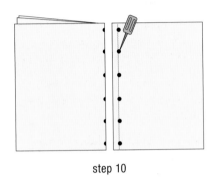

step 10

Weaving the cover

13. Align the covers with the spine piece in between them, about a board's width between each board, with a bit of the tails sticking over the edge of the table. Put a weight across the head so that all three pieces stay in place.

14. Take a length of colored waxed linen thread about three feet long (91.4 cm) and thread the bookbinding needle.

15. Weaving across the spine and connecting each corresponding set of holes is a 10-step process, indicated by the numbers in parenthesis, which correspond to the numbers in the diagrams. Begin weaving the thread through the cover. Start on the left and go down through the left hole at the tail. (1)

16. Come up in the gap between the board and the spine. (2)

17. Go down into the second gap. (3)

18. Come up through the hole in the second (right-hand) board. (4)

19. Go down into the gap. (5)

20. Come up in the second gap. (6)

21. Tie a square knot with the end of the thread. (See 6.5: this knot only happens once.)

22. Go back down into the same hole on the left. (7)

23. Repeat steps 16–18. (8,9,10, also 2,3,4)

24. Go down into the next hole in the right-hand board.

25. Come up in the gap between the board and spine. (2)

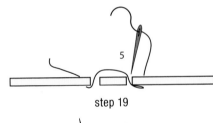

step 18

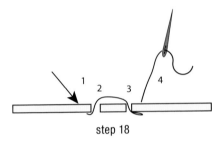

step 19

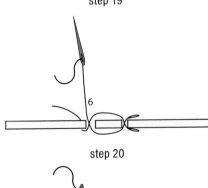

step 20

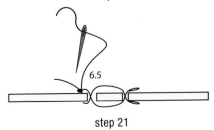

step 21

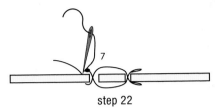

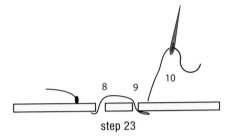

step 22

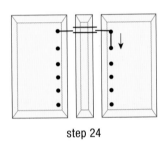

step 23

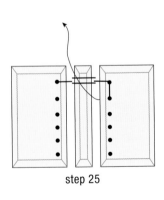

step 24

step 25

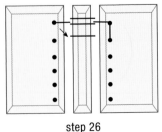

step 26

26. Go down into the second gap. (3)

27. Come up in the second hole in the left-hand board. (4)

28. Repeat the weaving process, this time weaving left, right, left, into the next set of holes. (5,6,7)

29. Repeat the weaving process again, this time weaving right, left, right. (8,9,10) Move down to the next hole in the left-hand board.

30. Continue until you have completed all sets of holes. Tie the thread to itself in a final knot. Trim the ends of the threads from head and tail, if necessary. The inside has vertical stitches on the boards. The outside has all horizontal stitches.

Sewing the book block with the cover

31. Stack the signatures so that the holes face you, the folded edges at the tail. You will use one folded piece as one signature (they do not nest).

32. Open the covers, and place the bottom signature on the back cover.

33. Take about 3 feet (91.4 cm) of regular bookbinding thread or heavy buttonhole thread and thread the curved needle.

34. Start from the outside (the mountain fold) of the signature and sew into the hole at the head. Leave about 2 inches (5.1 cm) of thread showing on the outside.

35. Sew to the second hole from inside to outside.

36. Before you sew into the third hole, take the needle and catch the next two sets of stitches showing on the inner spine. Sew into the third hole from out to in.

37. Sew into the fourth hole from in to out.

38. Catch the next two sets of stitches on the inner spine, and sew into the fifth hole from out to in.

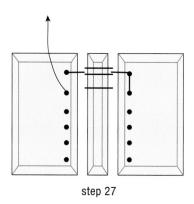

step 27

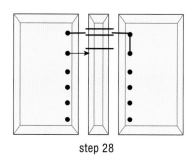

step 28

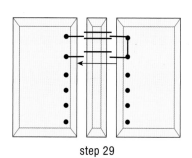

step 29

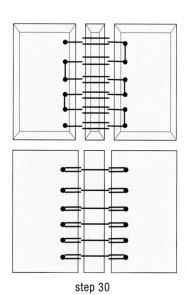

step 30

39. Sew into the sixth (last) hole from in to out.

40. Pull on the thread gently to tighten the signature to the cover spine. Add the second signature, and sew directly into the corresponding hole at the tail. Remember to keep each folded "pocket" edge at the tail.

41. Continue sewing in and out, catching the stitches that match the previous signature.

42. When you come out of the last hole at the head, tie a square knot with the 2 inches (5.1 cm) of thread from step 34.

43. Add the third signature, and sew from out to in, continuing to catch the stitches from the inner spine.

44. At the end of the third signature at the tail, do a kettle stitch (see page 25 for Kettle Stitch).

45. Continue sewing and catching the thread, and now, at the end of every signature, do a kettle stitch before adding a new signature. When all signatures are in place, do two kettle stitches, and trim the ends of the thread.

step 31

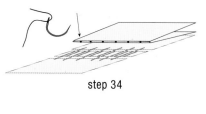

step 34

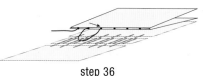

step 36

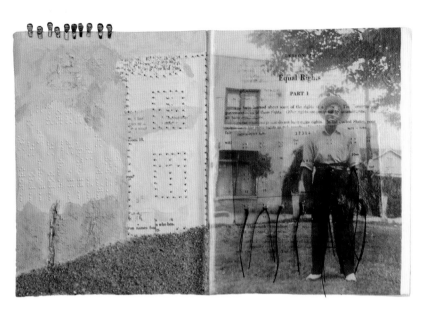

Lisa Kokin: *Equal Rights*, 2006; mixed media book collage; 10½ x 16 inches (26.7 x 40.6 cm) (photo: Lia Roozendaal/Jagwire Design)

ALTERED TEXTS

I sit in my studio cutting up, rearranging, and rewriting books to make them say what I believe to be true. Sounds and meanings of words have always fascinated me—puns and double-entendres make me ecstatic. I find humor in cutting up text from wildly different sources and then pasting them together in a sort of literary assemblage. I like the odd juxtapositions—religious text with phrases from Fortune magazine, a marriage manual with a guide to hunting game, and so on. I grew up in a house filled with books that were treated with utmost reverence. Cutting them up will probably land me in hell eventually, but at least I'm having fun.

LISA KOKIN

CODEX VARIATIONS

When nested into signatures, folded leaves, also known as gathered pages, may be sewn together in ways other than with the simple running and kettle stitches. If you like sewing as an activity, these are satisfying to learn. The signatures in this chapter are primarily bound into structures that have paper covers, emphasizing the beauty of the thread rather than the heaviness of wrapped boards or the formality of book cloth. A long strip holds a card in the center of the Woven Codex. The stitching on the Exposed Stitch Book (with or without beads) is meant to be seen, as is the threads for the Bundled Stitch and the Buttonhole Stitch. The unsupported spine of the Chain Stitch or Coptic (sometimes referred to as Ethiopian Binding), whose hard cover is part of the binding, shows off the highly decorative pattern made by the intertwining of colorful, waxed linen thread.

The codex can also be transformed beyond the binding. The many-paged structure can serve as a springboard. When you create a book with many pages, you need to think about how much time you want the reader to spend on each page. How much information you put on a page will control the pacing. A detailed collage or lots of text will cause the reader to stop and examine it. Conversely, a simple block of solid color or a single word will cause the reader to move on rapidly. A book will be read slowly or not at all if it contains only heavily detailed pages. A book with all simple pages will be read quickly. Think about balancing detailed pages with simple pages.

You can also vary the reading experience by adding the unexpected. Marie Dern finds a place for three-dimensional objects in some of her books. The books begin with a text, as you might expect,

but eventually you turn the page and find a three-dimensional object cradled in a hole. Marie combines surprise and humor with the seriousness of the text. By isolating an object within a book, you cause the reader to stop and think about its meaning and importance. Juxtaposition of seemingly unrelated events—such as Marie's bird's nest within a book—can awaken and delight the reader.

In her arrangements in the book *The Poetry of Ikebana* (Kodansha International, 1990) by Noriko Ohno, the author mixes traditional natural materials, such as pine branches, camellias, and other flowers, with found materials, such as nylon netting, glass rods, and cotton for a refreshing, inspiring, and new effect. Books can also benefit from this combination of natural and unusual materials. Keep your eyes open, and carry a big satchel. The unexpected treasures are waiting to be collected.

WOVEN**CODEX**

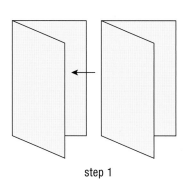
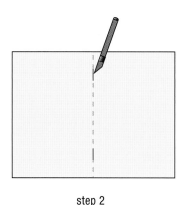
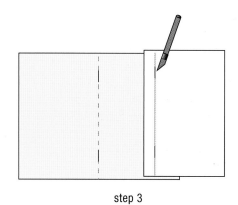

Current Under Lines, 2006; painted and masked paper, letterpress, transferred ink, Tyvek strips; edition of 13; 4¼ x 6 x ½ inches (10.8 x 15.2 x 1.3 cm) (photo: Sibila Savage)

Betsy Davids showed me this structure by Elizabeth Steiner and Claire Van Vliet; they describe variations of it in their book, *Woven and Interlocking Book Structures* (Janus, Steiner and Gefn Presses, 2002). I've renamed it for clarity. This book involves no thread, just two strips of paper, ribbon, or Tyvek that weave through the signatures. See detailed information on Tyvek on page 203. You can also make paper strips to use in place of Tyvek, as described on page 218. A card in each centerfold anchors each signature. This book may be made out of one sheet of 22 x 30-inch (55.9 x 76.2 cm) printmaking paper, which you can paint with acrylic inks, like I did for *Current Under Lines*.

Tools: bone folder; pencil; metal ruler; knife and cutting mat; scissors

Materials: 8 pieces medium-weight to heavyweight paper, each 8 x 4 inches (20.3 x 10.2 cm), grained short; 8 cards or pieces of heavyweight paper, each 4 x 6 inches (10.2 x 15.2 cm), grained long; 2 Tyvek strips (can be cut from envelope), each 10 x ½ inches (25.4 x 1.3 cm); 1 piece heavyweight paper, 16½ x 6 inches (42 x 15.2 cm), grained short

Example: 4 x 6-inch (10.2 x 15.2 cm) book

1. Fold each of the eight pieces in half, widthwise. Nest into pairs.

2. Take one of the folded pieces and measure, mark, and use the knife to cut two ⅝-inch (1.6 cm) slits along the fold about ¾ to 1 inch (1.9 to 2.5 cm) from the head and tail. Use this for a template: place inside the others, one or two at a time, and make slits in all of the folded pieces.

3. Measure, mark, and cut two corresponding slits in each of the cards, ½ inch (1.3 cm) from the left edges. This is the same cut size and position as on the folded pieces.

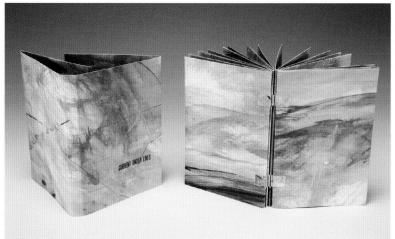

step 1 step 2 step 3

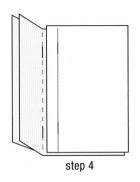

step 4

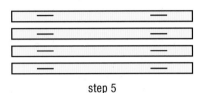

step 5

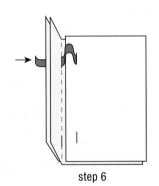

step 6

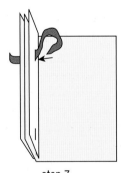

step 7

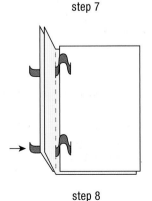

step 8

4. Put one card in the centerfold of each of four nested pairs of folded pieces.

5. Stack the signatures, one atop the other, spines aligned and facing you. You should see four signatures.

6. Begin with the first (top) signature by threading one strip of Tyvek from one outside slit to the inside. Leave about 1 inch (2.5 cm) of Tyvek as a tail. Take the Tyvek over the card and down through the matching slit in the card.

Tip: Trim the working end of the Tyvek into a point, or fold it diagonally, so it is easier to thread and weave it.

7. Come out the card and go back into the same slit you started with in the signature.

8. Repeat steps 6 and 7 with the second strip of Tyvek and the second set of slits.

9. Add the second signature and repeat steps 6, 7, and 8.

10. Continue the threading and weaving process until you have run out of signatures.

11. Trim the ends of the Tyvek to about 1 inch (2.5 cm), if necessary.

For the cover

12. Measure the depth of the spine of your woven book block. The cover dimensions given in the materials list assume a depth of about ½ inch (1.3 cm). You may need to adjust the width of the cover if your book block has a different depth. If smaller, trim the difference from the cover. If larger, your cover flaps will be slightly smaller.

13. Find the center of your cover paper. Measure and mark half of the depth on either side. Make these two marks at both the top and bottom of the paper.

14. From each of the two marks, measure out toward the edges, mark, and score at about 4⅛ inches (10.5 cm).

15. Fold the flaps all with valley folds.

16. Slip the book block into the folded cover by wrapping the flaps over the first and last pages.

Variation: shape the cards (leaving enough room for the slits) for a varied reading experience

Uses: travel journal with postcards in the centerfolds; event book with photos for the cards

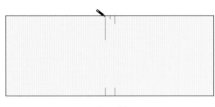

step 13

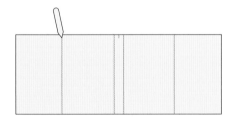

step 14

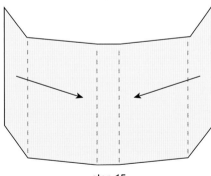

step 15

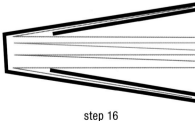

step 16

EXPOSED**STITCH BOOK**

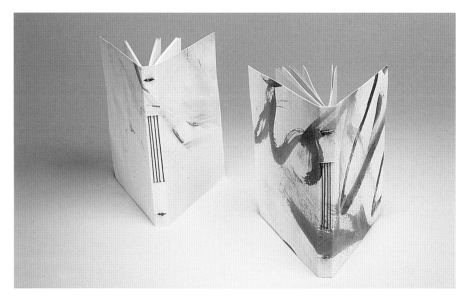

Exposed Stitch Models, 1997; acrylic inks and gesso; 4½ x 6 inches (11.4 x 15.2 cm) (photo: Jim Hair)

Sew directly to a heavy paper cover, or sew to a spine piece and glue to boards for one of the hard covers, keeping the sewing exposed or covering (see Split Board, page 210). For this binding, you need an even number of holes. A larger book might have six or eight. Variations of this structure appear in *Non-Adhesive Bindings* (Sigma Foundation, 1999) by Keith A. Smith. For general dimensions, the cover or wrapper should be the width of your pages, opened, plus the depth of the signatures stacked up.

Tools: pencil; metal ruler; needle; thread; bone folder; knife, and cutting mat; scissors

Materials: heavyweight paper, 5¾ x 9¼ inches (14.6 x , 23.5 cm) grained short; 16 pieces of textweight paper, each 5½ x 8½ inch (14 x 21.6 cm), grained short

1. Fold all the pages in half widthwise.

2. Nest four pages inside one another. Make four sets of four.

3. Stack up with the folded edges aligned, fold-side facing you. Measure ½ inch (1.3 cm) from the head and tail; with a pencil, mark vertically down all the signatures.

4. Poke the four holes in the fold with your needle. Or notch all the signatures at once with a knife.

Prepare the cover

5. Find the middle of your cover paper (don't fold it, just lightly mark it with a pencil).

6. If your book block is approximately ½ inch (1.3 cm) deep, measure ¼ inch (0.6 cm) on each side of your tiny midline pencil mark. Mark these two spots, top and bottom (head and tail).

step 8

GATEWAY TO A STORY

I relish the artifacts of the past and use them to create a reverence for things hand hewn, to elevate beauty and craftsmanship, and to serve as gateways into the texts. Combing antique stores, yard sales, and recycle centers, I search for objects begging to be books— like the 1930s toaster that inspired me to make books that slide out of it like pieces of toast or antique family lace that stirred questions about immigrant farmer women in the 1900s. My collection of broken watches speaks to me about the loss of time, the changing times, and the question of where time goes; I am curious to see what future form these parts will take. Although I have made letterpress printed books in large editions, my favorite creations are one-of-a-kind books made from found objects that evoke a memory as well provide new meaning, bringing forth stories that yearn to be told.

CATHY DEFOREST

7. Score these two lines with a bone folder against a rule. Fold. Open.

8. Line up the signatures within the cover. Mark along the spine of the cover exactly where the holes are in the signatures. Make a straight line from fold to fold horizontally across the spine of the cover, wherever the four marks are. Make four horizontal slits on the pencil marks.

9. You will be sewing your signatures through these slits.

To sew

10. Starting with one signature, hold it inside the cover, the holes of the signature aligned with the slits in the cover. With an arm's length, or approximately 20 inches (50.8 cm), of thread, begin sewing

from the outside of the cover, through the slit, through the end hole of the first signature. Leave a 4-inch (10.2 cm) tail.

11. Sew now from the inside of the signature, through the next slit, then in the next slit, and through the signature, creating a running stitch.

12. At the end of the first signature, make a French knot (double knot).

13. Line up the second signature with the slit, go into the cover and signature, and continue sewing a running stitch.

14. At the end of the second signature, make a French knot (double knot).

Tip: As you make the knot, hold the loop down on the book, as close to the hole as possible, as you slowly tighten the thread all the way, pulling perpendicular to the spine.

15. Sew into the cover and third signature, then back down the third signature.

16. When you get to the end, make a kettle stitch under the previous French knot; then make a second double knot.

17. Sew the fourth signature.

18. Make a kettle stitch at the end and a double knot; then, take your needle through the same end hole back inside the cover. Remove the needle.

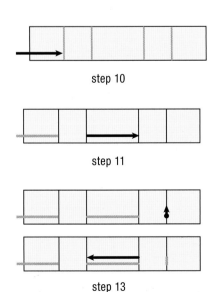

step 10

step 11

step 13

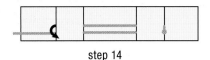

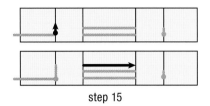

step 14

step 15

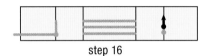

step 16

step 17

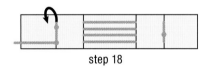

step 18

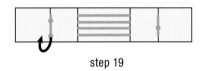

step 19

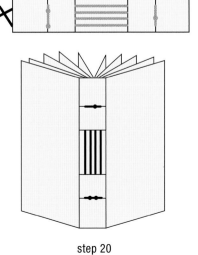

step 20

19. Re-thread the first end through the needle, and take the thread back inside the cover through the first hole.

20. Pull the two ends around and tie together in a square knot. Trim.

Variation: The cover may also have edge flaps that will be turned in (folded in); these should be at minimum half the width of the cover. For example, this size would need two 2⅛-inch (5.4 cm) flaps. To calculate: 8½ + ½ + (2 x 2 ⅛ inches) = minimum wrapper paper = 13¼ inches—or (21.6 + 1.3 + [2 x 5.4 cm]) = minimum paper wrapper = 33.7 cm. (Maximum flap measurement can be the same width, or 2 x 4¼ inches = 8½ inches [21.5 cm] totaling: 17½ inches [44.5 cm] maximum wrapper paper needed.)

Uses: journal or travel journal; sketchbook

⚜ VISUAL DIARIES

As a child I wrote but later liberally censored my five-year diary, confiding "Dear Diary, YOU know what happened..." Now, decades later, the diary tells me nothing. As an adult, I found myself still reluctant to write anything but the decorous in my journals—heaven forbid someone should read it. While researching the origin of Babylonian clay tablets for a children's book, it occurred to me that tablets might work for my diaries. I began to record events by placing objects into wet cement, then painting, drawing, or carving on the solid surface. These small-sized memory jogs never lose their ability to aid my recall of an event or certain period of time. I also make collaged diaries in accordion-fold books, and the pictures flow into one another, forming a timeline or a long mural. I like that information can be recorded, stored, then brought into focus without what we recognize as our traditional written language.

ANNE HICKS SIBERELL

EXPOSED**STITCH BOOK WITH BEADS**

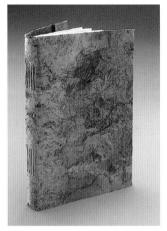
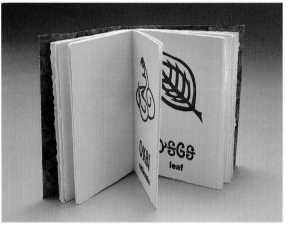

Catherine Michaelis: *Book: A Cherokee Primer*, 1993; letterpress, linoleum cuts; edition of 100; 4 x 5¾ inches (10.2 x 14.6 cm) (photo: Sibila Savage)

I purchased a copy of Catherine Michaelis's Book: *A Cherokee Primer* (May Day Press, 1993) because the materials she used intrigued me: I liked the bark paper and the turquoise-colored beads. I had never seen the beaded spine before and set out to make a model of it. It was harder than I thought. I found that I had to thread and unthread the needle several times. When you practice this binding, pick a time when you feel calm and unhurried. The finished product will be worth the effort.

Tools: pencil; metal ruler; bone folder; needle; scissors; knife and cutting mat; awl or needles; pin or cork cushion

Materials: 16 textweight papers, each 5½ x 8½ inch (14 x 21.6 cm), grained short; 1 heavyweight paper, 5¾ x 15 inches (14.6 x 38.1 cm), grained short; beads; thread

Example: 4½ x 5¾-inch (11.4 x 14.6 cm) book

1. Fold all textweight papers in half, widthwise.

2. Nest four sheets inside one another to make signatures.

3. Stack up signatures. Measure this depth (it should be about ½ inch [1.3 cm]).

4. Place the cover paper in front of you horizontally oriented.

Note: The cover or wrapper should be the width of your pages opened, plus the depth of the signatures stacked up (in this example, four signatures stacked should measure approximately ½ inch [1.3 cm]). You will also have edge flaps that will be folded in (3 inches [7.6 cm] in this example).

5. Find the middle of your cover paper (don't fold; just lightly mark with a pencil). Measure and mark ¼ inch

HONORING MY GRANDMOTHER

Book: A Cherokee Primer was my first May Day Press publication. I printed it in honor of my part-Cherokee grandmother for all that she taught me. The way she lived her life inspires me and brings me comfort. I find it difficult to put my feelings about her into words: perhaps that is why I continue to make pieces about her and for her. The text contains words of nature: *butterfly, flower, hummingbird,* and *sun,* and lists both the English and Cherokee with linoleum-cut illustrations for each page, much as a child's schoolbook would. I chose Mexican bark paper and the exposed stitched binding to give it a very raw, handmade quality. I wanted it to evoke a book made by someone with few materials and limited skills (like me) but in an older era.

CATHERINE MICHAELIS

(0.6 cm) on each side of your tiny midline pencil; mark both head and tail.

6. Score vertical lines with the bone folder against the ruler, connecting head and tail marks.

7. From the score lines, measure the width of your book (in our example, 4¼ inches, or 10.8 cm). Mark and score. You are measuring outward, toward the right and left edges.

8. Fold at the scores for the spine and the edge flaps.

To sew

The middle bead is sewn in line with the rest of the stitching, horizontally (when the book is being sewn). The end beads are sewn vertically to the next signature. For this binding, you will make eight sets of four holes (these will be your sewing stations) along the spine of your wrapper (soft cover). On the inside of the wrapper

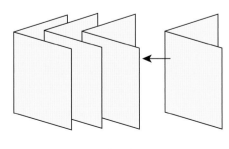

step 2

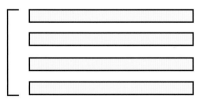

step 3

so the marks will not show, mark lines across where the holes will go.

9. Measure ½ inch (1.3 cm) from the head and tail. Mark these two places.

10. Measure and mark 1 inch (2.5 cm) from the head and tail.

11. Measure and mark 2 inches (5.1 cm) from the head and tail.

12. Measure and mark 2¾ inches (7 cm) from the head and tail.

13. Use a ruler and measure four vertical guidelines in the center; your light mark at the midline will be one of the lines' the other two vertical marks at the spine will be the second and third. Measure ⅛ inch (0.3 cm) between the midline mark and the outer marks to make the fourth and fifth lines.

14. With a needle, poke four holes, centered between each line.

15. With signatures stacked and spines facing you, using the wrapper as a guide, draw lines or mark on the signatures exactly where the holes will be on the signatures.

16. You may use a knife to cut notches at these marks or use an awl or needle to make holes in each signature separately.

step 13

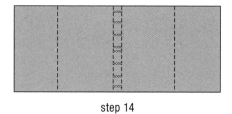

step 14

step 17

step 19

step 22

17. Stack signatures inside the wrapper, holes aligned with wrapper. Keeping the same orientation, remove the signatures and place them in front of you.

18. Place the wrapper with the spine facing you, the fore edge away from you. Start by placing the bottom signature inside the wrapper.

19. Use about an arm's length of thread, or four to five times the length of the book. Begin sewing from the outside of the signature at the head (but inside the wrapper).

20. Come back out the second hole, sewing through the wrapper as well.

21. Sew from outside to inside (third hole).

22. Sew inside to outside (fourth hole).

23. Take your needle off, and thread one of the center beads onto the thread.

24. Re-thread the needle, and sew from outside to inside (fifth hole).

25. Sew from inside to outside (sixth hole).

26. Sew from outside to inside (seventh hole).

27. Sew from inside to outside (eighth hole).

28. Remove your needle. (Poke it into cork or pin cushion briefly so you don't lose it.) Thread one of the tail beads onto the thread.

29. Sew into the second set of holes in the wrapper and into the second signature from outside to inside.

30. Continue the running stitch, in and out, until you get to the center, where you will add the bead.

31. Thread the bead, and keep going until you get to the head of the book. Don't sew through the wrapper at the head of the book.

step 29

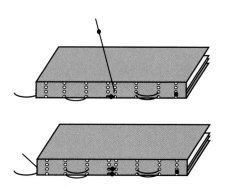

step 31

32. Continue sewing and adding beads, leaving the holes at the head of the book's wrapper empty until the very last signature.

33. When all four signatures are sewn to the wrapper, come out the hole at the head of the book through the wrapper.

34. Add one bead, re-thread the needle, and sew into the wrapper only.

35. Come back out the wrapper, and add the second bead.

36. Go back inside the wrapper only.

37. Find the first end, pull it around to the last end; tie the ends in a square knot inside the wrapper.

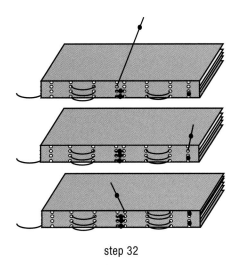

step 32

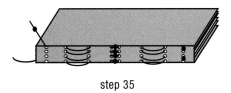

step 35

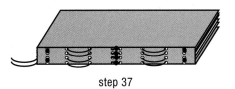

step 37

BUNDLED**STITCH BOOK**

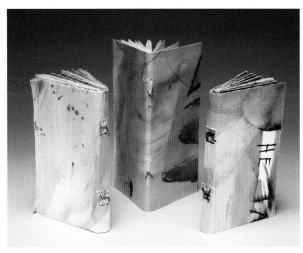

Bundled Stitch Book Models, 2008 (photo: Sibila Savage)

Marie Dern created a beautiful version of "Elephant" from *Elephant and Other Stories* (Harvill Press, 1998) by Raymond Carver, with drawings by her husband Carl Dern; it has a crinkly gray wrapper and this elegant exposed stitch through it. Neither Marie nor Shelley Hoyt, who had bound the book in 1988, remembered where it came from or what it was called. After examining it, I decided to make one using one needle and a sewing pattern that loops down one set of holes through the wrapper and up the other set. The cinched threads that bundle the stitches are mostly decorative, though they can hide any mistaken slack stitching. The stitching process reminds me of the loops of white icing on a Hostess cupcake, but when I tell students this, they stare at me blankly. This pattern works best with books under 8 inches (20.3 cm) tall.

Tools: bone folder; metal ruler; pencil; awl; knife and cutting mat; scissors, needle; cardboard to protect work surface

Materials: 16 sheets of textweight paper, each 6 x 5 inches (15.2 x 12.7 cm), grained short; scrap paper; heavyweight paper, 6½ x 5 inches (16.5 x 12.7 cm), grained short OR textweight paper, 6½ x 10 inches (16.5 x 24.5 cm), grained long, for the cover; waxed linen thread (plain and one or two other colors)

Example: 3 x 5- inch (7.6 x 12.7 cm) book

1. Fold each of the 16 textweight papers in half, widthwise. Nest them in pairs. You should have eight signatures.

2. Make a template for the holes by using a piece of scrap paper that is 5 x 2 inches (12.7 x 5.1 cm) (fold in half, lengthwise, then open), or by working directly with one of the folded pages. On the fold, measure and mark 1 inch (2.5 cm) from head and tail and ½ inch (1.3 cm) from these marks toward the center.

3. Use the awl or needle to poke holes at these four marks. Use the template as a guide to poke holes in all of the folded pages, one signature at a time.

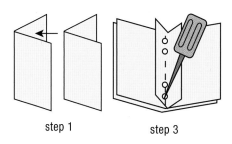

step 1 step 3

Preparing the cover

4. If you are using textweight paper for the cover, first fold it in half, widthwise, to make a cover that is 6½ x 5 inches (16.5 x 12.7 cm). If using heavyweight paper, proceed to step 5.

5. Orient the cover paper horizontally. Measure, mark, and score 3 inches (7.6 cm) from both the right and left edges. This should leave ½ inch (1.3 cm) for the spine.

6. Use the template, or one of the pages from step 2, and measure and mark for the wrapper slits, which will be four horizontal cuts in the covering paper.

7. Use the knife against the ruler and slit the wrapper in those four places.

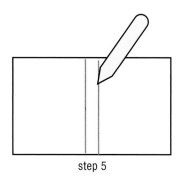

step 5

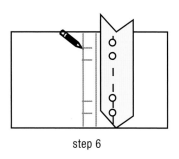

step 6

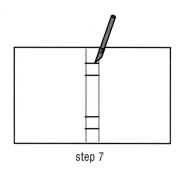

step 7

WORDS OVER WATER: THE 4,832-POUND-BOOK

Tempe Town Lake, Arizona
By typographer Karla Elling, artist Harry Reese, and poet Alberto Ríos

Typography made me do it—and 15 years printing for Arizona State University Creative Writing. The call came: place "story" around a new 2.5-mile-long (4 km) town lake, a $60,000 public art grant. We said we knew how to sandblast words and images into granite, and we got the grant. Six-hundred-four tiles later, I do know about engraved granite, about the resistance of stone to graffiti, and how literary criticism is done on the river—with rocks. If you don't like a rhyme in the kiddy-area, say, "*SOME FISHES / ARE DELICIOUS / BUT WHAT ABOUT / THE FISHES' WISHES*," just smack it. *WOW*, the Words Over Water book is 10 years old. My typography and graphics extend 5 miles on our lake's perimeter wall. Each 8-pound page still looks good—once you scrape off the green heron's literary criticism.

KARLA ELLING

Sewing the signatures to the wrapper

Stack up the signatures. Thread the needle with an arm's length of plain linen thread. You will work with only one set of holes at a time, beginning with the head. We'll call the hole at the end the "head hole" and the hole nearer to the center the "second hole." Later, we'll call the end hole the "tail hole."

8. Begin sewing from the inside of the first signature at the second hole. Leave a 1½-inch (3.8 cm) tail of thread. Sew out the corresponding second cover slit.

9. Sew into the head cover slit and into the head hole of the first signature.

10. Sew back out through the second hole in the first signature and out the second cover slit again.

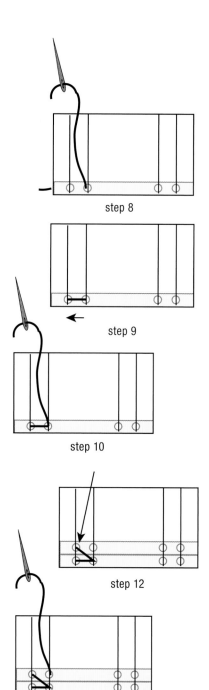

step 8

step 9

step 10

step 12

step 13

11. Sew from the second cover slit into the head cover slit only.

12. Add a new second signature. Sew into the head hole of the new signature.

13. Sew out the second hole of the signature and out through the second cover slit.

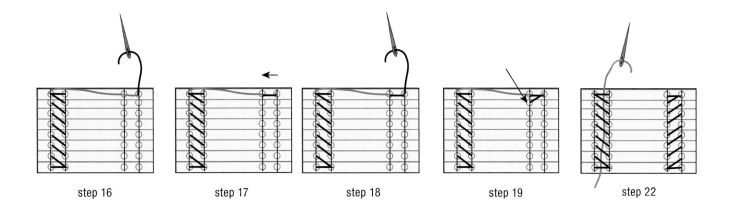

step 16 step 17 step 18 step 19 step 22

14. Repeat steps 11–13 for the remaining signatures.

15. Go back into the head cover slit only.

16. Make a very long stitch inside the cover, sewing from the head cover slit out the tail cover slit.

17. Sew a short stitch across the cover (this one will be visible from the outside) from tail cover slit into the book block at the second tail hole.

18. Sew out the tail hole and tail cover slit.

19. Sew into the second tail cover slit and into the second hole in the next signature.

20. Repeat steps 18 and 19 until you meet the tail of your thread in the very first signature.

21. Tie off the two ends in a square knot. Trim them to ¼ to ½ inch (0.6 to 1.3 cm).

22. To bundle the stitches, thread a needle with a 4 inches (10.2 cm) piece of colored waxed linen and sew under the row of threads. Pull to even out the thread; remove the needle and tie the ends in a square knot. Trim. Repeat for second bundle. The cinched stitches will pull in slightly.

Uses: Book of Hours; books that suggest time, family ties; journal; collection of short stories; poetry book

BUTTONHOLE**STITCH BOOK**

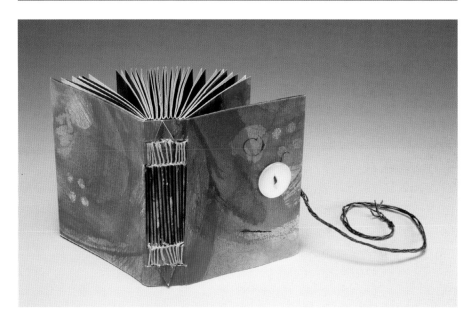

Buttonhole Stitch Model, 2009 (photo: Sibila Savage)

Students brought me versions of this book that they had made in workshops at the San Francisco Center for the Book. I found that a student of Keith Smith's had named it; Keith's version is included in his book *Non-Adhesive Bindings II* (Keith Smith Books, 1995). I prefer that bindings not have threads that wrap over the head and tail—possibly I worry about the wear on the threads as they slide on and off a bookshelf—so I revised this binding to keep the threads on the spine. The stitching takes a bit of practice to get it to look just right.

With the slotted soft cover, the added bonus is a set of decorative triangles at the head and tail. Since the spine is partially revealed, consider using double-sided decorative papers or folding a larger sheet into semi-pocket pages with the folds at the tail. Add a button and string closure (page 220) to further the concept and secure the book.

Tools: bone folder; metal ruler; pencil; knife and cutting mat; glue brush; weight; needle; scissors

Materials: 12 sheet textweight paper, each 6 x 8 inches (15.2 x 20.3 cm), grained long OR 24 sheets textweight paper, each 6 x 4 inches (15.2 x 10.2 cm), grained short; heavyweight paper, 13½ x 4 inches (34.4 x 10.2 cm), grained short; glue thread

Example: 3 x 4-inch (7.6 x 10.2 cm) book

1. If using the 12 sheets, fold them in half widthwise. Eventually, this fold will be at the tail. If using the smaller sheets, skip to step 2.

2. Fold the textweight papers in half, widthwise. Nest and stack the papers so that you have 12 signatures.

Prepare the cover

3. Place the heavyweight paper in front of you horizontally, wrong-side up. Measure 3⅛ inch (8 cm) from the right and left edges, and mark along the top and bottom edges. Using the bone folder against the ruler, score and connect the marks.

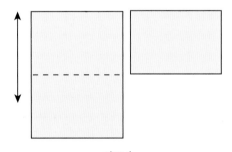

step 1

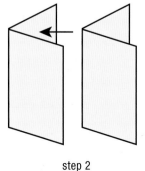

step 2

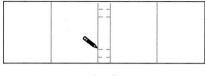

step 5

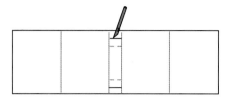

step 6

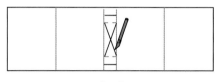

step 6

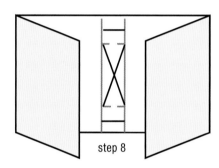

step 8

4. Measure, mark and score 6¼ inches (15.9 cm) from the right and left edges. This should reveal a 1-inch (2.5 cm) spine at the center.

5. Measure and mark at ½ inch (1.3 cm) and at 1 inch (2.5 cm) from the head and tail, along the two center scores.

6. Using a knife against a metal ruler, make a horizontal slit connecting the ½-inch (1.3 cm) marks at the head and another slit at the ½-inch (1.3 cm) marks at the tail.

7. Using a knife against the ruler, cut an X connecting the 1-inch (2.5 cm) marks.

8. Fold in the right and left cover flaps. Trim the ends of the cover flaps or adjust the folds so that the edges do not extend over the middle scores. Use the bone folder to make tight creases.

9. Using the bone folder, crease open the right and left triangles from the X cut.

10. Apply glue to the backs of the triangles, and glue them on top of the edges of the cover flaps.

11. Fold over the head and tail triangles from the X cut, opening the rectangle in the spine. Crease tightly with the bone folder.

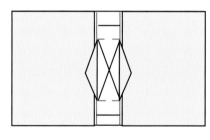

step 9

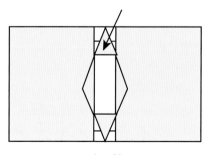

step 10

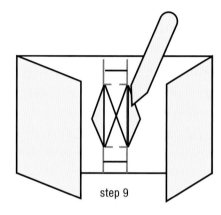

step 11

12. Tuck the tips of the triangles into the slits ½ inch (1.3 cm) from the head and tail.

13. Apply glue to the back of the triangles, and press to the outer spine. Let dry a few minutes under a weight.

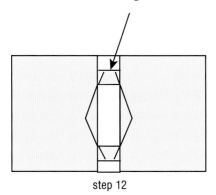

step 12

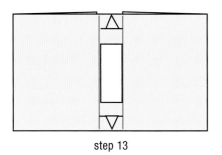

step 13

Sew the book block into the cover

14. Poke holes in each signature or folded page along the valley fold at ½ inch (1.3 cm) and 1 inch (2.5 cm) from the head and tail.

15. Stack the 12 signatures so that their spines are facing you.

step 14 step 15

16. Cut 24 inches (61 cm) of thread, and thread the needle so that you can sew easily with a single strand. Begin with the bottom signature (we'll call it the first signature). Put the first signature inside the cover.

17. Sew in through the second hole at the head of the signature and out the rectangular hole in the cover. Leave a 1½ inch (3.8 cm) tail of thread.

18. Sew into the head slit of the cover and into the corresponding head hole of the signature.

19. Tie the threads in a square knot inside before proceeding. Do not cut.

20. Sew out the second hole in the first signature and through the rectangular opening again.

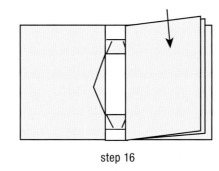

step 16

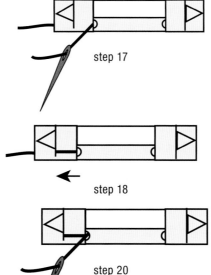

step 17

step 18

step 20

21. Take the needle under the first stitch, and make a half-hitch knot by bringing the needle through the loop of thread. Tighten at the base of the first stitch.

22. Sew into the head slit (next to the stitch already there) and into the head hole of the second signature.

23. Sew out of the second hole and out the rectangular opening in the cover.

24. With the needle pointing toward the head, take the needle underneath the knot from step 21 and bring the needle up between the two threads.

25. Sew into the second hole of the third signature.

26. Sew out the head hole and head slit in the cover of the third signature.

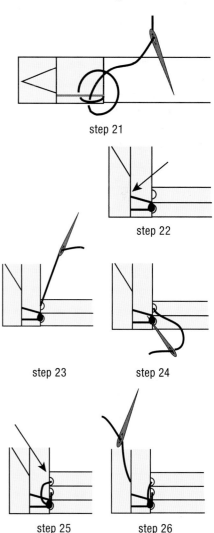

step 21

step 22

step 23 step 24

step 25 step 26

27. In two steps, pulling snugly after each, take the needle under the knot (between the first and second stitch), then under the second stitch (between the second and third stitches).

28. Sew into the second hole of the fourth signature.

29. Sew out the head hole and head slit of the fourth signature.

30. In two steps, pulling snugly after each, take the needle under the linked stitch, then under the third stitch. Pull parallel to the spine, then over perpendicular to it. With your thumbnail or the end of the needle, adjust the stitches so that they are all parallel and aligned, if they aren't already.

31. Sew into the second hole of the fifth signature.

Note: The fifth, sixth, seventh, and eighth signatures will all pierce the triangle when they come out of the head slit. You may choose to go around it, if you like.

32. Repeat steps 29 and 30 as you add signatures.

33. At the 12th signature, after linking the stitch (step 30), go back into the second hole of the 12th signature.

34. Tie off the thread by looping under the stitch inside the 12th signature and taking the needle through the loop in a half-hitch knot. Trim the end to about ¼ inch (0.6 cm).

35. Repeat steps 16–34 with a second thread and the holes and slit at the tail.

Variation: Make with origami wallet pages (see page 195).

Uses: journal; guest book; sketchbook; baby book, book about all the extra buttons that come with new clothes

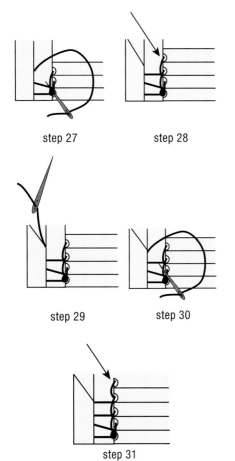

step 27 step 28

step 29 step 30

step 31

COPTIC**STITCH/CURVED NEEDLE**

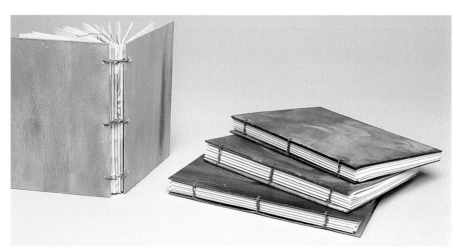

Coptic Curved Needle Models, 1996; each approximately 4 x 5 inches (10.2 x 12.7 cm) (photo: Jim Hair)

I was inspired to learn this binding after seeing Elsi Vassdal Ellis's miniature, *Dear El Lissitzky*. Her book is actually the Coptic with paired needles (see next project). This traditional book has a flexible spine, unsupported by paper or boards, just connected by threads. If you only use two holes, make it small; or add more holes to support a larger book. An advantage is that you can use any number of holes, odd or even. Note that linked stitches will be at the ends, a chain stitch will appear across the middle. Curved needles may be found in quilting sections of fabric or craft stores.

Tools: ruler; pencil; awl; curved needle; scissors

Materials: 14 to 28 medium-weight to heavyweight papers, each 5½ x 8½ inches (14 x 21.6 cm), grained short; 2 museum or Davey boards, each 5¾ x 4½ inches (14.6 x 11.4 cm), grained long; waxed macramé or other waxed linen thread

Example: 5¾ x 4½-inch (14.6 x 11.4 cm) book with three holes

1. Fold the 5½ x 8½-inch (14 x 21.6 cm) pieces in half, widthwise. Nest into sets (signatures) of two to four pages per signature, depending on the thickness you chose. Make five to seven signatures.

2. Stack the signatures, one atop the other, with the spines facing you. Measure for three holes along the spines, leaving at least ¼ inch (0.6 cm) but no more than ½ inch (1.3 cm) from (what will be) the top and bottom edges. You can just mark one of your signatures, then put it back atop the others.

3. With the stack even, draw straight lines down the folds where you marked the first signatures, so that when you sew, the signatures will align.

4. Poke holes with your needle at these lines on each signature, taking care to keep the orientation the same so the signatures will still align when you put them back together.

5. Poke three holes in your cover boards as well, ¼ inch (0.6 cm) from the left (front board) and ¼ inch (0.6 cm) from the right (backboard).

6. Place the boards, top and bottom aligned, to surround your signatures.

7. Treating the top board and the first signature as one unit, pick these up.

Begin to sew

8. Thread a needle with a length of waxed thread that is the height of the book (from head to tail) multiplied by the number of signatures.

9. Sew into the end hole from inside the first signature to outside. Leave a tail of about 3 inches (7.6 cm).

10. Sew through the first hole in the board from underneath, then come around the edge of the board and back through the same first hole in the signature.

11. Sew to the second hole in the signature, come out, go through the second hole in the cover, and go back through the second hole in the signature.

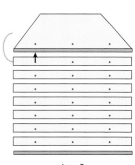

step 9

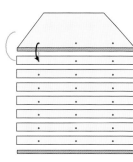

step 10

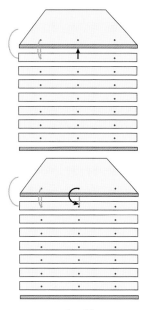

step 11

12. Sew out the third hole in the signature.

13. Go through the third hole in the cover and back into the third hole in the signature. Tie off inside by making a half-hitch knot around the stitch inside the signature. Do not cut the thread.

14. Come out the third hole of the first signature, loop under the stitch above it (between the signature and the board), and sew into the last hole in the second signature.

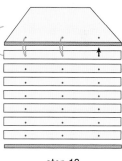

step 12

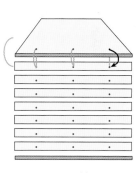

step 13

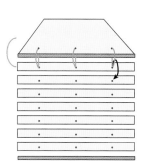

step 14

15. Go out the middle hole of the second signature. Here's the chain part: take your needle under the stitch between the board and the first signature. (Don't try to go through the loop; go under both ends of the loop.) Then go back into the middle hole of the second signature.

16. Proceed to the third hole, going under the last stitch between the first signature and the board. Instead of going back into the third hole, add the third signature and go in the last hole there.

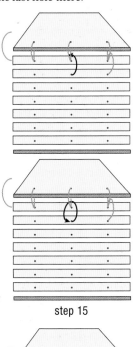

step 15

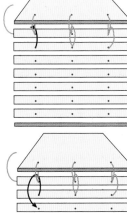

step 16

17. Repeat this pattern (out of a hole, loop, back into same hole or adding a signature) with the rest of the signatures.

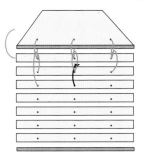

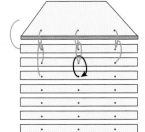

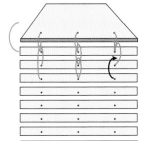

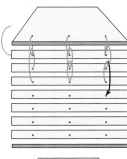

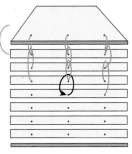

step 17

Attach the last board

18. Come out the last hole of the last signature, and loop under the previous stitch.

19. Go through the matching hole in the back cover.

20. Sew back into the hole in last folded page of the book.

21. Sew out the center hole, go through the matching hole in the cover, loop under the stitches, and sew back into the center hole.

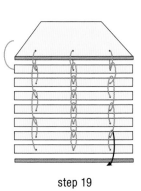

step 19

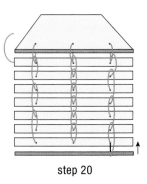

step 20

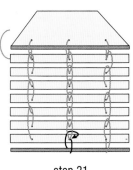

step 21

22. Sew out the last hole, go through the matching hole in the cover, loop under the stitches, and go back into that last hole in the signature.

23. Make a half-hitch knot connecting the end of the thread to the stitch inside.

Note: You will notice that the last section has one knot and doubled stitches inside. The first section has two knots and single stitches.

Variation 1: First, quickly paint both sides of your two boards, using acrylic paints sparingly, straight from the tube or squeezed out onto a paper towel with no water added. Paint the edges as well. The boards should dry within a few minutes.

Variation 2: Glue decorative paper to the front and back of the boards, wrap in waxed paper, and press under a heavy weight overnight before sewing.

Uses: travel journal; guest book; scrapbook; photo album; text about things that are linked

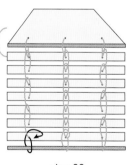

step 22

COPTIC**WITH ACCORDION**

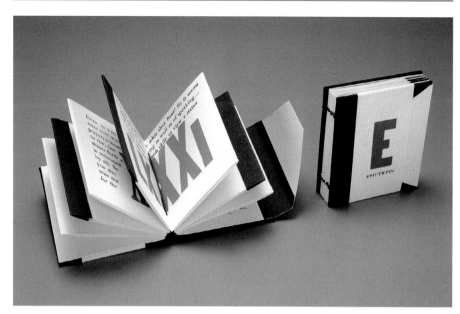

Once Said a Stoic: Epictetus, 2003; letterpress from wood and metal type; edition of 41; Coptic with accordion; 2½ x 3 inches (6.4 x 7.6 cm) (photo: Sibila Savage)

The lovely thing about making a Coptic binding with an accordion is that the pages are doubled so they are thicker, which means you need fewer of them, which means that you can complete the book sooner, which means not exactly instant gratification, but very close. On the other hand, an accordion makes the pages spring open, so you need to have a closure for this book. *Once Said A Stoic: Epictetus* utilizes a flap tucked into a strip of paper. You can also use ribbons.

Tools: piece of board or brush for gluing; paper plate to decant PVA; heavy book or weight; pencil; metal ruler; knife and cutting mat; awl; corrugated cardboard; needle; scissors

Materials: two 4-ply museum boards, each 2½ x 3 inches (6.4 x 7.6 cm), grained long; 2 pieces book cloth or lightweight paper, each 3½ x 4 inches (8.9 x 10.2 cm), grained long; magazines for scrap paper; PVA; medium-weight to heavyweight cover strip, 1½ x 4 inches (3.8 x 10.2 cm), short is preferable but long will work; waxed paper; 3 pieces of heavyweight paper, each 3 x 10 inches (7.6 x 24.5 cm), grained short; 1 piece of heavyweight paper (same kind of paper as previous piece), 3 x 12¼ inches (7.6 x 31.1 cm), grained short; 3 strips lightweight or medium-weight paper, each 1 x 4 inches (2.5 x 10.2 cm), grained long; waxed linen thread

Example: 2½ x 3 x ½ inch (6.4 x 7.6 x 1.3 cm) book

1. Cover the boards with the book cloth or lightweight paper. (See page 209 for Covering Separate Boards.)

2. Center the cover strip on the covered side of one of your wrapped boards both top and bottom and side to side. Fold over the excess at the top and bottom.

3. Apply glue to the folded-over flaps, one at a time, and press into place on the back of the wrapped board. Hold them firmly for at least 20 seconds so the glue has time to bond.

4. Wrap both boards in waxed paper, and set them flat under a heavy book or weight.

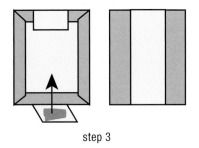

step 3

Folding the accordions

5. Fold the three shorter pieces of heavyweight paper (undecorated sides together, if applicable) in half, widthwise.

6. Fold each end back to the middle fold. When looking at it from the front, you should see the folds as valley, mountain, valley.

7. Orient the 3 x 12-inch (7.6 x 30.5 cm) piece of heavyweight paper horizontally, wrong-side up; measure, mark and score a line at 10 inches (25.4 cm) from what would be your left edge.

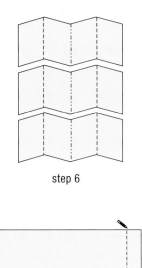

step 6

step 7

8. Fold the right edge at the scored 10-inch (25.4 cm) mark.

9. Keeping the right edge folded, take the left edge and align and crease it with the right (now folded) edge.

10. Fold the ends back to what now looks like the center fold, pretending the extra folded flap is not there. You should have an accordion with four equal panels and a fifth smaller panel. The latter will be your wraparound flap.

11. Open the accordion. Measure, mark and score ½ inch (1.3 cm) to the right of the 10-inch (25.4 cm) mark. The ½-inch (1.3 cm) panel will be the fore edge.

12. From the top and bottom of the right edge of the paper, measure and mark 1 inch (2.5 cm).

13. Using a knife against a metal ruler, make two diagonal cuts from these marks to the top and bottom of the first fold on the left.

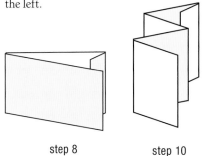

step 8 step 10

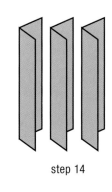

step 11

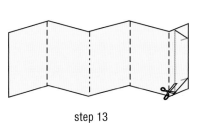

step 13

Attaching the accordions to each other with tabs

14. Fold the three 1 x 4-inch (2.5 x 10.2 cm) strips in half lengthwise.

15. Try working with the glued edge facing you so you can see it. Allow a tiny bit of space between the accordions as you work. Completely apply glue to one strip and press one-half to the end of one accordion and one-half to the beginning of the next one. The accordion with the diagonal cuts is last. Fold the top and bottom of the strip over the edges of the accordions and smooth down.

16. Apply glue to each strip, one at a time, and attach the remaining accordions in the same manner as step 15.

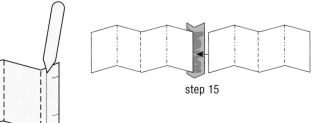

step 14

step 15

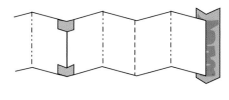

step 16

Preparing the covers and the accordion for sewing

17. Retrieve the covers from under the weight. On the front cover, measure ½ inch (1.3 cm) down from the head and up from head and ¼ inch (0.6 cm) from the spine, or left edge.

18. Put down some thick corrugated cardboard to protect your work surface. Use the awl to poke two holes at each penciled intersection.

19. Align the back cover with the front cover, wrong sides together. The back cover will have its exposed board facing up, the cloth facedown. Using the front cover as a template, poke two holes in the back cover as well.

20. Place the accordion with the spine toward you, the strips and flap away from you. Measure and mark ½ inch (1.3 cm) from the head and tail. These marks should be aligned with the holes in the covers.

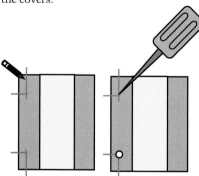

steps 17 & 18

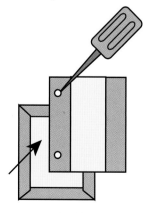

step 19

21. With your knife, lightly cut a shallow vertical slit down in each of the folds of the accordion. Use a needle to poke through and open up the holes, if necessary.

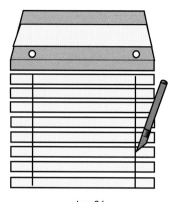

step 21

Sewing pattern

What makes this easier to sew than some multiple-signature bindings is that the pages are connected already, eliminating the need for clips.

22. Cut a 30-inch (76.2 cm) length of thread (approximately one length per folded edge). Pull the thread through the needle to make it a manageable length (about 18 inches [45.7 cm]). You will still use a single strand, however.

23. From the inside of the first fold, sew out one hole, go through the corresponding hole in the cover, and leave a 2-inch (5.1 cm) tail inside the folded paper of the book.

24. From the cover hole, go back into the same hole in the folded paper. Tie a square knot with the tail that was left inside.

25. Sew out the other hole of the fold, and go through the corresponding hole in the cover; this time, tie the knot around the inside stitch.

26. Go back out the same hole.

27. Sew into the corresponding hole on the second folded edge and come out the other hole.

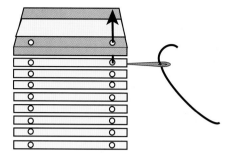

step 23

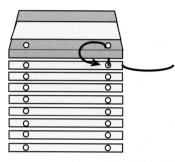

step 24

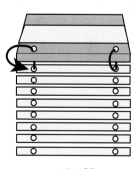

step 25

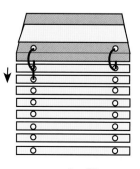

step 27

28. Take your needle under the stitch above it and sew into the first hole of the third folded edge.

29. When you come out the hole in each section (with the exception of the final hole), keep looping under the previous stitch until you have linked all eight folded edges.

30. Come out the final and last hole and loop under the previous stitch.

31. Go through the matching hole in the back cover and back into the hole in last folded page of the book.

32. Double back to the next-to-last hole, come out, loop around.

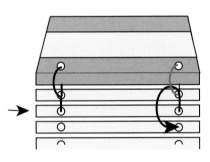

step 28

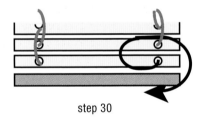

step 30

step 31

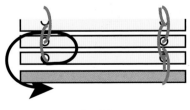

step 32

33. Go through the hole in the cover and back into that next-to-last hole.

34. Tie off the ends inside the book into a square knot.

Note: You will notice that the last section has one knot and two strings inside. The first section has two knots and one string.

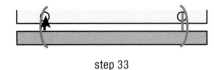

step 33

Gluing the ends to the boards

35. Place a sheet of scrap paper between the first and second pages (the cover does not count as a page).

36. Apply glue completely to the back of the first page.

37. Align the page with the front cover, and press it into place. Move it a little, if you need to, to make sure it is truly aligned. Let dry.

38. Repeat steps 35–37 for the back cover.

39. When the book is dry, you should be able to tuck the diagonal flap into the cover strip to hold the book securely closed.

40. Add a title to the front cover strip and to the fore edge panel on the flap if you haven't done so yet. Note: if tearing occurs at the fore edge panel folds, you may reinforce this section by gluing down a 1 x 3½-inch (2.5 x 8.9 cm) strip of decorative paper aligned with the height of the book and centered over the folds.

Variation: Measure for an even number or holes and sew as for a Coptic with Paired Needles (see next project).

step 36

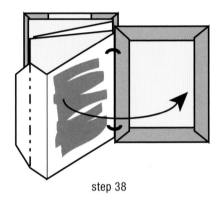

step 38

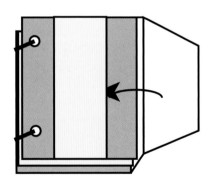

step 39

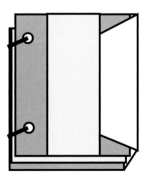

COPTIC**WITH PAIRED NEEDLES**

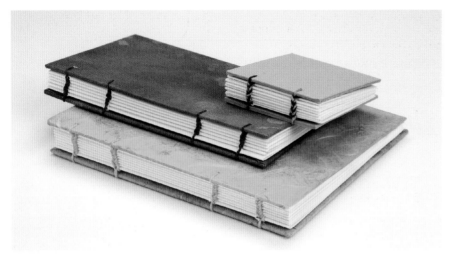

Coptic with Paired Needles Models, 2009
(photo: Lark Books)

The stitching for this Coptic binding makes a herringbone pattern across the spine at all sewing stations. For this version, the sewing stations must be in pairs, with a needle for each hole. A miniature book might have two holes (two needles); a book up to 8 inches (20.3 cm) tall might have four holes (four needles); books larger than 8 inches (20.3 cm) tall must have six or more holes to support the signatures (six or more needles). The instructions given are for four holes and four needles. Many variations on this theme may be found in Keith Smith's book *Exposed Spine Sewings* (Keith A. Smith Books, 1995).

To calculate thread for four needles, measure the height of the book. Multiply the height by the number of signatures plus three (the height of two covers plus an extra to make sure you will not run out). Cut the thread in half, and use one-half for each set of needles. Since one thread is used per set of holes, you may choose to have a different color of thread per pair of needles.

For a more finished appearance, cover two 4-ply boards with paper or book cloth, as per the instructions for Covering Separate Boards on page 209.

Tools: pencil; ruler; awl or punch and hammer; cardboard to protect table; 4 needles; scissors

Materials: two 4-ply boards, each 3½ x 5½ inch (8.9 x 14 cm), grained long; 16 to 24 sheets of textweight paper, each 6¾ x 5¼ inches (17.2 x 13.3 cm); waxed linen thread

Example: 3½ x 5½ inch (8.9 x 14 cm) book

1. Orient the front cover board vertically. On the back, measure and mark ¼ inch (0.6 cm) from the right edge (this will be the spine edge) at the head and tail.

2. Align the ruler with the two pencil marks. Measure and mark ½ inch (1.3 cm) from the head and tail. Measure and mark 1½ inch (3.8 cm) from the head and tail. Using the awl, poke holes at these four places.

3. Align the back cover with the front cover, backs touching. From the front, poke through the front cover holes, piercing the back cover this time.

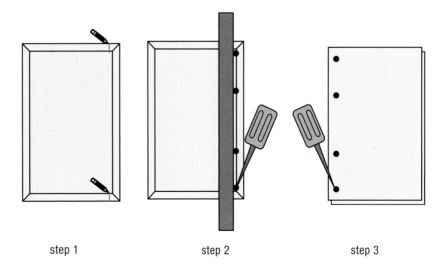

step 1 step 2 step 3

4. Separate the covers. Use the awl to make sure the holes on the back cover are opened wide enough for the needles to pass through.

5. Fold all of the textweight pages in half, widthwise. Nest into sets of two or three, making eight signatures total.

6. Using one of the covers as a guide, place it just behind the fold in one of the signatures. Punch holes into the fold, directly aligned with the holes in the cover.

7. Remove the cover. Use the punched signature as a template for the remaining signatures.

8. Thread four needles, two with one thread, two with the other thread (approximately 30 inches (76.2 cm) each; see the introductory paragraph for more information).

Tip: As you sew, carefully make sure the stitches are snug, but be gentle so you don't rip the paper; pulling perpendicular to the spine is helpful.

9. Working with the spine, or folded edge, facing you, from the inside of one signature, take each needle through its corresponding hole. The needles will dangle down in front of you. It helps to work at the edge of the table and rest your hand inside the signature.

10. From inside to outside, take each of the needles through the corresponding holes in the back cover.

11. Sew all four needles into their respective holes in the signature.

12. Each pair of needles now crosses to its pair's hole and comes out the opposite holes in the signature. This makes what looks like double stitches inside the signature.

13. In the direction of the head, take the first needle under the stitch between the cover and the signature, under the stitch there, and out again. Take the second needle in the direction of the tail, go under the stitch and out again. Take the

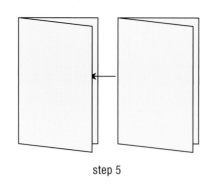

step 5

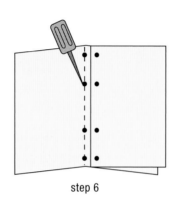

step 6

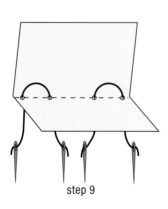

step 9

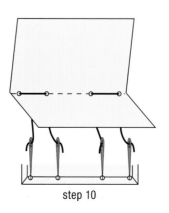

step 10

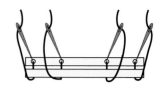

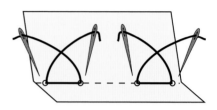

step 11

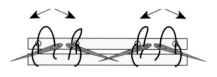

step 12

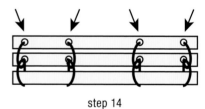

step 13

step 14

third needle in the direction of the head, go under the stitch and out again. Take the fourth needle in the direction of the tail, go under the stitch and out again.

14. Take each needle into the corresponding hole in the second signature.

15. Cross the needles over and come out the opposite holes, as you did in step 12.

16. Link under the stitches between the cover and the signature, as you did in step 13.

17. Add the third signature, sew into the corresponding holes, cross over, come out again.

18. From now on, make your links under the stitches between the two preceding signatures (as you would for a kettle stitch, if you are familiar with the kettle stitch). Again, alternate making the links toward the head, tail, head, tail, as you did in step 13.

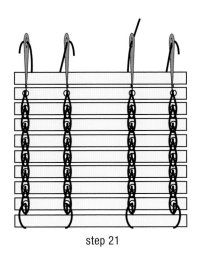

step 18

Tip: You can open the pages to locate the needle between the signatures.

19. Continue adding signatures, sewing across and linking under the stitch between the two previous signatures until you have crossed and come out of the final signature.

20. Sew from inside to outside through the corresponding holes in the front cover.

step 21

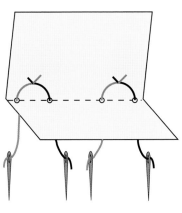

variation 2

21. Sew back into the corresponding holes in the signature.

22. Tie off each of the four threads inside to the closest stitches. Tie again for double knots. Trim ends to ¼ to ½ inch (0.6 to 1.3 cm). You will have four knots this way. Alternatively, tie the ends together for two knots; three threads will then show in each stitch.

Variation 1: Sew from front cover to back cover so the knots are at the last signature instead of at the first.

Variation 2: Instead of using one continuous thread for each pair of needles, tie two colors of thread together in a square knot, then treat them as one, centering the knot inside the signature. By adding more colors, the herringbone pattern becomes more pronounced.

Variation 3: Make the holes, or sewing stations, at unequal intervals.

Variation 4: Omit the covers. Start inside the first signature, then go directly into the second signature. Cross the needles, come out the second signature, and go into the third signature. Start linking when you come out of the third signature.

Uses: sketchbook; address book; notebook; book about being vulnerable

COPTIC **WITH FOLD-OUT PAGES**

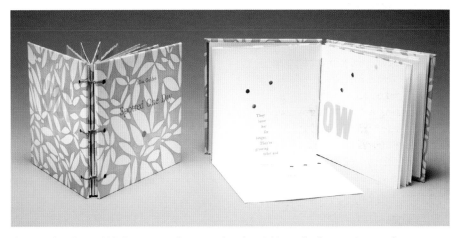

Spotted One Day, 2009; letterpress from wood and metal type, linoleum cuts, one drawing printed from photopolymer plate; edition of 30; Coptic with curved needle; 5¼ x 5⅛ inches (13.3 x 13 cm)

Inspired by the flaps and fold-outs in *The Crocodile Blues* (Candlewick Press, 2007), a children's book by Coleman Polhemus, I created *Spotted One Day*. It makes use of the fold-outs not so much to advance the story but to change the pacing, set a mood, and to create wordplay; *hold* becomes *old* as the flap is lifted, for example. Since I printed the linoleum cut of the leaf pattern on both sides of the pages and I wanted the leaves to be seen,

I chose the open spine Coptic binding. Create several sets (two or more) of the pages that follow, then sew them with either of the Coptic binding styles.

Tools: metal ruler; bone folder; pencil; knife and cutting mat

Materials: 1 piece of medium-weight or heavyweight paper, 10 x 15 inches (25.4 x 38.1 cm), grained long

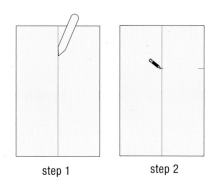

<div align="center">step 1 step 2</div>

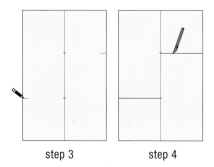

<div align="center">step 3 step 4</div>

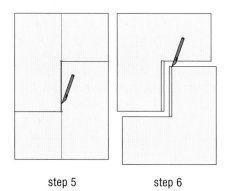

<div align="center">step 5 step 6</div>

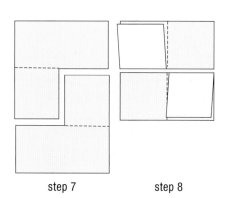

<div align="center">step 7 step 8</div>

Example: two 5 x 5-inch (12.7 x 12.7 cm) pages, closed, with one flap on each page

1. Orient the paper vertically. Measure, mark and score a line in the center of the paper parallel to the grain. (In this case, it is at 5 inches [12.7 cm]).

2. Measure and mark a dot one-third of the way down the score (5 inches [12.7 cm] again). Also measure and mark down one edge, parallel to the score.

3. Measure and mark a dot one-third of the way up the score (5 inches [12.7 cm]) and up the opposite edge from step 2.

4. With the knife against the metal ruler, cut from each center mark to each edge mark.

5. Again using the ruler and knife, connect the two center dots.

6. Trim ⅛ inch (0.3 cm) from each of the edges you cut out in step 5.

7. Fold down this flap on one page, fold up the page on the other. These folds are against the grain.

8. Fold each page in half, parallel to the grain.

Uses: these folded pages add dimension to any codex-style book

ALTERED**BOOKS & HIDDEN OBJECTS**

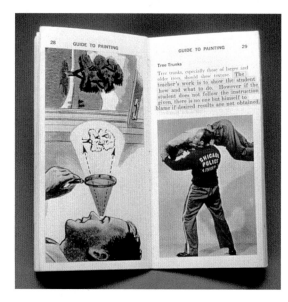

Lisa Kokin: *A Guide to Painting*, 1999; mixed media, altered book; 3 x 5¾ x 3 inches (7.6 x 14.6 x 7.6 cm) (photo: J.W. White)

There is a collaborator out there waiting for you. You don't have to get along. You probably won't ever meet. He or she is the author of an already published book, perhaps a third edition or damaged reprint of no monetary value. Here is a theme, perhaps a collection of characters or theories. Someone has started your project for you; you are not faced with a blank page.

For three and sixpence, Tom Phillips bought a book published in 1892 called *A Human Document* by William Hurrell Mallock. In 1966, Phillips began altering the book. Inspired by William Burroughs's technique of cutting up writing and rearranging text, Phillips began painting out and over much of the text of the old book, leaving only certain phrases made up of the text found there. The altered book, which he called *A Humument* (Thames & Hudson, 1980,

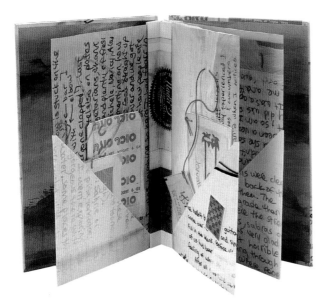

Sugar with That, 2004 from saved material from 1978; color copies, photocopies, acrylic ink and gesso; single flag book with pocket pages; 4½ x 7 inches (11.4 x 17.8 cm) (photo: Sibila Savage)

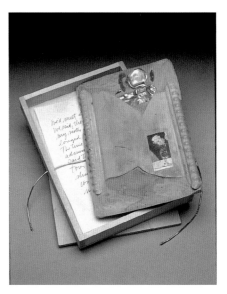

Anne Hicks Siberell: *The Day Before Yesterday's Ancient Tablets: We'd Meet at the Met*, 1980s–present; cement, wood, mixed media; 8 x 6 x 2 inches (20.3 x 15.2 x 5.1 cm) (photo: Gary Sinick)

If you don't want to alter the material you have or it is too bulky to be inside a book, consider scanning or photocopying it and using the copies. For my book *Sugar with That*, I made color copies of sugar packets I had saved from a trip to Israel, then photocopied pages from my journal to use in the book as well. I knew I had kept that bag of stuff around for a reason.

4th edition 2005), was first published by a commercial press in 1980 in a mass-market edition. Tom Phillips writes an acknowledgment to W.H. Mallock, his "unwitting collaborator."

Content is suggested; a theme is waiting to be discovered. If you live near a used bookstore, ask if they have a box of books they are going to throw away. Many times a book just needs a few repairs but is currently unsalable, so it gets discarded; you might get a book that was headed for the landfill, so you need not feel guilty revising it. Go to a garage sale and get old textbooks or other dry material that you can enhance.

Altering a book is another way of working with found material. Lisa Kokin uses thin strips of shredded money to block out lines of text. Sometimes she collages images on top of the pages, such as what she did for the old 1950s book called *A Guide to Painting* (see page 184). She also stitches over lines of text and provocatively chops books into thin slices.

Sometimes you can find one book inside another. Alastair Johnston is a letterpress printer and book artist who paired various words to make meaning in a book called *Cafe Charivari Charlatan Chrom* (Poltroon Press, 1975). The title itself is found text. He writes, "The idea came to me one night while looking through a German/English dictionary and reading the running heads. A simple pairing like *Pound* and *Prattling* made me think of Ezra Pound and his declining reputation. *Preengagement* because it is not hyphenated, made me think of *Preen* and preening for a date. I realized other people would bring their own associations to random phrases, too, so I made a quick list and set it in metal type. I don't remember why I left one page blank. The final page *Joe* and *Louis* was a list of boys' names, and of course Joe Louis was a famous boxer. It seemed profound at the time. Then there's all that blank space underneath that the owner of the book can use as a notebook or address book.

Anne Hicks Siberell created book objects from discarded materials for her series *The Day Before Yesterday's Ancient Tablets*. She used wet concrete to embed found objects that served as a kind of diary or "memory jogs" to her. Her house was built before there was a regular garbage pickup service so that the backyard was rather like a dump. She found shards of all kinds of things; her kids found old toys. She told me that she assembled objects that reminded her of personal stories in the form of Babylonian clay tablets. She wrote, "Symbols and souvenirs form a kind of language."

We use language so we can understand each other. When you work with discarded books and found materials, it may be tempting to glue or stitch together many things that interest you, but try thinking about what idea you might like to communicate and use only the materials that further that message. The more layers of meaning you can incorporate into your book, the more successful both visually and conceptually it is likely to be.

LIFE INTERSECTS ART

Inspiration for my books comes from gathering the things around me that I love—a teacup, a shell, even a recipe for meatballs. When I focus on the familiar, I find an unending supply of subjects. My book *Meatball Math* chronicles the number of meatballs I make in one year. The book is a circular form because meatballs are round and cooking them is a continual process. The book also folds up into a house shape to fit into its enclosure. While everyday life is an inspiration, I try to make the themes broad, so that viewers will bring their own experience to the book.

ALICE AUSTIN

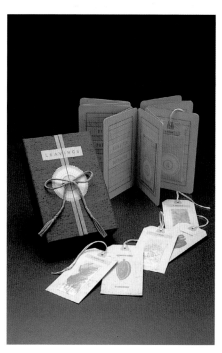

Julie Chen: *Leavings*, 1995; letterpress printed from photopolymer plates; edition of 100; 4¼ x 6½ inches (10.8 x 16.4 cm), stretches out to 51 inches (1.3 m); box is 7 x 5 x 1⁵⁄₈ inches (17.8 x 12.7 x 4.1 cm) (photo: Sibila Savage)

ENVELOPES & PORTFOLIOS

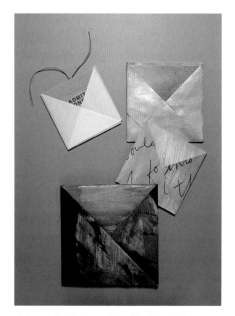

Origami Pocket Envelope Models, 2004; acrylic inks and gesso (photo: Sibila Savage)

ORIGAMI POCKET ENVELOPE

My mother gave me some stationery that was displayed in this pocket. I promptly removed the stationery and set it aside, then unfolded the pocket to find out how it was made. The pocket makes a nice slipcase for the Ox-Plow Pamphlet or the Origami Pocket Pamphlet. If you use different dimensions, make sure that the pocket is ¼ inch (0.6 cm) larger than the book it will hold.

Tools: bone folder; scissors

Materials: 1 piece of medium-weight to heavyweight paper that is four times as long as it is wide, grained short, 4½ x 18 inches (11.4 x 45.7 cm) for this example

Example: 4½-inch (11.4 cm) pocket envelope

1. Place paper horizontally on the work surface.

2. Fold paper in half, widthwise. Keep closed.

step 2

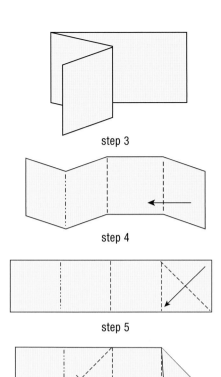

step 3

step 4

step 5

step 6

step 7

step 8

step 9

step 10

3. Take a single layer and fold it back to the first fold. Open.

4. Bring the other end to that center fold (gate fold). Open completely.

5. On the right square, fold down the top edge to form a triangle by aligning the top edge of the paper with the rightmost fold.

6. On the second square from the left, fold down another diagonal, making the total shape resemble a peaked roof of a house with a flat top. Do this by aligning the top edge of the paper with the center fold. This diagonal will have a square attached to it.

7. Fold up the square, covering the new diagonal.

8. Valley-fold the section on the left toward the triangle on the right. Make sure that the open right edge of the folded section does not extend over the valley fold of the flat section. If the folded section protrudes, you may need to nudge the folded section back toward the left and re-crease it. In all cases, when this section folds over, a triangle will be visible on the left.

9. Tuck the right triangle and into the triangle on the left. If the triangle doesn't fit neatly, open the project and adjust the folds so that they are aligned. If they still don't fit neatly, you may trim the right edge of the square flap or cut off a bit of the right triangle's point. Tuck it back together.

10. Slide a book or note into the pocket.

FOLDED**ENVELOPE**

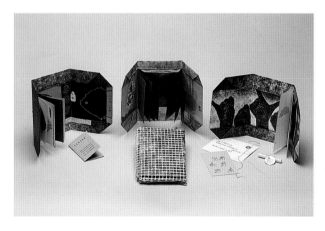

Catching a River: Delta, Dreamfish, The Island, 1993; letterpress, linoleum cuts, pressure printing, mixed media; edition of 40; folded envelope covers; 4¹⁄₈ x 6¹⁄₈ inches (10.5 x 15.6 cm) (photo: Jim Hair)

I used this envelope style as covers in the set of three books titled *Catching a Rive*r. I adapted it for a cover after Anne Schwartzburg (now Anne Stevens) mailed me a flyer folded up this way.

Tools: ruler, pencil, bone folder

Materials: medium-weight paper, 8½ x 11 inches (21.6 x 27.9 cm)

Example: 3¾ x 6½-inch (9.6 x 16.5 cm) envelope

1. Put paper in front of you horizontally (landscape orientation).

2. From the top left corner, measure 2 inches (2.5 cm) down and 2 inches (2.5 cm) to the right. Mark with a pencil.

3. Repeat for the other corners.

4. Fold up the corner so it touches the pencil mark.

5. Repeat for all four corners and pencil marks.

6. Bring up the bottom edge and fold it over 1 inch (2.5 cm), aligning the edge with the bottom two pencil marks, making an even straight line.

7. Repeat step 6 for the top edge.

8. From the left and right, fold the paper into thirds. Tuck one flap into the other and crease down.

Variation: Sew a single signature into the fold.

Uses: book cover; self-folding letter; prospectus for a book

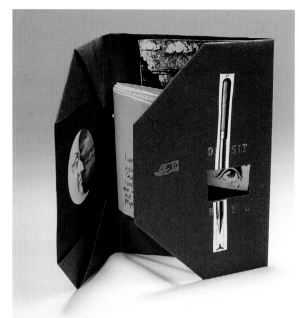

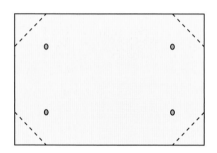

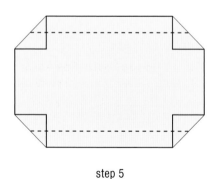

step 5

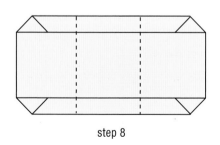

step 8

BOX **OF CIRCLES**

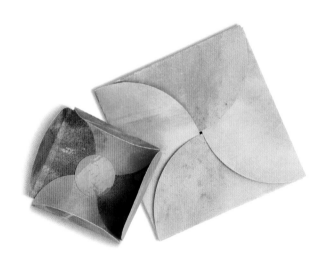

Box of Circles Models, 2009 (photo: Lark Books)

I adapted the idea for a box of circles from a circle envelope in *Gift Wrapping: Creative Ideas from Japan* (Kodansha International, 1987) by Kunio Ekiguchi. The box will hold a thicker book than the envelope. If you don't have a circle cutter, draw around a cup with a pencil, then use a knife to cut out the circle.

Tools: triangle; pencil; ruler

Materials: 4 circles of medium-weight or heavyweight paper (use two of one color and two of another to emphasize the pattern); glue or glue stick

To make an envelope

1. Fold equal-sized circles in half. Open.

2. Arrange the circles so that the valley folds make a square, overlapping in sequence. You may need to use a small triangle to ensure that you have 90° angles. Glue down the edges. When you reach the last circle, glue it under one circle and over another.

3. With valley folds up, fold over the flaps of each circle. When you reach the fourth circle, tuck it into the first one.

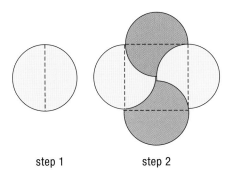

step 1 step 2

To make a box

1. Fold four equal-sized circles in half.

2. Measure ⅛ inch (0.3 cm), or ¼ inch (0.6 cm) for a thicker book, from the fold and fold the circles again. Each circle will now have a centerfold and an off-centerfold, making a shorter flap and a longer flap.

3. Arrange the folded circles with the off-centerfolds (the shorter flap) to make the square. You may need to use a small triangle to assure that you have 90° angles. There will be a small space in the center.

4. Glue down one circle at a time in rotation, as for the envelope, steps 2 and 3.

5. Glue a very small circle inside the box, over the hole in the middle.

Uses: container for a book with a circular theme such as a list of birthdays; the cycle of the seasons; merry-go-rounds; paying bills

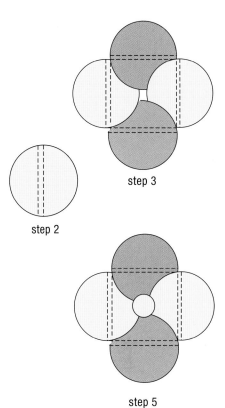

step 2

step 3

step 5

WINDOW**ENVELOPE**

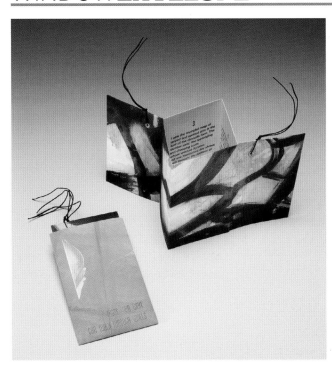

Those Who Wait Can Walk Through Walls, 2008; acrylic painted paper, letterpress, frosted polyester film, linen thread, eyelets; edition of 15; X-book and window envelope; 3 x 4¾ inches (7.6 x 12.1 cm) (photo: Sibila Savage)

This simple envelope can be used to hold small folded books or cards. You can easily make the window any shape you like. *For Those Who Wait Can Walk Through Walls*, I wanted to make the butterfly-inspired book come out of a chrysalis-like envelope, so I cut out the chrysalis shape and used frosted polyester film for the window. Look at different kinds and colors of polyester film and acetate for other inspiration for your window envelope.

Tools: metal ruler; pencil; bone folder; knife and cutting mat

Materials: lightweight or medium-weight paper, 10¾ x 6½ inches (27.3 x 16.4 cm), grained long; 1 piece of polyester film, 3 x 5 inches (7.6 x 12.7 cm); scrap paper

Example: 3¼ x 5 inches (8.3 x 12.7 cm)

1. With the paper wrong-side up, fold the paper in half, widthwise. Keep closed. Orient the fold at the top.

2. Measure and mark 1¾ inches (4.4 cm) from the right edge, top and bottom.

3. Score a line, connecting the marks.

4. Measure and mark 1½ inches (3.8 cm) from the left edge, top and bottom.

5. Score a line, connecting the marks.

6. Measure and mark ¾ inch (1.9 cm) up from the open, bottom edge on the right and left sides.

7. Score a line, connecting the marks.

8. Cut out a shape for the window in the center panel, cutting through both layers.

Note: The folded edge will eventually be the opening of the envelope, so keep that in mind as you decide the placement and shape of the window.

9. Using the knife against the metal ruler, cut along the bottom score from the right and left edges, stopping at the right and left scores.

10. Open the paper and complete the cut across one of the outer edges.

11. Trim the sides and corners of the other edge. This will be the bottom flap.

12. Slide the polyester film into the folded paper in the center panel.

13. Valley-fold the right and left sides along the scores. Tuck one side into the other. Smooth down with the bone folder.

14. Put scrap paper under the project. Apply glue to the flap. Remove project to clean surface.

15. Wrap the bottom flap around the edge, and press down.

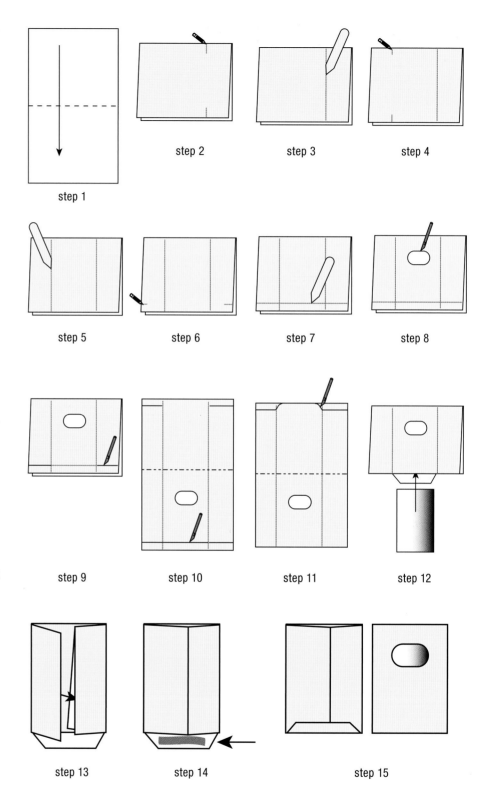

step 1

step 2

step 3

step 4

step 5

step 6

step 7

step 8

step 9

step 10

step 11

step 12

step 13

step 14

step 15

MATCHBOX-STYLE**BOX**

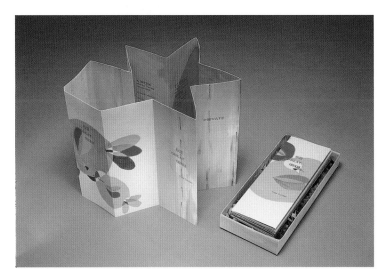

Oh, Great Chicken, 2000; letterpress, hand-painted paper with acrylic inks, polyester film; edition of 15; 3½ x 8 x 1 inches (8.9 x 20.3 x 2.5 cm); matchbox-style box with circle accordion (photo: Sibila Savage)

If you want a longer-lasting box, use cotton rag paper. For a larger box, like the one that contains *Oh, Great Chicken*, use paper that is a little larger than the size of your book plus a margin on all sides of twice the depth. The box for *Oh, Great Chicken* measures 3½ x 8 x 1 inches (8.9 x 20.3 x 2.5 cm); the paper used was 7½ x 12 inches (19.2 x 30.5 cm).

Tools: pencil; metal ruler; bone folder; knife and cutting mat; brush or piece of board for gluing

Materials: heavyweight paper, 3½ x 2⅛ inches (8.9 x 5.4 cm), grained long, but either way will work; PVA; magazines for scrap paper

For the bottom of the box

1. Arrange paper vertically. Measure ⅜ inch (1 cm) from top and bottom edges. Mark and score lines horizontally.

2. Measure ⅜ inch (1 cm) in toward the center from those top and bottom scores. Mark and score these second sets of horizontal lines.

3. Measure ⅜ inch (1 cm) from right and left edges. Mark and score lines vertically.

4. Make slits along the vertical lines just up to the second horizontal scores, top and bottom. You need to cut just a sliver out of the top and bottom midsections.

5. Valley-fold at all scores.

6. Bend and fold the flaps up toward you.

7. Fold the right and left sides so they are perpendicular to the rest of the paper. You are making box sides.

8. Take a small bit of glue and put it on the back of the flaps.

9. Fold the top edge up and press to the flaps.

10. Run a thin line of glue across the top edge and glue to what will be the inside of your box.

11. Repeat steps 8–10 to make the fourth wall of the box.

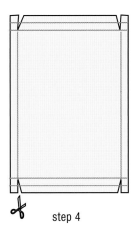

step 4

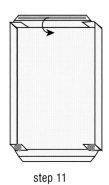

step 11

Variation: Make a 5 x 8 x 1½-inch (12.7 x 20.3 x 3.8 cm) box out of heavy paper that measures 9½ x 11 inches (24.1 x 27.9 cm). For steps 1 to 3 measure, 1½ inches (1½ inches [3.8 cm] instead of ⅜ inch [1 cm]).

For the top of the tiny box

Use a piece of paper that's 4⅛ x 3⅛ inches (10.5 x 8 cm). For a display box or box with a see-through top, use a piece of polyester film cut to 4⅛ x 3⅛ inches (10.5 x 8 cm). If you choose polyester film, you will need to use a bone folder to make very tight creases.

1. Turn paper horizontally.

2. Mark and score (from left to right) four vertical lines to make five sections with the following widths: ⅜ inch, 1⅜ inch, ½ inch, 1⅜ inch, and ½ inch (1 cm, 3.5 cm, 1.3cm, 3.5, and 1.3 cm).

3. Valley-fold all scores.

4. Put a thin line of glue on the right flap.

5. Wrap the right flap around to meet the left flap.

6. Glue what will be the inside of the right flap to the outside of the left flap. Hold in place until the glue has set. If you are using PVA, this should be about a minute.

Note: If you use polyester film, you may want to connect the lid flaps with self-adhesive linen tape. To customize your tape, paint the tape with acrylic paints and gesso first before you adhere it.

Catherine Michaelis: *Stack the Deck*; Twenty-Two Artists Mark the Cards for Women's Health & Healing, 1999; 5 x 7¼ inches (12.7 x 18.4 cm); letterpress printed exchange project (photo: Sibila Savage)

Variation 2: Make a hardcover box bottom, such as the one used for *Stack the Deck*, following instructions for the bottom of a Two-Piece Box on page 226. For the box lid, Catherine Michaelis covered a lightweight board with dyed Tyvek.

INK ON PAPER

In addition to being such a great vehicle for communicating directly to an audience, artists' books have the wonderful advantage of being time-based, like video and film. Static pictures on a wall can seem an impoverished way of making an artistic statement after one works with sequence, rhythm, movement, translucency, and the narrative arc. Design and typography are also critical parts of the making of books, two of my parallel loves. The medium is so rich with possibilities that it is hard to go back to working any other way, despite all the hype about the book being dead. All my work starts out digitally but still ends up as ink on paper. I love ink on paper. Forget all those digital e-texts and digital flash and multimedia books, the software and hardware will be obsolete and inaccessible in 10 to 20 years. The material book, with paper and ink, still rules!

PHILIP ZIMMERMANN

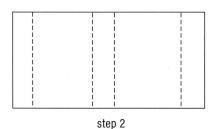

step 2

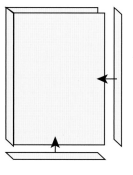

variation 2

PAPER**SLIPCASE**

Paper Slipcase Models, 1995; one painted, one covered; 5 x 6 x ¾ inches (12.7 x 15.2 x 1.9 cm) (photo: Jim Hair)

A paper slipcase is a compact way to contain the Woven Accordion, to hold a softcover book or books, or to organize a set of cards. By making this open-ended box out of paper that relates to one you've used for the book or cards, you can give the viewer a clue to what is inside. It is easier to remove items from this kind of box if you make a thumbhole. You can trace around a penny for the half-circle thumbhole or create another shape. I liked the thumbhole shown in Barbara Mauriello's book, *Making Memory Boxes* (Rockport Publishers, 2000), which is the half circle plus two little circles. Instead of the thumbhole, you may want to cut a large triangle at the edge of the slipcase.

Tools: metal ruler; pencil; bone folder; knife and cutting mat; scissors; brush or piece of board for gluing

Materials: heavyweight paper or 2-ply museum board, which can be painted with acrylic inks on both sides, 6 x 6½ inches (15.2 x 16.5 cm), grained long; PVA; magazines for scrap paper

Example size: 2¾ x 5¼ x ½ inches (7 x 13.3 x 1.3 cm)

Note: To change the size of this slipcase start with the book you want to contain.

Paper Width = (book width x 2) + depth

Paper Height = book height + (depth x 2) + ¼ inch (0.6 cm)

1. Orient the paper vertically on a work surface. Measure and mark ½ inch

(1.3 cm) down from the top on the right and left edges. It doesn't matter which side of the paper is up.

2. Using the ruler to guide the bone folder, score a horizontal line to connect the marks.

3. Repeat steps 1 and 2, this time measuring ½ inch (1.3 cm) up from the bottom.

steps 1 & 2

step 3

4. On the top edge, measure and mark 2 ¾ inches (7 cm) from the right edge (or measure the width of the book that will go inside the case). Measure and mark the same distance from the left edge. Repeat to measure and mark the bottom edge. Score lines from top to bottom to connect each pair of marks.

5. Using the knife, cut the scored line on each side of the center square in the top and bottom margin and then cut again at an angle to remove two notches inside each square; don't cut past the margin.

6. To make a template for the thumbhole, cut a rectangle of scrap paper with one side the same height as the slipcase paper. Fold this paper in half so it is half as tall as the slipcase paper.

7. At one edge of the fold, draw a shape half the size desired for the thumbhole. Using scissors or a knife, cut out the shape; discard the cutout.

8. Unfold the template. Align the template on one vertical edge of the slipcase paper. Use the pencil to draw the shape onto the slipcase.

9. Cut out the shape, using the knife or small scissors. Mark and cut another thumbhole in the opposite edge of the slipcase.

10. Choose one side of the paper for the inside of the slipcase, and place that side up. Using the ruler as a guide, fold the paper up along each scored line.

11. At one end of the slipcase, apply a thin line of glue to both sides of one of the flaps and to the outside of the little tab. Layer the flaps over the tab, placing the glued flap in between the tab and the dry flap.

12. Holding the layers together, turn the slipcase so it rests it on the joined flaps. Make sure the edges are aligned at the open end. Rest a pencil horizontally inside the slipcase so that it touches the spine. Press down on the pencil to apply pressure evenly while the glue sets.

13. Repeat steps 11 and 12 to glue the other end of the slipcase.

Variation: For a double slipcase, use a thick paper that is twice as wide and mark, fold, and cut as shown. Glue the sides together if you like, or leave them as movable connected cases.

step 13

variation

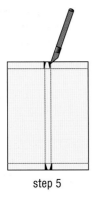

step 4

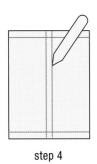

step 5

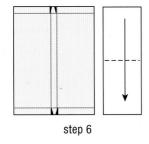

step 6

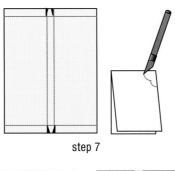

step 7

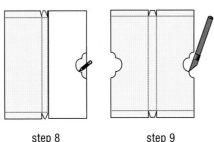

step 8 step 9

ORIGAMI**WALLET**

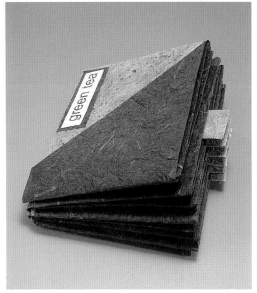
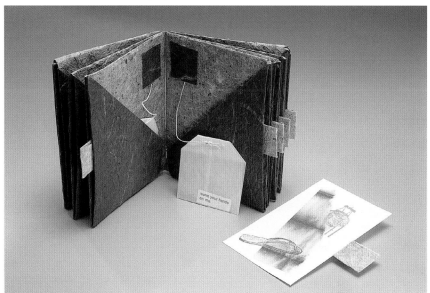

Green Tea, 2000; double-sided paper, glassine, laserprinted text, linen thread; 4¼ x 5¼ x 2¾ inches (10.8 x 13.3 x 7 cm) (photo: Sibila Savage)

This Origami Wallet may used to hold folded books, or it may become a page in a Codex, Slot and Tab, or Triangle/ Diamond Book or sewn into an Accordion. Make several and bind them together for a book completely made out of wallet pages. See page 57 for instructions on how to make the wallet into a book.

I used a double-sided paper for *Green Tea*; it is dark green on one side and a natural bark-flecked color on the other. I did not have a text or a title when I began folding the pages; the title occurred to me as I assembled the book. I folded glassine paper into tea bags and put them in the pockets, then attached the tea bag strings to the book so they would not fall out. Each tea bag contains a line of text and a small amount of real green tea. I made a mistake: although I like the look of the vertical title strip, the title should have

been right-side up to cue the reader that this book is vertically oriented. *Green Tea* has 4-ply boards in the front and back openings, heavyweight paper with ½-inch (1.3 cm) tabs in the remaining openings.

Tools: pencil; metal ruler; bone folder; scissors or knife and cutting mat

Materials: 1 sheet of lightweight paper 11 x 17 inches (27.9 x 43.2 cm)

Example: 4¼ x 5¼ inches (10.8 x 13.3 cm)

1. Place the paper in front of you, horizontally.

2. Fold the paper in half widthwise. Open.

3. Measure and mark 1½ inches (3.8 cm) from the edge of the top long side. This will be the top of your page. To make it easier to fold, you can score a line here.

EXCERPTS FROM "TACTILITY"

The rise of artist's books can be explained in many different ways, but certainly one of them has to do with a longing for tactility. Tactility primarily involves the sense of touch, but it is the common sense meeting place of all of the senses. Each sense creates its space. We learn though the fingers and hands in ways we cannot investigate otherwise. Constant touch, however, is not tactile. Tactility is the space of the resonant interval, what is touched and let go. When we touch books, we bring together materials and ideas. We find a way to touch words, visual impressions, and feelings. Through all forms of portable sculpture, private picture planes, and tactile resonance, artist's books link the senses together.

HARRY REESE

4. Fold at the score across the top. Open.

5. Measure and mark ¼ inch (0.6 cm) on either side of the center fold.

6. Fold in the ends to these marks, each end to the mark closest to it. Open.

7. With your scissors or knife, cut out the top right and left rectangles (or squares). Leave the two top middle sections intact.

8. Diagonally fold down each of the four corners of the main part of the paper, aligning the vertical edges just before the vertical folds. Keep these folded.

9. Fold the edges over again, this time to the middle pencil marks.

10. Turn the paper over, keeping everything folded.

11. Fold up the bottom to align with the top fold. The top tab will protrude.

12. Fold the top tab over the page, and tuck it into the pockets at the edges.

13. Fold the wallet/page in half widthwise.

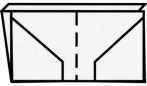

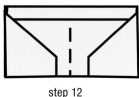

step 12

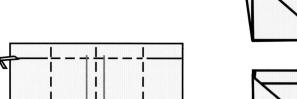

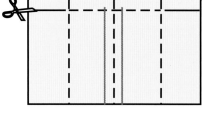

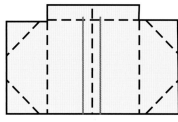
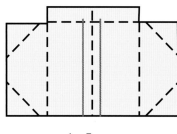

step 7

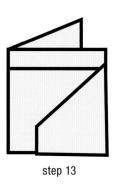

step 13

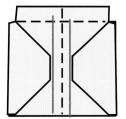

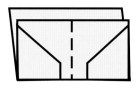

steps 10 & 11

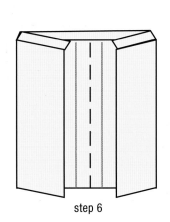

step 4

step 5

step 6

PAPERMAKING AND BOOKMAKING

My artwork, whether in the form of book installation or artist book, reflects on my interest in materials as much as the content and issues that comprise its core. Handmade paper has been my preferred material for more than 25 years, and I continue to explore its expressive potential in my image making, object making, and process. Additionally, I've been making the paper into artist books since the early 1980s, and I see the book form as a potent vehicle for my ideas.

ROBBIN AMI SILVERBERG

POCKET**FOLDER**

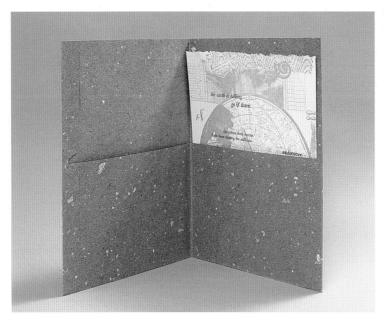

Pocket Folder Model (with *Earthwords* broadside), 1997; 9 x 12 inches
(22.9 x 30.5 cm) (photo: Jim Hair)

This looks like the school folders you can buy in the grocery or stationery store, but it is surprisingly handsome when you use thicker, handmade paper. I made my first pocket folder when I was sending sample photographs to the publisher of *Creating Handmade Books* (Sterling, 2000) and didn't want to send the pictures in a plain folder.

Tools: metal ruler; bone folder; knife and cutting mat; glue brush; 1-inch (2.5 cm) coin or other small heavy circle; pencil; weight

Materials: heavyweight paper, 20 x 17 inches (50.8 x 43.2 cm), grained short; PVA; scrap paper; waxed paper

Example: 9 x 12-inch (22.9 x 30.5 cm) folder with a 5-inch (12.7 cm) pocket

1. Put the paper in front of you horizontally (landscape format).

2. Measure and mark 1 inch (2.5 cm) from the right and left edges, top and bottom. Score to connect the marks.

3. Measure and mark 5 inches (12.7 cm) up from the bottom at the right and left edges. Score to connect the marks.

4. From the bottom edge, cut vertically along two of the outermost score lines to leave two 1 x 12-inch (2.5 x 30.5 cm) flaps at the right and left edges.

5. Fold up the bottom flap.

6. Score and fold the folder in half.

7. Fold over the edge flaps. They will be glued on top of the pocket.

8. Trace around the coin or circle with a pencil, drawing a half-circle, centered where the pocket will end.

9. Repeat for the other side.

10. Cut out the half-circles, rounding the edges.

11. Open the side flaps; apply a thin, flat line of glue; and press down.

12. Wrap in waxed paper. Press overnight under weights.

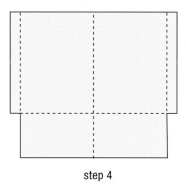

step 4

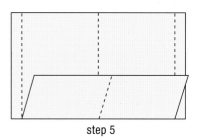

step 5

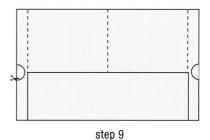

step 9

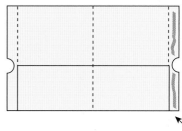

step 11

PAPER**PORTFOLIO**

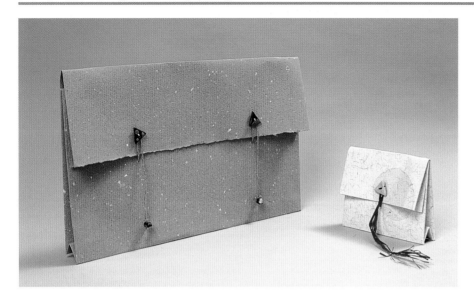

Paper Portfolio Models, 1997; polymer clay buttons, jute, raffia; 16 x 10 inches (40.6 x 25.4 cm) and 5¾ x 4¾ inches (14.6 x 12.1 cm) (photo: Jim Hair)

My friend Val gave me a paper portfolio many years ago that is still useful for carrying books. My husband, Michael, and I examined it closely. He made a pattern for me; then I made my own. I like making simple buttons of polymer clay for the portfolio. I flatten and shape the clay, poke holes with a toothpick, and bake it in my preheated toaster oven on low heat for about a minute. The toaster oven gets really hot, and the clay can char at the edges if you don't watch carefully. Let the button cool before handling it.

Tools: metal ruler; bone folder; knife and cutting mat; pencil; small glue brush; needle

Materials: heavyweight paper, 16 x 23 inches (40.6 x 58.4 cm), grained long; PVA; scrap paper; one button; waxed linen thread; macramé cord

Example: 9 x 12 inches (22.9 x 30.5 cm)

1. Turn your paper vertically (portrait orientation); if one side of your paper is different from the other, place the cover side down. Measure 2 inches (2.5 cm) from right and left sides.

2. Mark and score with the bone folder. Do not cut. Fold in.

3. Measure in from the folded edge at 1 inch (2.5 cm). Mark and score.

4. Fold the edge back to the place you just scored, making an accordion fold. You should have two edges, each with two folds at 1 inch (2.5 cm) and 2 inches (2.5 cm).

5. Measure up from the bottom, 9 inches (22.9 cm). Mark, score, and fold. Unfold.

6. Measure 2 inches (2.5 cm) from this fold; mark, score, and fold.

7. Measure 9 inches (22.9 cm) from here; mark, score, and fold. You should have 3 inches (7.6 cm) remaining at the top. Unfold.

8. Now you will make one opposite fold by turning the paper over. When you turn it over, the two valley folds will become mountain folds. Match the two folds, dividing the 2-inch (5.1 cm) space into two 1-inch (2.5 cm) spaces with a valley in the middle.

9. Open completely.

10. With your knife, cut one slit on each side of the 2-inch (2.5 cm) squares.

11. With your knife, cut a diagonal on each side of the squares as follows: measure 1 inch (2.5 cm) from the square on each side. Draw or cut directly a diagonal line from the inside corner of the square to the mark you just measured. Repeat for the three remaining sides. Put aside these triangular scraps.

step 10

step 11

12. Take the corner of each tab and match it to its opposite corner, folding a triangle. Do the other corner this way. Repeat with the other square. You have just folded an *X*.

13. Glue up as follows: with a tiny brush or your fingers, put glue on the side edge of the folded *X*, along that side's triangle on the back.

14. Bring up one long side (the side with the 3-inch [7.6 cm] flap at the top), and align the cut with the *X*. Repeat for the other long edge.

15. To glue the remaining whole sides, put glue along all the edges, overlap, aligning to the *X*, and press into place.

16. Repeat for the other short side.

17. Re-crease the now-glued folds.

18. Fold the 3-inch (7.6 cm) side over the top.

19. Sew a button onto the outside of the envelope, centered and about ½ inch (1.3 cm) from the edge flap. For durability, you may want to first glue down one of those scrap triangles underneath.

20. Poke a hole on the bottom pocket, thread macramé cord through it, and tie off. Glue a scrap triangle to the back to cover the knot and enhance its strength.

Uses: portfolio for transporting books; stationery holder; stack of cards

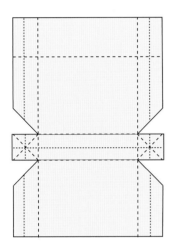

step 12

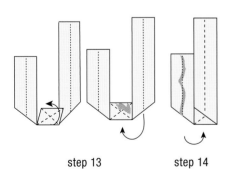

step 13 step 14

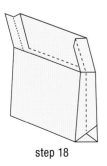

step 18

STOCK**BOOK**

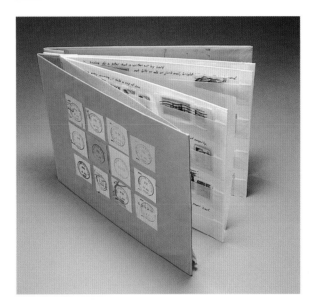

Priority Mail, 2000; Manila envelopes, glassine, stamps, handwritten text; 10 x 7 inches (25.4 x 17.8 cm) (photo: Sibila Savage)

Stamp collectors use a book with narrow glassine pockets to store the stamps they have collected before they go into the stamp album. The book, called a stock book, keeps the stamps dry and flat until they are transferred to the stamp album. The glassine is acid free and therefore will not transfer any yellow spots to the stamps. When you purchase postage stamps, save the glassine bags. Cut the bags and use them for the pocket strips for this project. Or buy glassine in a large sheet from an art supply store.

Glassine sheets are often placed between drawings or other artwork to be stored.

Tools: ruler; pencil; scissors; heavy book; awl or punch and hammer; cardboard to protect work surface; needle

Materials: 12 glassine strips, each 2 x 9 inches (5.1 x 22.9 cm), grained long; glue or glue stick; three 2-ply boards, each 7 x 9 inches (17.8 x 22.9 cm), grained short; three 2-ply board spine strips, each 7 x 1⅛ inches (17.8 x 2.9 cm), grained long; 6 self-adhesive linen tapes, each

4½ inches (11.4 cm); two 4-ply boards, each 7¼ x 10 inches (18.4 x 25.4 cm), grained short; two 4-ply board spine strips, each 7¼ x 1 inches (18.4 x 2.5 cm), grained long; 2 cover papers, each 13 x 9¼ inches (33 x 23.5 cm), grained short; scrap paper; 2 inner cover papers, each 10¾ x 7 inches (27.3 x 17.8 cm), grained short; waxed paper; 2 glassine pages, each 7 x 10 inches (17.8 x 25.4 cm), grained short; 2 endpapers, each 7 x 10 inches (17.8 x 25.4 cm), grained short; ribbon or heavy thread, 14 inches long (35.6 cm)

Example: 7¼ x 10-inch (18.4 x 25.4 cm) book

1. Fold all glassine strips lengthwise.

2. Apply a thin line of glue or glue stick to the inside of the open edge. Press down.

3. Place the three 7 x 9-inch (17.8 x 22.9 cm) boards horizontally in front of you. Measure and make light pencil lines from top to bottom every 1¾ inches (4.4 cm).

4. Put a thin line of glue on one of the pencil lines. Align a glassine strip with the newly glued edge pointed down. You are making a long, thin pocket, with the folded edge as the opening of the pocket.

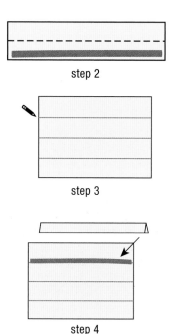

step 2

step 3

step 4

5. Repeat step 4 for all pencil lines.

6. Align one 1⅛ x 7-inch (2.9 x 17.8 cm) board strip with a board page, leaving a gap of ³⁄₁₆ inch (0.5 cm).

7. Place an 8-inch (20.3 cm) strip of self-adhesive linen tape across the gap, and wrap it around the edges.

8. Turn the page over. Place a 6½-inch (16.5 cm) strip of the self-adhesive linen tape on the back across the gap.

9. Take a 7-inch (17.8 cm) piece of linen tape or a decorative paper strip, and wrap it around the fore edge. This will secure the glassine strips.

10. Repeat steps 2–9 for all the board pages.

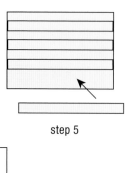

step 5

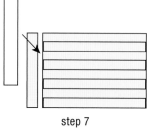

step 7

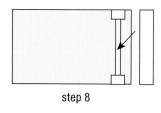

step 8

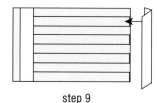

step 9

For the cover

For detailed instructions and diagrams, see Hard Cover: for side bindings, page 93.

11. Arrange the cover paper horizontally, wrong-side up.

12. On the cover paper, place one board and one strip with ¼ inch (0.6 cm) between them. Leave a 1-inch (2.5 cm) margin around the edges.

13. With a pencil, draw lines around the board and board strip. Remove the boards.

14. Apply glue to the paper. Align the boards and press down.

15. Turn over the project, and smooth down the paper onto the boards.

16. Turn it back over. Cut off the corners with scissors, leaving approximately a ⅛-inch (0.3) space between the paper you cut off and the board.

17. Spread glue on each of the flaps and turn them in, one by one. After gluing one or two flaps, or if your scrap paper gets messy, get new scrap paper and continue gluing.

18. Smooth down all paper.

19. Spread glue on the wrong side of one of the inner cover papers.

20. Center it and smooth it down on the back of the boards just covered.

21. Place the covered boards between two sheets of waxed paper and put under a heavy book.

22. Repeat steps 11–21 for the second cover.

step 14

23. Let the boards dry for one to five days under the heavy weight before assembling the stock book.

Assembling the book

24. Measure ½ inch (1.3 cm) from one edge of each of the cover strips. Measure 1½ inches (3.8 cm) from the head and tail. Poke or punch holes in the strips at the intersection of these marks.

25. Take the back cover and bend the strip of board to the inside. The strip will be on the left.

26. Align the left edge of the back cover with the left edge of each of the inner pages. Keep the inner pages flat.

27. Turn the front cover wrong-side up so that the strip is on the right. Align it with the inner pages so that when the cover is closed, the front and back covers will be aligned.

28. With a pencil, draw around the inside of the punched holes of the cover strip onto one of the inner pages, glassine pages, and endsheets.

29. Use the cover for a template, and draw circles on all the inner pages.

30. Punch or poke the holes in the pages.

31. Stack the inner pages neatly with the endpapers, front and back, and the glassine pages between them.

32. Using approximately 14 inches (35.6 cm) of ribbon or heavy thread, sew from front to back through the holes.

33. Tie the ends of ribbon together in a square knot. Then make a bow and another square knot, if desired.

Note: You may substitute two screw posts for the ribbon. Look for these in a bookbinding supply, stationery, or hardware store. They may be made of plastic, aluminum, or brass. If you use the posts, you can easily add pages to your stock book. The posts fit holes the size of standard office hole punches.

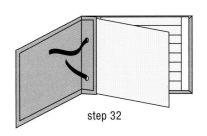
step 32

STAMP**WALLET**

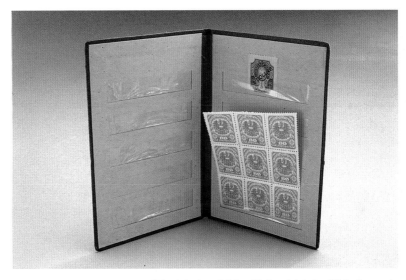

Stamp Wallet, date unknown; 4¼ x 6 inches (10.8 x 15.2 cm) (photo: Sibila Savage)

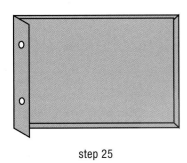
step 25

This stamp wallet was found among some old family papers. Its origin is mysterious. I adapted it so I could make one. For more details on how to cover the boards, see page 209.

Tools: metal ruler; bone folder; pencil; knife and cutting mat; glue brush; white plastic eraser; heavy weight

Materials: 2 medium-weight to heavy-weight endsheets, each 4 x 6 inches (10.2 x 15.2 cm), grained long; 6 strips of heavy polyester film, each 2 x 3½ inches (5.1 x 8.9 cm); PVA; magazines for scrap paper; 2 pieces of 4-ply museum board, each 4½ x 6½ inches (11.4 x 16.5 cm), grained long; 1 sheet of cover paper, 6½ x 8½ inches (16.5 x 21.6 cm), grained short; 1 spine strip, 6½ x 1 inches (16.4 x 2.5 cm), grained long; waxed paper

Example: 4½ x 6½-inch (11.4 x 16.4 cm) book

1. Orient one of the endsheets vertically.

2. Measure and mark ¾ inch (1.9 cm) from the top down along the right and left edges.

3. Measure and mark 1 inch (2.5 cm) from the first mark and from each successive mark. You should have six marks when you get to the bottom of the endsheet.

4. Measure ½ inch (1.3 cm) from the right and left edges. Draw two vertical lines.

5. With a knife against a ruler, cut horizontal slits (between the vertical lines) at the second, fourth, and sixth horizontal lines. Cut vertical slits connecting horizontal lines 1 and 2, 3 and 4, 5 and 6. You are creating flaps that look like long, squared-off *U* shapes.

6. Repeat steps 1–5 for the second endsheet.

7. Fold each of the six polyester film strips in half lengthwise. Crease well with the bone folder.

8. Turn over one endsheet.

9. Take one flap of the endsheet and bend it up slightly. Sandwich the flap between the folds of the polyester film.

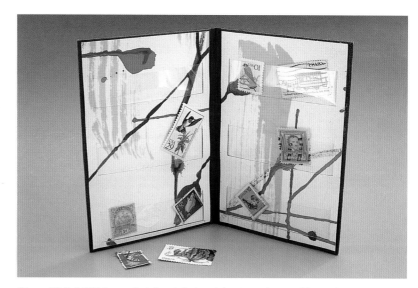

Stamp Wallet, 2000; acrylic ink painted endsheets, polyester film; 4¼ x 6 inches (10.8 x 15.2 cm) (photo: Sibila Savage)

10. Apply a dot of PVA to the right and left edges of the polyester film. Slip the ends through the slits and press them to the back of the endsheet.

11. Repeat steps 8–10 for all six pieces of polyester film.

12. Cover the boards with one piece of paper, leaving a ⅝-inch (1.6 cm) gap at the spine.

13. Put a thin, even coat of PVA on the spine strip, and adhere it across the gap.

14. Put an even coat of PVA on one endsheet, turn it over, and adhere the endsheet to one half of the covered boards.

15. Put an even coat of PVA on the second endsheet, turn it over and adhere the endsheet to the remaining covered board.

16. With a white plastic eraser, erase the pencil lines on the endsheets. Don't use a pink one; it will leave smudges.

17. Put waxed paper in the center, and let the wallet dry overnight under heavy weights.

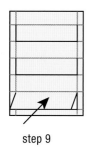

step 5

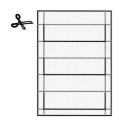

step 9

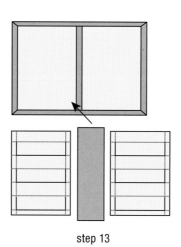

step 13

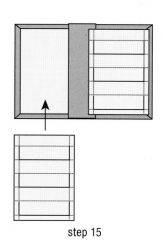

step 15

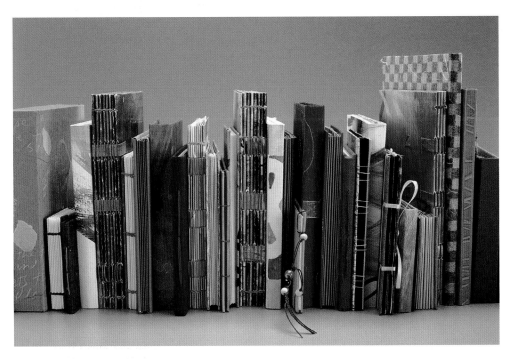

(photo: Sibila Savage)

COVER **TECHNIQUES**

Cover styles are versatile and frequently may be used with a variety of book blocks and structures. Soft Wrap Cover, Open Spine, Wrapped Hard Cover, and Covering Separate Boards may house accordions or sewn bindings, for example. Two cover techniques are listed in the chapters with their book blocks since those covers work best only for those structures: Multiple Signature with Rounded Spine (page 155) and Sidebound (page 93). The names of the cover styles here are for reference purposes and are not necessarily used universally.

For adhesive hard covers, you may cover boards with paper, book cloth, or Tyvek. For best results, paper should be high-quality and contain cotton or kozo. Experiment with small pieces of various papers to see how they react to the adhesive; some may bubble and not lie flat.

Book cloth comes in a variety of colors, textures, and fabrics; all are meant to cover boards. It is highly durable and looks terrific, but you must keep the outside free from water and unwanted glue while you work. You can also make your own book cloth; see the directions for Backing Cloth on page 22.

Tyvek, a synthetic material made of polyethylene fibers bonded by heat and pressure, has become widely used in bookmaking for its strength and water resistance. It can be stained with acrylic inks for cover papers; made into hinges for accordions; cut into strips for the Woven Codex; or used as sewing tapes. Buy large envelopes made of Tyvek from stationery stores, and cut them to size. Bookbinding supply companies also sell Tyvek in 60-inch (1.5 m) wide rolls.

In all cases, determine the size of the covering paper by laying out the boards with the necessary spacing between them and add 1½ inches (3.8 cm) to the width and height; this will give you a ¾-inch border (1.9 cm) border or margin on all sides of the boards for the turn-ins.

Traditionally, glue is applied to the entire cover paper; then the boards are glued, the corners cut, and the flaps turned in immediately. I find it easier and less sticky to apply glue as I go, adding it sparingly each time I adhere a flap. For detailed information about adhesives, please see page 20.

Many of the adhesive hard covers require that you leave a $\frac{3}{16}$-inch (0.5 cm) gap between the board or boards and the spine to enable the book to hinge open. If you consistently use 4-ply museum boards ($\frac{1}{16}$ inch [0.2 cm] thickness), buy

Carolee Campbell: *The Intimate Stranger* by Breyten Breytenback, 2007; letterpress from metal type and photopolymer plates, hand-applied pigments, handmade paper by Bridget O'Malley at Cave Paper; edition of 100; 13 x 7½ inches (33 x 19.2 cm) (photo: Carolee Campbell)

a couple of ³⁄₁₆-inch (0.5 cm) brass or metal spacing bars, available at hardware stores, which will make it easier to place the boards parallel and will ensure the correct spacing. If you use heavy cover paper or thicker boards, you will need to create a gap wider than ³⁄₁₆ inch (0.5 cm). Vicky Lee told me about spacing bars after Mary Laird showed them to her. Mary Laird paints, makes books and prints, and teaches letterpress and book art classes in Berkeley, California. If you use book board or any other board, leave three boardwidths between the spine and the covers.

Cut 4-ply museum board or book board with a heavy-duty utility or mat knife against a metal ruler. You will get a better cut by standing up and leaning your weight onto the ruler and the knife. Keep fingers away from the edge of the ruler. Always use a sharp blade. If you make a ragged edge, smooth it out with very fine sandpaper. Measure and cut a spine, if needed, after the signatures are all sewn.

When you are ready to do a series of hard covers, go to a lumberyard (or similar place), and have them cut up a piece of double-sided smooth fiberboard into 12 x 16-inch (30.5 x 40.6 cm) boards. The boards may be any thickness, but heavier is better. Each time you glue a book or cover, place waxed paper between the part you glued and the rest of the book block so that the dry pages won't warp. Cover the entire book with waxed paper, and sandwich it between the boards. Place a heavy weight, dictionary, or art history book on top. Press overnight or for several days, depending on the amount and type of adhesive used, the size of the book, and the temperature and humidity of the room. A book made with paste only on a cold, rainy day may require a week or more under weights.

If you have not made hard covers before, it may take a few tries to make a book with which you are satisfied. You may want to read the instructions through once and prepare materials for two covers

at a time before you begin. The more you make, the more you will learn. Once that knowledge is clear and absorbed by your hands as well as your mind, the easier the subsequent projects will become.

CREATING A MOOD

These books are about remembering something carefully. I generally start in book form with a series of folded, unbound sheets of paper. I first touch the pages all over with paint or ink. Then I gradually layer in drawings and place the handwritten text through the book, working with either liquid inks or gouache. I turn my memories over and over in the making process: re-sequencing images of places or people, cultivating a textual voice with a pitch and timbre that fits the drawings, and working the texture of the page's surface. I am trying to recreate my experiences for others in a way that provides the reader a mood and pace close to what I feel.

ANNE HAYDEN STEVENS

SOFT**WRAP COVER**

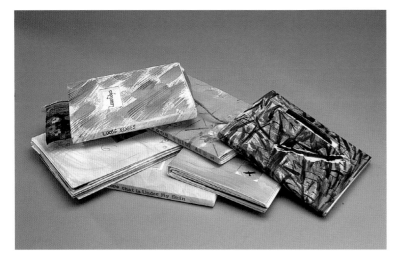

Rotating Notebooks, 2000; mixed media books by Patricia Behning, Alisa Golden, Lynne Knight, Marc Pandone, Val Simonetti, Nan Wisner, Yoko Yoshikawa (photo: Sibila Savage)

A simple cover can be made by taking a piece of heavyweight paper and wrapping it around the book block. For this cover, you will want approximately ⅛-inch (0.3 cm) margins at the head, tail, and fore edge. You may prefer the cover to be the same height as the book block. For more stability, add end flaps that fold around the front and back pages, as indicated by the variation and the books in the photograph.

Tools: pencil; ruler; bone folder; needle (optional)

Materials: 1 heavyweight paper, twice the width of the book block plus ¼ to ½ inch (0.6 to 1.3 cm) for the spine x the height of the book block plus ¼ inch (0.6 cm); thread, glue, or linen tape

Example: For a 4 x 6-inch (10.2 x 15.2 cm) book with a ⅛-inch (0.3 cm) spine depth, the cover should be 6 ¼ x 8 ¼ inches (15.6 x 21 cm), grained short.

1. At each edge of the paper, use the bone folder to mark, score, and fold the width of the book plus ⅛ inch (0.3 cm); in this example, it would be 4⅛ inches (10.5 cm).

2. The spine should be in the center (⅛ inch [0.3 cm] here).

3. Sew this cover with the book block. As an alternative to sewing, glue or tape (with linen tape only) the book block to the fore edges. Glue the front and back covers completely to the book block.

Variation: Thread a ribbon through the cover paper before you sew or glue it to the book block.

Variation 2: Use a longer piece of paper, four times the width of the book block plus the spine (if needed). Fold flaps for the front and back covers to add stability to the soft cover. Wrap the cover around the first and last pages of the book, or glue the flaps to the endsheets.

Uses: for single signature booklets and pamphlets; programs; announcements; cards

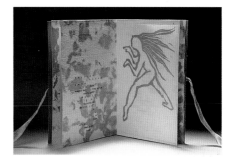

Pencil Turns, 1991; letterpress, linoleum cuts, waxed masa and St. Armand papers; edition of 56; single signature; 4¾ x 7 inches (12.1 x 17.8 cm) (photo: Jim Hair)

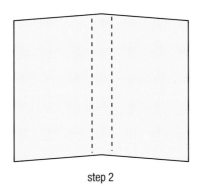

step 2

variation 2

OPEN**SPINE SOFT COVER**

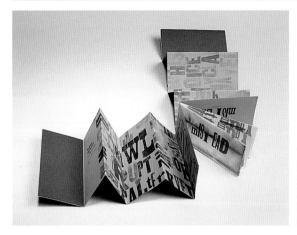

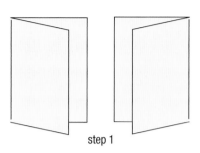

step 1

Talking Alphabet, 1994; letterpress from wood and metal type; edition of 34; pants book or simple accordion; 3⅜ x 6¼ inches (8.6 x 15.9 cm) (photo: Jim Hair)

Diane Meltzer brought me to teach a group of Albany schoolteachers. I taught the simple accordion structure and showed them *Talking Alphabet*. One teacher looked at the accordion and said, "Now what?" so I showed them how to make an open-spine cover and a wrapped hard cover.

If you use an open-spine soft cover for a pocket book, you lose a pocket, front and back. If your cover paper is slightly thin, you may want to trim most of each pocket (only first and last) so that it won't show through as much. Unfold; use your knife to cut along the bottom fold, up until ½ inch (1.3 cm) from the first vertical fold. Cut vertically to slice off the pocket, leaving just a very short flap.

Tools: bone folder; glue brush

Materials: 2 cover papers, each twice the width of the book block; PVA; scrap paper; waxed paper

1. Fold cover papers in half.

2. Open one cover, and put a flat line of glue along the open edges of the cover.

3. Sandwich the first page of the book; fold at the fore edge. The open part will be along the spine. Smooth down. Put waxed paper between the cover and the rest of the book block.

4. Repeat for the back cover and last sheet.

OPEN**SPINE WITH RIBBON**

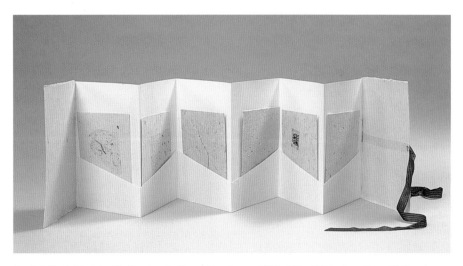

Pocket Book Model with Handmade Paper Envelopes, 1995; 5½ x 8¾ inches (14 x 22.2 cm) (photo: Jim Hair)

Do the following if you wish to have a ribbon tie in the back cover. This may be used with various accordion, single signature, and flag books; the ribbon keeps the pages secure when not being handled. It also adds an introductory pause to the reading experience.

Tools: metal ruler; pencil or bone folder; knife and cutting mat; glue brush; weight

Materials: ribbon; cover papers; PVA; waxed paper

1. Measure halfway up the fold of the last page and mark. Cut a small slit in the fold just a little wider than your ribbon.

2. Make a corresponding slit, measuring the same way, on the fold of the cover.

3. Thread one long piece of ribbon through the two slits so the ends stick out evenly. The ribbon should show on the back page, with the ends disappearing out the back.

4. With a dot of glue, glue the ribbon in place across the sheet. When you glue the covers, put glue on half the cover at a time.

5. Open the cover. Spread glue in a fanlike manner to completely cover half the cover.

6. Smooth down onto the first page.

7. Do the second half in the same manner. Glue the other cover. With the last page, leave the ribbon threaded through the accordion and the cover as you do this.

8. Apply glue to the inner part of the cover; press down over the back page and the ribbon.

9. Turn the page to the back. Open the back cover, apply glue, then press down to the back of the last page.

10. Insert waxed paper between the cover and the next page, front and back.

11. Put waxed paper on top and under the book; then, put the book under weights overnight.

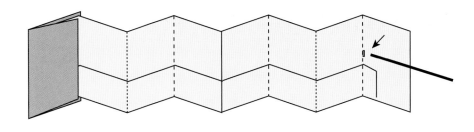

step 1

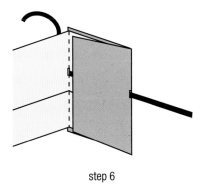

step 2

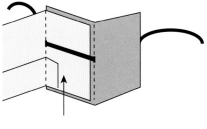

step 4

step 6

THE LEARNING PROCESS

When teaching bookmaking, I remind people that they can learn something or they can make it perfectly, but they cannot do both at the same time. Very often in my work, I learn from making models...what will work, how it will work and what doesn't work and why. It is important to remember that what doesn't work gives you as much information as what does work. Then I can make it better the next time, or the next.

BONNIE THOMPSON NORMAN

CORNERS

Every time you glue boards to paper or book cloth and cover them you will also be covering the corners of the boards. A little bit of extra material is available during the process to insure no naked corners. The time to be alert to the corner situation is when you have just covered two parallel sides. With your thumbnail, push in toward the middle of the board. Then add glue to that perpendicular flap, wrap over the side, and press down. Be attentive to all four corners with this method.

WRAPPED**HARD COVER**

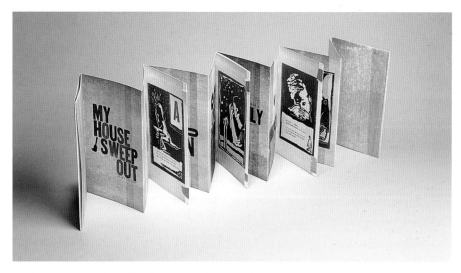

ACTIVATED OBJECTS

Books are, to me, activated objects. They are culturally charged. They allow me to work with time in rhythmic sequence. They allow for a physical relationship that is missing in almost every other art form. They can be held and touched. And books necessitate engagement also in their making: I create my own material, so content starts at the very beginning. The richest experience is when all aspects are engaged into the bookmaking: paper, binding, structure, images.

ROBBIN AMI SILVERBERG

My House I Sweep Out, 1989; letterpress from metal and wood type, linoleum cuts; edition of 48; accordion with tabs and signatures; 6¹/₈ x 10¹/₈ inches (15.6 x 25.7 cm) (photo: Jim Hair)

This is a simple, nonadhesive way to attach a hard cover. I used this cover for *My House I Sweep Out*. The first and last pages of the book just slip into the cover.

Tools: ruler; bone folder; scissors

Materials: 2 cover papers, each 4¼ x 7½ inches (10.8 x 19.1 cm), grained short; 2 cover papers, each 5½ x 6¼ inches (10.8 x 15.9 cm), grained short (these can be different colors from the first papers); two (2- or 4-ply) museum boards, each 4¼ x 5½ inches (10.8 x 14 cm), grained long; 1 piece of spine paper, 2 x 5½ inches (5.1 x 14 cm), grained long (optional)

Example: 4¼ x 5½-inch (10.8 x 14 cm) cover

1. Orient longer pieces vertically. Fold one inch in on the top and bottom of the long pieces.

2. Orient the shorter pieces horizontally. Fold one inch in on both sides of the short pieces.

3. Take one board and wrap one of the shorter, fatter pieces around it.

4. Turn the wrapped board over.

5. Tuck the sides of the long thin piece into the first paper.

6. Repeat for the second board. If you are having trouble tucking the paper, use the scissors to trim a slight diagonal at the corners, from the edge up to the fold.

7. Take one end of the book and tuck it into the cover. Repeat for the other end to the second board.

8. If a spine is desired, cut a piece of paper 2 x 5½ inches (5.1 x 14 cm), grained long.

9. Measure the depth of the book, and mark the spine piece, leaving an equal distance on each side to tuck.

10. Score with the bone folder.

11. Tuck into the wrapped boards.

Uses: This style cover works with signature books, flutter books, accordions, and most other books as well.

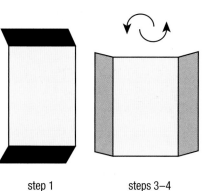

step 1

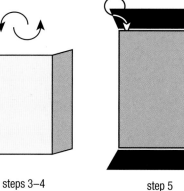

steps 3–4

step 5 step 7

COVERING SEPARATE BOARDS

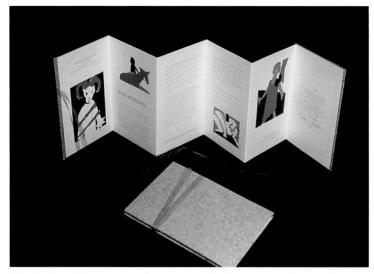

The Binding, 1986; letterpress, three-color linoleum cuts; edition of 48; accordion; 4³/₄ x 7¹/₈ inches (12.1 x 18.1 cm) (photo: Saul Schumsky)

For a retelling of the biblical story of the binding of Isaac, I used an accordion structure attached to separate boards. I added a ribbon that has to be wound around the book to keep it closed. You may also use it successfully for any of the Coptic structures.

Tools: brush; pencil; ruler; scissors; bone folder; fiberboard

Materials: two pieces of lightweight paper or book cloth for covers, 5³/₄ x 7³/₄ inches (14.6 x 19.7 cm); 2 pieces of scrap paper; glue; two 4-ply museum boards, each 4¹/₈ x 6¹/₄ inches (10.5 x 15.9 cm), grained long; two pieces of lightweight or decorative paper for endpapers, 4 x 6 inches (10.2 x 15.2 cm); waxed paper

Example: 4¹/₈ x 6¹/₄-inch (10.5 x 15.9 cm) book for a 4 x 6-inch (10.2 x 15.2 cm) book block

1. Place the cover sheet, wrong-side up, on a piece of scrap paper. Apply glue in a fanlike manner, from the center out, spreading evenly.

2. Center one of the boards on the glued sheet.

3. Cut diagonals at the corners, leaving a slight margin, about two boards widths. (Don't cut right up to the edge of the board.) Remove the triangles.

4. Move the work to a clean surface; discard the scrap paper.

5. Glue, fold, and rub down the side flaps over the boards: parallel sides first, then pushing in slightly at the corners before continuing.

6. Place one endpaper wrong-side up on a second piece of scrap paper. Apply glue completely to all edges.

7. Pick up carefully and center this paper on the covered board. Press and rub down.

8. Repeat steps 1–7 for the second board.

9. Place the covers between two pieces of waxed paper and put between fiberboards. Put books or bricks on top. Let the covers press flat at least overnight, preferably for a couple of days.

Variation: You can also paint the boards instead of wrapping them in paper.

Variation 2: Attach them to your book block by omitting endpapers from step 6 and putting glue on the backs of the first and last pages of your book block.

Uses: accordion-fold book; pocket book; Jacob's ladder; exposed stitch

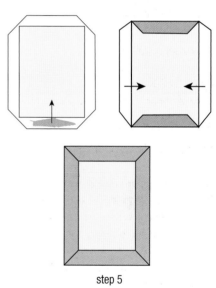

step 5

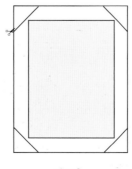

step 3

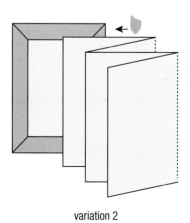

variation 2

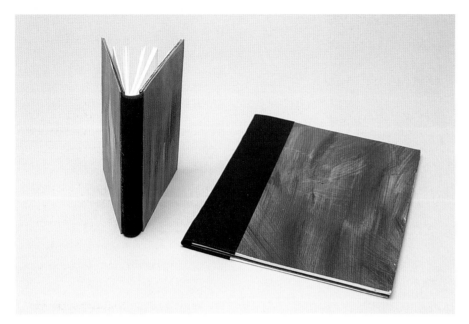

Split Board Models, 1995 (photo: Jim Hair)

For a simple hard cover using painted or unpainted boards, glue the cloth spine between the double boards (see the standing model), or wrap it around the top and bottom of the outer set of boards like a portfolio (the purple model). A more complex version utilizes book cloth wrapped around boards and several extra steps; however, the elegant result is worth the extra time. A variation of this is often referred to as the "Gary Frost binding." Use just the numbered steps for the simple version, add the lettered steps for the complex one.

When using either technique, first sew the book block to the inner spine using a Single Signature, Multiple Signature, French Link Stitch, Exposed Stitch, or Bundled Stitch. To make the book more secure, you may wish to add more sewing stations (six holes total, for example.) For this binding, the outer spine will conceal the stitches.

Tools: knife and cutting mat; ruler; pencil; weight; glue brush

Materials: scrap paper; PVA; 1 paper spine piece cut to 2½ x 5½ inches (6.4 x 14 cm), grained long; 1 spine piece of book cloth, 2½ x 7½ inches (6.4 x 19.1 cm), grained long; waxed paper; four 2-ply boards, each 5¾ x 4½ (14.6 x 11.4 cm), grained long

Additional materials for cloth version: 1 spine piece of 2-ply board, ¼ x 5¾ inches (0.6 x 14.6 cm), grained long; 2 pieces of covering material, each 6 x 7½ inches (15.2 x 19.1 cm), grained long; 2 covering strips, each 1½ x 6 inches (3.8 x 15.2 cm), grained long; 2 endsheets, each 4 ¼ x 5 ½ inches (10.8 x 14 cm), grained long OR 2 endsheets, each 8½ x 5½ inches (21.6 x 14 cm), grained short

Example: 5¾ x 4½-inch (14.6 x 11.4 cm) covers with ¼-inch (0.6 cm) spine

1. First, sew a book block, as for the Bundled Stitch or for the Exposed Stitch (with kettle stitches made under the inner spine in place of the French knots made on top of it). In either case, substitute a spine piece (cut the same height as your book and approximately 2 inches [5.1 cm] plus the depth of the book) for the full cover paper.

2. Cover your workspace with old magazines. Orient the book cloth vertically, wrong-side up.

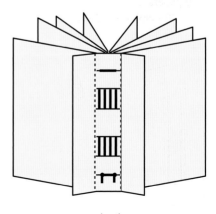

step 1

Split Board Model, 2009 (photo: Lark Books)

2a. Apply PVA to the book cloth, center, and press down the 2-ply board spine piece.

3. Measure and mark 1 inch (2.5) from the edges of the top and bottom of the book cloth; apply PVA to these 1-inch (2.5 cm) segments, fold the cloth over in both places, and press down.

4. Apply glue to the outside of the flaps of the paper spine attached to the book block.

5. Wrap the cloth spine around the book block, wrong-side in, laminating the cloth and paper spine pieces together. Smooth down flat. Put waxed paper between the book block and the spine. Put under a weight for now.

5a. For the outer boards, use the two cover papers that are 6 x 7½ inches (15.2 x 19.1 cm). Glue down one board to one cover paper, cut the corners, and glue

down *only* the flap that will be closest to the spine. Repeat for second outer board.

5b. For the inner boards, use two strips, 1½ x 6 inches (3.8 x 15.2 cm). Fold one strip in half, lengthwise. Apply glue to one-half of the strip, and press the board in place. Miter the corners. Glue down the top and bottom flaps first, then tuck in the corners and glue down the third long flap. Repeat for the second strip and inner board.

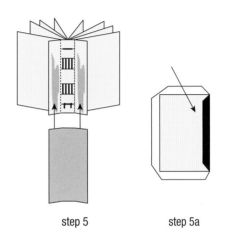

step 5 step 5a

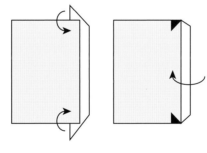

step 5b

6. Open the book block. Brush a thin layer of glue on the inner side of the back inner paper spine. Align one inner board and press down. Repeat for the front inner paper spine. Put waxed paper inside between the boards and the book block. Close the book.

7. Put a thin, even layer of glue on one outer board. Align the outer board with the inner board (the one connected to the book block), pressing firmly and rubbing down. Repeat for the other side.

7a. Apply glue to the flaps of the outer board covering paper, and wrap and press over both boards, tucking in the corners carefully.

7b. Apply glue and center the endpapers, 4¼ x 5½ inches (10.8 x 14 cm).

8. Wrap the book in waxed paper and press under a weight overnight.

Variation: For the simple version, cover your boards with decorative paper first, as for Covering Separate Boards on page 209.

step 7a

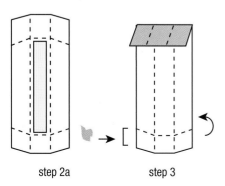

step 2a step 3

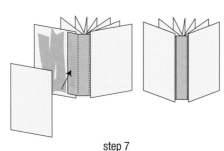

step 7

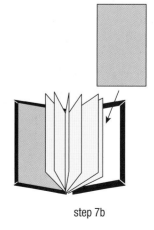

step 7b

HARD**COVER: SINGLE SIGNATURE**

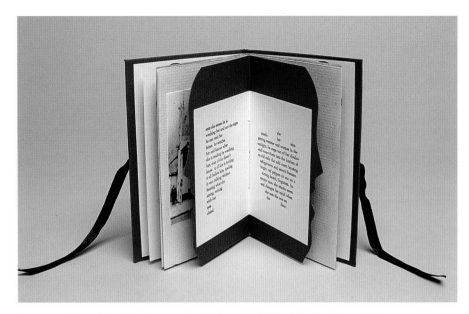

Shadowinglovenote, 1990; photocopies of photos by Michael Budiansky c. 1960s; letterpress; edition of 45; single signature; 3¼ x 4¾ inches (8.3 x 12.1 cm) (photo: Jim Hair)

When adding a hard cover to a single signature, be aware that the book may not open completely. A single signature was all I needed for my book *Shadowinglovenote*. The story is about a man and woman who need each other to interpret the world around them. I used photocopies of pictures of Europe that my husband Michael took when he was a child.

Tools: bone folder; pencil; ruler; glue brush; scissors

Materials: scrap paper; PVA; waxed paper

For the example size, use boards that are 4½ x 5¾ inches (11.4 x 14.6 cm), grained long, and lightweight cover paper or book cloth that is approximately 6 x 10¾ inches (15.2 x 27.3 cm), grained short. This gives a ¾-inch (1.9 cm) border for the turn ins.

Example: 4½ x 5¾-inch (11.4 x 14.6 cm) pamphlet

1. Spread magazines over your work surface.

2. Find the center of the cover paper, and mark it with pencil or fold.

3. Apply glue to the back of the cover paper in a fanlike motion, covering one-half the paper.

4. When half the paper is covered, apply one board to the exposed glue, leaving the border (½ to 1 inch [1.3 to 2.5 cm]) that you chose. Press down.

5. Apply glue to the other half of the paper.

6. Leaving about three boardwidths as a margin for the spine for a thin pamphlet, place the other board on the glued paper and press down.

7. Cut diagonals across the corners, leaving the paper the width of the board before you cut.

8. Glue and fold down the flaps, one at a time, working with parallel flaps first. Make sure to push in slightly at the corners to make sure they are covered before you continue with the perpendicular flaps.

9. Remove the project to a clean work surface. With waxed paper between the bone folder and the paper, rub down the glued paper.

10. See Attaching the Book Block on page 215 to complete your project.

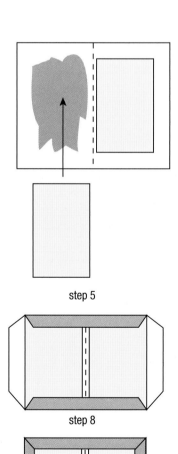

step 5

step 8

step 9

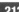

CASE**BINDING: FLAT SPINE**

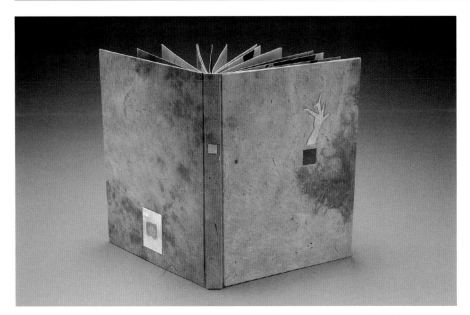

Egg Hunts a Bird, 2004; acrylic inks and gesso, multiple signature binding; 5¼ x 7⅛ inches (13.3 x 18.1 cm) (photo: Sibila Savage)

This hard cover adds a spine to the basic single-signature cover. To find the width of the spine needed, put one board atop your book block, and measure from the table up to the top of the last signature. Cut your cover paper so that it gives you approximately ¾ inch (1.9 cm) border all the way around with three boardwidths on either side of the spine piece. This cover version works best with multiple signature books up to ½ inch (1.3 cm) in depth. For a thicker book, see Multiple Signature with a Rounded Spine on page 155.

Tools: bone folder; pencil; ruler; scissors; glue brush; spacing bar; scrap paper; PVA; waxed paper

Materials: for this example use boards 4¼ x 5½ inches (10.8 x 14 cm), grained long; spine piece that is ⅜ inch x 5½ inch (1 x 14 cm) ; covering paper that is 11¾ x 6¾ inches (29.8 x 17.1 cm), grained short

Example: 4¼ x 5½-inch (10.8 x 14 cm) book with a ⅜-inch (1 cm) spine

1. Spread magazines over your work surface.

2. Put the cover paper wrong-side up. Find the center on the back of the cover paper and mark it with a pencil, or fold.

3. Apply glue to the center of the cover paper; glue down the spine.

4. With a fanlike motion, apply glue to cover one-half the cover paper.

5. Put a spacing bar next to the spine. The bar will probably be on top of some exposed glue; that's okay. Abut the board. Remove the spacing bar.

6. Apply glue to the other half of the paper.

7. Put down a spacing bar, then the board; remove the bar, and press down the board.

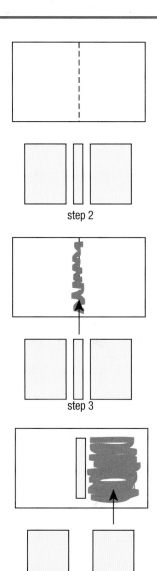

step 2

step 3

step 4

step 6

8. Cut diagonals across all the corners, leaving the paper at least the width of the board, and almost two boardwidths, before you cut it.

9. Glue and fold down the flaps, one at a time, starting with parallel flaps.

10. Remove the project to a clean work surface. With waxed paper between the bone folder and the paper, rub down the glued paper.

11. See Attaching the Book Block on page 215 to complete the project.

HARD**COVER WITH RIBBON**

Once your boards are covered on the outside, proceed as follows:

1. In the middle of the back board or the across two boards covered together for a case, center a ribbon, roughly 24 inches (61 cm) long, or twice the width of your boards plus at least 12 inches (30.5 cm); center the ribbon vertically and horizontally.

2. Put a dab of PVA glue to hold it down so it will stay there when you paste down the endsheet or end accordion.

3. Continue as for Attaching a Book Block or for Covering Separate Boards. See page 215, or page 209.

Variation: Make two slits or punch holes at the edges of the hard covers. Thread a ribbon through each side before adding the endpapers.

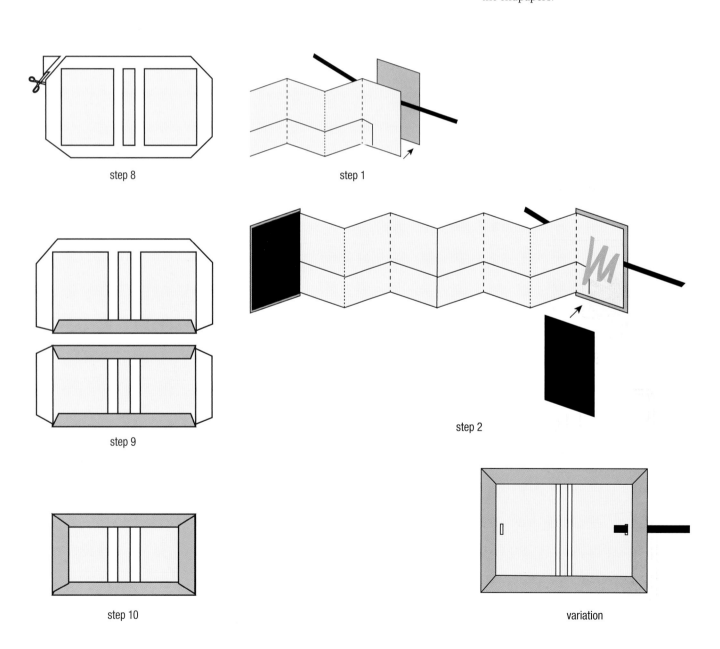

step 8

step 1

step 9

step 2

step 10

variation

ATTACHING **THE BOOK BLOCK**

These directions apply to all books with signatures and case bindings.

1. Have scrap paper handy. Open the first page of the signature and slip a piece of scrap paper under it, leaving the rest of the signature closed. Apply glue evenly in a fanlike manner only to the back of this first page.

2. Remove the scrap paper. Pick up the book block, taking care not to get glue on the rest of the book. The front and back boards for your book will be approximately ¼ to ½ inch (0.6 to 1.3 cm) larger than your book block. Arrange the now-sticky endsheet on the covered boards so it has a border of ⅛ to ¼ inch (0.3 to 0.6 cm) around it.

3. Rub down the sheet with a bone folder. Put a piece of waxed paper between the newly glued sheet and the rest of the book block. Close the book, and face it to the left.

4. Open the back cover. The rest of the book block should be closed on the left.

5. Put a piece of scrap paper between the last sheet and the rest of the book block. Apply glue to the back of the last sheet. Remove the scrap paper.

6. You may need to close the book slightly (possibly to a 45° angle) to obtain the same margins (⅛ to ¼ inch [0.3 to 0.6 cm]): whatever border you chose in step 12) as the front inner cover. Press the sticky sheet down onto the back board.

step 5

7. Over waxed paper, rub down with the bone folder.

8. Place waxed paper between the newly glued sheet and the rest of the book block. Close the book.

9. Place between waxed paper and fiberboards. Put a heavy weight on top. Let the project dry overnight.

step 6

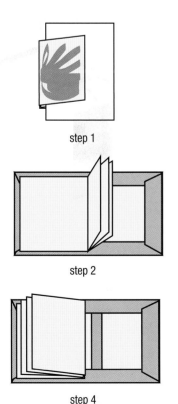

step 1

step 2

step 4

COVERING **A MISTAKE**

When gluing hard covers, the board will peek out if you cut the corner of the covering paper too close to the edge of the board. The best technique is to allow the width of the board plus the paper before cutting, but if you make a mistake, you can salvage the project: make a patch by gluing the cut corner over the gap, then glue the endsheet on top.

DISTRESSED **BOOK COVERS**

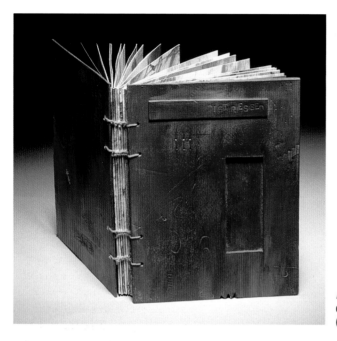

Distressed, 1998; coptic (curved needle) binding; acrylics, distressed covers, letterpress, iron-on transfers; 4½ x 4¾ inches (11.4 x 12.1 cm) (photo: Jim Hair)

A student showed me some polymer clay book covers she had made in a class. She had made marks and dents in the clay, then rubbed it with paint. I liked the concept, but I didn't like the final texture. The baked polymer clay felt funny and not very durable. I tried a similar technique with layers of museum board and was very happy with the results. I used them for the cover of my one-of-a-kind book *Distressed*. It is a long poem about stress and trying to get things done too fast. Adding layers and recesses to the covers gives the book a pleasing physical texture.

Tools: stencil brush; hammer or mallet; self-healing cutting mat; sandpaper; objects with which to make marks: paper clips, hardware such as screws, bolts, picture hangers, nuts, keys, old metal type, needles or pushpins to poke holes, cookie cutters, other metal objects that have distinctive shape or texture; art knife and spare blades

Materials: boards for covers, random strips of 2- or 4-ply boards; PVA or gel medium, acrylic paint

1. Make dents and marks in the board by hammering objects into it, then removing the objects. Scratch the board with keys, paper clips, or needles. Poke holes with pushpins. Enjoy doing a little damage. With your art knife, cut a sawtooth pattern into one of the edges, or just cut some slits.

2. Glue down strips of 2-ply or 4-ply board that have either been cut or torn or both. Cut a window in one or two of the strips to make a recess, if you like.

3. Take a very tiny amount of two different colors of acrylic paint, enough to wet the brush, and scrub the paint into the board, one section at a time. Add more paint and continue until the board is covered.

4. Paint the back of the board, too, so it doesn't warp. (You don't need to paint the back of the board if you will be applying glue to it later, such as for a cover of an accordion-fold book.)

RECESSES AND INSETTING A TITLE

An indicator on the front cover lets the reader know which end is up. My biggest pet peeve is spending extra time opening the book and rotating it until I get to right-side up. I'd rather use that time to experience the book itself. Titles and/or recesses are ways to indicate the book's beginning. If you want to glue a title to the front cover, you may apply PVA to the back of the title strip and glue it down, or you may prepare your cover boards with a slight recess or inset. If you create an inset, the title will lie flush or slightly lower than the boards, which will make it less likely for the title strip to pull up, fall off, or become abraded when pulled out from between other books on a bookshelf.

Recesses add three-dimensional physical depth to artwork. You can make a recess in a book cover in one of two ways. The first way involves using two or more 2-ply boards that you glue together. The second way involves partially cutting into a 4-ply board and peeling off a layer or two. In a recess, you can place a title strip or a thin object. I used a recess to give shadow to the cover of *Distressed* and to protect the reader's fingers from a tied fly for the book *I Hide a Wild Fish Cry*. You can also glue layers on top of the front board before you cover it for a dimensional effect.

Large or Deep Recess

1. Cut two covers exactly the same size from a 2-ply board with grain going in the same direction.

2. Decide where you want the recess, and measure and mark a window on one cover board only. Using an art knife, cut out the window.

3. Apply glue to the back of the board with the window. It will probably be less awkward if you leave the window board faceup and press the unglued board on

top of it instead of trying to move the glued window board. Align the edges of the two boards, and press them together.

4. Put the laminated boards between two sheets of waxed paper, and leave them under a heavy weight overnight. Use a 4-ply board for the back cover.

Note: If you want a thicker cover with a deeper recess, cut more boards with windows and glue them all together.

Windows

1. Cut out windows in both 2-ply boards.

2. Wrap the boards in paper or cloth, making *X*s across the windows and tucking the extra material around the edges to the back sides.

3. Glue a layer of drafting vellum or glassine between the two boards, making the "glass" for the window of your recess.

4. Glue the boards together, sandwiching the vellum.

Small or Shallow Recess

The second technique involves no glue. I recommend it for small recesses under a couple of inches in width and length.

1. Measure and mark a recess in a 4-ply board.

2. With your art knife next to a metal ruler, cut into the board about halfway.

3. Use the knife to dig in and loosen the edges.

4. With your fingers or a tweezers, pull up the layers of board to make a uniformly flat recess. If you are having trouble pulling up the layers, either you may have not cut deeply enough into the board or you have made your recess too large. It may be easier to peel up the layers in the direction of the grain.

CLOSURES

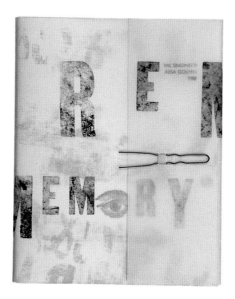

RE: Memory (a collaboration with Val Simonetti), 1988; photocopy, letterpress, brayer printing; 5¼ x 7 inches (13.3 x 17.8 cm) (photo: Jim Hair)

Some boxes and books require a tie or link so they do not spring open. You can use paper, ribbons, bone closures, buttons, Velcro, or other boxes to secure the book. When choosing a closure, consider using materials that relate to the contents of your book, and think about the experience the reader will have when opening the clasp or ribbon.

The extra time it takes to open a book or box adds suspense and contributes to the feel of the book. Bone closures add dignity to books and boxes; if you use two, point the ends toward each other. Paper clasps and buttons and string can provide a variety of interesting closures. To make your own buttons, use a polymer clay, bake it hard in the oven, then varnish it for a custom look. When you choose a

closure for your book or box, think about the message you wish to convey as well as the function.

Paper Strips, Bands, and Clasps

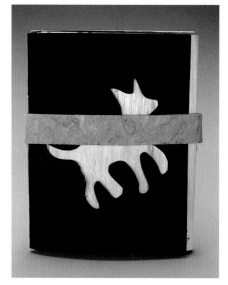

Blue Leash for a Black Dog, 2004; gesso and acrylic inks, cutouts, stencils; $4^3/_8$ x $5^1/_2$ inches (11.1 x 14 cm) (photo: Sibila Savage)

A paper strip may be used in various ways to help keep a book closed. The strip may be threaded through a bone closure and a second strip threaded through a board to make a loop; it may be glued to itself in a loop to make a band; or it may be notched, creating a clasp. Doubling the paper and adding glue, as in the directions that follow, make the paper strip durable.

Tools: glue brush; bone folder; ruler; pencil; scissors

Materials: a piece of lightweight paper, 2 inches (5.1 cm) x approximately 8 inches (20.3 cm), grained long—you can change the width of the strip by using paper (four times the desired width) x (desired length); PVA; scrap paper

1. Fold the paper in half lengthwise, wrong sides together (if there is a wrong side). Open.

2. Fold the edges in to the middle fold, making the paper thinner. Open.

3. Spread a thin layer of glue on the middle two sections of the paper. Refold the edges in to the middle fold and press down.

4. Spread a thin layer of glue on the paper again on top of one of these folded edges.

5. Fold the paper in half, making it even longer and thinner. Press it flat with a bone folder. Glue the ends together in a circle for a paper band, or continue for a paper clasp.

6. Take this glued paper and center it at the back of the scroll or book. Bring each side up and around so that they almost cross each other. Leave a comfortable margin (about ¼ to ½ inch [0.6 to 1.3 cm]).

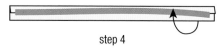

step 1

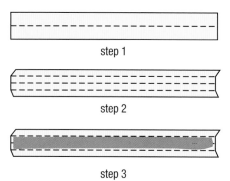

step 2

step 3

step 4

step 5

7. Make marks on the glued paper where the two parts of the paper will meet.

8. With scissors, make a vertical slit at each of the marks; one slit should go half-way down and one slit should go halfway up.

9. Wrap this paper clasp around the scroll or book, carefully sliding the top slit into the bottom slit. Trim the ends if desired.

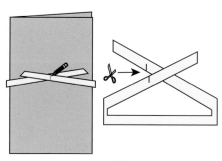

steps 7 & 8

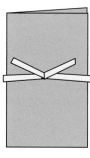

step 9

Variation: Cut slits in the front and back covers, and thread a paper strip through each slit. Mark and make vertical slits so the book will stay closed.

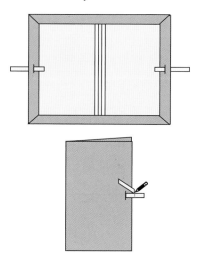

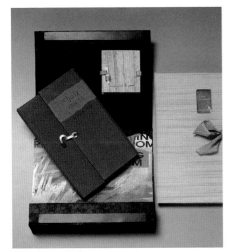

(photo: Sibila Savage)

Magnets

Magnetic strips give the front of the book a clean look. You can find them in many office supply stores. If you need a stronger closure, look for flat "rare earth magnets" online. Rare earth magnets can be glued onto the boards, then covered so that they are not visible. Self-adhesive magnetic strips may be cut to size and placed on top of the endpapers, or, if using them together with the rare earth magnets, they may be stuck underneath the endpapers as well. The rare earth magnets are quite strong, so you do not need many of them.

Bone Closures

Long and triangular in shape, the bone closure has a slit into which you thread a loop of reinforced paper or a ribbon.

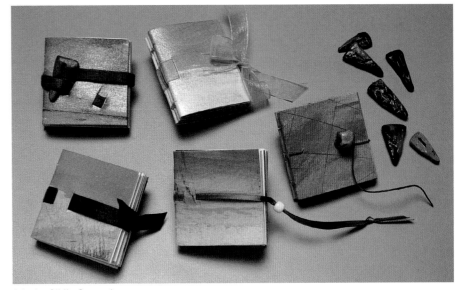

(photo: Sibila Savage)

Make the paper strip only after you have purchased the closure (or made it out of polymer clay); they come in different sizes with different-sized slits. This closure must be added to the cover before the endpapers and book block are glued in.

Tools: ruler; pencil; scissors; knife and cutting mat; bone folder

Materials: lightweight paper, ¾ x 6 inches (1.9 x 15.2 cm), grained long; 1-inch (2.5 cm) long bone clasp or flat triangular polymer bead with a ¼-inch (0.6 cm) slit; book, box, or portfolio; glue; small square of self-adhesive linen tape (optional)

Example: ³⁄₁₆ x 6-inch strip (0.5 x 15.2 cm)

1. Make a Paper Clasp Strip (see page 218; steps 1–5).

2. Thread one end of the paper strip through the slit in the bead. Leave about a 2-inch (5.1 cm) tail.

3. Cut the strip so that the cut end aligns with the other end. The bead will be in the center of a 4-inch (10.2 cm) strip. Save the cut piece.

4. With the knife, make a vertical slit through the back cover of the book or portfolio. It should be ½ inch (1.3 cm)

from the fore edge and centered, top and bottom, and be about ¹⁄₁₆ inch (0.2 cm) wider than the paper strip.

5. Push both ends of the strip with the bead through the slit, from front to back. Use the dull side of the knife to push it through. You can trim any ragged ends later. Leave about ½ inch (1.3 cm) on the inside of the book.

step 2

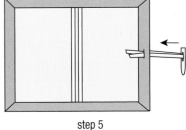

step 5

6. Make a vertical slit through the front cover of the book. It should be ½ inch (1.3 cm) from the fore edge and centered, top and bottom, and about ¹⁄₁₆ inch (0.2 cm) wider than the strip.

7. Moving toward the spine, make a second vertical slit ¼ inch (0.6 cm) from the first one.

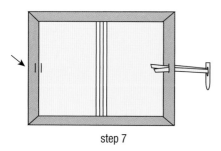

step 7

8. Using the dull side of the knife, push the leftover strip, from back to front, through one of the two front slits.

9. Push the end of the strip, from front to back, through the second front slit to create a loop on the front cover.

10. Close the book, and reach the clasp around to tuck into the loop. Adjust the tightness of the loop so that it is snug but not impossible to remove the clasp. Adjust the strip that holds the clasp as well.

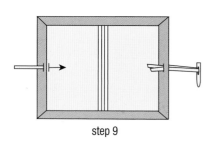

step 9

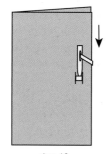

step 10

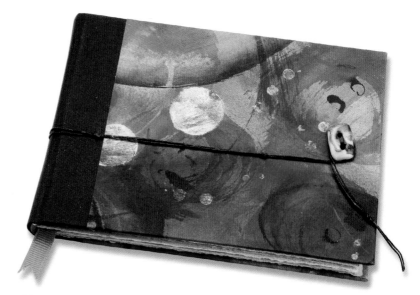

Journal for Nan, 2009 (photo: Lark Books)

11. Trim any ragged ends of the paper strip on the inside, leaving ½ inch (1.3 cm).

12. Apply glue to the ½-inch (1.3 cm) ends, and adhere them to the cover boards, facing their ends toward the spine. Press down for about 20 seconds or until they are set. You may apply a small square of self-adhesive linen tape over the ends of the strips for reinforcement.

13. Apply an endpaper or endpapers as directed for the particular project.

Button and String

The button and string may be added after the book has been completely bound, which makes it an easy addition. I liked the relationship of this closure to the Buttonhole Stitch Book on page 171, so used them together for the model above.

Thread a bookbinding needle with enough waxed linen thread to be able to wind it at least three times around the book from spine to fore edge. Double that amount. If you are using book board, use an awl to poke holes in the front cover that match the holes in a large button. Thread a needle and sew into the button and through the front cover, adjusting

the single threads so that they are even after the first stitch. When the button is securely sewn, tie the ends snugly in a square knot against the back of the inside cover. Add another length of thread, and braid the three strands or just twist the two threads together. Wind the cord around the book twice, then loop around the button one or two times.

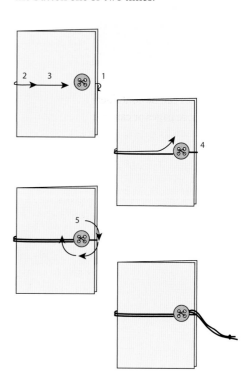

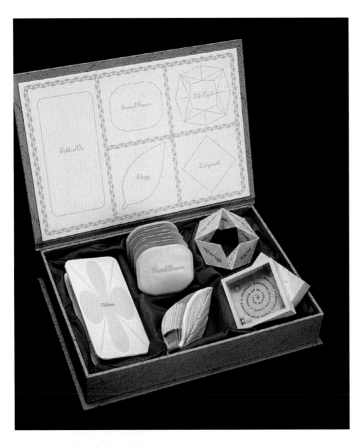

Julie Chen: *Bon Bon Mots*, 1998; letterpress printed from photopolymer plates; edition of 100; 10 x 7 x 1¾ inches (25.4 x 17.8 x 4.4 cm) (photo: Sibila Savage)

BOXES & SLIPCASES

Boxes can be containers for a series of loose pages or cards, or they can be protection for a book. In general, if a book has a hard cover, it does not need a box, although it may look nicer in one. A box or slipcase can protect a thick softcover book. It can present two or more related books together or make a hardcover book look more formal.

A portfolio functions best when it houses loose pages that can be viewed coherently in any order. If the pages are numbered, the reader has to do additional work to make sure the story is in order. Poems or nonsequential prints or photographs work well in a portfolio.

If you have a set of prints, photographs, or loose pages, the box serves as a frame as well as protection. Choose cover materials to reflect or enhance the contents.

Book board is dense and is the best material for building boxes. You will need a large, sharp craft knife and a steady hand (or a professional-quality papercutter). See page 204 for tips on cutting boards. PVA holds the box together. Self-adhesive linen tape is good for reinforcing corners, particularly on larger boxes. Paper-backed book cloth is one of the best covering materials since it is sturdy and wears well, but decorated papers are recommended for lining the boxes.

Many of the techniques for making hardcover books are applicable to making boxes. These techniques include using lightweight to medium-weight paper or backed cloth as well as cutting corners or insetting a title. Cut the cover paper ½ to 1 inch (1.3 to 2.5 cm) larger than the intended box size on all sides to allow for the gaps between the boards. The inner papers should be ⅛ to ¼ inch (0.3 to 0.6 cm) smaller on all sides. The proportions for the hardcover boxes and portfolios (with the exception of the slipcases) assume you use 4-ply museum board, which is ¹⁄₁₆ inch (0.2 cm) thick.

PVA glue is essential to building boxes with rigid walls, as it is strong and dries quickly. Use paste or a paste/glue mixture when covering the boards; this will give you a little time to reposition the boards before the glue sets.

The time required for each project depends upon the size and complexity of the box. Larger boxes or ones with many pieces take more time; allow yourself a few hours to make and cover them.

This chapter covers a basic slipcase, a portfolio (with or without a ribbon tie), a two-piece box, a theater box, a clamshell box, and some ideas about partitions and raised trays.

PACKAGING THE BOOK OBJECT

The box has become an increasingly important element in my work. More than just an elegant and practical form of storage, the container is an integral part of the reading experience. The box is the first step in creating an atmosphere that helps to prepare and focus the reader on the book itself. I have always been fascinated by the sculptural potential of the artist book form, both the structure of the book as well as the packaging. I find that the box contributes to the "objectness" of the piece: the book can be viewed as an artifact as well as simply a book.

JULIE CHEN

FOLDED SLIPCASE

Use a light application of acrylic paint on the boards first, or laminate decorative papers to each side before you fold and score this slipcase. The following example is cut and glued. Because it is made with thin 2-ply board, this slipcase is best for holding smaller books.

Tip: Prevent ragged folds by scoring the museum board first with your sharp knife. Bend the flaps against the score, or place your ruler next to the score.

Tools: stencil brush for painting; metal ruler; knife and cutting mat; bone folder; pencil

Materials: one 2-ply board, 11½ x 9 inches (29.2 x 22.9 cm), grained short; acrylic paints; gel medium (optional); PVA; scrap paper

Example: 6 inches (15.2 cm) tall x 5 inches (12.7 cm) wide x 1½ inch (3.8 cm) deep open box (slipcase)

To prepare your board, paint the front and back, using acrylic paints straight from the tube or squeezed out onto a paper towel with no added water. Keep the paint thin and dry, not gloppy. Paint the edges as well. The board should dry within a couple of minutes. Alternatively, apply PVA to a piece of decorative paper slightly larger than your board, and smooth the paper over the board. Repeat for the other side. Trim with the knife against the metal ruler.

1. Put your 2-ply board horizontally in front of you. Measure 1½ inch (3.8 cm) from the top and bottom of the board. Mark and score lightly with your knife against the side of the ruler. You should have two horizontal lines.

2. Measure 5 inches (12.7 cm) from the left and right edges of the board on what will be the outside of the slipcase. Mark and score (a light cut with your knife) two vertical lines. The distance between the two lines should be approximately 1½ inch (3.8 cm).

3. With your knife, cut out that 1½-inch (3.8 cm) square in the center top and center bottom of your board. Crease and fold up all other edges.

4. Apply PVA to one flat edge of one of the top flaps. Pull the other flap over it, and press together. Hold for five to ten seconds while the glue sets. Repeat for the bottom flaps, gluing the opposite edge under instead of over. One flap from the right side should be under one from the left, and one flap from the left should be under one from the right.

Uses: protection for several softcover books; box for a book with painted covers

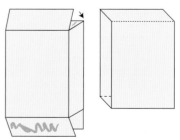

step 4

COVERED**SLIPCASE**

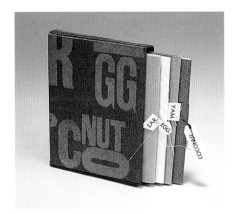

Ear. Egg. Yam. Coconut., 1987; letterpress on paper; single signatures in covered slipcase; 3 ¼ x 4 ¼ inches (8.3 x 10.8 cm) (photo: Jim Hair)

The collection *Ear. Egg. Yam. Coconut.* has a version of this covered slipcase with a letterpress printed covering sheet. The title of the little books comes from a quirky desire to use things that had different colors inside and outside.

Tools: glue brush; knife and cutting mat; pencil; metal ruler; scissors; bone folder

Materials: one 2-ply board, 11½ x 9 inches (29.2 x 22.9 cm), grained short; gummed reinforcement tape or self-adhesive linen tape (optional); 1 piece of cover paper or book cloth, 6 x 16 inches (15.2 x 40.6 cm), grained long; scrap paper; PVA or glue/paste mixture; 1 back spine piece, 1⅜ x 5⅞ inches (3.5 x 15 cm), grained long

Example: 6 inches (15.2 cm) tall x 5 inches (12.7 cm) wide x 1½ inch (3.8 cm) deep covered, open box

1. Build the box as for the Folded Slipcase (page 222) or for the bottom tray of a Two-Piece Box (page 226).

2. If your board is thick and you need to cut out the little squares at the spine, cut two squares of gummed reinforcement tape or adhesive linen tape and place over the two short, open slits where there is a slight gap.

3. Cover your work area with scrap paper. Put the long cover paper on the scrap paper, wrong-side up, oriented vertically.

4. Apply glue to the entire top half of the paper.

5. Place the box ½ inch (1.3 cm) from the top edge of the paper and centered side to side.

6. Apply the glue or a glue/paste mixture to the last section, rubbing down and rolling the box over so you can work around it. (You may choose to apply glue to the whole piece of paper, but I find it unwieldy working with so much exposed glue.)

7. When the box is wrapped, cut slits at each corner. These slits will allow you to wrap the paper over the front edges and inside the slipcase. For the back, you may wish to cut straight slits, then taper them by cutting them into triangles, like you would to cover a board for a hardcover book. Apply glue, and rub down. For the front (open end), just glue and fold over inside the box. Rub down.

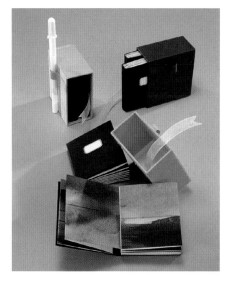

Little Black Books, 2004; acrylic ink painted paper; circle accordions and covered slipcase with paper loop pen holders; single signatures in covered slipcase; 3 x 3⅛ x 1½ inches (7.6 x 8 x 3.8 cm) (photo: Sibila Savage)

8. Apply PVA or a glue/paste mixture to the back spine piece. Place over the back of the box. Rub down.

Variation: Use a wider covering paper. Instead of centering at step 5, place the box with the closed side ½ inch (1.3 cm) from one edge. This will allow you to cover more of the inside.

Uses: protection for several softcover books or one hardcover book; stand for the piano hinge book

step 1

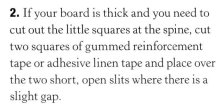

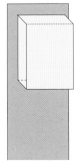

step 5

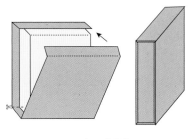

steps 7 & 8

HARDCOVER**PORTFOLIO WITH RIBBON TIE**

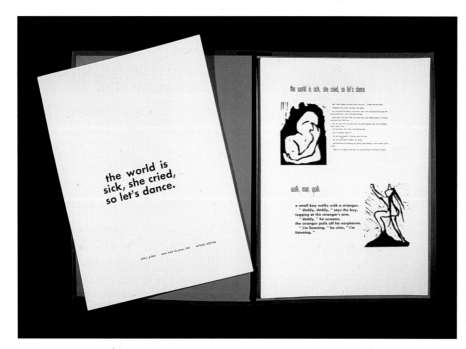

the world is sick she cried, so let's dance,
1983; letterpress and handprinted linoleum
cuts; edition of 15; 12¼ x 16⅛ inches
(31.1 x 41 cm) (photo: Jim Hair)

This is variation number three, an improved version of the first portfolio I made in 1983, *the world is sick she cried, so let's dance*; it has a folded-over spine that leaves no gaps at the head and tail. This version also allows the use of a book cloth outer spine. The decorative paper is glued on top of the rough cloth edges. You can get more information about making portfolios from *Creative Bookbinding* (Dover, 1990) by Pauline Johnson, and from *Books, Boxes, and Portfolios* (Design Press, 1990) by Franz Zeier.

Tools: cardboard to protect work surface; ruler; pencil; glue brush; bone folder; scissors; awl or wood gouge; fiberboard; weights

Materials: (all paper grained long): 1 piece of heavier paper or book cloth for outer spine, 4 x 12 inches (10.2 x 30.5 cm); glue/paste; scrap paper; two 4-ply museum boards, each 9½ x 12 inches (24.1 x 30.5 cm); 2 pieces of decorative paper, each 9½ x 14 inches (24.1 x 35.6 cm); 1 lightweight piece for the inner spine, 3½ x 9 inches (8.9 x 22.9 cm); 1 yard (92.4 cm) of ribbon; 2 lightweight inside sheets, each 9 x 11½ inches (22.9 x 29.2 cm); waxed paper

Example: 9½ x 12-inch (24.1 x 30.6 cm) portfolio

1. Place the outer spine strip (the heavier paper or book cloth), wrong-side up, vertically in front of you.

2. Measure 1½ inch (3.8 cm) from the right and left edges; draw a line with a pencil.

3. Apply glue to the strip of outer spine, from each line outward toward the edge.

4. Place the two boards on the pencil line. Press down.

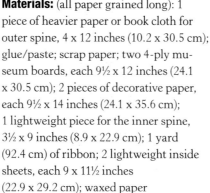

steps 2 & 3

step 4

5. Add glue at the top and bottom tabs of the spine paper. Fold the spine paper over the top and bottom of the boards and press down.

6. From the inner edge of each board, measure away from the center and mark 1¼ inch (3.2 cm) on the folded-over spine paper at the top and bottom.

7. Apply glue to the back of one sheet of the decorative paper. Remove to a clean work surface.

8. Align one museum board with the pencil lines from step 6.

9. Cut diagonals on the two corners. Remove the two corners (triangles).

10. Fold down the flaps over the boards. Use a bone folder to rub down.

11. Repeat steps 7–10 for the other board.

12. Apply glue to the back of the inner spine paper. On the inside of the portfolio, align the sides of the inner spine with the outer spine, making sure it is centered at the top and bottom. Press down.

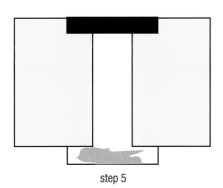

step 5

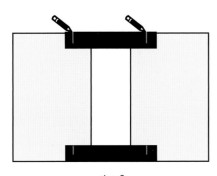

step 6

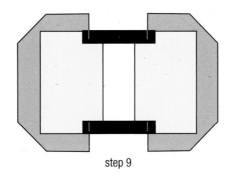

step 9

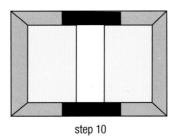

step 10

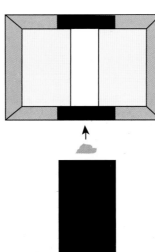

step 12

To add ribbons, continue below, or skip to step 18

13. Cut two pieces of ribbon, one for each board.

14. Measure ½ inch (1.3 cm) in and halfway down the boards.

15. Poke a hole in each board with an awl or wood gouge, or cut a slit as shown.

16. Thread the ribbon through, leaving 1½ to 1 inch (1.3 to 2.5 cm) of ribbon inside the cover.

17. Apply a little glue to each ribbon. Glue down to the boards.

18. Apply glue to the back of one inside paper. Place down on one board, being careful that the ribbon is lying flat.

19. Put waxed paper on the board, and rub down with a bone folder.

20. Repeat steps 18 and 19 for the other board.

21. Place waxed paper to cover the fiberboard. Place the portfolio on the waxed paper, open. Cover with waxed paper and another board. Put weights on top.

Note: If you make a larger portfolio, you can put the waxed paper inside and press with the portfolio closed.

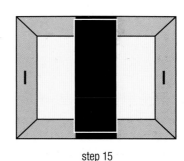

step 15

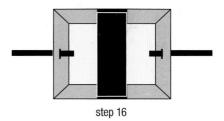

step 16

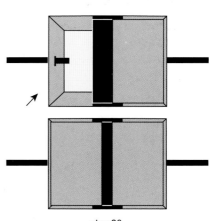

step 20

TWO-PIECE **BOX OR CANDY BOX**

Box for Val's Letters, 1989 (photo: Jim Hair)

A couple of years ago, I consulted with John Demerritt of Emeryville, California, boxmaker extraordinaire, to learn tips for making a great container. He showed me the secret to measuring without a ruler and working with trays.

My friend Val and I had an art day where I showed her how to make this box. Since we had been exchanging so much mail art, we made boxes to hold each other's letters. She likes umbrellas. I glued extra boards underneath in an umbrella shape, then glued paper over the box to wrap it.

For a smooth look, make the top lid with edges flush, the bottom with a lipped edge. To make the box easier to open, give the top a lip as well, giving the final project the look of a candy box. To determine different measurements, make the bottom of the box at least ¼ inch (0.6 cm) larger (on all sides) than the book or contents that will go into in.

Tools: pencil; ruler; glue brush; knife and cutting mat; scissors; bone folder; weight

Materials: 4 large boards, each 8¾ x 5½ inches (22.2 x 14 cm), grained long; 2 boards, each 5½ x 2 inches (14 x 5.1 cm); 2 boards, each 8¾ x 1½ inches (22.2 x 5.1 cm); 2 boards, each 8¾ x 2 inches (22.2 x 5.1 cm); 2 boards, each 5½ x 1½ inches (14 x 3.8 cm); PVA; scrap paper; paper plate for paste or glue; four square pieces of self-adhesive linen tape, ¾ to 1 inch (1.9 to 2.5 cm) wide; 2 pieces of book cloth or lightweight papers, each 10¼ x 7 inches (26 x 17.8 cm), grained long; 2 pieces of book cloth or lightweight papers, each approximately 32 x 6 inches (81.2 x 15.2 cm) (preferably grained short); waxed paper; 2 decorative or lightweight inner papers, each 8½ x 5¼ inches (21.6 x 13.3 cm), grained long

Example: 8¾ x 5½ x 2–inch (22.2 x 14 x 5.1 cm) box

Building the trays

1. Arrange these sets of board pieces for the top tray as follows: one large board (vertical); 2-inch-wide (5.1 cm) short end pieces, top and bottom; 2-inch-wide (5.1 cm) long side pieces right and left. To the right of the first set, similarly arrange one large board, with the 1½-inch-wide (3.8 cm) side and end pieces around it. Ignore the two remaining large boards for now.

2. Trim the end pieces for the left-hand tray (lid) two board thicknesses shorter than the tray width only. Hold two pieces of scrap board at the edge of one end board, and make a mark on the end piece with your pencil to determine where the cut will be. Repeat the mark and cut for the second end board. The left-hand tray will have two long pieces exactly the length of the cover board, so they do not need to be trimmed.

step 1

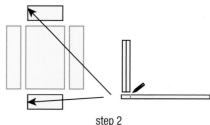

step 2

3. With a small brush or squeeze bottle, apply straight PVA to the edge of one long side piece of the left-hand tray. Stand the side piece perpendicular to and on top of the matching edge of the large board. Make sure the boards are aligned where they join. Wipe away excess glue. Hold it a minute or so until set.

4. Check to see that the other wall pieces are exactly the same height when they stand up next to each other. Trim if necessary. Apply glue to one short side, putting a little on the edge that will touch the side you just glued down as well.

5. Repeat steps 3 and 4 for the third and fourth sides. Let dry while you continue with the bottom tray.

6. For the right part of the box (the bottom), you will need to trim all of the boards. Trim the large board 3 to 4 board thicknesses in both directions (three if you are using lightweight paper, four if your covering paper is book cloth). Trim the longer 1½-inch-wide (3.8 cm) side pieces to the new height of the large board. Trim the smaller 1½-inch-wide (3.8 cm) end pieces so they are two boards shorter than the width of the new board (as you did in step 2).

7. Apply glue to the sides and ends as you did in steps 3 and 4. Check that the sides are not hanging over.

8. Place a square of linen or paper tape to overlap and join the side pieces inside each of the four corners of each tray for reinforcement.

step 8

Covering the trays

9. Measure the height of the book cloth or cover paper that you will need for each by taking a long strip of scrap paper, putting it under the tray, bringing it up the outside, wrapping it over the top, down the inside and leaving about 1 inch (2.5 cm) resting flat on the bottom inside. Trim the scrap paper, and use for a guide.

10. To measure the length of book cloth or cover paper that you will need, place the tray on a strip of book cloth (cut to the height in step 9), with about ½ inch (1.3 cm) exposed on one edge and ½ inch (1.3 cm) exposed at a perpendicular edge. Roll the tray carefully down the cloth or paper until you have used all four sides. Leave a little at the edge (you will trim this later), and mark this place. Cut the cloth or paper on this mark.

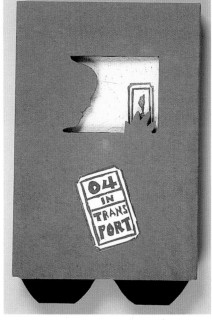

Four in Transport, 1990; four sidebound books in a shaped box; edition; approximately 6 x 10 inches (15.2 x 25.4 cm) (photo: Jim Hair)

11. Orient one cloth or paper strip wrong-side up. Apply PVA ½ inch (1.3 cm) from the bottom in a band the height of your tray (2 inches [5.1 cm] or 1½ inch [3.8 cm]) by the length of your tray (approximately 9 inches [22.9 cm]). Affix the tray so that ½ inch (1.3 cm) of the cloth or paper is exposed at one edge, ½ inch (1.3 cm) (no glue here) is exposed at the bottom. Smooth the ½-inch (1.3 cm) edge over the outside corner of the tray. Smooth down the rest of the cloth or paper.

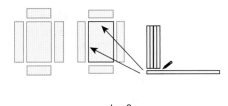

step 6

step 7

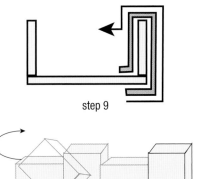

step 9

step 10

step 11

12. Continue applying glue, affixing the tray, and smoothing down. Before you affix the last side, trim the cloth or paper so it does not extend over the outside corner.

13. On the closed side of the tray, cut small triangles at the corners.

14. On the open side of the tray, cut two slits on one side that are just inside the walls.

15. Cut these same slits on the opposite parallel side.

16. Without gluing yet, wrap each covering paper over the side and down into the tray. Crease. Unfold.

17. With a scissors, slightly miter the corners of the cloth or paper that will be lying on the bottom of the tray, stopping at the fold.

18. With the tray on its side, apply glue to the flaps, one at a time. Begin with the larger flaps, the ones that will be covering the inner corners. Glue down the slightly smaller ones last.

19. Apply glue on the smaller flaps on the bottom, outside the box, and press them into place, being careful to check that the tiny corners of the board are covered. Smooth into all corners and joints with a bone folder; put waxed paper or other protective sheets between the bone folder and the box, if you like.

20. Repeat steps 11–19 for the remaining tray.

21. Cover the two larger boards with the two large rectangular papers or book cloth as you would for separate boards (page 209).

22. Apply glue to the bottom of the tray. Affix to the uncovered side of one board. Press and hold. Repeat for the second tray. Make sure that the box bottom is centered before you press in place.

23. Check that the lining papers will fit into the box without running up the inner walls. Adjust by trimming, if necessary. Apply glue to the back of the lining paper. Smooth into place inside the corresponding tray. Repeat for the remaining tray.

24. Line the boxes with waxed paper, open edges up, and put a weight on top of each. Leave to dry overnight or a few days.

Variation: if you are using heavy book cloth to cover the trays, add a liner of heavyweight paper or bristol after step 21 to even out the surface before you glue it to the tray. Measure the area of the exposed board, and cut the paper to fit. Adhere with PVA. Continue with step 22.

step 24

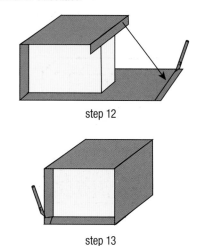

step 12

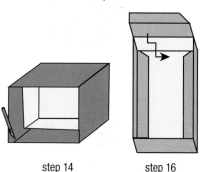

step 13

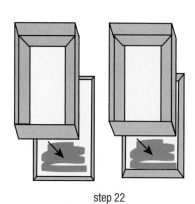

step 22

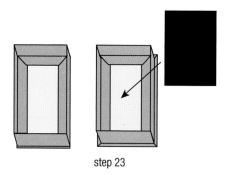

step 14

step 16

step 23

PARTITIONS **& RAISED TRAYS**

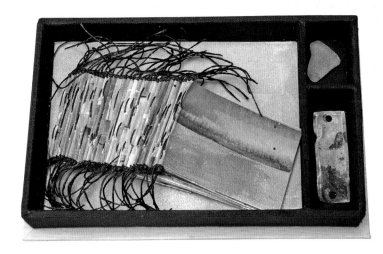

Century, 2007; acrylic inks, linen thread, book cloth, found objects; 8 x 5 x 1¾-inch (20.3 x 12.7 x 4.4 cm) partitioned box (photo: Sibila Savage)

C reating a book in a box with an object or two can enhance your concept, either clarifying your idea or adding mystery. Build a partition to separate the book from the object, or make a tray that fits in the top over the book. The partitions must be wrapped and glued into the box before the cover material is applied. The tray can be made like the shallow bottom of a Two-Piece box; you will need to add a support to the outer box before you wrap it to hold the tray in place. You will need to read through and be familiar with the Two-Piece Box instructions to complete these two projects.

Partition

Tools: knife and cutting mat; pencil; metal ruler; scissors; bone folder

Materials: 1 piece of board, 5½ x 1⅜ inches (14 x 3.5 cm); book cloth or paper to cover the board, 6½ x 4 inches (16.5 x 10.2 cm); PVA

1. Build the Two-Piece Box, steps 1–8. Trim the extra piece of board by two board thicknesses, like you did for the shorter box ends of the bottom (right-hand) tray in step 6.

2. Fold the covering paper in half, lengthwise. Place the board so that the long edge is touching the center fold and center it

side-to-side. Draw around the board with a pencil.

3. Remove the board. Apply PVA to the rectangle you drew in step 2. Press the board into place.

4. Apply PVA to the exposed board and wrap the covering material over the edge. Use a bone folder to smooth the edge and smooth the faces of the covered board.

5. Use the scissors or knife to slit from the covering material towards the board at the top on the right and left edges.

6. Fold back the covering material on both sides, exposing the back of the covering material at the right and left edges.

7. Fold up the covering material at the bottom edge, also exposing the back of the covering paper.

8. Cut out the four squares at the corners: the right and left edges, on both sides.

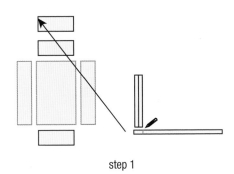

step 1

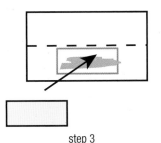

step 3

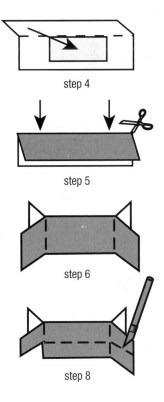

step 4

step 5

step 6

step 8

9. Apply PVA to these exposed flaps and glue into the bottom tray, wherever you desire.

10. Continue with step 9 of the Two-Piece Box, cutting two extra slits in the cloth or paper (one on each parallel side) so that the covering material will go over the wall and into the new compartment you created.

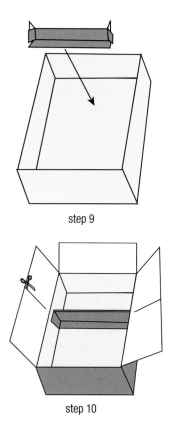

step 9

step 10

Raised Tray

Tools: pencil; ruler; bone folder; scissors; knife and cutting mat; glue brush; waxed paper; four square pieces of self-adhesive linen tape, ¾ to 1 inch (1.9 to 2.5 cm) wide

Materials: PVA; scrap paper; paper plate for paste or glue; 2 decorative or light-weight papers, each 8½ x 5¼ inches (21.6 x 13.3 cm), grained long (these are approximate sizes and will need to be trimmed to fit inside the Two-Piece Box) 1 large board, 8¾ x 5½ inches (22.2 x 14 cm), grained long; 2 boards, each 5½ x ½ inches (14 x 1.3 cm); 2 boards,

each 8¾ x ½ inches (22.2 x 1.3 cm); 1 piece of book cloth or lightweight paper, 32 x 3 inches (81.2 x 7.6 cm), preferably grained short

1. Build the Two-Piece Box, steps 1–8.

2. Build an extra tray using the materials above and the Two-Piece Box directions, making the extra tray 3 to 4 boardwidths smaller than the bottom tray (in both directions). Cut the walls to fit the new tray before you glue it together.

3. Cover the new tray, following the Two-Piece Box, steps 9–19.

4. Trim one of the decorative 8½ x 5¼ inches (21.6 x 13.3 cm) lining papers so it will fit into the box without running up the inner walls. Apply glue to the back of

the lining paper. Smooth into place inside the new tray.

5. Trim the other decorative 8½ x 5¼-inch (21.6 x 13.3 cm) paper so that it fits on the underside of the new tray with at least a ⅛-inch (0.3 cm) margin. Glue in place over the exposed board.

6. To the bottom tray of the Two-Piece Box itself, glue two strips of board, each the same size as the top and bottom walls of the tray. Let dry. Check to make sure they will support the tray. Add two more wall pieces, this time of 2-ply board, if they do not seem thick enough.

7. Cover the Two-Piece Box, steps 9–24.

8. Let dry. Rest the new tray on the supports.

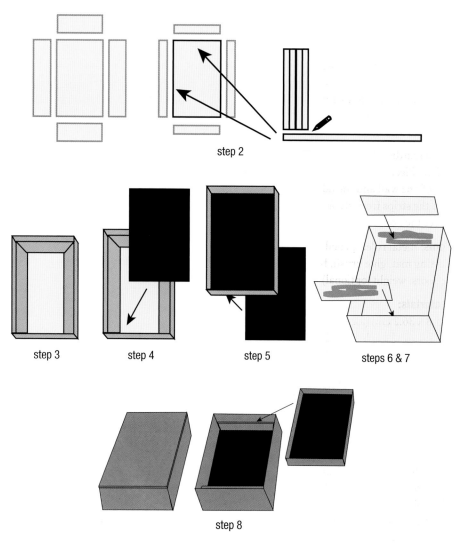

step 2

step 3　　step 4　　step 5　　steps 6 & 7

step 8

THEATER**BOX**

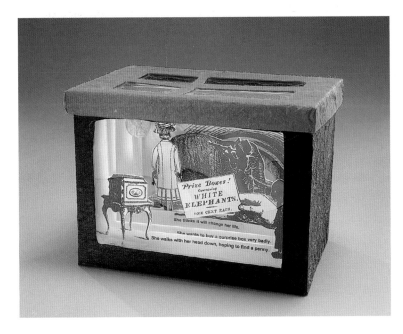

Surprise Box, 2000; laserprinted clip art, museum board, polyester film; 6¼ x 5 x 4 inches (15.9 x 12.7 x 10.2 cm) (photo: Sibila Savage)

Make a three-dimensional book in a box that works like scenery in a theater. The pieces are removable and interchangeable so you can make as many scenes as you like.

For a sturdier theater, you may also build a Two-Piece Box (page 226): cut a window out of one wall and the lid; build the box; add the strips from steps 9–14, below; and cover the box.

Tools: metal ruler; pencil; knife and cutting mat; glue brush; bone folder; scissors; weight (optional)

Materials: 2-ply board, 12½ x 14¼ inches (31.8 x 36.2 cm) (for the box); 12 strips of 4-ply board, each 4¼ x ½ inches (10.8 x 1.3 cm); PVA; self-adhesive linen hinging tape cover paper, 5½ x 22 inches (14 x 55.9 cm) (for the box); cover paper, 6 x 3 ¾ inches (15.2 x 9.6 cm) (for the bottom of the box); polyester film, 5¾ x 4 inches (14.6 x 10.2 cm) (for the front of the box); 2-ply board, 5½ x 7½ inches (14 x 19.2 cm) (for the lid); cover paper, 6 ½ x 8 ½ inches (16.5 x 21.6 cm) for the lid; polyester film, 6¼ x 4¼ inches (15.9 x 10.8 cm) (for the lid); 1 piece of paper, 4½ x 6¼-inch (11.4 x 15.9 cm);

6 pieces of 2-ply board, each 4½ x 6¼ inches (11.4 x 15.9 cm) (for the scenes); paint (optional)

Building the box

1. Orient the 12½ x 14¼-inch (31.8 x 36.2 cm) board vertically.

2. Measure and mark 4¼ inches (11.4 cm) from the right and left edges.

3. Measure and mark 4 inches (10.2 cm) from the top and bottom edges.

4. With your knife against the ruler, make light scores connecting the top and bottom marks and the right and left marks, making what looks like a tic-tac-toe grid.

step 4

5. With your knife against the ruler, cut out the top and bottom middle sections. Your board should now look like a capital *H*.

6. In the right-hand middle section, you will be outlining and cutting a rectangular window. Measure and mark ½ inch (1.3 cm) from the right edge and ½ inch (1.3 cm) from the top and bottom of this particular section.

7. Measure and mark ¾ inch (1.9 cm) from the left side of this section.

8. With your knife against the ruler, cut out the rectangular window.

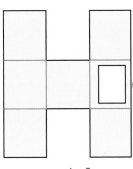

step 8

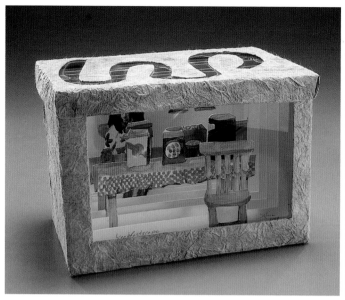
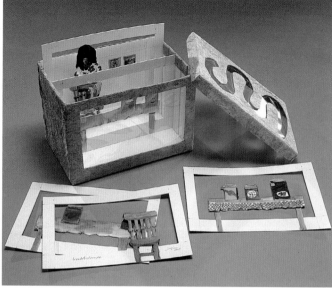

BreakfastScape, 2000; acrylics, museum board, polyester film; 6½ x 4½ x 4¼ inches (16.5 x 11.4 x 10.8 cm) (photo: Sibila Savage)

9. Now you will glue down the 4¼ x ½-inch (10.8 x 1.3 cm) strips of board. Start measuring and gluing from the side below and closest to the cut-out section. Progress toward the outside edge. Mark ⅛ inch (0.3 cm) from the top edge of the middle section.

10. Glue down one strip of board so that one edge touches the ⅛-inch (0.3 cm) mark.

11. Measure another ⅛ inch (0.3 cm) from the edge of that board.

12. Glue down another strip of board.

13. Continuing measuring and gluing until you have ⅛-inch (0.3 cm) space, ½-inch (1.3 cm) board, space, board, space, board, space, board, space, board, space, board.

14. Repeat steps 9–13 for the top edge of the cut-out section.

15. Fold up the box along the score lines with the paneled sections visible on the inside.

16. With the linen hinging tape, tape the unpaneled sides to the bottom of the box.

17. Apply glue to the flat side of the paneled flaps, and press them to the standing walls. Hold them together for about a minute or until the PVA is set.

Covering the box

18. Now you will cover the box. Start at the back of the box (the side without the window). Glue your 5½ x 22-inch (14 x 55.9 cm) piece of cover paper so that approximately 1½ inches (3.8 cm) covers the back of the box. Leave a top and bottom margin of about ¾ inch (1.9 cm) (at least ½ inch [1.3 cm]).

19. Apply glue to the next side of the box, and rub down the cover paper.

20. Continue to apply glue and press down the paper until all four sides are covered. (You will cover up the window temporarily.)

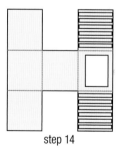

step 14

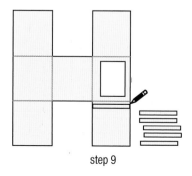

step 9

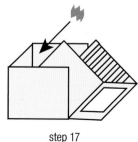

step 17

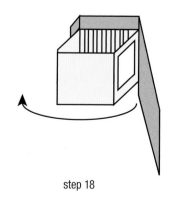

step 18

21. Cut very thin triangles or slits at each of the eight corners.

22. Apply glue to each flap of cover paper and rub down one by one.

23. Apply glue to the 6 x 3¾-inch (15.2 x 9.6 cm) paper, and cover the bottom of the box.

24. Make diagonal slits from each of the corners where the window will be. Trim down the points of these triangular flaps to about ½ inch (1.3 cm) from each edge of the window.

25. Apply glue to each flap and cover the edges of the window.

26. Run a line of glue around the border of the window on the inside of the box. Press the 5¾ x 4-inch (14.6 x 10.2 cm) polyester film into place. Hold for about a minute.

Building the lid

27. Measure and mark ½ inch (1.3 cm) from each edge of the 5½ x 7½-inch (14 x 19.2 cm) piece of board.

28. Lightly score this tic-tac-toe grid with your art knife.

29. Cut slits from the edges in, parallel to the long sides only.

30. Cut a shape in the large middle panel. You may also cut a rectangle that has at least ½-inch (1.3 cm) margin all the way around. This will be your top window.

31. Fold up the lid along the scores.

32. Apply glue to the top of the four little flaps, and press them to the short sides of the lid.

33. Press down a small piece of linen tape to help hold the flaps in place.

Covering the lid

34. Put the 6½ x 8½-inch (16.4 x 21.6 cm) cover paper in front of you, wrong-side up.

35. Apply glue to the top of the lid, around the window. Center it on the cover paper and press down.

36. Abut a ruler to the side of the lid, and draw lines extending from each side. Do the same for all four sides. You will now have another tic-tac-toe grid.

37. Draw diagonals across the end squares at the corners closest to the lid. Leave at least ¼ inch (0.6 cm) between the lid and the corners you will cut.

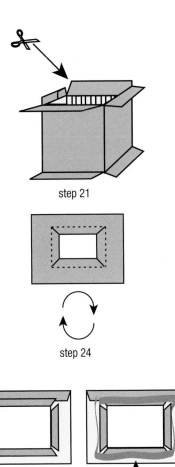

step 21

step 24

step 25 & 26

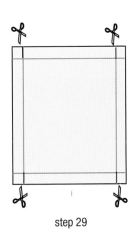

step 29

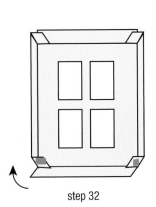

step 32

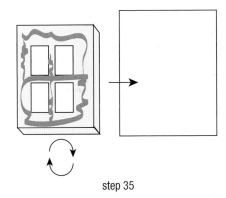

step 35

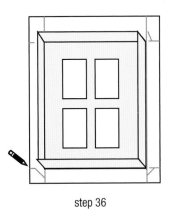

step 36

38. Cut along the lines and across the corners, making sure that the cover paper will overlap slightly to cover the lid corners.

39. Make an *X* with your knife across the cover paper just where the window will be.

40. Apply glue to each outer flap, and press down against the lid. Tuck in the corners as you go.

41. Apply glue to the window flaps, and wrap the cover paper around the edges of the window. If you have an unusual shape, you may need to trim the flaps so they will not be visible from the outside.

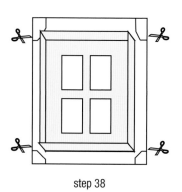

step 38

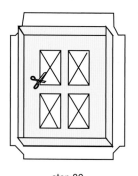

step 39

42. Apply glue to the margin around the window, and place the 6¼ x 4¼-inch (15.9 x 10.8 cm) polyester film here. Hold in place for a minute or two, or put a light weight on top.

For the scenes

The objects in each scene need to be connected to the sides or top or bottom of the card for this tunnel to work.

43. Draw a scene on a 4½ x 6¼-inch (11.4 x 15.9 cm) piece of paper. Think about the depth of the scene; what is behind something? Try to think of a scene where many things are behind many other things. Draw only the outlines. You will do the details later.

44. Shade the back side of the paper with the side of your pencil.

45. Align the paper with the scene on it with one piece of the 2-ply board. Trace over your lines. Repeat for the remaining five boards.

46. Number your boards lightly from 1 to 6.

47. Take the first board. What is at the very front of the scene? Draw only this object/character on the first board. Put in all the details.

48. Draw the object that is directly behind the first one on the second board. Repeat for all the boards. Use board number six as the background for the entire scene, such as a back wall, the sky, etc.

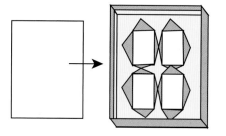

step 42

49. Take a ruler and pencil, and measure a border that is ½ inch (1.3 cm) on the top and sides and ¾ inch (1.9 cm) from the bottom edge of each scene (except board number six).

50. Make sure that the objects in each scene are touching or overlapping the border on at least one edge.

51. With your knife, cut out the silhouette of the object, leaving it in contact with the borders. Repeat for all but board number six. Board number six will not be cut. It is the final background.

52. Paint, color or collage the images. Leave the borders white.

53. Arrange the boards in the box. You may need to trim them a bit so they will fit in the grooves.

54. Place the lid on top. You are finished. You may make another set of six cards to change the scene whenever you like.

⚜ THE BOOK AS CONTAINER

For many years, I've put things away in books: letters, flowers, mementos of one kind or another, only to find them months, or even years, later. I like the surprise of finding something between the pages of a book. It is no doubt in the natural course of things that I began to put things in the books I make. The very shape of a book suggests a box, so I began cutting out the insides of books and putting things inside. This led to making the books from scratch, designed to be hollowed out. I've made many of these over the years.

MARIE DERN

CLAMSHELL**BOX**

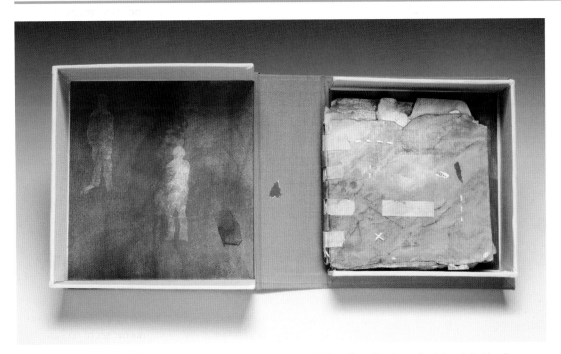

Clamshell Box, 2009; box holds a crossed-structure binding made from found and acrylic-ink-painted business envelopes (photo: Sibila Savage)

Also known as a presentation box or drop-spine box, this container has two three-sided top and bottom trays that are connected by a case: when opened, the spine drops down like a book. The open-sided trays make it easy to remove the contents of the box. You can make this box with or without a lipped lid. While the lip makes it easier to open, you may like look of the box without it.

If you have already made a book that needs a box, determine the size of the bottom tray by adding ½ inch (1.3 cm) to the height of the book and ¼ inch (0.6 cm) to the width. The top tray should be four board thicknesses taller (head to tail) than the bottom board and three board thicknesses wider (spine to fore edge). The depth of the bottom tray walls should be about ¼ inch (0.6 cm) more than the

thickness of the book. The depth of the top tray walls should be about ¼ to ½ inch (0.6 to 1.3 cm) more than that.

The boards for the case will be the same dimensions as the top tray. If you want a lip, add ⅛-inch (0.3 cm) spine to fore edge and ¼ inch (0.6 cm) head to tail. The spine of the case will be the same height, head to tail, as the case boards and the depth of the top tray walls.

Tools: bone folder; knife and cutting mat; pencil; glue brush; ruler; scissors; weight

Materials: 4 boards, each 8¾ x 5¾ inches (22.2 x 14.6 cm), grained long; 2 boards, each 3 x 5¾ inches (7.6 x 12.7 cm); 2 boards, each 3 x 8¾ inches (7.6 x 22.2 cm), grained long; 2 boards, each 2½ x 5¾ inches (6.4 x 14.6 cm); 1 board, 2½ x 8¾ inches (6.4 x 22.2 cm); PVA; scrap paper;

paper plate for glue; 4 square pieces of gummed or self-adhesive linen reinforcement tape, each ¾ to 1 inch (1.9 to 2.5 cm) (optional); 1 piece of book cloth for the case, 17 x 7¼ inches (43.2 x 18.4 cm), grained short; 2 decorative papers, each 6 ½ x 8½ inches (15.2 x 21.6 cm), grained long; 2 pieces of book cloth or lightweight paper, each 22 x 8 inches (55.9 x 20.3 cm), grained short; inner spine strip (same material as the case), 5 x 8½ inches (12.7 x 21.6 cm), grained long; heavyweight or bristol paper (optional. Size may vary: see step 33); waxed paper

Example: 8¾ x 5¾ x 3-inch (22.2 x 14.6 x 7.6 cm) box to hold papers or a book that is approximately 8¼ x 5½ x 2¼ inches (21 x 14 x 5.7 cm)

Building the trays

1. Arrange these sets of board pieces for the top tray as follows: 1 large board (vertical); two 3 x 5-inch (7.6 x 12.7 cm) short end pieces for the top and bottom; one 3 x 8¾-inch (7.6 x 22.2 cm) long side piece on the left of the large board. To the right of the first set, similarly arrange one large board with the two 2½ x 5¾-inch boards on the top and bottom and the 2½ x 8¾-inch board (6.4 x 22 cm) on the right side. Ignore the two remaining 8¾ x 5¾-inch (22.2 x 14.6 cm) large boards and the 3 x 8¾-inch (7.6 x 22.2 cm) spine for now.

2. Trim the end pieces for the left-hand tray (lid) one board thickness shorter than the tray width. Hold one piece of scrap board at the edge of one end board, and make a mark on the end piece with your pencil to determine where the cut will be. Repeat the mark, and cut for the second end board. The left-hand tray will have one long piece exactly the length of the cover board, so it does not need to be trimmed.

3. With a small brush or squeeze bottle, apply straight PVA to the edge of one long side piece of the left-hand tray. Stand the side piece perpendicular to and on top of the matching edge of the large board.

Make sure the boards are aligned where they join. Wipe away excess glue. Hold it a minute or so until set.

4. Check to see that the other wall pieces are exactly the same height when they stand up next to each other. Trim if necessary. Apply glue to one short side, putting a little on the edge that will touch the side you just glued down as well.

5. Repeat steps 3 and 4 for the third side. Let dry while you continue with the bottom tray.

6. For the right part of the box (the bottom), you will need to trim all of the boards. Trim four board thicknesses from the head of the large board to make it shorter, then three board thickness from spine to fore edge. Trim the longer, 2½-inch-wide (6.4 cm) side pieces to the new height of the large board. Trim the smaller, 2½-inch-wide (6.4 cm) end pieces so they are two boards shorter than the width of the new board (as you did in step 2).

7. Apply glue to the sides and ends as you did in steps 3 and 4. Check that the sides are not hanging over.

8. Place a square of linen or paper tape to overlap and join the side pieces inside each of the four corners of each tray for reinforcement.

TRAY COVERING CHECKLIST

1. Glue outer tray walls

2. Cut triangles at base

3. Glue down flaps on base

4. Cut slits on top: two slightly outside walls, one to fit exactly over and inside.

5. Fold over inside and crease

6. Cut tab/flap out of open side, cut straight to edge

7. Glue flap

8. Cut (miter) corners from edges to creases

9. Glue wider material over sides

10. Glue exact material over sides

11. Add spacing (liner) paper

12. Cover inside tray

Covering the trays

9. Measure the height of the book cloth or cover paper that you will need for each by taking a long strip of scrap paper, putting it under the tray, bringing it up the outside, wrapping it over the top, down the inside and leaving about 1 inch (2.5 cm) resting flat on the bottom inside. Trim the scrap paper and use for a guide.

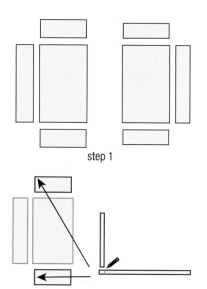

step 1

step 2

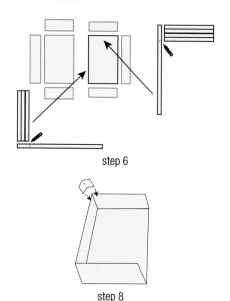

step 6

step 8

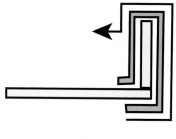

step 9

DISPLAYED AND READ

Book as a medium is interactive, capable of being read, seen, touched and felt, all at one's own pace. However, when exhibited, artists' books often become hands-off objects with only the covers or, at most, a few pages in view. Instead of fighting the tradition of viewing art as untouchable objects, I try to make books that are both readable in conventional ways and displayable as art objects in their own right. Thinking about structure is a big part of my process.

PENNY NII

10. To measure the length of book cloth or cover paper that you will need, place the tray on a strip of book cloth (cut to the height in step 9) with about ½ inch (1.3 cm) exposed on one edge and ½ inch (1.3 cm) exposed at a perpendicular edge. Walk or roll the tray carefully down the cloth or paper until you have used all three sides. Leave another ½ inch (1.3 cm) at the edge, and mark this place. Trim the cloth or paper on this mark.

11. Orient one cloth or paper strip wrong-side up. Apply PVA ½ inch (1.3 cm) from the bottom in a band the height of your tray (3 inches [7.6 cm] or 2½ inches [6.4 cm] by the length of your tray (approximately 9 inches [22.9 cm]). Affix

the tray so that ½ inch (1.3 cm) of the cloth or paper is exposed at one edge with no glue there yet and with ½ inch (1.3 cm) (no glue) exposed at the bottom. Smooth down the rest of the cloth or paper where they have been glued.

12. Continue applying glue, affixing the tray, and smoothing down. Apply glue up to ½ inch (1.3 cm) of the end of the strip.

13. On the closed base of the tray, cut small triangles at the four corners.

14. Apply glue on the smaller flaps on the bottom outside the box and press them into place, being careful to check that the tiny corners of the board are covered. Smooth into all corners and joints with a bone folder.

15. On the top side of the tray, cut one slit that is just inside the walls, then cut diagonally to the edge. Cut the same slit and diagonal cut on the opposite parallel side.

16. Apply glue to the two ½-inch (1.3 cm) flaps on the open sides of the tray. Wrap those around the top and bottom walls.

17. Without gluing yet, wrap each covering paper over the side and down into the tray. Crease. Unfold.

18. With a scissors, slightly miter the corners of the cloth or paper that will be lying on the bottom of the tray, stopping at the fold.

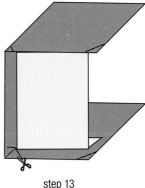

step 13

step 14

step 15

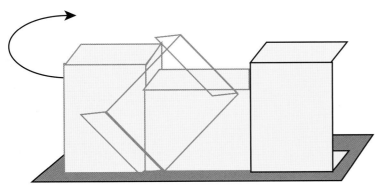

step 10

step 17

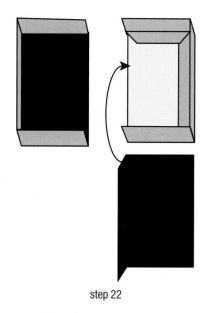

step 22

19. With the tray on its side, apply glue to the larger flaps, one at a time. Begin with the longer wall flap, this cloth or paper will cover the inner corners as well. Glue the covering flap up the wall and down into the tray. The narrower flaps will cover the small end flaps from step 17.

20. Repeat steps 11–19 for the remaining tray.

21. Cut each of the decorative papers so that they fit exactly into their corresponding trays from head to tail. Do not cut them side-to-side (spine to fore edge).

22. Apply glue to the wrong side of one decorative paper. Arrange so that it does not run up the inner walls. Wrap the extra flap around one edge of the base of the tray. Repeat for the second tray.

Preparing the case

23. Arrange the large covering book cloth or paper in front of you horizontally. Center the 3-inch (7.6 cm) spine board that you saved from step 1 (you may fold the covering cloth or paper in half to find the center).

24. Measure two board thicknesses for thin covering paper, three board thicknesses if using thick covering paper or book cloth, then place one of the remaining boards on the cloth or paper. Repeat for the other board.

25. With a pencil, draw around the boards.

26. Trim the cloth or paper so that you have an equal ¾-inch (1.9 cm) border all the way around.

27. Apply glue to the center of the cloth or paper. Press the spine board on the glue and smooth down.

28. Apply glue to the area for one board. Press that board in place and smooth down. Repeat for the second board.

29. Cut diagonals at the corners as you would for other covers.

30. Apply glue to the flaps, one at a time. To begin, choose one flap, then apply glue to the one parallel to it. Push in the corners of the covering material so that the corners will be covered.

31. Apply glue to each of the last two flaps, wrap the board, and press down. Smooth the entire case with a bone folder.

32. Apply glue to the back of the inner spine cover. Press into place across the spine, down into the grooves, and across some of the front and back boards. Smooth out with a bone folder.

33. Add a liner of heavyweight paper or bristol to even out the surface of the case before you glue it to the trays. Measure the area of the exposed board, and cut the papers to fit. Adhere with PVA. Smooth out with the bone folder.

34. Apply glue to the bottom of one of the trays. Affix to the uncovered (now with the liner) side of one board. Press and hold. Repeat for the second tray. Make sure that the box bottom is centered and that the box will close evenly before you press it into place.

35. Line the boxes with waxed paper, open edges up, and put a weight on top of each. Leave to dry overnight or a few days.

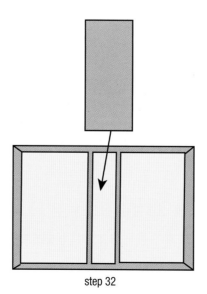

step 32

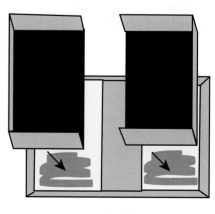

step 34

IDEAS & CONCEPTS

A woman came into my class with a basket of books she had made in other workshops. She took them out one by one, and the other students and I exclaimed at how beautiful and unusual the books were. But she didn't feel satisfied; the books were pretty, but they were all blank. She wanted to put words or images inside but didn't know where to start.

The previous chapters focus on techniques, tools, and materials for physically creating a book or box. After you feel comfortable with your acquired skills and accumulated book models you, too, may begin to wonder what to do next. Many people ask where they can take a class on "content." A teacher can help you begin, but the content comes from you. It may take the form of an overheard conversation, a family story, a series of photographs, but whatever content you work with, you should choose something that has emotional value to you, or you will lose interest in it.

Love it, hate it, think it's hilarious, grieve over it—all of these and more are good starting points. "It" could be anything from formal concepts like colors or textures that you love to a personal story— and all that fills the chasm between them.

Experiment with words as you would with art materials. When writing, your primary goal is to get thoughts onto paper. Edit and revise only after you are satisfied you have said everything you need to say. You may find that figuring out your conclusion first will make beginning easier. Or just start, and let the piece evolve as you write freely. For more inspiration, read Natalie Goldberg's *Wild Mind: Living the Writer's Life* (Bantam, 1990) or *A Life in Hand: Creating the Illuminated Journal* (Peregrine Smith Books, 1991) by Hannah Hinchman.

You can take any random thing, usually something in which you are interested, then connect it to something else about you. Examine two things. Weave them together. Sometimes you can take two things that seem to have absolutely no connection and then make one up. Take a *potato* and *chair*, for example. The only obvious connection may be that they are both brown. What about a *hot potato* and *sitting in the hot seat*? Now *hot* is the connector. The unifying emotion can be things to avoid or discomfort. As a quick exercise, pick two random objects and try the same connection practice. See the books *Poem Crazy: Freeing Your Life with Words* (Three Rivers Press, 1997) by Susan Goldsmith Woodridge or *What It Is* (Drawn and Quarterly, 2008) by Lynda Barry for more ideas.

You can bind a blank book first if you prefer, but if you compile loose pages first, you can edit or redo the pages before they are permanently attached to one another. I find gluing things or writing in blank books much more intimidating than creating the book one page at a time. It's hard to put that first mark on the paper: I'm afraid I won't like it later. Creating the pages separately gives you extra time for thinking, exploring, and repositioning.

PHYSICAL**LAYERS**

A book that has a punch line may be discarded or ignored once the punch line is reached. But if the book also has many layers, whether physical layers or multiple texts, it is more likely that readers will be intrigued and come back again to see what else they can find.

You may have a text but wish to add layers via images. The images in your book don't always have to be literal illustrations of the words. In a papermaking class at California College of Arts and Crafts, Don Farnsworth suggested that showing only part of something was much more interesting and mysterious than revealing everything at one time. Part of the beauty of bookmaking is that because you have multiple pages, you have the opportunity to reveal and conceal the subject in different places and at different paces.

One example of layers appears in the work of the Japanese artist Hon'ami Koetsu, who worked in the 1600s. He wrote on top of scrolls painted by other artists. Sometimes the poems he calligraphed seemed to have no connection to the paintings beneath them. Each of his pieces takes on new meaning as the viewer strives to understand the relationship of the words to the image. Even though the layers seem very different, the viewer still tries to connect them.

A very old layered book was rediscovered in 1998: a 10th-century manuscript called the *Archimedes Palimpsest*. Archimedes's text about mathematical physics was scraped off the parchment, leaving very faint writing. Then the text of a 12th-century prayer book was written over and perpendicular to Archimedes's original text. Although *palimpsest* (Greek for "rubbed again") used to refer only to parchment or vellum, it is now used to refer to other kinds of layers as well.

I first heard the word in reference to 20th-century poetry by H.D. (Hilda Doolittle). You can make a book with a palimpsest theme: a life that changes, one story with different endings, how a house or an object or article of clothing gets passed from one owner to the next; palimpsest can refer to anything that has semi-visible layers of history. Layers can be visual, such as the words erased and redrawn, or physical objects such as torn papers.

A travel journal is a good place to start with layers. When you travel, you may start to find yourself lining your pockets with ticket stubs, receipts, stickers, and wrappers. Maybe you don't have to travel past your own neighborhood; you collect ephemera naturally. Create a travel journal or household journal while you are still in transit or before you have an overwhelming pile on your desk. You may find it easy to do this every night before bed, while you can still remember little details of the day. Just let your hands assemble and write without trying to edit or worry how it will look. You will get more ideas as you keep your hands busy. Betsy Davids made a book with bags she collected in Greece and called it *Excess Baggage.*

Work a little at a time. Experiment. There is no one right way.

A CHILD'S INTERPRETATION

One day, I told my then five-year-old nephew Daniel that I was working on a book, not an ordinary book, but an artist's book about the earth. I was gluing pebbles to the covers and putting roots inside the book. We talked about how the stories in books could be told in many ways not only through words. He went outside and a while later came in with a collection of rocks and leaves and twigs and sat down at a table to work. He found heavy paper, glue, and tape. He experimented with how to place the materials and how to hold it all together. Hours later he showed me what he had made. He opened the heavy rock cover to reveal a page of twigs and a page covered in leaves, all layered and glued and taped together. He had made a book. Not an ordinary book, but his own artist's book.

KAREN SJOHOLM

CONCEPTUAL**LAYERS**

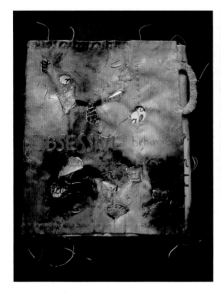

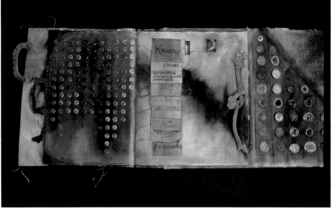

Sas Colby: *Obsessive Behavior*, 1991; acrylic on canvas, mixed media; three-panel format; 18 x 45 inches (45.7 x 114.3 cm) (photo by Sas Colby)

You have many pages to present your images and concepts, and you have plenty of time to go deeply and provide a rich experience for the reader/viewer. One way to use layers is with the materials, such as translucent pages. As you turn the pages, the information becomes revealed gradually. Think about planning physical layers to conceal, then reveal your ideas through the use of different types of papers, pockets, or flaps.

You can also layer the concepts, which can provide an even richer experience for the reader. The more successful you are with the layering, the more times the reader/viewer will want to come back to your book. Each layer in the following example assumes you have also used the layers previously listed. The book doesn't have to go like this; it could have two or three layers that aren't on this list, aren't consecutive, or begin somewhere other than with the first layer. We will work with one concept as an example.

First Layer (idea, collection). Say we take a magnifying glass and burn a hole in a piece of paper every day for two weeks. If it is raining or cloudy, we'll leave the page blank. The outcome is that we have a 14-page book with a variety of burn spots. It might be more interesting to make etchings or prints of the shapes or textures of the burns—this way we are interpreting them, transforming them, and showing that they are important or intriguing enough to make into art.

Second Layer (document). Same idea. Add the dates and times as documentation that these are our pages and that they took time to create.

Third Layer (meaning/context). Say we have used the magnifying glass that our grandmother used when she was a little girl, but no one knows this except us. We can make a note about this in the colophon or possibly on the title page. The outcome is the same as above, but we have just hinted that the magnifying glass has some value to us. We have put the pages into context.

LAYERING AND CANVAS BOOKS

The canvas books I make are layered paintings, bringing the viewer into close contact with paint and canvas. They are meant to be seen over time: turn an occasional page and experience a different relationship of color, form and space. I often cut holes as the first step and then fit the text around these voids. Seeing through layers is one of the devices unique to books, and I want my books to have this complexity. I see each painted spread as its own two-dimensional design, but it must also relate to the previous and following pages; I never sew a book together until all the painting is completed. In *Obsessive Behavior*, I combined obsessive habits, such as counting one's footsteps, with the labor-intensive textile processes, such as stitching. In addition I listed my own obsessive habits. I sold this book to a therapist. Fragility and decay are not concerns with canvas books: they are still holding up well after more than 10 years.

SAS COLBY

Fourth Layer (emotional content). Let's add a story about our grandmother and how she used her magnifying glass. In journalism, they say "put a face on it." Instead of an abstract object, we have created a character to relate to. We might understand the importance of a magnifying glass by imagining ourselves as the owner. Alternatively, we might add where we were when we burned the holes, what mood we were in, what we were thinking about, what was on the front page of the newspaper, etc. In that case, the face is our own.

Fifth Layer (research and nonfiction). We research magnifying glasses, discover who invented them and why, or write about arson or the sun, and add that to our book. This will connect our personal story to documented knowledge.

Sixth Layer (creativity/fiction). We create a mystery, write about a detective, refer to Sherlock Holmes somehow, or add a dream we have had about magnifying glasses.

Seventh Layer (surprise). We incorporate either a tactile surprise, such as a pop-up flame, or a twist to the written or visual material. We might use a dragon as a symbol. It might be that the holes portray the wrath of our grandmother because we have stolen her magnifying glass.

Eighth Layer (connection to materials and structure). By using materials that relate to our concept, we can reinforce our ideas. Our book might be round like the holes, the typeface may suddenly get very large like a flame, the book may be translucent like smoke or painted on glass or have a handle like the magnifier. It might be wrapped in our grandmother's handkerchief or placed in a matchbox-style box. If we do incorporate all of the previous layers, the book can be something to come back to over and over again.

Sheer Volume

Sometimes the number of things in a book is so impressive that it gives weight to the concept even if we don't have all of the layers. If the book in our example had 365 pages, it would certainly get more notice, no matter what anyone might think about holes burned in pieces of paper. It might inspire awe, but perhaps not a second look. We can see many examples of artists today painting a hundred views of something, or collecting a piece of paper every day, or keeping a dream journal for a year.

One example of a book that only works because of the huge number of somethings in it is *Book from the Sky* by Xu Bing, which contains 4000 characters that he carved and printed; they look like they might be Chinese, but they are all nonsense. Paraphrasing what he said at a lecture at California College of the Arts in 2007: "If it were only one sheet of paper, everyone would say it was a joke and then move on. Since there are so many characters, and it is bound in a traditional manner, it looks like a very important book, like a bible or something."

COLLABORATIONS, COMPILATIONS & EXCHANGES

Another way of adding layers is by working with other people through a collaboration, a compilation or an exchange. While each of these types of projects involve careful planning and more than one person, each project has its own advantages and limitations. You may meet your partners, or you may work independently and never meet. You may get a copy of the final book, or it may be one-of-a-kind and given away. Choose a project appropriate to the particular occasion and to your temperament.

At least three situations can provide the catalyst for a collaborative book. In one instance, you may feel confident about your writing but don't feel comfortable making images. In the other, you like your writing and your drawing, but you admire someone else's work and would like to incorporate this person's work in your book. Thirdly, you are interested in the experience of working with someone you admire. In all of these cases, you can make a book with the help of a partner or group of people.

WORKING WITH THE ELDERLY

In 2008, I volunteered at a residential facility to work with four elderly women who had varying degrees of dementia. After a few months of one-on-one sessions making prints and watercolors, I designed an edition of a book for each woman based on the art we made together and the life stories she told me. During the process, the women were keenly focused on past things that continued to interest them, and they expressed their tales in creative ways. Although their initial reactions to this book project ranged from enthusiastic to skeptical, their responses to the finished books were overwhelmingly positive. One woman, perhaps the most skeptical at the beginning, now carries a copy of her book in her walker, never missing an opportunity to show it to everyone she meets. This project led me to establish Relay Replay Press to continue creating collaborative artist's books with the elderly.

SHU-JU WANG

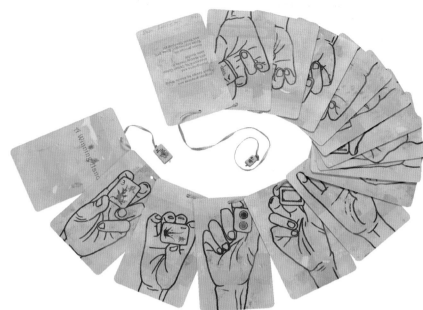

Shu-Ju Wang and Esther: *Esther*, 2008; gocco printing on paper, mah-jongg tile closure; palm leaf book; edition of 20; 6$^{1}/_{16}$ x 3$^{15}/_{16}$ x $^{5}/_{8}$ inches (15.4 x 10 x 1.6 cm) (photo: Bill Buchhuber)

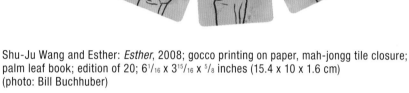

Robbin Ami Silverberg: *titok*, 1996/98; Twenty-seven 4-inch (10.2 cm) boxes; mixed media, images made of photos, photocopies, prints; CD of violin music; collaboration with 20 artists who sent their secrets; edition of 5; 12 x 12 x 12 inches (30.5 x 30.5 x 30.5 cm) when closed (photo by József Rosta)

A Secret Collaboration

Robbin Ami Silverberg created a one-of-a-kind bookwork called *titok* ("secret" in Hungarian). She sent letters to 21 artists, writers, and musicians and asked them to tell her about a secret. Many times she altered or added to the material she received; she also responded by creating her own secrets. She then created blocks; one secret to a box. Some of the boxes are fully closed, some have peepholes, and some are open with additional boxes within. Robbin writes, "*titok* is not a linear narrative, since secrets, a priori, cannot be known, or they cease to exist. There is no one entry and no one exit. It is about reading a book by its cover, not turning the pages."

COLLABORATING ACROSS CULTURES

The concept was to hand out the T-shirts to friends and to people at the Seongnam, Korea, 2007 book fair where I was invited to speak and where Ivary and I had a booth. The T-shirts were given with the stipulation that the recipients would photograph themselves in the shirt and e-mail a jpeg to either one of us. Eventually we got about a 50% response, and the book was made. We are currently working on a published fold book of the pictures that will be about 3.5 x 5 inches [8.9 x 12.7 cm].

KEITH SMITH

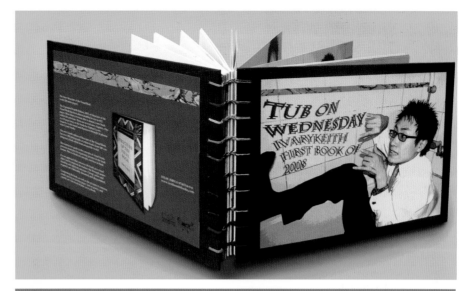

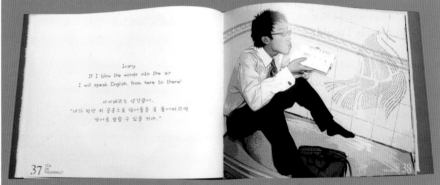

Ivarykeith: *Tub on Wednesday*, 2009; print-on-demand pages; Coptic with paired needles; prototype for edition of 20; 7 x 9 inches (17.8 x 22.9 cm) (photo: Keith Smith)

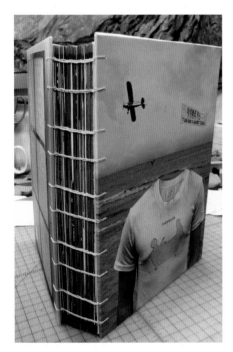

Ivarykeith: *Clothes Friends*, 2008; Coptic with paired needles; 12 x 9 x 2 ¼ inches (30.5 x 22.9 x 5.7 cm) (photo: Keith Smith)

A Digital Collaboration

Keith Smith has been collaborating with a Korean artist, Kim, Myoung Soo. In an e-mail Keith wrote, "Half my work in the last four years is books made with him. Those books are under the name Ivarykeith. (Ivary is his English name.) We were speaking in pictures since we had no common verbal language at the time." Sometimes, Ivary makes collages with the pictures that Keith sends him. Other times, one will make a new picture in response to one sent. The pictures speak across language, culture, and generation. Keith continues, "When my books were exhibited at the rare Books Library at University of Rochester, the curator said he saw a six- or seven-year-old boy standing, looking at the two

pictures. He exclaimed to his father, 'Look! He is a super hero. He climbs out of the book!'"

Keith and Ivary work on digital pages that they then upload to a print-on-demand online service. The tricky part is that the book they order from the website is a single stapled signature, which is best suited to about five folded sheets. Since their books contain as many as 72 pages, they upload the pages in an alternate order so that when they unbind the too-fat single-signature book, they can rebind it into a more sensible multiple signature binding and have it make sense. They add endsheets, a new cover, and hand sewing, creating a full-color book that is printed easily by machine but bound by hand.

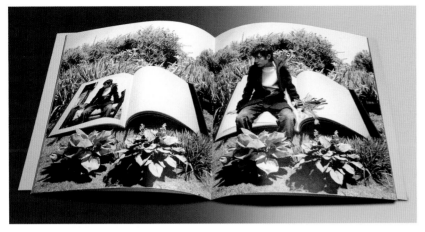

Ivarykeith: *The Blue Book, 2007*; Coptic with paired needles; larger version is a 15-inch (38.1 cm) square inkjet-printed accordion fold book; smaller version is 8½-inch (21.6 cm) square codex from print-on-demand pages (photo by Keith Smith)

For a week, Keith sent me a "book a day" via e-mail, which consisted of digital photos and a detailed description. It was quite a treat to be able to view them this way, the only way I could see them since he is in New York and I am in the San Francisco area. This brings up the possibilities for creating books that appear only online, but that is the subject for another book and another author!

Collaborating with someone who is very different from you can be a tremendous learning experience. Be ready to compromise, explore, and let the book have a life of its own!

In academic circles, there is the custom of the compilation called a Festschrift, which is German for "festival writings." When a scholar is to be honored, such as for a birthday or celebration of many years of teaching, colleagues and admirers write academic articles and essays. Create a tribute or birthday book with the flavor of the Festschrift using writings and images that are personal. You might assemble photographs, jokes, anecdotes, a time line or biography, songs, photocopies of favorite objects, collages that depict the honoree's interests, or anything else that will lie flat in a book.

While it is fun to create a one-of-a-kind collaborative or compilation book, you can also create an edition of a book that incorporates pages from different people: an exchange.

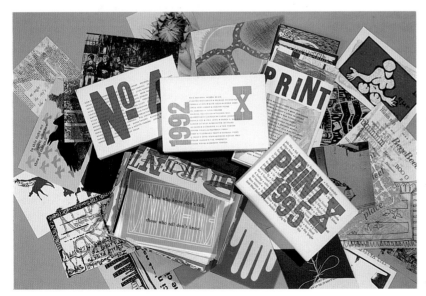

Print Exchanges, 1992-1995; varying editions of 50-75; 6 x 4 inches (15.2 x 10.2 cm) (photo: Sibila Savage)

Exchanges

In 1991, fourteen people responded to my request to make a page for an exchange book, although two people did not leave the margin I requested. If you instigate an exchange project, remember to give specific instructions, but try to plan your book so that the limiting factors are few; even the most well-intentioned people do not read carefully. Each person printed 50 copies of their page. I collated the pages and bound 50 small books. Each participant received three copies of the book. The following year we made postcards instead, and the project continued for five more years. The themes were broad, and, I hoped, provocative in some way. I expressed my desire for the contributors to merge words and images in one piece.

Catherine Michaelis organized an exchange for a printer's deck of cards based on a project of large-scale quilted cloth cards. She called the project *Stack the Deck* and asked the participants to work with the theme "women's health and healing." Twenty-two letterpress printers participated; each was assigned three cards (jokers, title, and index cards were included). (See page 192.)

Letterpress printing is not required for this type of project. A group of women poets in the San Francisco Bay area created an ongoing poetry journal called *Rooms*. Each participant sent 50 photocopies of her piece plus a nominal postage fee. The organizers collated and bound the poems and send a copy of the collection to each contributor.

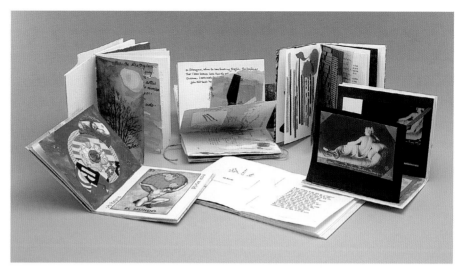

Rotating Notebooks, 2000; each multiple signature codex; 6 x 7½ inches (15.2 x 19.2 cm); back row: *Le Royaume du Ciel* by Patricia Behning, page by Patricia Behning; *Loose Edges* by Lynne Knight, orange page by Yoko Yoshikawa, green page by Alisa Golden; *Logdark* by Nan Wishner, page by Nan Wishner; front row: *Guide from Thin Air* by Marc Pandone, page by Val Simonetti; *The Hope That Is Under My Skin* by Alisa Golden, page by Lynne Knight; *i scream u scream* by Val Simonetti, page by Marc Pandone (photo: Sibila Savage)

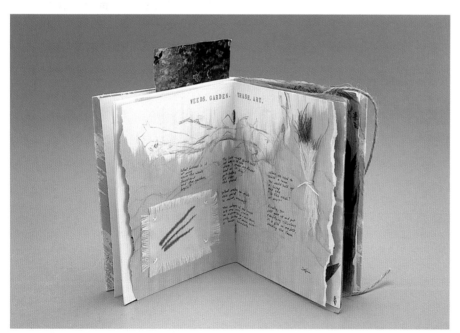

Rotating Notebooks, 2000; *Loose Edges* by Lynne Knight, page by Alisa Golden; mixed media; multiple signature codex; 6 x 7½ inches (15.2 x 19.2 cm) (photo: Sibila Savage)

Rotating Notebooks

Another exchange, sometimes known as rotating notebooks or a round robin, is a good excuse for a group to gather regularly. In this exchange, each person begins with a blank book of her own choosing to which she gives a theme and a title. You could also make the first meeting the time to make the books. Each artist draws or writes on one page, then passes it on to the next person in the group until everyone has created a page in response to the theme and entries before it. You will then have as many unique books as you have participants. This is not an edition but a kind of series. I recommend giving each participant a time limit, such as a month, so that the books are finished in your own lifetime. Find a place like a public library to exhibit all the books, or have a book party if the participants all live near one another.

Exquisite Corpse

Another collaboration, one of the Surrealist games of the 1920s, *Cadavre exquis* got its name from the first sentence that appeared the first time the game was played: "The exquisite / corpse / will drink / the new / wine."

The Silver Buckle Press at Memorial Library at the University of Wisconsin at Madison organized *A Printer's Exquisite Corpse*. Each printer was assigned a segment of the body: head, upper torso, lower torso, and feet. The size of the card was specified, with marks on the card determining where the participant's segment should go. The final cards were printed in an edition of 100, collated and placed in a beautiful handmade box that had dividers in it so that one corpse could be displayed at a time. The project was so successful that a few years later the press launched a second project called *Exquisite Horse*.

One particularly exciting exquisite corpse book is *Emandulo Re-Creation*. Robbin Ami Silverberg organized the project at Artist Proof Studio, a printmaking facility set up for black artists in South Africa. Nineteen South African artists, one artist from Ghana, Robbin, and her husband András (both professional artists themselves) each made a full-size print depicting a creation myth. The prints were then cut in half and each half cut into thirds to create two exquisite corpses, which were bound into an accordion-style spine. This exchange proved dynamic as Robbin did not tell the artists where the body parts were to end exactly, only which quadrants to use. Sometimes the legs are in the middle, sometimes on the side, sometimes there are no legs.

This use of the exquisite corpse format is also conceptually interesting as it literally created a mix between a wide range of artists of both different artistic styles and also cultural and racial backgrounds.

Create your own exquisite corpse, and put it in a book with pockets. Or make a flag book, adhere it to an accordion, color-photocopy or print the pieces via inkjet, and make a folded pamphlet or other accordion or ox-plow book.

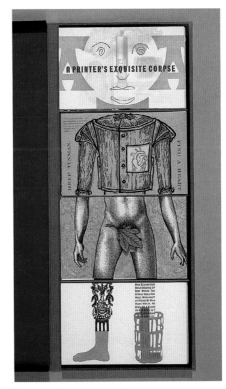

Silver Buckle Press: *A Printer's Exquisite Corpse*, 1992; cards from top to bottom by: Silver Buckle Press; Bonnie O'Connell, The Penumbra Press; M.J. Pauly, Lychnobite Press; Alisa Golden, never mind the press; 18½ x 21½ inches (47 x 54.6 cm)

WRAPPING**IT UP**

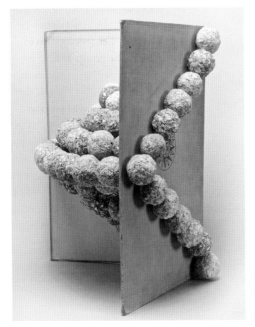

Lisa Kokin: *Four Balls Short*, 2008; reassembled atlas, PVA, wire; 15¼ x 15 x 10 inches (38.7 x 38.1 x 25.4 cm) (photo: Lia Roozendaal Jagwire Design)

I heard a story about a baker. He had made pies for years and years, and they were perfect. One day he mistakenly left a thumb print in one of the piecrusts. That day he sold the pie with the thumb print first. Suddenly he was aware that people like to know that a human actually made the goods. Does the thumb print signify a mistake? Reassurance that no one is perfect? Reassurance that a person made the pie, that it wasn't made by machine? In the late 1800s, the Industrial Revolution changed how people thought about the world. Eventually, the craftsperson was driven out of business by factories that could make the same item faster and cheaper. Now, in the 21st century, we are finding that we miss the look and feel of things made by hand; we are buying the

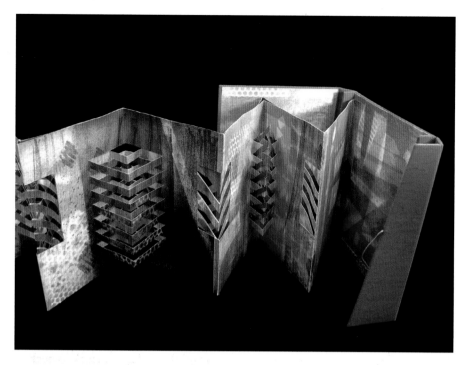

Carol Barton: *Rhythmic Notes*, 1990; offset lithography with paper plates; accordion with pop-ups; 7¹/₈ x 9 x 12 inches (18.2 x 22.9 cm); 58 inches (1.5 m) extended (photo: Carol Barton)

irregular piecrust with the thumb print. The story is about all aspects of making things—in our case making book art.

Through your mistakes, you will find which structures work for you and which can be modified. You can make the same book from many angles; there is no "right" way. Adapt the bindings for your particular project and make them your own. See what your book "wants." Then, pass your findings along to others.

You can make books more exciting to children by giving them a sense of pride as they learn to make their own, or you can make books for children you know that are personal and related to something with which they are familiar. Looking at books in a personal, fresh way can excite and stimulate an interest in reading and writing as well as provide a structure for creative expression.

Book art doesn't have to be mysterious and formal, subject to other people's decisions. You have the power to create your own books. You can present a story in various ways; different book structures enhance each telling. Your books must be technically proficient to be taken seriously, but something of you must show; it must be apparent that you touched every piece included in your book. Maybe you decorated the paper or painted the cover, cut out shapes in the pages, or added tags, doors, or windows. An unusual structure shows that you thought about the content and that the theme of your book is echoed in it.

Your books will soon have an identity; only you could have made them. We often define ourselves by our stuff: what colors we like, the things we collect, the way we arrange pictures on a blank wall. Look in your desk drawer, and you may find a collection: canceled stamps, dried flower petals, beads, or pens. What does this say about you and your relationship to the world? Create a book from your collection.

The more books you make, the better you get at both the art and the craft. Give yourself time to practice. Be flexible and willing to explore. As you explore, you will learn to make sturdy books that convey your unique vision. But don't stop there. Although you may never think you're done, show your work. Your personal expression can become inspiration for others.

In our expanding world of screens and keyboards, we need handmade books that have texture and smell and a personal feel. If you think you've made a mistake, add to it, change it, and let the book evolve into something else. It's yours.

Alice Austin

Alice Austin is a printmaker and book artist in Philadelphia, Pennsylvania. She teaches book structures at the University of the Arts, works as a rare book conservator, and is a longtime member of the Guild of Bookworkers. Her artist books are in many collections and are also featured in *500 Handmade Books* and *Magic Books and Paper Toys*. www.amaustin.com

Carol Barton

Carol Barton is a book artist, curator, and teacher who runs Popular Kinetics Press. She has been creating her own offset editions of sculptural and pop-up books for almost 30 years. She served as curator for the Smithsonian Institution's exhibition Science and the Artist's Book and is on the faculty at the University of the Arts in Philadelphia. Her most recent books, *The Pocket Paper Engineer, Volumes 1* and *2*, are how-to guides to making pop-up cards and pages.

Carol J. Blinn

Since 1973, Carol J. Blinn of Warwick Press in Easthampton, Massachusetts, has been designing with type, letterpress printing texts, illustrating, writing, hand-binding, decorating paper, selling her work, and doing commercial work for hire. Carol's ephemera, broadsides, and limited editions are widely collected by rare book dealers, libraries, and private collectors throughout the United States. Her penchant for drawing waterfowl has earned her the title, "The Duck Lady."

Carolee Campbell

Carolee Campbell is the proprietor of Ninja Press, which she inaugurated in 1984. She designs each edition, which she illustrates, hand-sets in type, prints, and binds. Her books are exhibited internationally and collected both privately and in such institutions as the Getty Center and The British Library. The entire Ninja Press archive is housed at the University of California, Santa Barbara.

Julie Chen

Julie Chen is an internationally known book artist who has been publishing limited edition artist's books under the Flying Fish Press imprint for over 20 years. Her work can be found in numerous collections, such as that of Yale University, The Museum of Modern Art, and the Victoria & Albert Museum. She teaches in the book art program at Mills College in Oakland, California, as well as teaching workshops at institutions around the country.

Sas Colby

Sas Colby has been making mostly one-of-a-kind books since 1972. She teaches art retreats in New Mexico and Spain and workshops at Haystack Mountain and Penland, among others. Her work may be found in The Bibliotheque Nationale and the National Museum of Women in the Arts and is collected and shown by many other institutions and libraries. Colby has been awarded residencies at The Ucross Foundation, Villa Montalvo and at the Djerassi Foundation.

Betsy Davids

Betsy Davids began making books in 1970. Her own imprint, Rebis Press, became known for editions that merged new literary texts and images, fine print production values, and nontraditional materials. She was an early practitioner of the artist book. Since 1990, her books have been one-of-a-kind and handmade, emanating from her dream writing practice and travel experience. At California College of the Arts, where she is Professor Emerita, she has taught bookmaking and letterpress printing since 1972.

Cathy DeForest

Cathy DeForest has been making books since 1992 based on her original text, drawings, etchings and photography. Jubilation Press and her gallery, Gallery DeForest, specialize in artist books and letterpress broadsides of Poet Laureates and other writers. She is a guest teacher at Santa Reparata International School of Art in Florence, Italy, and her work is collected by: UCLA, Yale, and the Oakland and SF Palace of Legion Museums.

Marie C. Dern

Marie C. Dern began Jungle Garden Press in Berkeley, California, in 1974. The Chandler & Price letterpress was housed in a basement behind a tangle of vines and wild roses. The press moved to Fairfax, California, where she has continued, producing over the years some 50 editions of letterpress printed, hand-bound books. She publishes poetry and prose and often collaborates with other visual artists.

Johanna Drucker

Johanna Drucker is the inaugural Breslauer Professor of Bibliographical Studies at UCLA. She is known for her work in experimental typography and visual poetry as well as in the history of artists' books, digital aesthetics, and graphic design. *Graphic Design History: A Critical Guide*, which she authored with Emily McVarish, was published by Pearson/Prentice-Hall in 2008.

Karla Elling

Karla Elling is the proprietor of Mummy Mountain Press & Paper Mill, where she has produced many limited edition broadsides for poets and writers, including Alberto Rios, Rita Dove, Donald Hall, Stanley Kunitz, and Peggy Shumaker. Her typography and design extends from the page to the neighborhood—in the form of a six-mile-long "book" at the Tempe Town Lake.

CJ Grossman

cj grossman is a mixed media artist who specializes in books and unique papercuts. Grossman has an MFA from CCA. She exhibits nationally, and her work may be found at www.artjazzbooks.com. Her books can be found in many university libraries. She teaches adults and kids, and lives in Berkeley with some real people and her invisible dog, Celery, whose name changes every month.

Michael Henninger

Michael Henninger has been making book art under the Rat Art Press imprint since 1988. He is also a professor of art, teaching book, print, and digital arts at Cal State University, East Bay. His work can be found in special collections across the United States, including the Brooklyn Museum, UCLA, and University of Utah Marriott Library.

Charles Hobson

Charles Hobson has worked with artists' books for more than 25 years, covering such topics as famous couples who met in Paris (*Parisian Encounters*) and Leonardo's lessons on drawing the human figure (*Leonardo Knows Baseball*). He teaches at the San Francisco Art Institute, and his works are held by the Museum of Modern Art and the Whitney Museum, among others. His archive has recently been acquired by Stanford University. www.charleshobson.com

Terry Horrigan

Terry Horrigan has been making letterpress books and broadsides under the imprint Protean Press since 1982. A complete collection of her work may be found at San Francisco Public Library Book Arts and Special Collections and California State Library and is included in the collections of many other institutions, libraries, and private individuals. Her archives are available at the Bancroft Library, University of California Berkeley.

Ed Hutchins

Ed Hutchins is the proprietor of Editions, a studio for producing artist book multiples. He has given workshops in five countries in two hemispheres.

Paul Johnson

Paul Johnson is internationally recognized for his pioneering work in developing literacy through the book arts and as a book artist. He is the author of over 15 titles, including *A Book of One's Own* and *Literacy Through the Book Arts*. He is represented in most of the major collections in the United States. In 2008, he was awarded the Colophon Award from the Canadian Bookbinders and Book Art Guild.

Alastair Johnston

Alastair Johnston co-founded Poltroon Press in Berkeley with Frances Butler in 1975. He teaches design and typography classes at the University of California Extension and book arts and creative writing at elementary schools in Contra Costa County. His published books include *Alphabets to Order* (British Library, 2000), *Zephyrus Image: A Bibliography* (Poltroon Press, 2003), *Ellipsis* (essays about book arts, 2008), and *Nineteenth-century American designers and engravers of type* by Wm F. Loy (Oak Knoll, 2009).

Susan King

Susan King is an artist and writer who started making letterpress and offset books in the 1970s. She produced editions of artists' book at Paradise Press in Los Angeles for over 25 years before moving to rural Kentucky. Her work is in major collections, such as the Getty Research Library and The Museum of Modern Art Library in New York. She teaches workshops around the country. www.susanking.info

Lisa Kokin

Lisa Kokin has been making one-of-a-kind artist's books from found materials since 1991. She alters, reassembles, shreds, pulps, and otherwise rearranges discarded books, which she collects at the local recycling center. She teaches art in skilled nursing facilities and bookmaking with found materials at the California College of the Arts, John F. Kennedy University, and privately in her studio. Her work is in numerous private and public collections. www.lisakokin.com

Emily Martin

Emily Martin has been making books since 1975 and mostly movable and/or sculptural books under the imprint of the Naughty Dog Press since 1985. She teaches at the University of Iowa Center for the Book. Her work may be found in the Metropolitan Museum of Art in New York and the Victoria & Albert Museum, London, and collected and shown by many other institutions and libraries nationally and internationally.

Dan Mayer

Dan Mayer produces experimental bookworks at his Nomadic Press, which was established in 1983. He has been the Master Printer/Studio Manager for Pyracantha Press, Arizona State University since 1986 and teaches artist's books and printmaking. Collections include the Getty Center and the Klingspor Stadt-Museum, among others. Activities include public art projects, national and international exhibitions, and residencies at Franz Mayer Architectural Glass in Munich, Ucross Foundation, and the Glasgow Print Workshop.

Catherine Alice Michaelis

Catherine Alice Michaelis has been making letterpress printed editioned and artist's books under the imprint of May Day Press since 1991. Her work is in over 50 public institutions including The Heard Museum, Getty Research Institute, and Yale University. She is the recipient of the Best Letterpress Design award from Bumbershoot Arts Festival and Third Choice Artist Book from NW Bookfest.

Scott McCarney

Scott McCarney is an artist, designer, and educator based in Rochester, New York. His primary art practice has been in book form since 1980. His works are widely distributed and can be found in the library collections of The Museum of Modern Art, New York, and Victoria & Albert Museum, London, among others. His work is shown internationally as well as close to home. He is currently an adjunct faculty member of Rochester Institute of Technology.

Katherine Ng

Katherine Ng, proprietor of Pressious Jade, has been making artist books since 1992. She currently works as an art teacher in Los Angeles. Her work can be seen at the Smithsonian and the Walker Art Center and is collected by other institutions and libraries. She is the author of *Banana Yellow* and a past recipient of California Arts Council grants.

Penny Nii

Penny Nii has been making artist's books for about 10 years. Her books have been exhibited in galleries and museums as well as libraries and traveling shows. Her books are in private collections and at University of California, Santa Cruz. She served on the board of the San Francisco Center for the Book, where she founded their imprint and artists-in-residence programs.

Bonnie Thompson Norman

Bonnie Thompson Norman has been proprietor of The Windowpane Press, a letterpress printing and book arts studio, for over 20 years. She works full-time as a hand bookbinder in a commercial bindery. Evenings and weekends, she teaches classes in printing and bookmaking. Her studio contains a variety of printing presses, hundreds of cases of type, a guillotine paper cutter, a Jacques board shear and, not the least, a wonderful library.

Nance O'Banion

Nance O'Banion is a professor of printmaking at the California College of the Arts, teaching book arts, print seminars, interdisciplinary courses, and graduate students since 1974. Her innovative works in textiles, papermaking and artist's books have been recognized internationally since the 1970s and are included in major museum collections in Europe, Japan, Canada, and the United States. Nance creates both unique and editioned books, along with other artworks.

Linda Race

Linda Race was introduced to book making through calligraphy classes beginning in the early 1990s. She makes art in a wide variety of media. Her books have been exhibited at the San Francisco Public Library, The Mills College Olin Library, and the Berkeley Art Center. Linda has served on the board of the Friends of Calligraphy and written articles on calligraphy and artist's books for the guild's journal, *Alphabet*.

Harry Reese

Harry Reese is professor of art at the University of California, Santa Barbara, where he has taught print, papermaking, book art, visual literacy, public art, and media ecology classes since 1978. His partnership with Sandra Liddell Reese began in 1975, and together they produce limited edition print and book projects for their Turkey Press and Edition Reese imprints.

Coriander Reisbord

Coriander Reisbord (the Skeptical Press) has been making books since 1988. Her work can be found in various collections, including Yale University, Stanford University, and the Getty Research Library. She teaches when she can, and her day job is repairing rare books, primarily those of the 19th century.

John Risseeuw

Professor John Risseeuw, Arizona State University (ASU), teaches book arts and printmaking. He has directed Pyracantha Press at ASU since 1982 and his own Cabbagehead Press since 1972. His work has been shown and collected widely in the United States and abroad. Publications referencing it include *The Complete Printmaker*, Ross, Romano, and Ross; Sarah Bodman's *Creating Artist's Books*; and Betty Bright's *No Longer Innocent*.

Anne Hicks Siberell

Anne Hicks Siberell has made handmade books for more than three decades. Her one-of-a-kind and editioned books have been distributed internationally and, more recently, in the Middle East, where she teaches book arts during school visits. Her work is in many collections, including the Victoria & Albert and the Getty Museum. She has received several grants and residencies and was a visiting artist at the American Academy in Rome.

Karen Sjoholm

Karen Sjoholm is an exhibiting artist whose book works and installations focus on the intersection of materiality and spirit. She is chair of the department of arts & consciousness at John F. Kennedy University in Berkeley, California .

Robbin Ami Silverberg

Robbin Ami Silverberg is an artist living and working in Brooklyn, New York. Her artwork is divided between solo and collaborative artist books and large paper installations. Silverberg is founding director of Dobbin Mill, a hand-papermaking studio, and Dobbin Books, a collaborative artist book studio. She is assistant professor at Pratt Institute and has exhibited and taught extensively internationally. Her artwork is found in numerous public collections and has appeared in such publications as *The Smithsonian Book of Books*.

Val Simonetti

Val Simonetti is a book artist and letterpress printer in Richmond, California, working under the imprint Hand-in-Glove Press. Since 2000, she has also worked for One Heart Press, a commercial letterpress shop in San Francisco.

Keith Smith

Keith Smith has made 270 books since 1967. Fifty-four of these have been self-published, including nine textbooks. Smith has received two Guggenheim Fellowships and grants from the National Endowment for the Arts and other agencies. His work is in the collections of the Museums of Modern Art of New York and San Francisco and others in the United States, England, Canada, France, and Japan.

Anne Hayden Stevens

When Anne Hayden Stevens makes books, it is under the imprint Hayden Press. Her work is included in the collection of Columbia University and Mills College, among others. Her practice stretches from public art to painting. She has lived and worked in the Bay Area, Seattle, and works now in the Chicago area.

Peter and Donna Thomas

Peter and Donna Thomas, authors and illustrators of *More Making Books by Hand*, are self-employed book artists, papermakers, and letterpress printers who write, illustrate, and bind their own book. Since 1977 they have produced over 125 limited edition books and over 300 one-of-a-kind artist's books, which can be found in collections around the globe.

Andie Thrams

Andie Thrams is a visual artist and occasional publisher as Larkspur Graphics. Her forest field journals have evolved into unique artist's books now held at Yale University, University of Washington, and other collections. Her work is widely exhibited and has received awards from institutions including Yosemite Renaissance. She teaches for San Francisco State University Field Campus, San Francisco Center for the Book, and other institutions.

Shu-Ju Wang

Shu-Ju Wang started making books in 1999. She creates books under her own name and as Relay Replay Press, working with seniors with dementia to create artist's books that illuminate the lives of the elderly. She is known for her technical excellence with the Print Gocco, the main medium for her artist's books. Her books can be found in numerous publications and public collections.

Dorothy A. Yule

Dorothy A. Yule has been making unique and limited edition artist's books under her imprint, Left Coast Press, for 20 years. Her work is in museums and libraries in the United States and in Europe. Two of her limited edition books — *Souvenir of San Francisco* and *Souvenir of New York* — were produced in offset facsimile as gift books by Chronicle Books in 2005.

Philip Zimmermann

Philip Zimmermann has been making artist's books since 1974. After 24 years at Purchase College, SUNY, he now teaches at the University of Arizona. His work is in numerous national and international special collections, both private and public. He is the author of 21 artist's books and has been the recipient of fellowships such as the National Endowment for the Arts and the New York Foundation for the Arts.

ABOUT THE AUTHOR

Alisa Golden is an artist and writer who has been making books under the imprint never mind the press since 1983. She is adjunct professor at California College of the Arts, teaching bookmaking and printmaking, and the author of several instructional books, including *Expressive Handmade Books* and *Painted Paper.* Her book art is exhibited and collected by libraries and institutions nationally; a complete collection may be found at the University of Iowa and at Kansas State University, and on her website at www.neverbook.com.

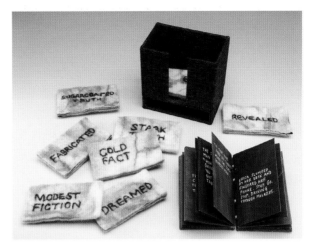

Fuzzy Logic (The Decoy), 2010; handmade felt, Davey board, acrylic ink, painted paper, linen thread, book cloth; four-needle Coptic binding 4 x 4 x 2½ inches (10.2 x 10.2 x 6.4 cm) box; 2⅜ x 3½ x 2 x⅝-inch book (6 x 8.9 x 1.6 cm) (photo by Sibila Savage)

ACKNOWLEDGMENTS

Several key people have contributed to the field of bookbinding in book art. They have been teachers, writers, conservation binders, and more. Keith Smith has explored books, beginning when he was a photography student, and has written volumes of bookbinding books. Hedi Kyle, now retired from her career in teaching and as a conservator of rare books, continues to experiment with paper-folding techniques. Paul Johnson has coupled his own developments of folded paper structures with teaching reading and writing in a classroom setting, and he has written many books of his own. Edward Hutchins has collected these bindings, designed others, and has taught extensively, making connections across the United States and abroad. Johanna Drucker has written about the history of bookmaking and contemporary book art and continues to teach in academic settings. Betsy Davids, who pioneered book art at California College of Arts and Crafts, was my first teacher and is now my colleague and friend. These are only a few people of the many, including the artists presented here, who have been expanding their and our knowledge of how a book can work. Thanks to everyone who has worked with me, including my students! I wish I could list all of you here.

Combined with new material, this book also merges with my first two books, *Creating Handmade Books* and *Unique Handmade Books.* I wish to reiterate thanks to the folks who were directly part of one or both books: Betsy Davids; Jim Hair, photographer; Sibila Savage, photographer; Nan Wishner, for editing *Creating Handmade Books'* first draft; and Anne Hayden Stevens (neé Schwartzburg) and Val Simonetti for proofreading and for their input and suggestions on *Creating Handmade Books.* I would also like to thank my then-editor at Sterling, Hannah Reich, who encouraged me and made the revision process as entertaining as it was productive. Big thanks to the book "testers," who tried out some of my written instructions: Gina Covina, Linda Faber, Laurie Gordon, Trish Henry, Marie Mason, Peter McCormick, Claudia Moore, Val Simonetti, Karen Sjoholm, Melissa Slattery, Nan Wishner, and especially to Gina Lewis. Thanks to Lisa Kokin for inviting me to teach with her more than once at homeless shelters in Oakland and Berkeley and for our monthly lunches. Thanks to Nan's art and writing salon group, which tested the first rotating notebook project: Patricia Behning, Lynne Knight, Marc Pandone, Val Simonetti, Nan Wishner, and Yoko Yoshikawa. Acknowledgments also to Patti and Roger Golden, my parents, for supporting my art education and to my sister Nina for collecting and promoting my work. I thank most of all my husband, Michael, who encouraged me to write the first book and has strongly supported me all along, and my children, Mollie, now a college student, and Ezra z"l, whom I will always miss.

BIBLIOGRAPHY

Barry, Linda. *What It Is.* Canada: Drawn & Quarterly, 2008.

Barton, Carol. *The Pocket Paper Engineer, Volume 1: Basic Forms: How to Make Pop-Ups Step-by-Step.* Maryland: Popular Kinetics Press, 2005, 2007.

Bradbury, Ray. *Zen in the Art of Writing: Releasing the Creative Genius Within You.* New York: Bantam Books, 1992.

Carter, David A. and James Diaz. *The Elements of Pop-Up.* New York: Little Simon, an imprint of Simon & Schuster Children's Publishing Division, 1999.

Courtney, Cathy. *Speaking of Book Art: Interviews With British & American Book Artists.* California: Anderson-Lovelace, 1999.

Ekiguchi, Kunio. *Gift Wrapping: Creative Ideas from Japan.* Japan: Kodansha, 1987.

Goldberg, Natalie. *Wild Mind: Living the Writer's Life.* Author of *Writing Down the Bones: Freeing the Writer Within).* New York: Bantam Books, 1990.

Gross, Gay Merrill. *The Art of Origami.* 1993, 1995.

Heller, Steven and Mirko Ilic. *Handwritten: Expressive Lettering in the Digital Age.* New York: Thames & Hudson, 2006.

Hinchman, Hannah. *A Life in Hand: Creating the Illuminated Journal.* Utah: Gibbs M. Smith, Inc., Peregrine Smith Books, 1991.

Ikegami, Kojiro. *Japanese Bookbinding: Instructions from a Master Craftsman.* New York; Japan: John Weatherhill, Inc., 1986.

Johnson, Paul. *A Book of One's Own: Developing Literacy Through Making Books.* New Hampshire: Heinemann, 1992.

Johnson, Pauline. *Creative Bookbinding.* Washington: University of Washington Press, 1963; New York: Dover Books, 1990.

Kahlo, Frida. *The Diary of Frida Kahlo.* New York: Harry N. Abrams, 1995.

Kalman, Maira. *The Principles of Uncertainty.* New York: The Penguin Press, 2007.

Kitagawa, Yoshiko. *Creative Cards: Wrap a Message with a Personal Touch.* New York: Kodansha America, 1990.

Kirwin, Liza. *More than Words: Illustrated Letters from the Smithsonian's Archives of American Art.* New York: Princeton Architectural Press, 2005.

LaPlantz, Shereen. *Cover To Cover: Creative Techniques for Making Beautiful Books, Journals & Albums.* North Carolina: Lark Books, 1995.

Lark Books. *The Penland Book of Handmade Books: Master Classes in Bookmaking Techniques.* North Carolina: Lark Books, 2004.

Lark Books. *500 Handmade Books.* North Carolina: Lark Books, 2004.

Mauriello, Barbara. *Making Memory Boxes.* Massachusetts: Rockport Publishers, 2000.

McCloud, Scott. *Making Comics: Storytelling Secrets of Comics, Manga and Graphic Novels.* New York: HarperCollins, 2006.

New, Jennifer. *Drawing from Life: The Journal as Art.* New York: Princeton Architectural Press, 2005.

Philips, Tom. *A Humament.* England: Thames and Hudson, 2005.

Polhemus, Coleman. *The Crocodile Blues.* Massachusetts: Candlewick Press, 2007.

Rico, Gabriele Lusser. *Writing the Natural Way.* California: J.P. Tarcher, Inc., distributed by St. Martin's Press, 1983.

Shulevitz, Uri. *Writing with Pictures: How to Write and Illustrate Children's Books.* New York: Watson Guptill (reprint 1997).

Smith, Keith A.. *Non-Adhesive Binding, Books without Paste or Glue.* New York Sigma Foundation, Inc., 1992. Also: *Structure of the Visual Book* (Expanded Fourth Edition); *Text in the Book Format; Non-Adhesive Binding, Vol. 3: Exposed Spine Sewings.*

Thomas, Peter and Donna. *More Making Books by Hand: Exploring Miniature Books, Alternative Structures, and Found Objects.* Massachusetts: Quarry Books, 2004.

Steiner, Elizabeth and Claire Van Vliet. *Woven and Interlocking Book Structures.* Vermont: Janus Gefn Unlimited, 2002.

Webberley, Marilyn. *Books, Boxes & Wraps: Bindings & Building Step-By-Step.* Washington: Bifocal Press, 1995.

Wilson, Adrian. *Design of Books.* California: Chronicle Books, 1994 (reprint).

Wooldridge, Susan Goldsmith. *Poemcrazy: Freeing Your Life with Words.* New York: Three Rivers Press, member of the Crown publishing group, 1996.

Zeier, Franz. *Books, Boxes & Portfolios: Binding, Construct and Design, Step-By-Step.* New York: Design Press, imprint of TAB books, division of McGraw-Hill Inc., 1990.

INDEX